Asia's Wildlife

# A Journey to the Forests of Hope

Published by
Bjorn Olesen Wildlife Photography, Singapore

First published in 2018

Copyright © Fanny Lai and Bjorn Olesen
www.bjornolesen.com

© Photography: Bjorn Olesen, 2018, except individual photographers credited on page 247.

This Forestry Stewardship Council™ logo offers a guarantee that the products used to make this book come from responsible sources.

The representation of material on maps throughout the book does not imply the expression of any opinion whatsoever on the part of the authors concerning the legal status of any country and territory, or concerning the delimitation of its frontiers or boundaries.

ISBN: 978-0-7946-0813-2

Printed in Malaysia by TWP Sdn. Bhd.

Distributed by
**North America, Latin America & Europe**
Tuttle Publishing, 364 Innovation Drive, North Clarendon, VT 05759-9436 U.S.A.
Tel: 1 (802) 773-8930; Fax: 1 (802) 773-6993
info@tuttlepublishing.com; www.tuttlepublishing.com

**Asia Pacific**
Berkeley Books Pte. Ltd, 61 Tai Seng Avenue, #02-12, Singapore 534167
Tel: (65) 6280-1330; Fax: (65) 6280-6290
inquiries@periplus.com.sg; www.periplus.com

**Indonesia**
PT Java Books Indonesia, Kawasan Industri Pulogadung, Jl. Rawa Gelam IV No. 9, Jakarta 13930
Tel: (62) 21 4682-1088; Fax: (62) 21 461-0206
crm@periplus.co.id; www.periplus.com

21 20 19 18    5 4 3 2 1    1801TW

Asia's Wildlife

# A Journey to the Forests of Hope

Fanny Lai & Bjorn Olesen

Editor
Yong Ding Li

**BirdLife**
INTERNATIONAL

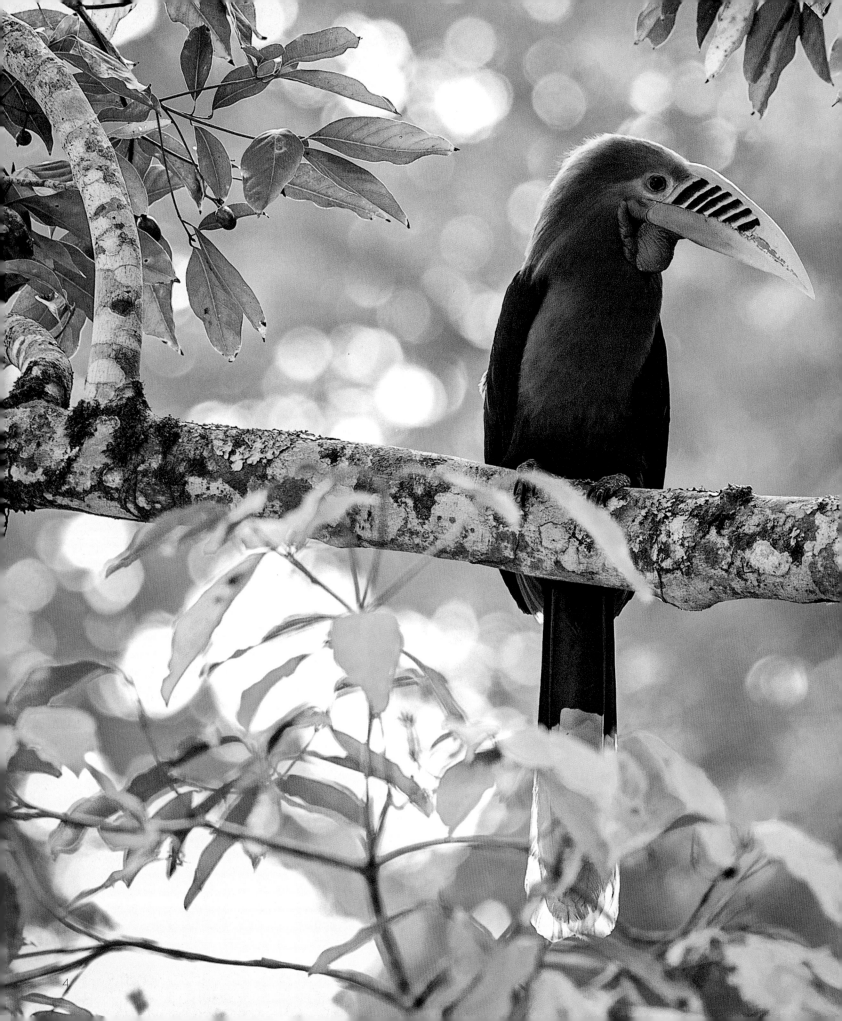

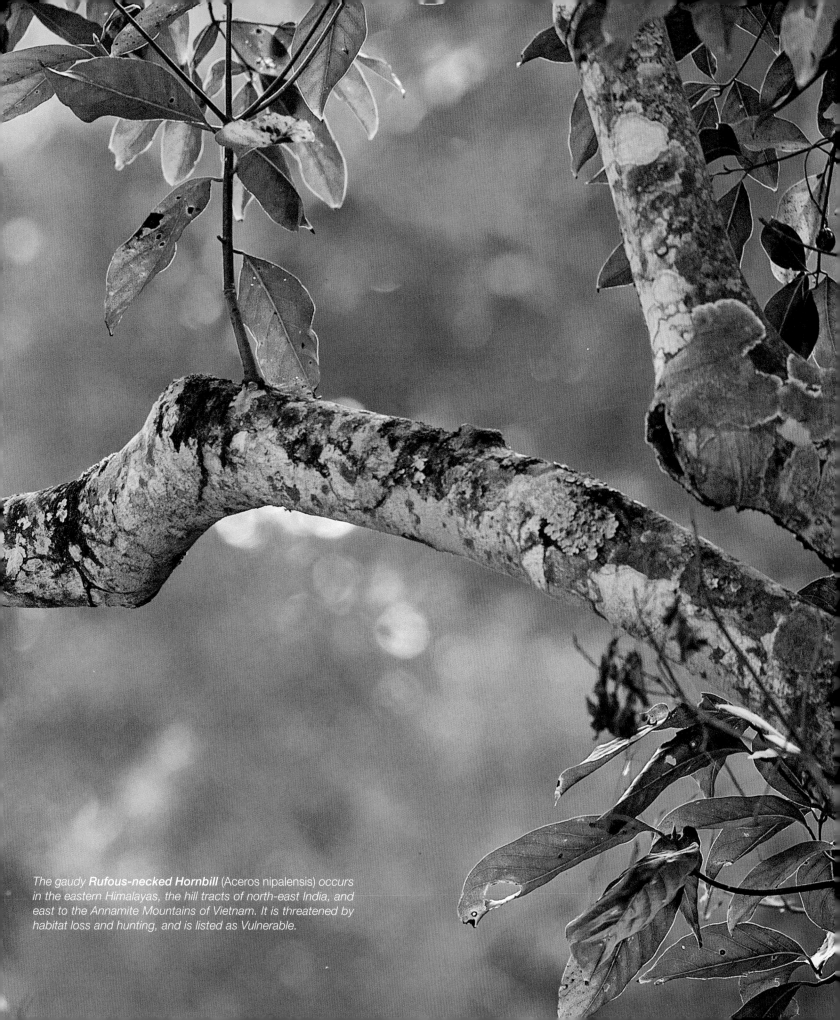

The gaudy **Rufous-necked Hornbill** (Aceros nipalensis) *occurs in the eastern Himalayas, the hill tracts of north-east India, and east to the Annamite Mountains of Vietnam. It is threatened by habitat loss and hunting, and is listed as Vulnerable.*

A significant population of the **Black-necked Stork** (Ephippiorhynchus asiaticus) occurs in the forested plains of northern Cambodia. However, it has vanished from most areas across Southeast Asia in the past decades.

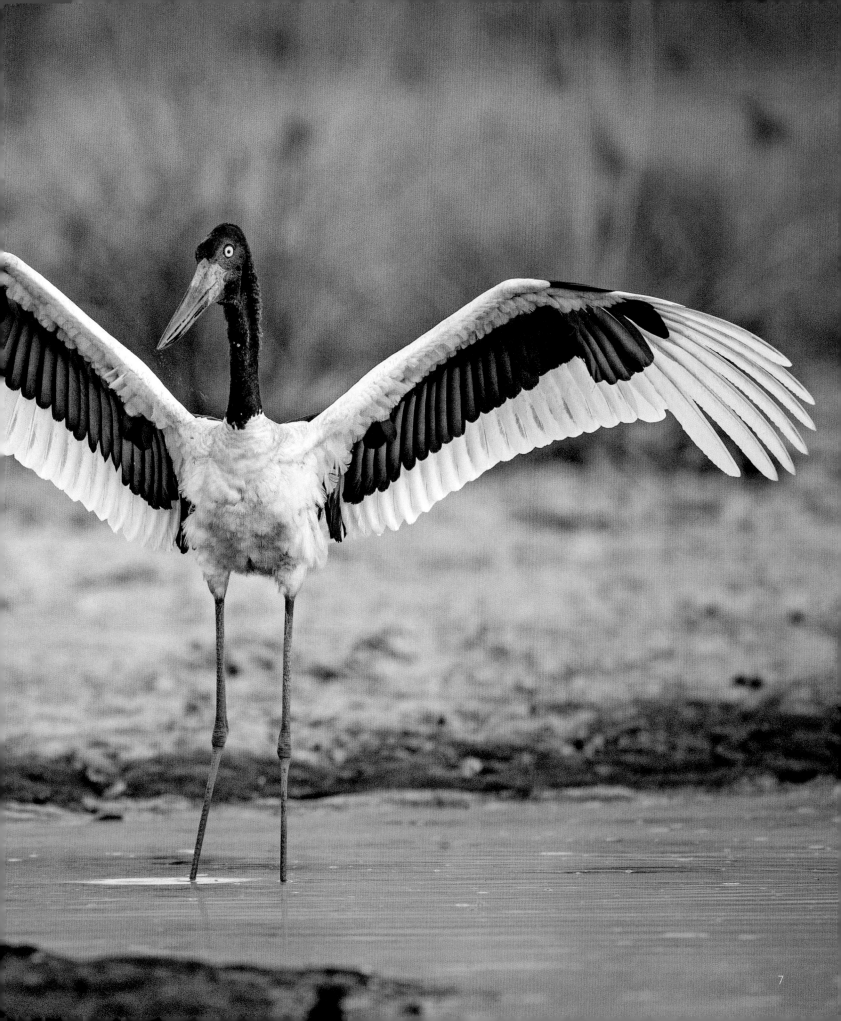

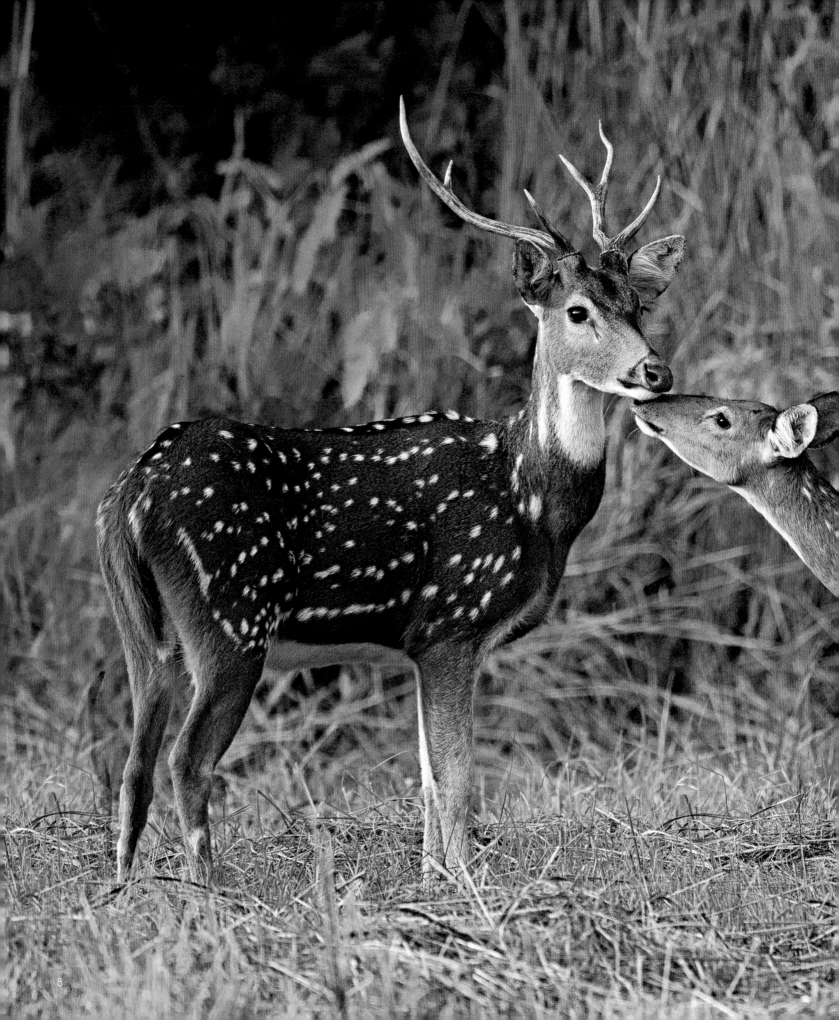

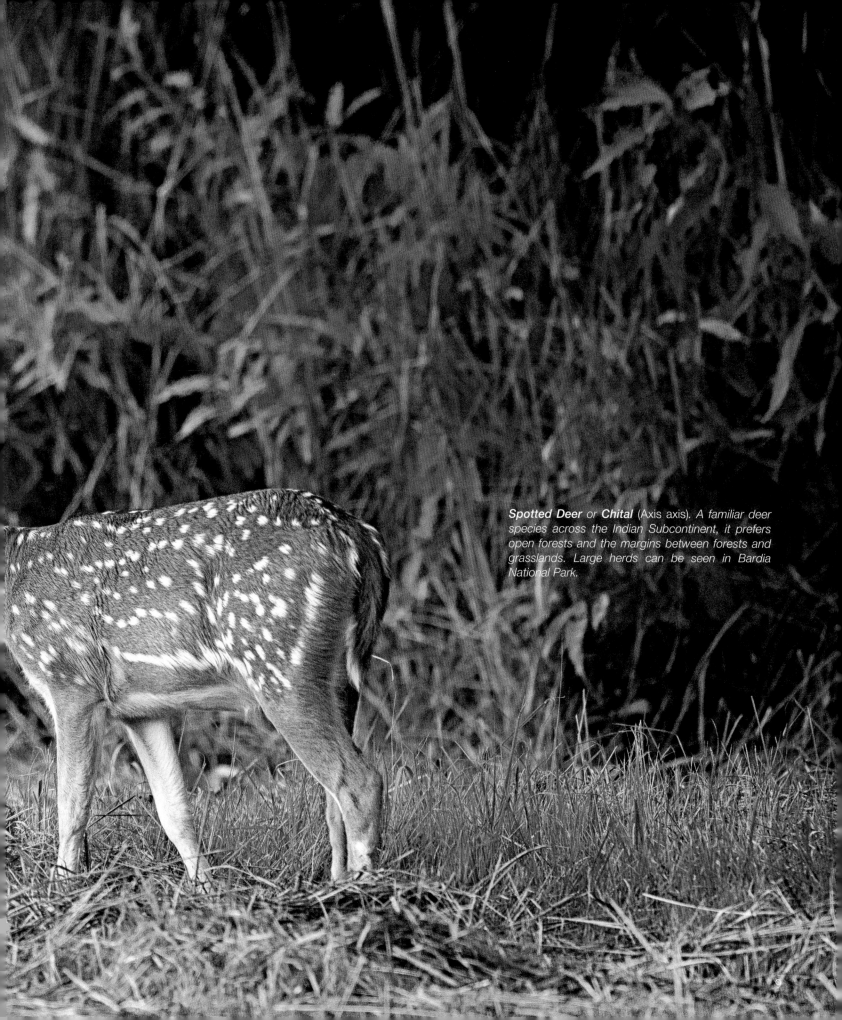

**Spotted Deer** or **Chital** (Axis axis). *A familiar deer species across the Indian Subcontinent, it prefers open forests and the margins between forests and grasslands. Large herds can be seen in Bardia National Park.*

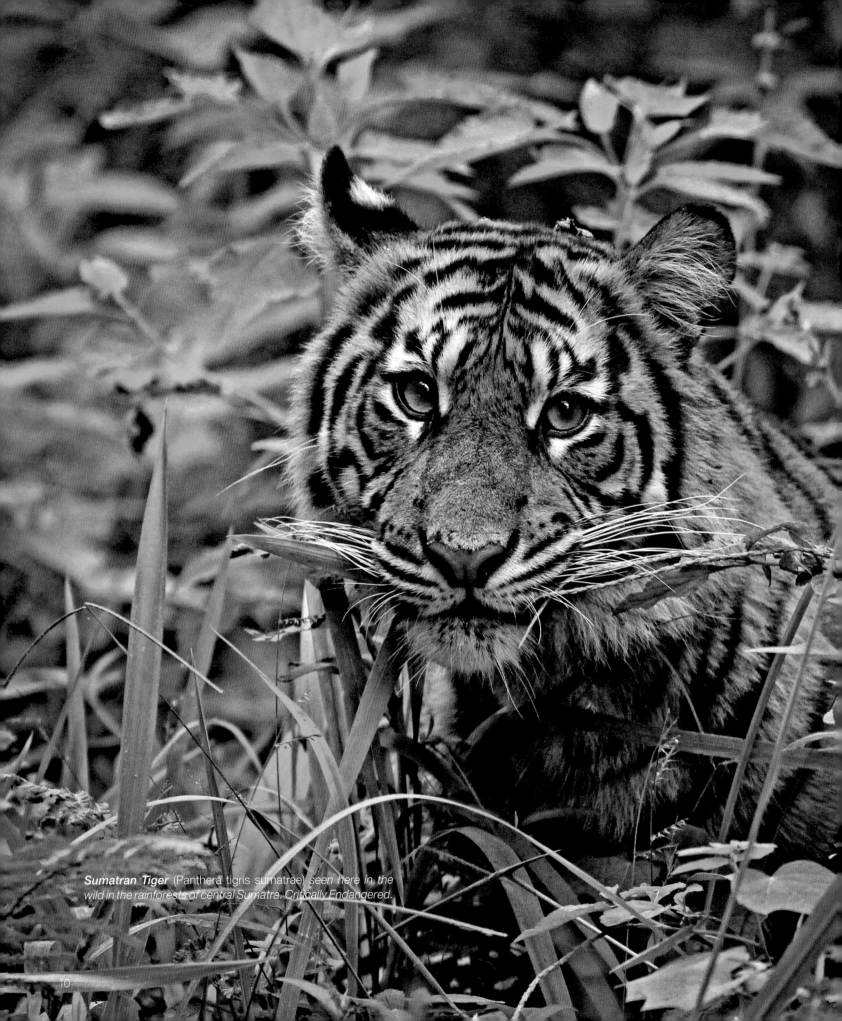

*Sumatran Tiger* (Panthera tigris sumatrae) seen here in the wild in the rainforests of central Sumatra. Critically Endangered.

# Contents

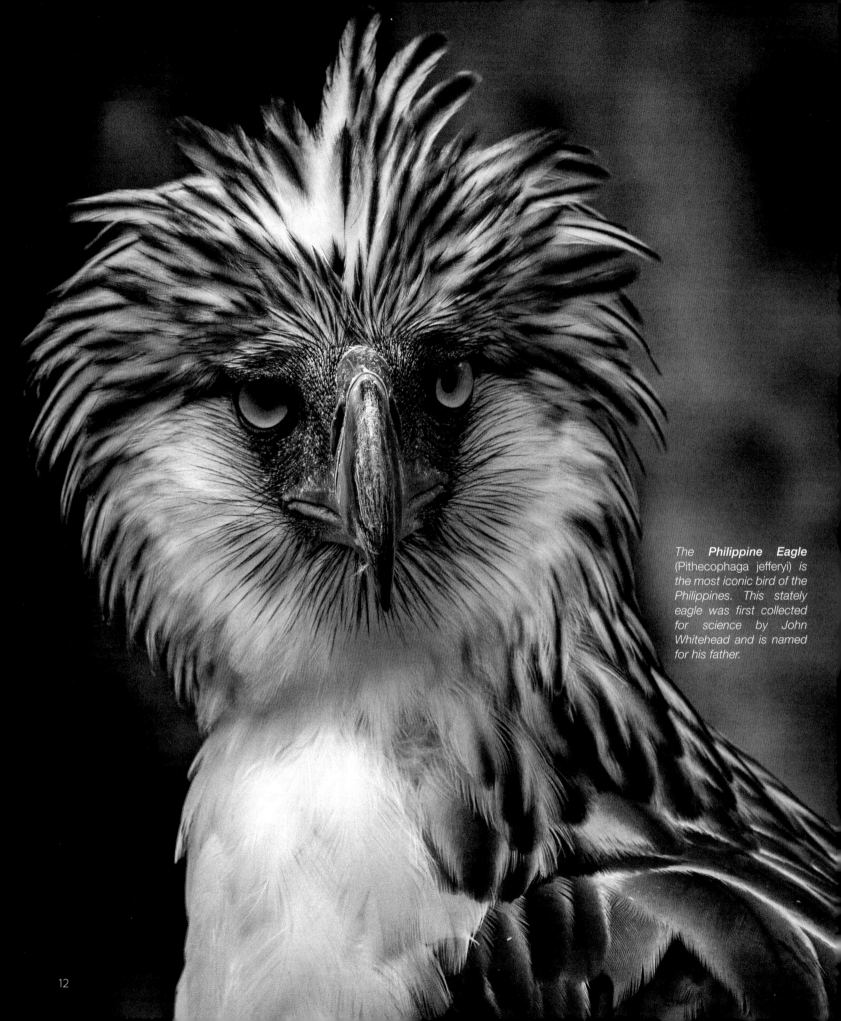

The **Philippine Eagle** (Pithecophaga jefferyi) *is the most iconic bird of the Philippines. This stately eagle was first collected for science by John Whitehead and is named for his father.*

# Foreword

Forests of hope is such a lovely, inspiring phrase, a conjunction of two beautiful ideas, the twinning of trees and trust, the marriage of earth and spirit. And yet, it is these forests that are calling out to us. It is these forests that need our help.

'Hope is the thing with feathers', wrote Emily Dickinson, 'that perches in the soul'. Her wonderful poem makes a small bird that survives gale and storm, cold and exile, the emblem of human optimism in the face of all adversity. Hope is a life force, she is saying; indeed, hope is *the* life force, for all humanity.

Birds live throughout Asia's forests of hope, as this breathtaking book demonstrates with such clarity. Ibises, falcons, hornbills, pittas, pheasants, floricans, eagles, owls and broadbills crowd these pages, each of them a thing with feathers, each of them a survivor, the life force flashing in their eyes and in the vibrant colours of their plumage. They are defiant in their beauty and their purpose.

But it is a chilling moment when we turn a page and see the doomed Amur Falcons being carried to be killed for food in Nagaland. They remind us how fragile the lives of birds are, and how strong we conservationists need to be, how vigilant and resourceful, to ensure that their forests are never lost and their existence never obliterated. For it is *people* who hope; birds just *are*.

The forests of hope that this book evokes so vividly are forests for *people* to care for, to hope for. And the people who also dot these pages—the reformed hunter, the schoolchildren bearing messages to their parents, the students supporting the hornbills, the indigenous inhabitants, the volunteer 'reforesters', the wardens—are the ones whom we, who hold this book in our hands, must fill with hope.

There is, even so, another group of people, to whom we must reach out. These are people who, unlike conservationists and local communities, have no immediate personal stake in these forests. It would be a wonderful thing if these politicians, business leaders, planners, investors, all looking at the world through different lenses, would keep this book on their desks, to remind them that these forests depend on their decisions, their judgement, their feelings, their values. We need them to share *our* hope.

In these pages, we can read about eight forests in eight countries of Asia that we call forests of hope because of the love and commitment we have for them. The powerful photographs evoke feelings in me, and I suddenly realise that that is because Asia is my homeland. That we are blessed with such beautiful forests is a joy and a responsibility. But they are, of course, just examples of the miraculous riches that forests possess, and on this tiny planet we want *all* forests to be forests of hope.

Hope is the life force we all share. Hope is the thing with feathers. It perches in our souls.

HIH Princess Takamado of Japan.
Honorary President of BirdLife International

# Background

The Forests of Hope (FoH) is a conservation programme of BirdLife International. It links forest conservation on the ground to policy work at the national and international level through BirdLife's comprehensive partnership network. The focus is on three key areas:

1) Conserving and restoring significant areas of natural forests:
2) Combating climate change; and
3) Benefitting local people and community.

We have been inspired by what this programme has done for people and biodiversity, and wanted to do something to increase awareness of these excellent conservations initiatives in Asia. This was how the project began.

Originally we started with BirdLife's five Asian Forests of Hope: in Cambodia, Indonesia, Malaysia, Philippines and Vietnam. However, we soon realised that there were several other sites that merited inclusion.

In the end we included the forests of Doyang in Nagaland, India, Bardia National Park in Nepal and the Sinharaja Forest Reserve in Sri Lanka. These three sites were under severe threat, but have survived to tell a successful conservation story as a result of solid advocacy work and a strong local will to conserve them.

This book has been a most exciting project! It was breathtaking on many counts. Eight different countries, eight unique 'Forests of Hope' sites were visited in one year. When we started with the planning, the schedule and logistics looked daunting. However, we were soon reassured by the hospitality and enthusiasm of the eight local BirdLife partners, which supported our journey through Asia. It was a massive logistical challenge to plan the schedule to overlap with the optimal time to record and photograph some of the most remarkable species in Asia.

◄ *Female **Giant Pitta** (Pitta caerulea) in the lowland rainforests of Peninsular Malaysia.*

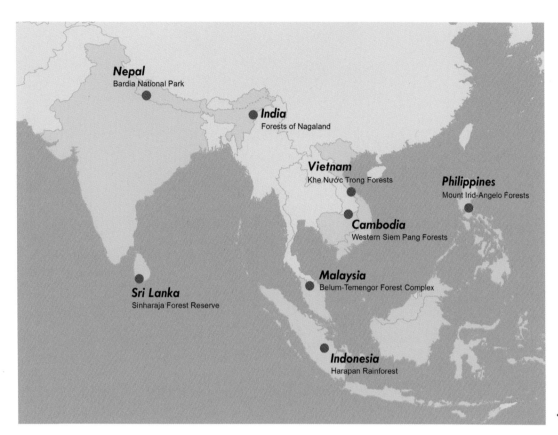

*'Forests of Hope' sites visited in Asia.*

**Nepal**
Bardia National Park

**India**
Forests of Nagaland

**Vietnam**
Khe Nước Trong Forests

**Philippines**
Mount Irid-Angelo Forests

**Cambodia**
Western Siem Pang Forests

**Malaysia**
Belum-Temengor Forest Complex

**Sri Lanka**
Sinharaja Forest Reserve

**Indonesia**
Harapan Rainforest

### Why is conserving tropical forests important?

Tropical forests are among the most extensive and at the same time the most threatened biomes worldwide. In Asia these forests are almost entirely within recognised biodiversity hotspots, including our eight Forests of Hope: Indoburma (Bardia, Forests of Nagaland, Khe Nuoc Truong, Western Siem Pang), Sri Lanka (Sinharaja), Philippines (Irid-Angelo), Sundaland (Harapan Rainforest, Belum-Temengor).

Asia's tropical forests are among the richest in biodiversity on the planet, supporting a high diversity of vascular plants, mammals, birds, amphibians, and invertebrates. In particular, rainforests have also been called the ultimate pharmacy of medicines and chemical compounds, and numerous extracts from plants and trees have proven useful in drugs.

Forests are an important direct source of livelihood to millions of people in provision of timber and non-timber products (agarwood, wild honey, herbal plants, rattan, bamboo). Equally, many of the foods we eat today, like bananas and cacao were once only found in the wild in tropical forests. For many indigenous peoples forests are important both culturally and spiritually.

Furthermore, forests provide protection for the watersheds of many of the region's most important rivers, stabilizing and maintaining quality of water flow, and they regulate run-off of water from soil. Forests reduce the risks of flooding, landslides and ground erosion. Tropical forests influence rainfall patterns. They create their own moist environment and drive precipitation: if these forests are removed entire regions may become drier. At the same time, they hold vast storages of carbon, so important in the battle against man-made climate change.

Last, but not least, tropical forests are an important source of tourism revenue for many Asian countries.

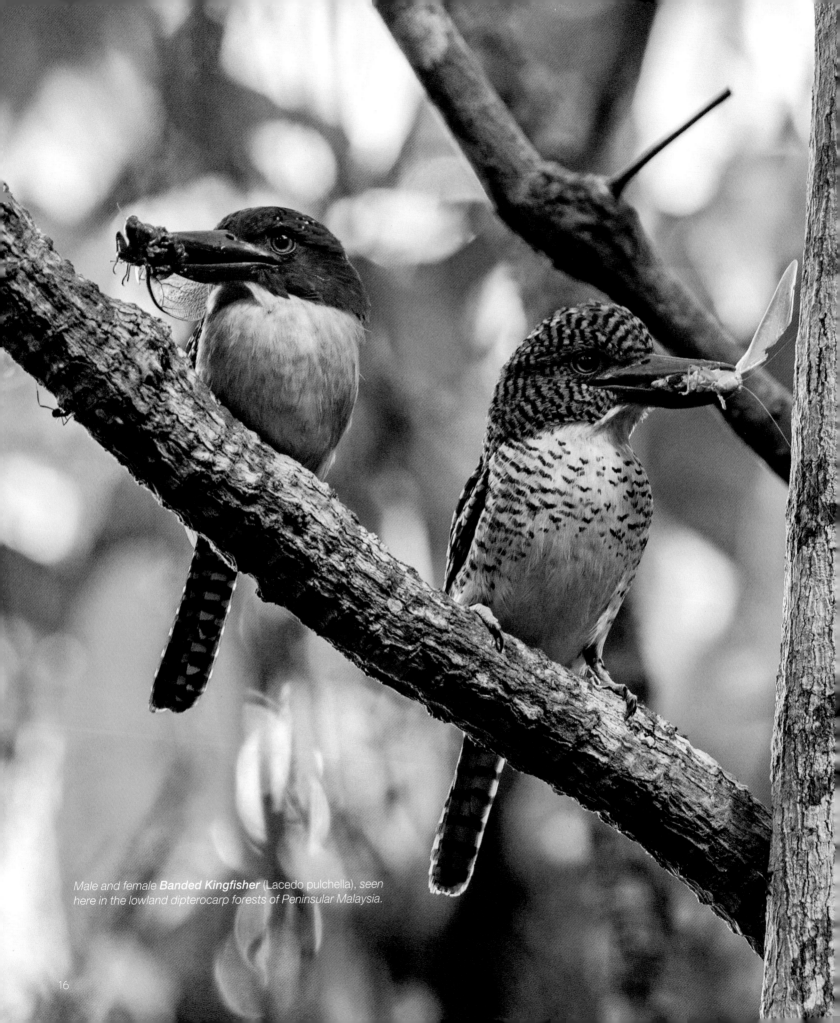

Male and female **Banded Kingfisher** (Lacedo pulchella), *seen here in the lowland dipterocarp forests of Peninsular Malaysia.*

# Introduction

Nature photography has matured into a powerful medium to empower conservation. It is about the making of aesthetically appealing and moving images that can be used to advance conservation objectives. We need to influence people, touch their hearts and engage them to take action on their environment. We need to make people realise that nature is a treasure to be looked after and protected for generations to come.

It is our hope that this publication can create an insightful picture of current conservation issues, and call attention to the diverse threats faced by Asia's biodiversity. Photographs can give a voice to animals and many of these last wild places that are facing diverse threats from forest fires to pollution, poaching and population pressures.

Creating images that tell stories, that can make a difference, only starts when you press the shutter. However, the more important challenge is to ensure that such stories reach the wider audience that needs to see and feel them, to make a change. We believe that books like *Asia's Wildlife, A Journey to the Forests of Hope*, reaching out to thousands of readers, will be important in promoting public awareness of conservation issues and responsible eco-tourism. This publication has also distilled information from more than one hundred of the latest scientific papers in journals that would otherwise have a comparatively limited circulation.

Conservation photography is most effective when done together with NGOs and scientists with aligned objectives, and this collaboration with BirdLife International and their Asian partners has been a timely attempt at this.

We have made a point of featuring some of Asia's most threatened species like the Giant and White-shouldered Ibis, not forgetting the three Critically Endangered vultures, the White-rumped, Red-headed and Slender-billed Vultures which we photographed in Cambodia.

We also drew attention to little known species in Asia, among others the latest research on the Saola, an enigmatic large mammal, which was discovered in the secluded Annamite Mountains on the border of Vietnam and Laos in 1992. The Saola is possibly the greatest terrestrial mammal discovery since the Okapi almost 100 years earlier.

It is our wish that *Asia's Wildlife, A Journey to the Forests of Hope* will not only serve as a celebration of what well-run conservation initiatives can achieve, but also as a timely audit of current and future challenges to ongoing conservation work, so that we can redouble our efforts to protect our forests in Asia before it is too late. There's not a moment to lose.

Since 2010, we have had the privilege to work closely with BirdLife International, which is the world's largest nature conservation partnership with 122 BirdLife partners worldwide. BirdLife International is recognised as the leading organisation in global bird conservation that has worked to provide sustainable solutions for the benefit of nature and people.

We have published *Asia's Wildlife, A Journey to the Forests of Hope* to raise funds in support of BirdLife International and to increase awareness of nature conservation and the Forests of Hope Programme in Asia. On our part, we have contributed our time and resources on a pro bono basis for the production, research and field travel for this one-of-a-kind publication.

Having visited all these sites, we are rejuvenated with the hope that together, we can secure the vanishing biodiversity of Asia for posterity. Together we must make a difference.

*Fanny & Bjorn*

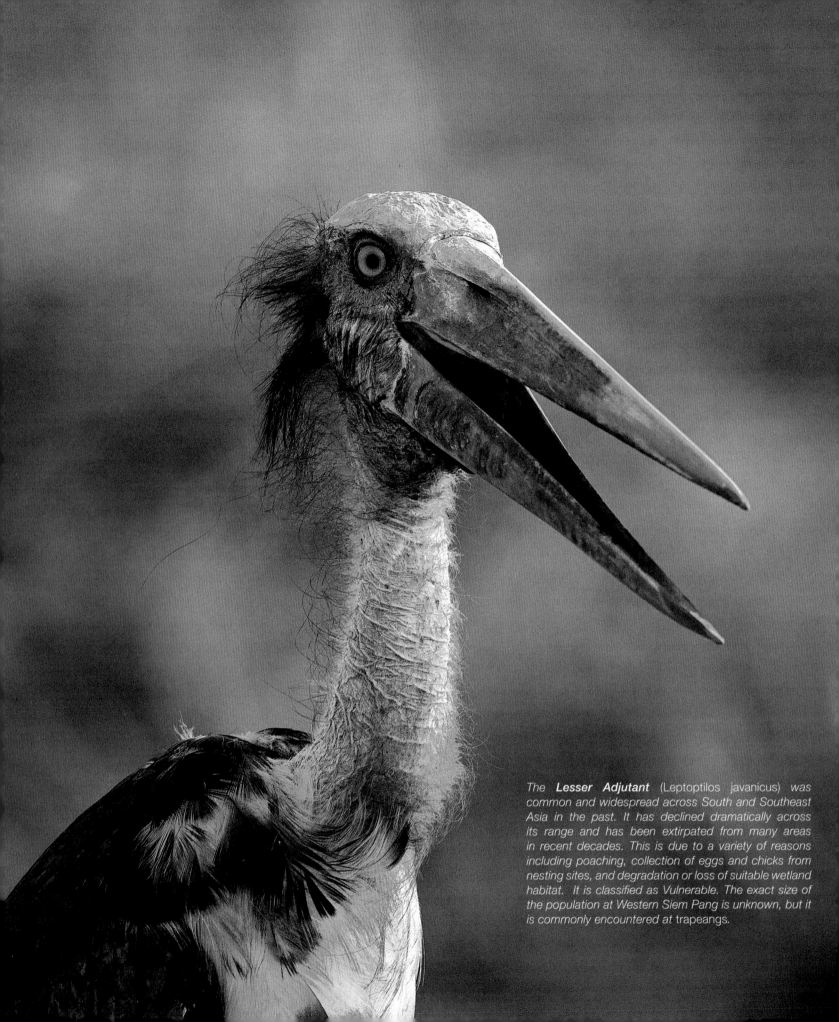

The **Lesser Adjutant** (Leptoptilos javanicus) was common and widespread across South and Southeast Asia in the past. It has declined dramatically across its range and has been extirpated from many areas in recent decades. This is due to a variety of reasons including poaching, collection of eggs and chicks from nesting sites, and degradation or loss of suitable wetland habitat. It is classified as Vulnerable. The exact size of the population at Western Siem Pang is unknown, but it is commonly encountered at trapeangs.

# The Forests of
# Western Siem Pang,
# Cambodia

# The Forests of Western Siem Pang

## Introduction

Nestled in the remote north-eastern corner of Cambodia, the newly designated Western Siem Pang Wildlife Sanctuary represents one of the most important areas of deciduous dipterocarp forest remaining in Cambodia. Located in Stung Treng Province, and adjacent to the international border with Laos, these forests are home to populations of five Critically Endangered bird species as well as important populations of other globally threatened bird and mammal species.

## Background

BirdLife International has worked in the area since 2003 with its government partners and local communities. Today, BirdLife, together with the Cambodian Ministry of Environment, implements a major project at the site. Currently, about 30 staff based at the site work on a range of activities including protected area law enforcement, livelihoods support and species monitoring. For years, the area was protected essentially by its remoteness, but this has unfortunately been negated in the light of the recent demand for timber and land, and new infrastructure developments.

In 2009, with support from BirdLife, the Forestry Administration of the Government of Cambodia began the process to establish the Siem Pang Protected Forest covering an area of 66,932 ha. Although the process was completed and approved in 2014, this left a large part of the Important Bird and Biodiversity Area (IBA) unprotected and, worse, designated as an

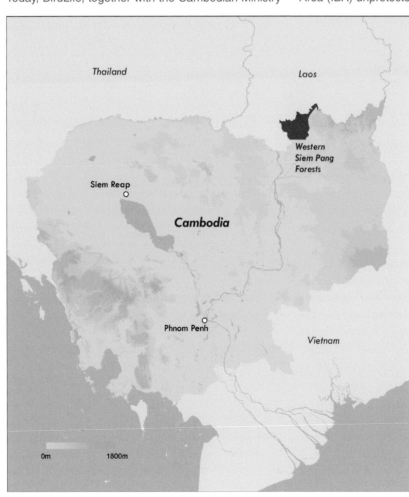

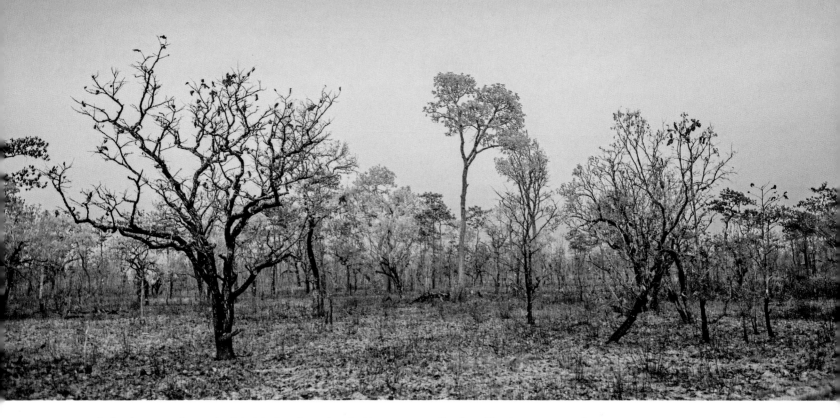

economic land concession, scheduled to be cleared for agriculture. In 2015, after concerted advocacy by BirdLife and the Forestry Administration, the area of agricultural concession was reduced from over 150,000 ha to 9,800 ha. At the same time, BirdLife proposed the establishment of a second protected forest covering just over 70,000 ha incorporating vital habitats for the Giant and White-shouldered Ibis (Eames, J. C. pers.comms.).

Finally, in May 2016, the Cambodian Prime Minister Hun Sen signed a sub-decree that established the Prey Siem Pang Lech Wildlife Sanctuary with boundaries similar to those proposed by BirdLife. At the same time the northern half of the Western Siem Pang forest was upgraded from its protected forest status, to wildlife sanctuary, effectively creating a protected area of 132,321 ha. Meanwhile, jurisdiction for management of the sanctuary was transferred to the Ministry of Environment. Since then, the Ministry of Environment has amalgamated the two protected areas and they are referred to collectively as the Western Siem Pang Wildlife Sanctuary. This was the final piece in the jigsaw

that is now connecting forest landscapes spanning over 700,000 ha in Laos, Cambodia and Vietnam, making it one of the most extensive protected landscapes in Southeast Asia (Hurrell, S. 2016).

Over the years, BirdLife International and its partners have completed a number of studies in the Western Siem Pang Wildlife Sanctuary, including research work on the White-shouldered Ibis, Giant Ibis, Green Peafowl, the three vulture species and, most recently, Eld's Deer. This has involved collaborations with the University of East Anglia, UK, the Royal University of Phnom Penh, Cambodia and the University of Queensland, Australia.

The Giant Ibis and White-shouldered Ibis are two of the most threatened bird species in Southeast Asia and are almost wholly reliant on the remaining dry forest and their associated wetlands in the northern and eastern parts of Cambodia. Both ibis species have globally significant local populations within this landscape, with perhaps 50 per cent of the world population of the White-shouldered Ibis and 10 per cent of the Giant Ibis occurring.

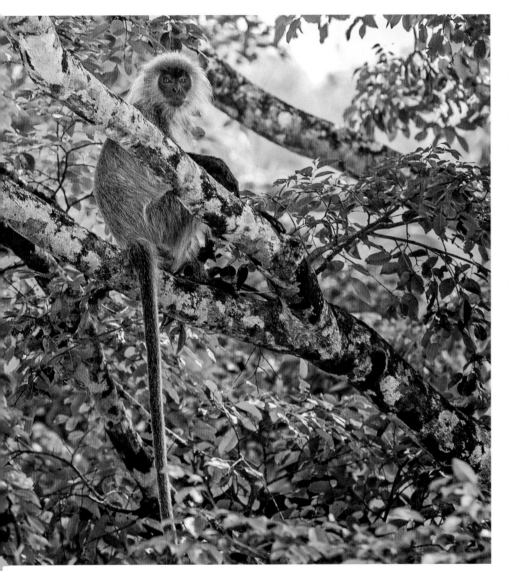

▲ *The Endangered* **Annamese Silvered Langur** (Trachypithecus margarita) *remains quite widespread in Cambodia. It is observed in riverine forest and adjacent semi-evergreen forest areas in Western Siem Pang Wildlife Sanctuary. The biology of this species is poorly known. Leaf monkeys have a specialised stomach holding symbiotic bacteria, which enables them to eat and digest leaves that are high in toxins and plant fibre. Their diet also includes flowers and fruits.*

## Habitats

Close to 90 per cent of the Western Siem Pang Wildlife Sanctuary is covered by a mosaic of forests typical of the original vegetation along the Mekong basin. Fifty per cent of this habitat consists of dry deciduous dipterocarp forest dominated by four species of Dipterocarpaceae in many places, which are resistant to annual fires. Forty per cent of the landscape consists of semi-evergreen forest in the more hilly northern areas and along the Sekong River. The remaining landscape consists of a mix of degraded forests and open areas of grassland.

Western Siem Pang is a lowland region with the highest elevation of just over 300 m above sea level. Scattered throughout the forest are a great number of seasonal forest pools called *trapeangs* in the Khmer language. Throughout the dry season, these *trapeangs* provide a vital source of water for wildlife.

The site's significance for wildlife is greatly increased by its location acting as a corridor connecting Virachey National Park across the Sekong river to the east with the Xe Pian National Protected Area in Laos to the west. This effectively creates a block of contiguous protected areas, allowing free movement of some of the rarest animal species in Asia.

Local villagers depend on the forest and the *trapeangs* for water, and the harvest of fish, frogs, and non-timber forest products. Traditionally, the local communities here have used extensive areas for grazing of cattle and buffalo, carving out small clearings in the forest. Interestingly, these domestic herds fill an ecological function, which in the past was provided by wild ungulate species, many of which are now locally extinct (BirdLife International 2012).

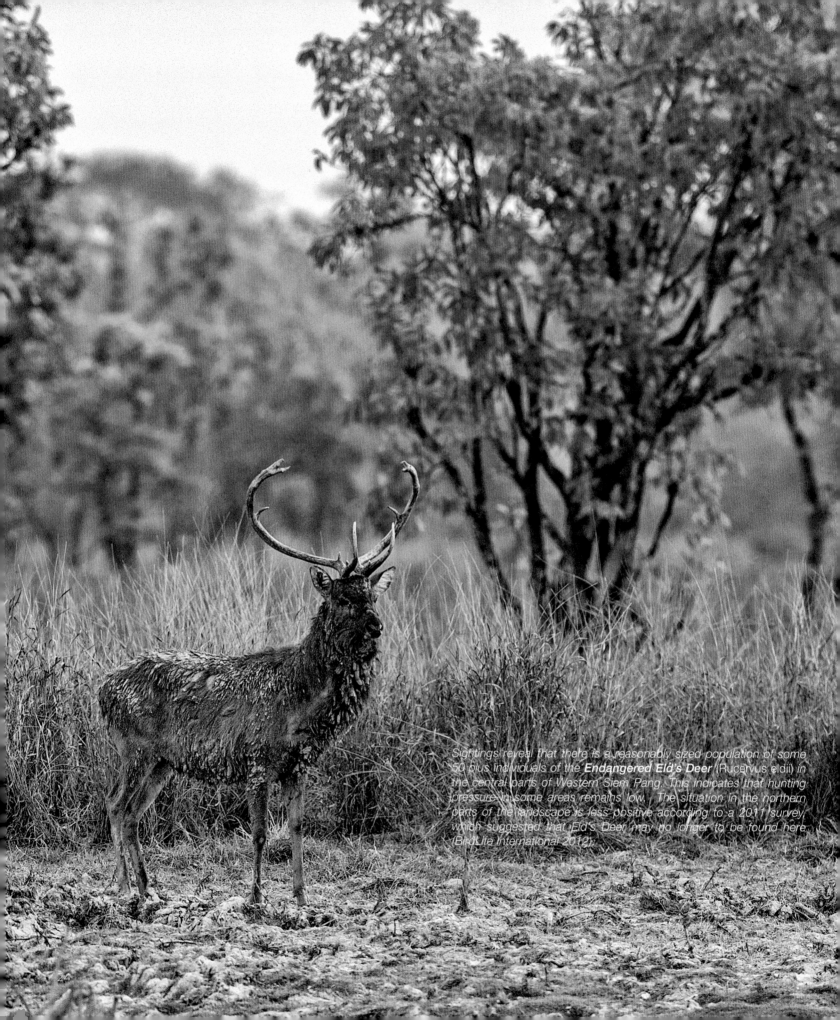

Sightings reveal that there is a reasonably sized population of some 50 plus individuals of the **Endangered Eld's Deer** (Rucervus eldii) in the central parts of Western Siem Pang. This indicates that hunting pressure in some areas remains low. The situation in the northern parts of the landscape is less positive according to a 2011 survey which suggested that Eld's Deer may no longer to be found here. (BirdLife International 2012).

## Mammals

Historically, Cambodia's dry forests were rich in wildlife, including numerous mammal species that are now very rare, such as Eld's Deer and Banteng *(Bos javanicus)*, or already extinct like the Kouprey *(Bos sauveli)*, Cambodia's national animal and one of the least studied of the world's wild cattle. The Tiger *(Panthera tigris)* was once widespread, but has suffered a remarkable decline due to systematic hunting, to the extent that it may no longer occur in Cambodia. One of the last reports of tigers in Western Siem Pang was from an ex-hunter who claimed to have killed a tiger in 1993-94.

In the Western Siem Pang Wildlife Sanctuary, Gaur *(Bos gaurus)*, Banteng and Eld's Deer remain, together with Asian Elephant *(Elephas maximus)*, which was only confirmed for the sanctuary in 2016. The riverine forest along the Sekong River supports a population of the Endangered Annamese Silvered Langur.

Other mammals that are currently known to occur at the site include the Eurasian Wild Pig *(Sus scrofa)*, Golden Jackal *(Canis aureus)*, Long-tailed Macaque *(Macaca fascicularis)*, Common Palm Civet *(Paradoxurus hermaphroditus)* and Siamese Hare *(Lepus peguensis)*.

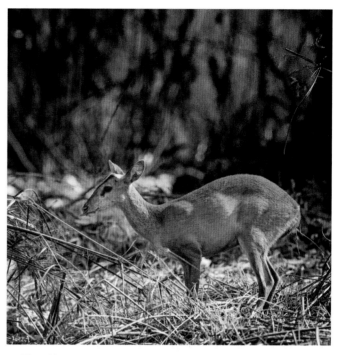

▲ *The* **Northern Red Muntjac** (Muntiacus vaginalis) *is still common and can be observed in the deciduous dipterocarp and semi-evergreen forests. It is able to tolerate some levels of habitat degradation. As the diet includes fruits, buds, seeds and seedpods, leaves and grass, the muntjac is clearly an important agent of seed dispersal for many native plants.*

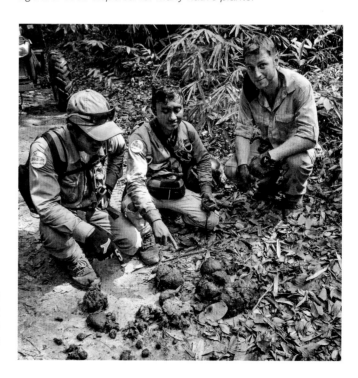

▶ *In June 2016, BirdLife Cambodia Field staff (from left, Vann Vichet, Mai Mem and Robin Loveridge) collected the first documented evidence of the Asian Elephant inside the Western Siem Pang Forest. The footprints and dung of a mixed group of 3-4 adults and young were encountered.*

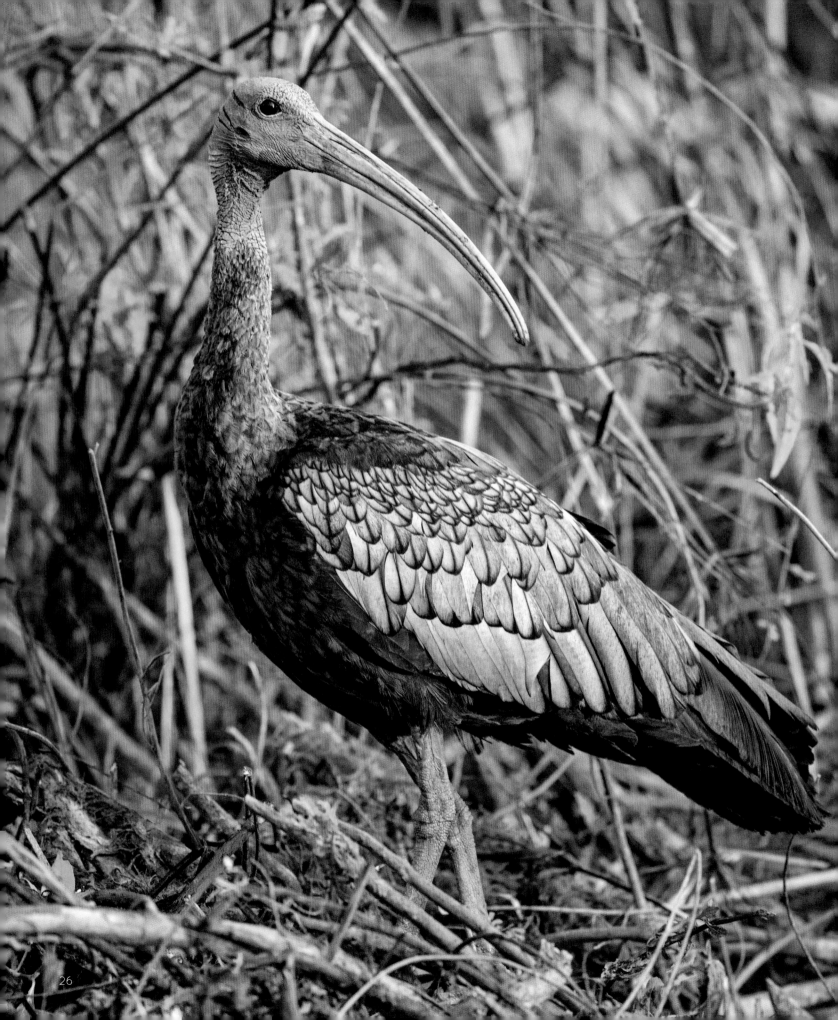

# Birds

Western Siem Pang Wildlife Sanctuary is classified as an Important Bird and Biodiversity Area (IBA) and it is home to around 300 bird species. Of these, 14 species have been classified as globally threatened and eight species Near Threatened. It is one of only a handful of sites on Earth that support five Critically Endangered bird species.

The dry forests are also home to important populations of other threatened species including the Great Slaty Woodpecker *(Mulleripicus pulverulentus)*, Lesser Adjutant *(Leptoptilos javanicus)*, and Green Peafowl *(Pavo muticus)*, whilst smaller numbers of Sarus Crane *(Grus antigone)*, and Indian Spotted Eagle *(Aquila hastata)* also occur. However, of all the forest birds present in this landscape, the White-shouldered Ibis and the Giant Ibis stand out because of their highly significant populations.

◄ *The Critically Endangered Giant Ibis is now mostly confined to the northern and eastern parts of Cambodia, and possibly to the extreme south of Laos. It was previously found in Thailand and Vietnam but is now either very rare or extinct in these countries. The global population is estimated at less than 200 mature individuals and decreasing. The limited range and small population has led to its classification by IUCN as Critically Endangered since 1994. It is estimated that the number of individuals in Western Siem Pang is around 50 birds.*

*The ecology of the species is not well understood. Giant Ibises are wet season breeders, and they often nest in Dipterocarpus trees. At the beginning of the dry season the chicks are fledged and this is the best time to see family parties feeding around seasonal trapeangs. Observing them, however, is not easy. The species is very shy: at even the slightest disturbance the birds will stop feeding and take cover. It is recorded infrequently in the parts of the forest visited by people even though suitable feeding grounds are often present.*

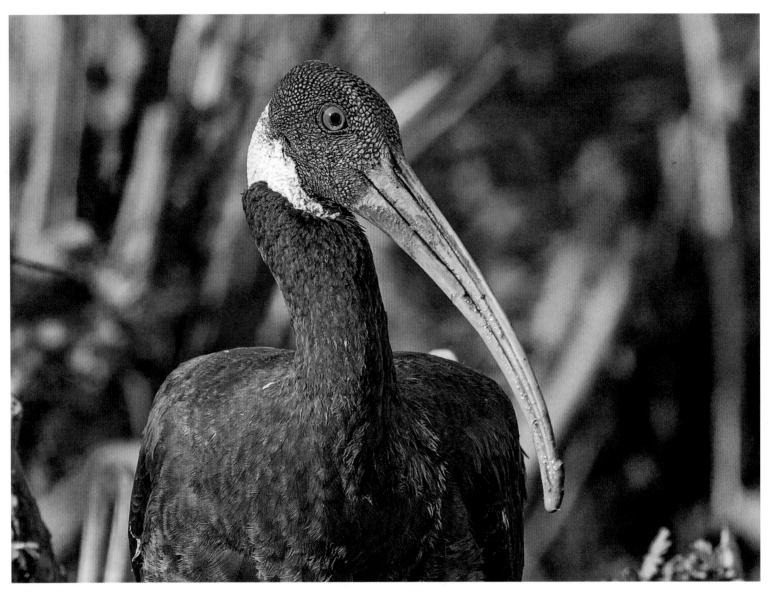

▲ The **White-shouldered Ibis** (Pseudibis davisoni) *breeds in the dry season. In Western Siem Pang, it is known to nest in two species of dipterocarp trees that shed their leaves early in the dry season, and are re-foliated again when the ibises breed. During this period the species largely feeds in* trapeangs *where frogs pulled out of mud-cracks appear to be the preferred prey item. In the wet season, large gatherings of as many as 360 birds have been witnessed at a single roost.*

▶ *The large* **Giant Ibis** (Thaumatibis gigantea) *is the national bird of Cambodia. This individual was part of a group of three Giant Ibises foraging around* a trapeang.

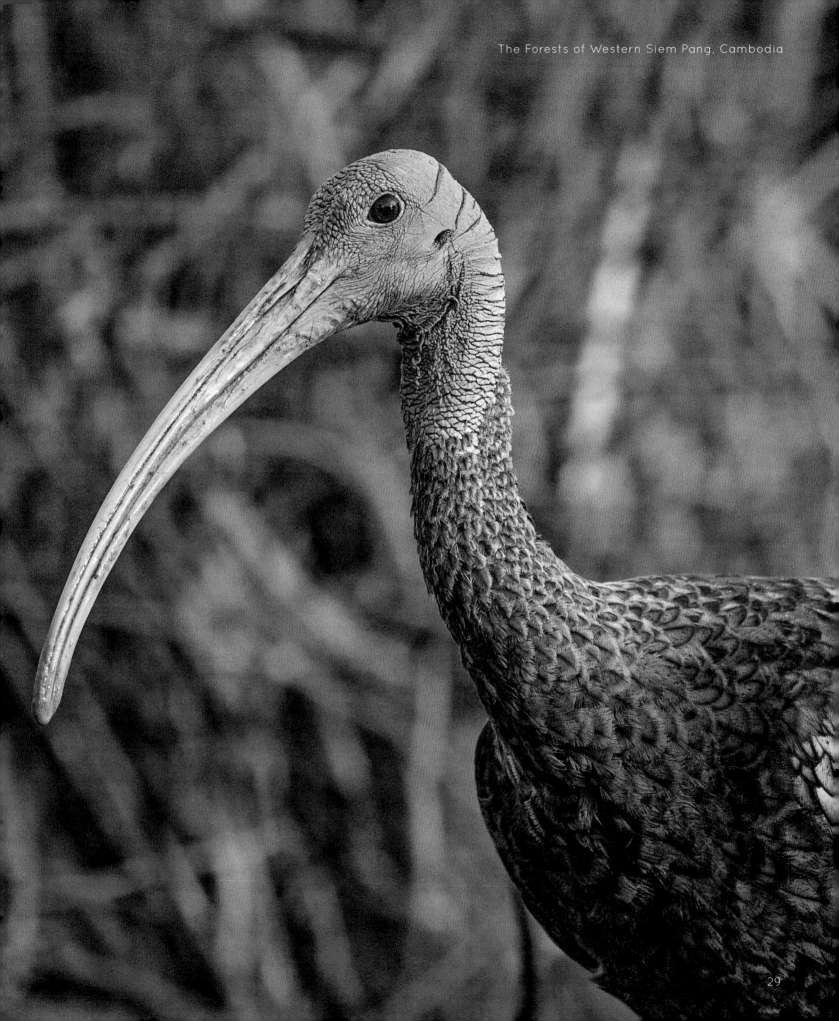

▸ **White-shouldered Ibis** (Pseudibis davisoni)

*The global range and population of the Critically Endangered White-shouldered Ibis has steadily shrunk over the past century. This severe decline is no doubt due to habitat loss and fewer protected roosting and nesting sites, compounded by widespread hunting pressure. It was formerly found widely in Thailand, Laos, Myanmar and Borneo, extending as far north as southwest China.*

*Today, the global population (estimated at no more than 1,000 birds) is mainly restricted to the northern and eastern parts of Cambodia. A small breeding population persists precariously along the Mahakam River in Indonesian Borneo. Western Siem Pang is now considered the single most important site for this ibis species, with a population of over 400 individuals.*

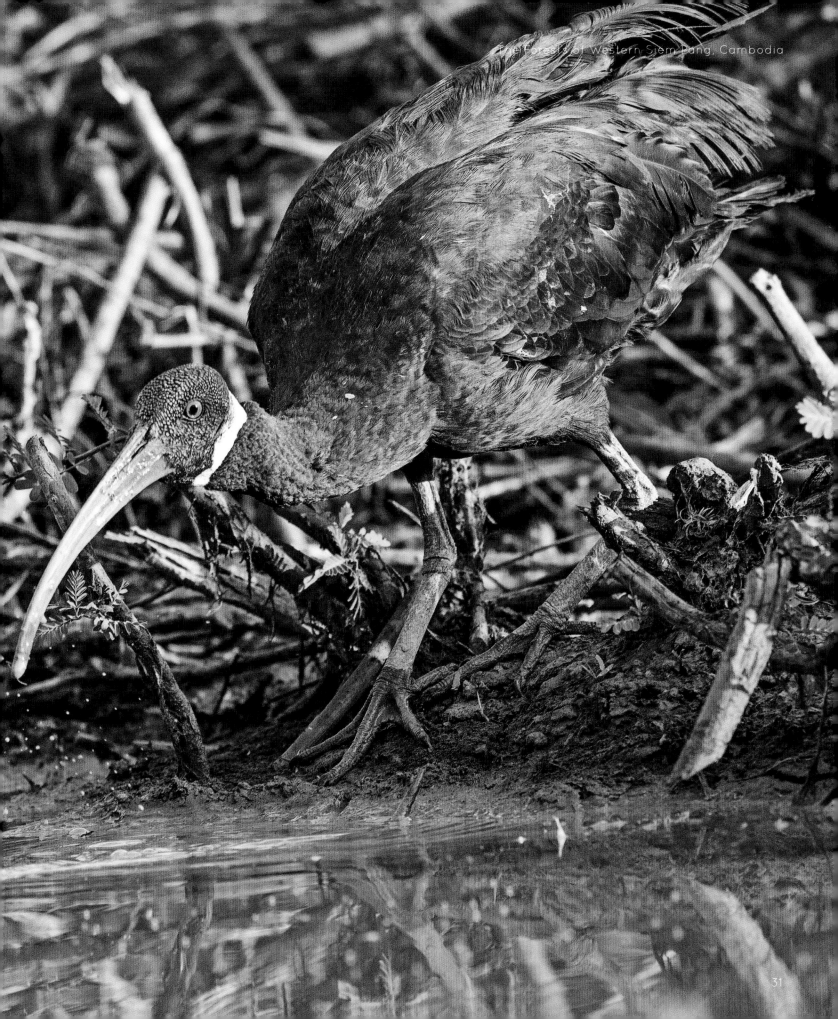

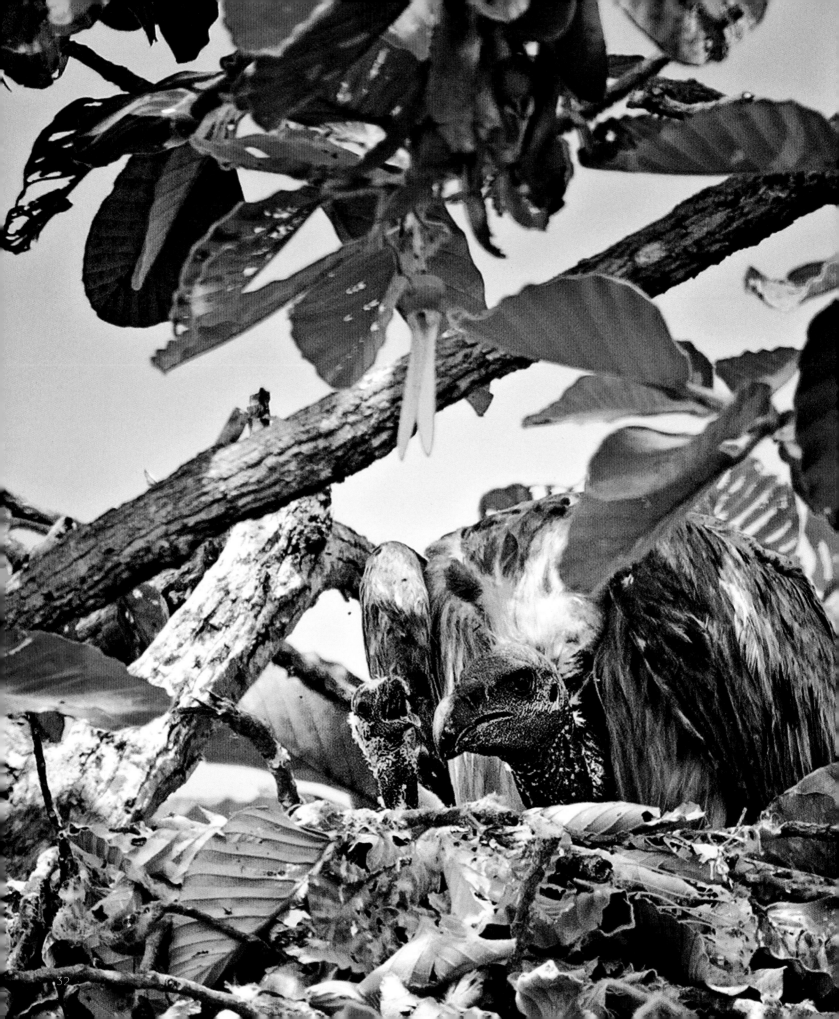

## Vultures

The South Asian subpopulations of White-rumped, Slender-billed and Red-headed Vultures have been in steady decline for decades as a result of secondary poisoning caused by the non-steroidal anti-inflammatory drug diclofenac, which was widely given to cattle. In Southeast Asia the decline in vulture numbers has mainly been attributed to a general reduction in carcass availability; more recently poisoning has become an important threat. All three species of vultures are regularly seen and all breed in the forests of Western Siem Pang.

◄ **Slender-billed Vulture** (Gyps tenuirostris) *seen here with a young chick. Western Siem Pang is probably the last remaining stronghold of this Critically Endangered species in Southeast Asia.*

*Red-headed Vulture* (Sarcogyps calvus) *versus* **White-rumped Vulture** (Gyps bengalensis). *Vultures have extraordinary vision and can detect an animal carcass from great heights. They are very careful when approaching a potential meal, and often wait in nearby trees for up to 36 hours to make sure the prey item is dead and that no threats are around.*

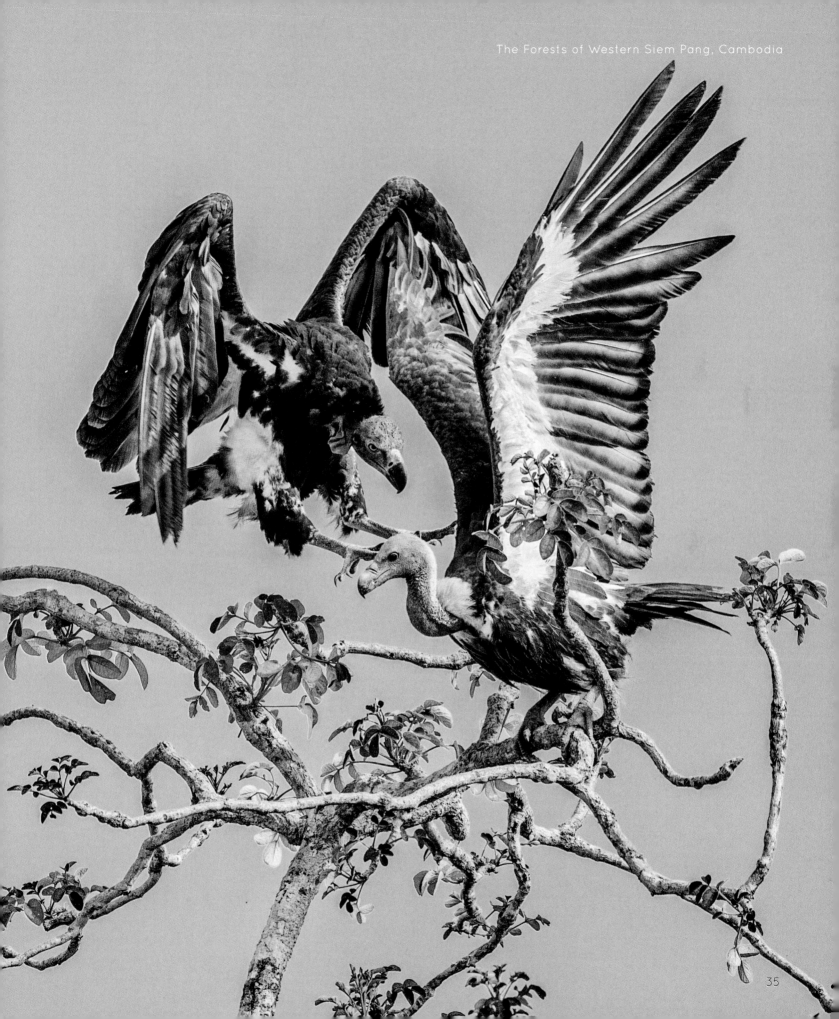

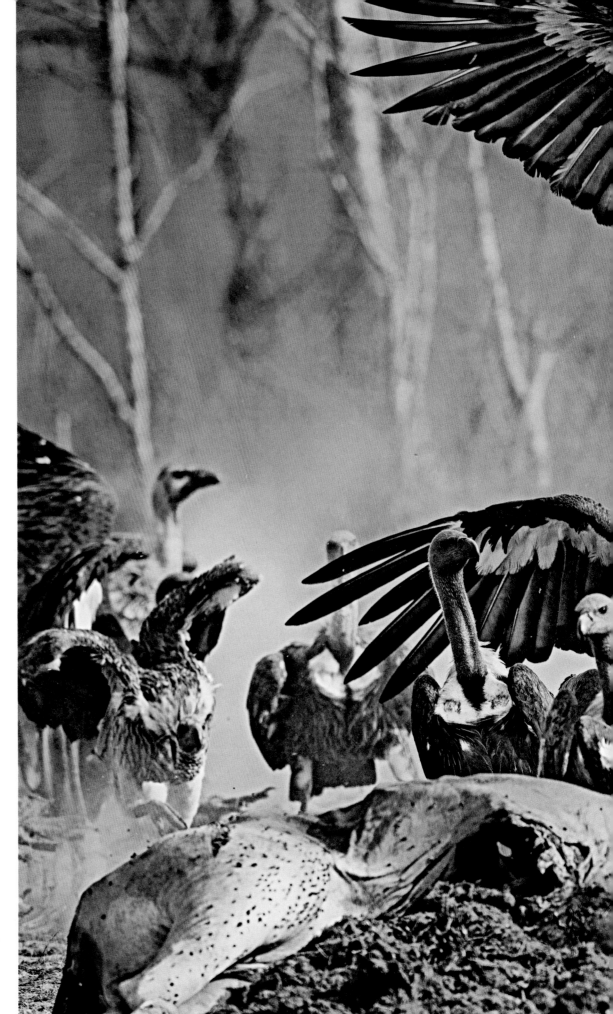

▶ The **White-rumped Vulture** is the most commonly seen species at the vulture restaurants in Western Siem Pang. On this occasion we counted 56 White-rumped, 14 Slender-billed and four Red-headed Vultures.

One of the key threats to vultures in Cambodia is inadequate food availability. This problem arises because populations of large wild ungulate species here are low as a result of hunting pressure. Vulture restaurants are sites where conservationists provide carcasses of livestock animals to study vulture populations and also to provide supplementary food in lean periods. In Western Siem Pang, a vulture restaurant is now prepared twice a month.

Once the vultures have descended to the ground and the feeding frenzy starts, caution is thrown aside and it soon becomes a free-for-all event. Squabbles often take place both between individuals of the same and different species. However, it rarely gets too serious.

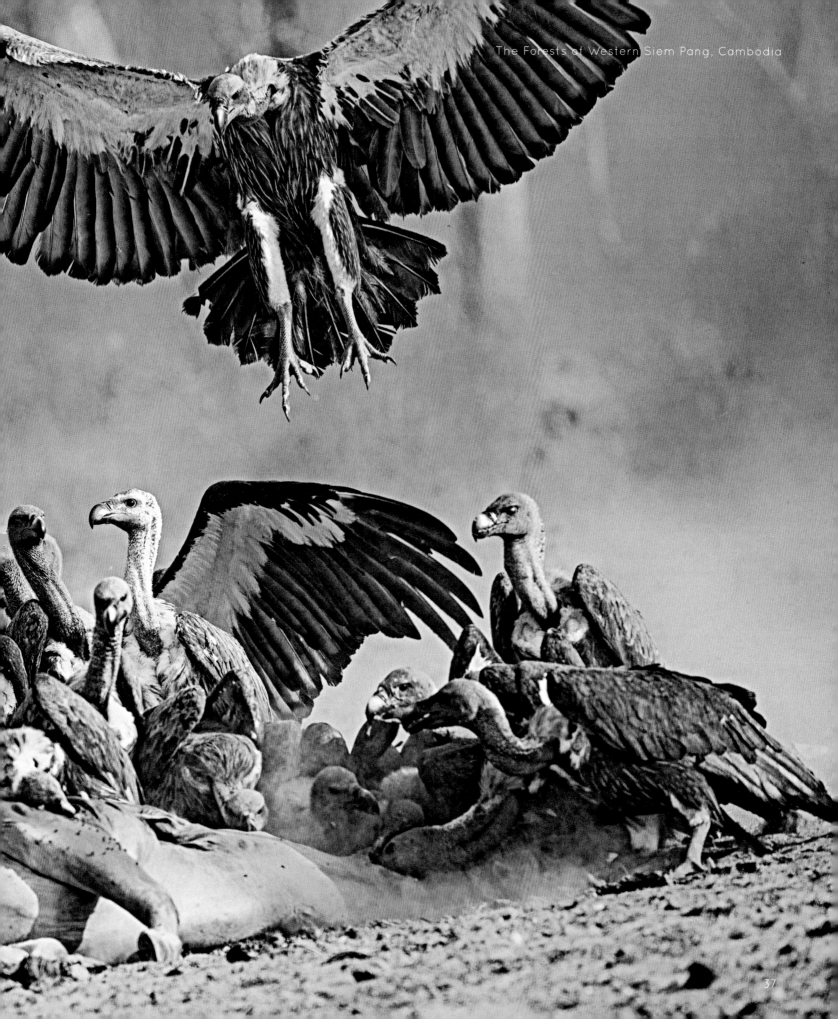

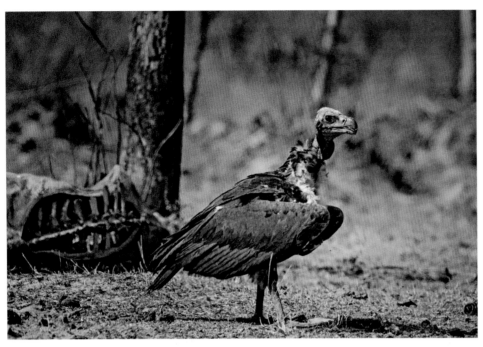

▲ Unlike most of the larger species of vulture, the **Red-headed Vulture** is most often found alone or in pairs. The courtship behaviour in this species can be quite impressive to observe, with both male and female engaged in acrobatic soaring and cartwheeling displays.

▸ The **Black-necked Stork** (Ephippiorhynchus asiaticus) is a very large waterbird bird with a stunning plumage. When observed up close, its seemingly 'black' neck can appear blue, green, or purple, depending on the angle. This species feeds on a wide range of prey, including fish (in this case a small catfish), amphibians, small crustaceans, large insects, lizards, and snakes.

The combined South and Southeast Asia populations of the Black-necked Stork are thought to number fewer than 1,000 individuals (Sudarin, G. in litt. 2002, 2006). While its Asian population is in serious decline, the species is doing a lot better in northern Australia, where there is a large, stable population. In Western Siem Pang, at least one pair has bred regularly in recent years.

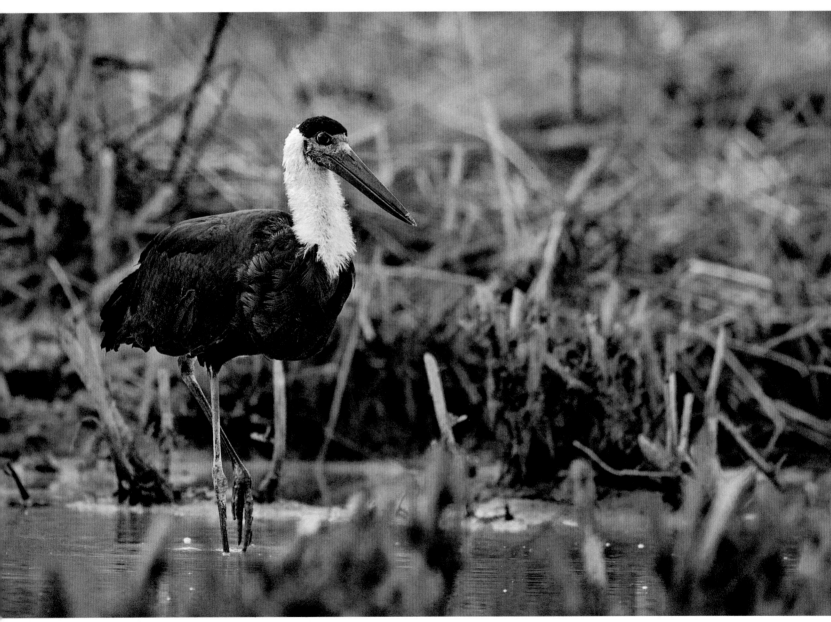

▲ The Vulnerable **Asian Woollyneck** (Ciconia episcopus) *is a medium-sized stork normally seen foraging alone or in pairs. It is predominantly carnivorous and the diet includes frogs, fish, lizards, snakes and large insects. It is a non-colonial breeder that usually nests in tall trees, sometimes in the vicinity of water. As with other large birds across the region, hunting is a perennial threat in many areas outside protected areas.*

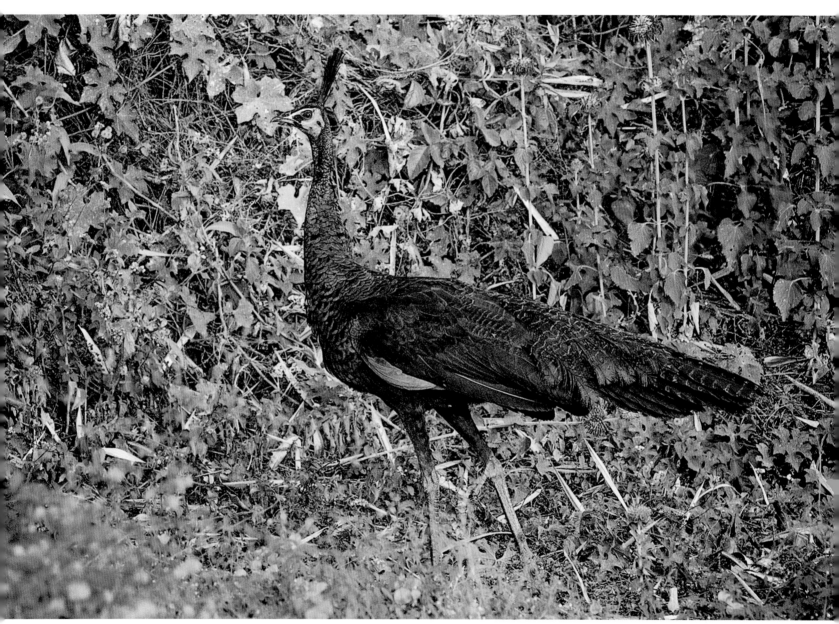

▲ *Green Peafowl* (Pavo muticus) *seen along the Sekong River that runs through Western Siem Pang Wildlife Sanctuary. A century ago the striking Green Peafowl was one of the commonest game birds in continental Southeast Asia, but widespread hunting combined with habitat destruction has decimated its population and it has been classified as Endangered by IUCN since 2009. The Western Siem Pang population is threatened by the rapid encroachment and loss of its riverine forest habitat by squatters.*

## Mai Mem - From Hunter to Conservationist

***Mai, can you tell us a bit about yourself***

*I am 45 years old, married with three sons and one daughter. I also have a grandson five years old.*

*My parents were farmers. In my early years there were not many jobs in the countryside, and I joined in the military for two years starting in 1988. After that living conditions were difficult and many villagers like me took up hunting to support our household.*

*I joined BirdLife in 2003. I can still remember that my salary at that time was just $20 a month. It has taken me some time to learn the English names of most of the animals that we can see in the Siem Pang forest. This has been a quite difficult task for me.*

### How was the hunting done in those days?

*The most popular hunting equipment was a homemade rifle often made by hunters themselves, but also traps and snares were popular. Hunting dogs were used in tracking wildlife such Wild Pig, Sambar Deer, Red Muntjac, Hare, Civet, Tiger, Crested Serpent Eagle, and Sarus Crane. We were close to our hunting dogs, which followed us all the time and were very loyal to us. Most of the hunting was done in the dry and early wet season with May and June being good months.*

*There were still Tigers around back then, and I can clearly remember one time in 1992-93, when my dogs cornered a Tiger, which I had to shoot many times until it died with a horrible sound.*

*All the wildlife meat was for eating and sharing with other villagers, and some for exchange for things. As I said, in those days there were few options besides hunting wildlife to support your family.*

*Unfortunately, today Wild Pig meat continues to be found in the market, although it is not allowed.*

### Why did you change from hunting to protecting wildlife?

*Someone told me that BirdLife was recruiting locals, and I was very interested in this announcement, and I finally joined BirdLife*

*in 2003. This was a big life change for me; from hunter to become a conservationist. I somehow realised that if we did not change, soon all the wildlife would be hunted to extinction, and my children would never be able to see the same the wonderful things in nature as I have.*

*It has been a big experience for me to learn about wildlife conservation, such as wildlife ecology, and details of the breeding season, incubating, hatching, and feeding of chicks. I now realize that animals in many ways are quite similar to human beings.*

*Sadly, I saw the last Tiger in the area back in 1993 between the O'koul and O'kampha only around 18 km from our present Siem Pang BirdLife office. I can so clearly remember the encounter, it was around 3-4 in the afternoon and I saw it for several minutes not so far away.*

### What do you enjoy most of your field monitoring duties.

*Wildlife monitoring is really exciting. What is most enjoyable is finding new nests of Giant Ibis, White-shouldered Ibis and the three kinds of rare vultures, and also locating Eld's Deer that we can see in Western Siem Pang. The breeding season brings me lots of joy. To observe all the small nesting chicks of threatened species multiply is the highlight of my job.*

### What will the future bring?

*I have tried to educate my family to appreciate wildlife and nature. I hope that one or two of my sons will also find a job in nature conservation, actually not only my sons, but also other villagers in the community. My father told me: 'The life of a tree is often close to the trunk'. However, in the end it is up to my children to decide what they want to do in life, and I accept this.*

*It is important that we continue to educate the young in nature conservation, as it is easier for them to learn how to appreciate our forest, nature and all the animals. We have to try harder to make them love wildlife.*

*In future if we do not protect our forests and the animals in it, many species like ibis, vultures and deer will disappear as they are already close to extinction. This is so important because we all want our children and children's children to experience our wild nature and forests and all the animals.*

*Shown here is the transformation of the forest floor into a flowering carpet of Holarrhena curtisii (Apocynaceae). The forest flowering occurs every year in April and May not long after the first rains.*

## The Future

Although now a protected area, the Western Siem Pang Wildlife Sanctuary is far from secure. It is threatened by illegal land grabbing by villagers and infrastructure development in the form of a new road that encircles the wildlife sanctuary west of the Sekong River. Although established for security reasons, the fear is that settlement will be allowed along the road, granting easy access to the forest and undermining the integrity of the protected area.

Climate change is increasingly becoming a major threat to ecosystems in Southeast Asia, and dry forest ecosystems in north and east Cambodia may be some of the most vulnerable. The likely effects are not well understood but may involve the increased frequency and magnitude of fires. Many local villages depend heavily on agriculture and the natural resources of Western Siem Pang for their livelihood and will certainly be affected. Some practices like low intensity rice cultivation and farming of livestock (in the absence of wild ungulates) appear to benefit biodiversity to some extent. However, human population growth will have more serious implications for ecosystems here as it could lead to unsustainable use of natural resources.

Growing scarcity of natural resources may force a livelihood change and lead to a switch towards farming, with less reliance on harvesting forest products. One example of change is the recent success of households trying out small-scale aquaculture (Wright, H.L. 2012).

Ultimately, the conservation of large areas of dry forest in Cambodia faces many challenges. A major challenge is the provision of sufficient financial resources for effective management of the area. The Government's establishment of the Western Siem Pang Wildife Sanctuary is a welcome development and gives hope for the future, where both local communities and biodiversity can together face a sustainable future.

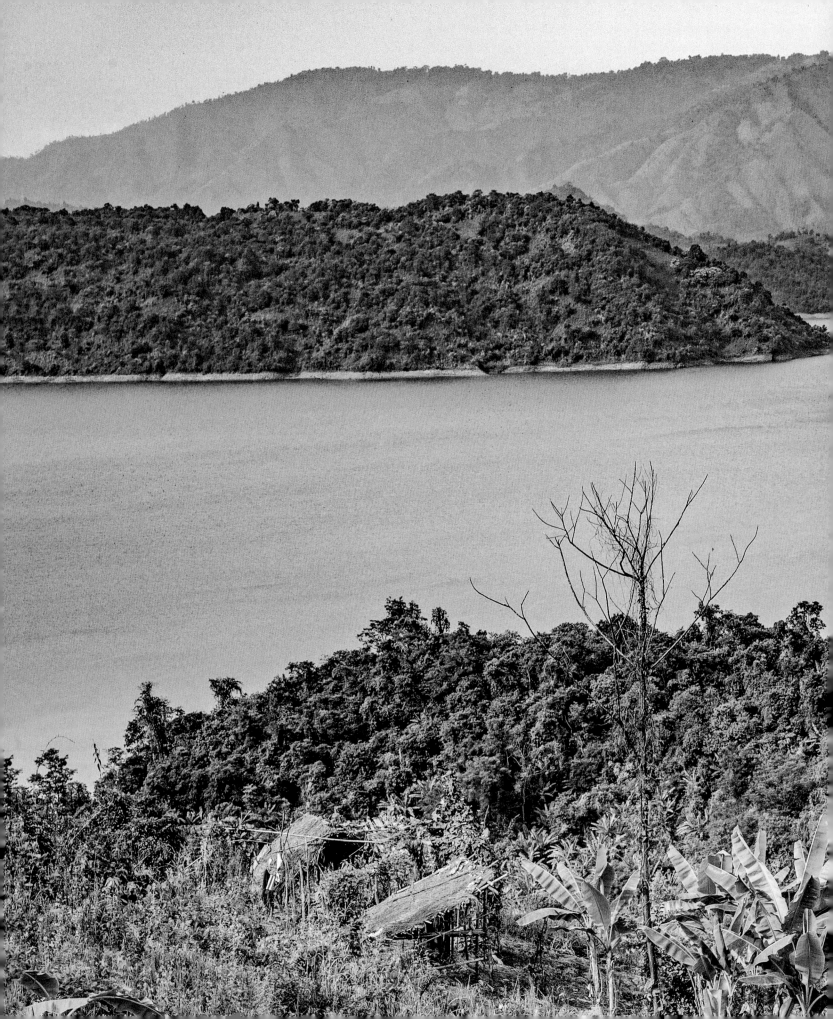

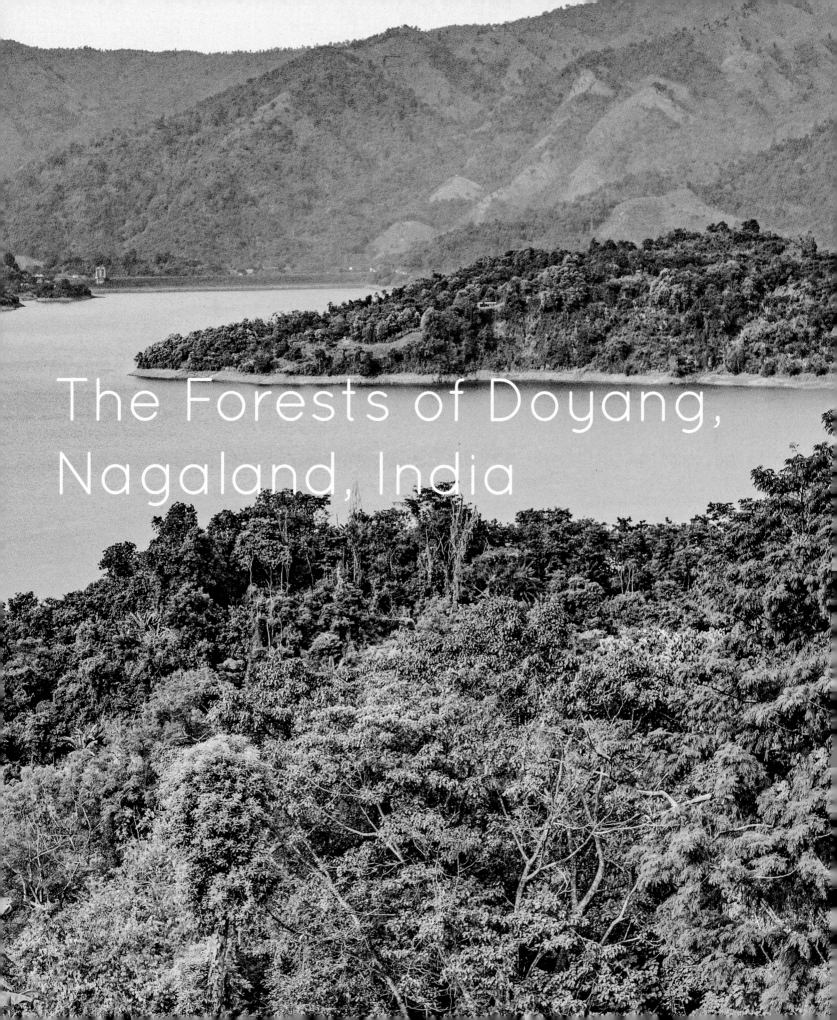

The Forests of Doyang, Nagaland, India

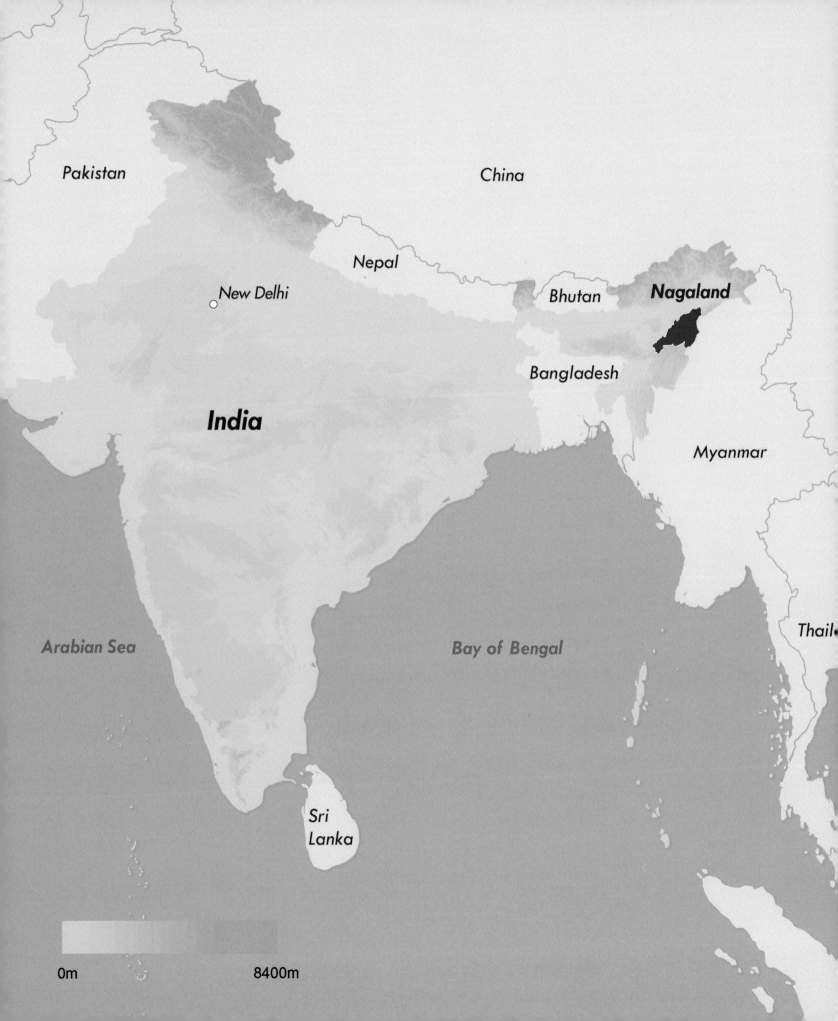

# The Forests of Doyang, Nagaland

## Background

Nagaland is a small, mountainous state located in the north-eastern part of India bordering Myanmar. It covers an area of 16,579 square km, with a population of just below two million, making it one of the smallest states in India. Around 90 per cent of the population are Christians and fall within 16 main indigenous tribes.

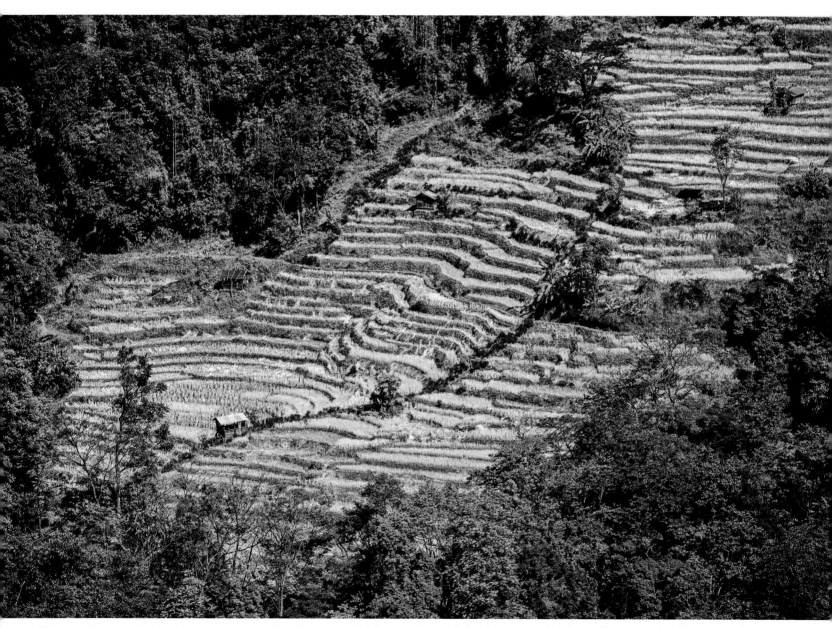

▲ *Nagaland has an agricultural economy; more than 70 per cent of the population depends on crops like rice, millet and maize. Cash crops include potato and sugar cane. Around 40 per cent of the state is under terraced cultivation as seen here, with the balance under shifting (slash-and-burn) cultivation.*

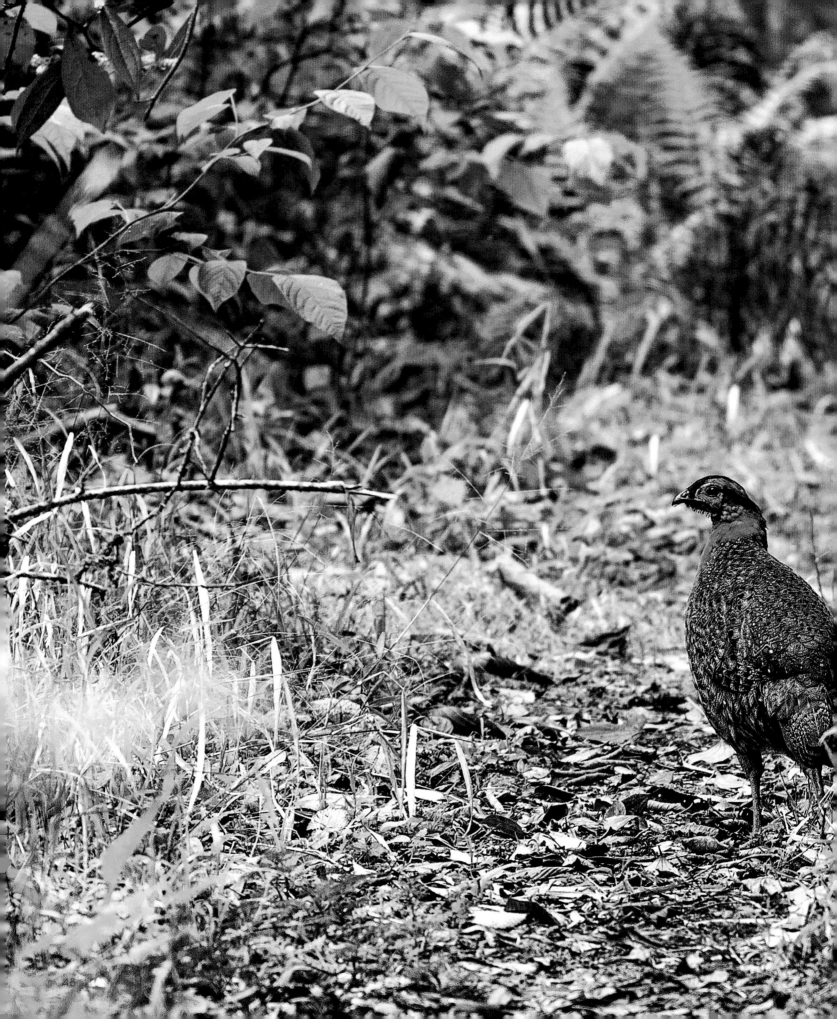

The state's closed-canopy forest declined from 43 per cent in the 1970s to 21 per cent in the 1990s. Logging, slash-and-burn cultivation and poaching of wildlife for food and local trade are the main conservation issues in Nagaland.

With the increasing human population and improving accessibility to remote forests in India's north-eastern states, hunting has become a severe problem. This, combined with increasingly degraded forests, has resulted in the 'empty forest' syndrome which is increasingly common in many parts of Asia. Although India's wildlife laws prohibit hunting of all wild animals, enforcement remains a major challenge. In Nagaland there is an established tradition in hunting wildlife. The practice of eating wildlife and using it for medicinal and ritualistic purposes is ingrained in the local culture. Even today, bush meat is commonly and openly sold in the markets.

◄ **Blyth's Tragopan** (Tragopan blythii) *is the official State Bird of Nagaland, where it is now locally extinct in many areas because of overhunting and loss of habitat. The last populations of the Blyth's Tragopan persist in eastern Nagaland, especially in the district of Kiphire.*

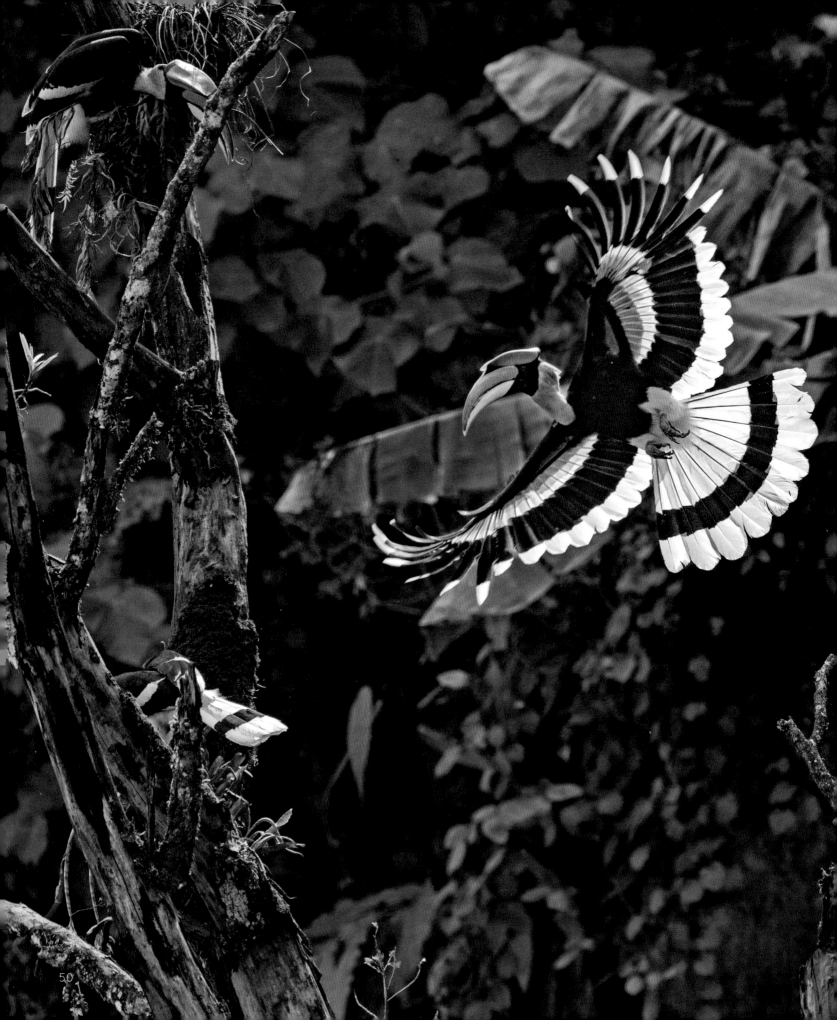

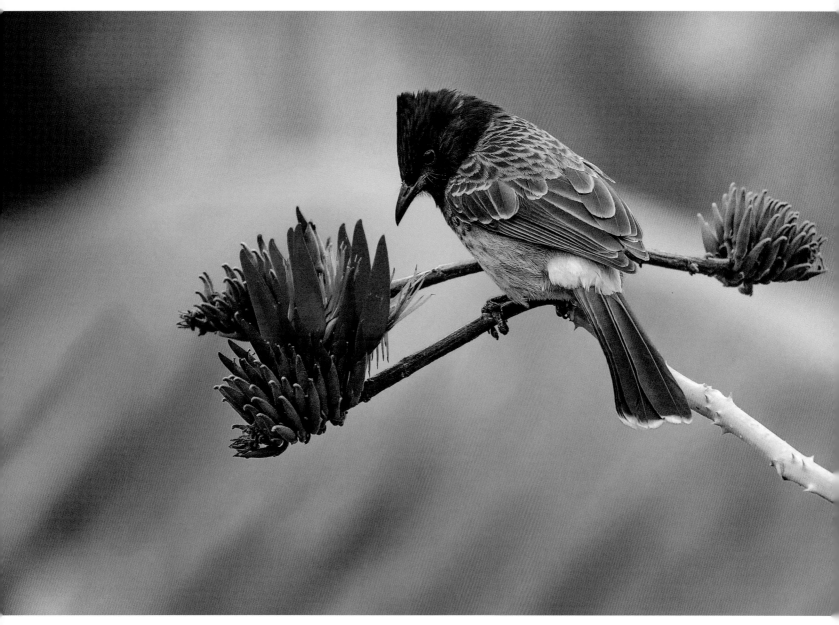

▲ *A **Red-vented Bulbul** (Pycnonotus cafer) feeding on* Erythrina stricta *flowers. Even small birds like bulbuls are hunted for food in Nagaland. Records show that in one year more than 13,000 birds and 3,500 mammals were sold in just one market in Tuensang, a small town in eastern Nagaland (Bhupathy S. and colleagues, 2013).*

◀ *The **Great Hornbill** (Buceros bicornis) has almost disappeared in Nagaland, especially in areas where tribesmen and warriors customarily use the tail feathers for head dresses, while the skulls and heads are often worn as decorations. These traditional dresses are today worn during the many Naga tribal festivals, including the annual Hornbill Festival during the first week of December. The Great Hornbill is an important symbol to the Naga people, and features regularly in tribal folklore.*

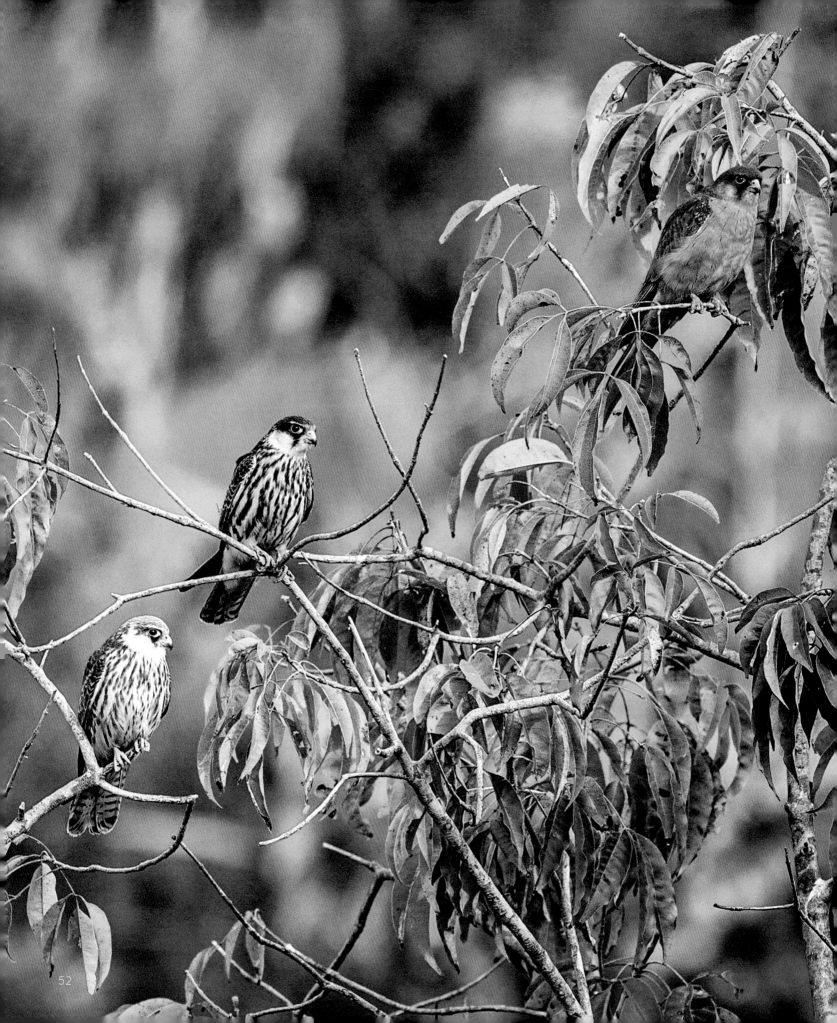

# The Amur Falcon

These trans-equatorial migrants are among the planet's greatest long-distance travellers. From May to June they breed in northern China, eastern Mongolia and south-eastern Siberia. As the boreal autumn sets in and days become shorter, they start their arduous migration in October, crossing more than a dozen countries, two continents and one ocean.

Their annual 22,000 km journey takes them through north-eastern India, followed by a three-day crossing of the Indian Ocean to arrive at Somalia, Kenya and eventually reaching their winter destination in southern Africa.

The mass migration of the Amur Falcon through northern India has been happening over thousands of years, but has been documented only recently. According to Conservation India, observations indicate that the falcons have only stopped over and roosted in the area since the creation of the Doyang hydro project reservoir in 2002, whereas in the past they were just briefly passing through.

Rhonchamo Shitiri, the Village Counsel Chairman of Pangti village, said, *'The Amur Falcons have been visiting the Pangti village as long as I can remember, but their numbers only started to increase in 2002 and 2003 and they were hunted from 2006 and onwards'.*

With up to one million falcons making a pit stop in this remote forested valley, this is possibly one of the largest gatherings of raptors in the world. In the centre of all this activity is the small village of Pangti, now called the 'Falcon capital of the world'.

◄ The **Amur Falcon** (Falco amurensis) *is a slender raptor with long, pointed wings. The male is a largely dark grey bird (top), with a whitish underwing which is visible in flight. The female (middle) is slightly bigger in size and has a markedly different plumage with cream underparts, with dark streaks and bars. The juvenile (bottom) resembles the female but is paler.*

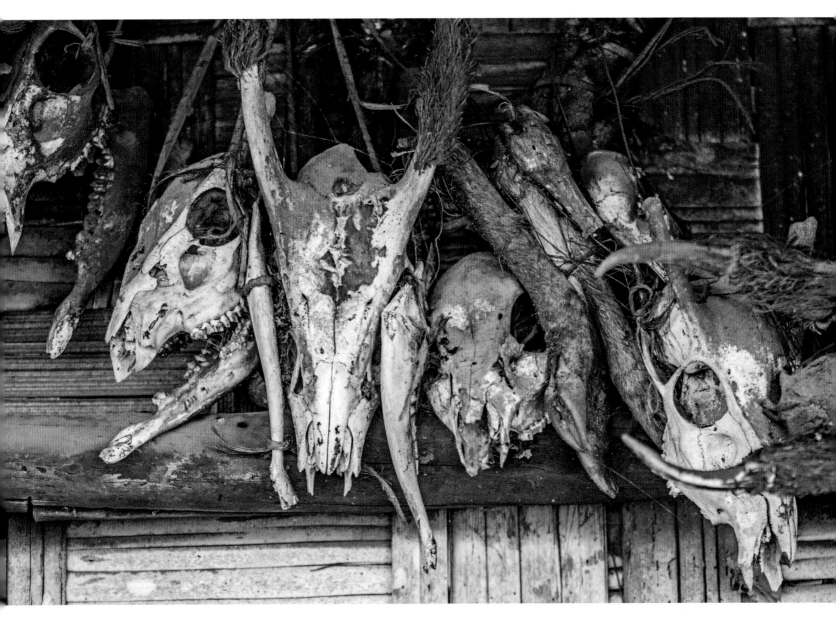

▲ Walking around Pangti village, the Naga hunting culture is evident and explicit. Inside homes, photographs of family members with hunted wild animals are often on display. A lot of village houses have decorated their doorways with antlers and animal skulls, obtained from hunting trips.

## The Hunt & the Sale

The creation of the Doyang artificial lake may have increased the abundance of flying termites and ants, dragonflies and other winged insects breeding there. This stopover has, in fact, made the Amur Falcon vulnerable. In the past, hunting of these pigeon-sized falcons was done using catapults and guns for local consumption, with limited impact on the population.

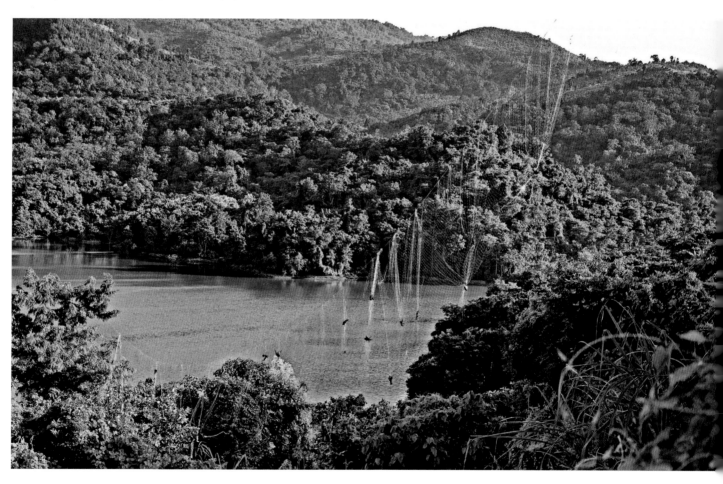

▲ *In the morning thousands of falcons spend their time on transmissions wires resting and hawking for insects, and during this time the birds are out of reach of the hunters. However, later in the day the falcons descend to the forests near the reservoir to roost.*

*The hunters callously exploit this particular behaviour of the falcons by setting up huge fishing nets up to 40 m long and 10 m tall around the roosting sites. The falcons get caught in the nets in large numbers while coming to roost in the evening or when they leave the roost.*

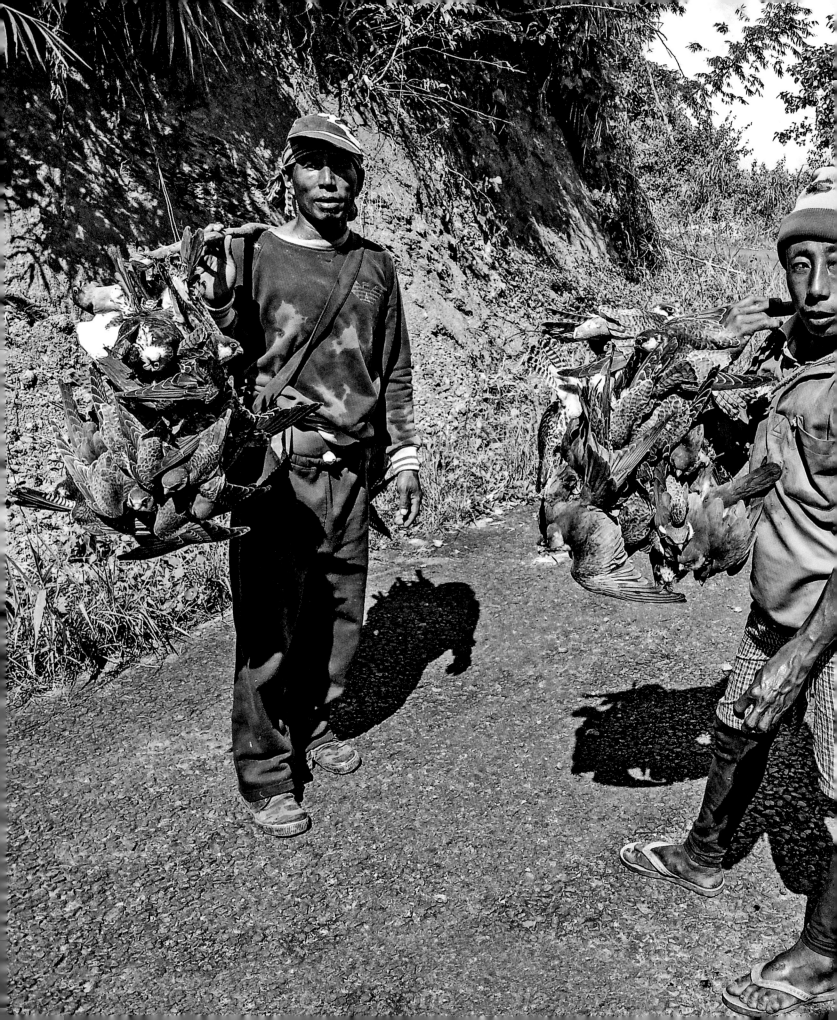

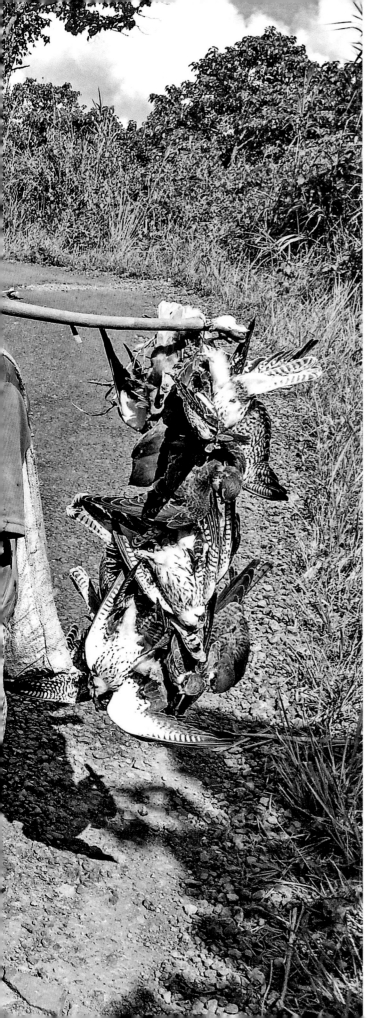

It was not until October 2012 that the world learned about the disturbing news of large scale commercial slaughter of the Amur Falcons in Nagaland. A group of conservationists from Conservation India went to investigate and reported that thousands of Amur Falcons were being commercially harvested and sold in the local markets.

*'Amur falcons are so easy to catch,' said Mr. Tajolo Jami, 52, from Pangti village. 'We don't have to do anything. They just fly into nets. You could call it, I think, a stupid bird. Laws are made; they are then forgotten,' said Mr. Jami. 'Give me a reason to not hunt that is of use to me'* (Sinha 2014).

◀ *The hunting groups consist of a handful of members each managing at least 10 nets. Up to 60-70 hunting groups operate at a time and total figures suggest that 100,000 – 140,000 falcons were slaughtered in 2012 alone.*

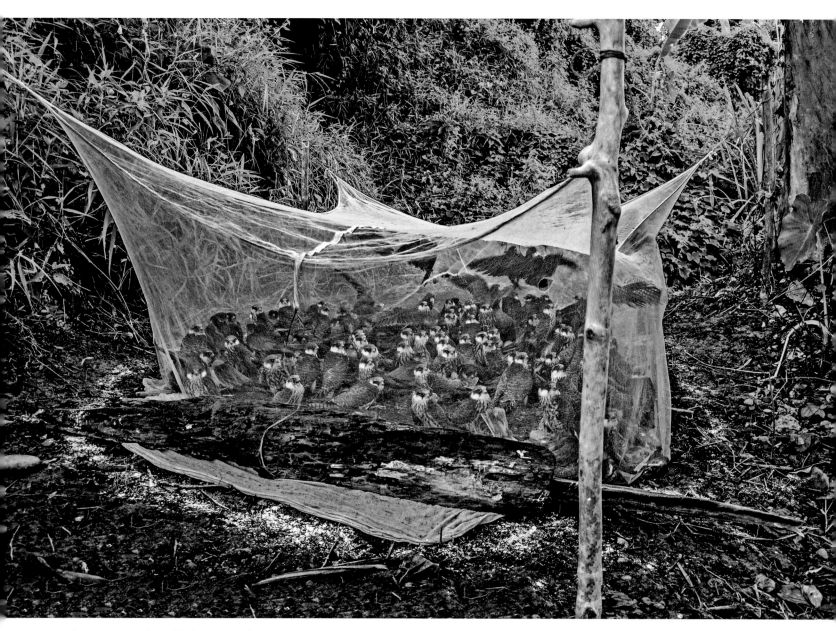

▲ Once captured, the birds are kept in cane baskets and mosquito nets, so they can be transported alive to the markets. The birds that die in the process are plucked and smoked, to increase the shelf life before being sold. Many of the birds are offered through door-to-door sales in Pangti village, Doyang and Wokha towns at US 30 cents to 50 cents each.

## The Action

In October 2012, immediately after the discovery of the appalling massacre of thousands of falcons, Conservation India initiated an on-line campaign with hard hitting images. The story swiftly went viral through social media, helping to galvanise local and international action.

At the same time, BirdLife International organised a campaign asking birders to support by donating to an emergency fund. This was to help their Indian partner, the Bombay Natural History Society (BNHS) to co-ordinate a plan to ensure this massacre will not be repeated. Donations made a big difference to the future of this small falcon, helping to establish field teams monitoring the roost and markets, as well as subsequent establishment of educational and engagement programmes within local communities in Nagaland.

Both national and state government ministers were alerted and soon action followed to remove nets along the banks of the Doyang reservoir and release captive falcons. The sales of the birds were effectively stopped in the local markets.

The following year, the preparation to welcome the the Amur Falcons to Nagaland and to stop the killing was comprehensive. BNHS co-ordinated a broad campaign of action that was implemented locally by the Nagaland Wildlife and Biodiversity Conservation Trust. Others supporting the campaign include Wildlife Conservation Society (WCS) India, the Raptor Research and Conservation Foundation and the Wildlife Conservation Trust.

Several BirdLife partners including the RSPB and BirdLife South Africa were involved in the establishment of a long term international advocacy campaign targeting the United Nations Environmental Programme (UNEP)'s Convention on Migratory Species (CMS), an international multilateral treaty aimed at conserving migratory animals. This treaty has been ratified by India.

The Wildlife Institute of India and its partners initiated a satellite-tagging project in November 2013 when three birds were released with solar-powered transmitters, and ringed with a BNHS metal band. The main purpose was to understand better their behaviour and ecology during their sojourn in Nagaland and along the migration routes and to raise appreciation of the international significance of the species. Two of the falcons completed their trip to South Africa and headed back to north-east India the following spring.

Award-winning filmmaker Rita Banerji was commissioned to document the story of the Amur Falcon. Her short-film 'Flight to Freedom – The Amur Falcon Story' was subsequently released and among other prizes, received special jury mention at the Indian Wildlife Conservation Awards.

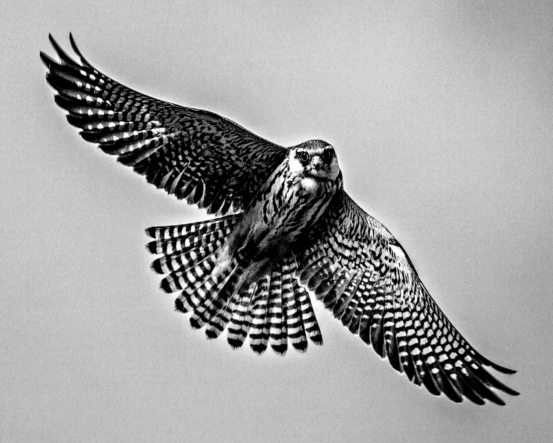

**The Amur Falcon song**

*Falcons flying over Doyang river.*
*Don't chase them*
*Don't let them fly away from us*
*Amur Falcon they are beautiful creatures*
*Flying thousand miles to be with us*
*Mysterious birds flying from here to Africa*
*We will wait for them to return next year*

# Conservation Education

In 2013, the Nagaland Wildlife and Biodiversity Conservation Trust (NWBCT) launched a comprehensive programme to protect the Amur Falcons migrating through Nagaland every October and November. BirdLife International, Wildlife Conservation Society (WCS), Bombay Natural History Society (BNHS), Raptor Research and Conservation Foundation (RRCF) and Wildlife Conservation Trust (WCT) have all supported this campaign.

During the year, co-ordinated efforts by NGOs, local villagers, the state forest department, and the Wokha district administration were made to pre-empt the killings of Amur Falcons seen in 2012. NWBCT established a base in Pangti village, the largest in the district, and enlisted support from the local community and church leaders. Neighbouring villages were invited to participate in the awareness programme.

In August 2013, the 'Friends of the Amur Falcon' campaign was launched. It was based on the development of a comprehensive teaching manual used during a rigorous four day 'Under the Canopy' programme to train 20 teachers about the Amur Falcon and their amazing migration. These teachers today run four EcoClubs that conduct activities such as wildlife conservation, fieldwork, creative arts and photography. The Amur Falcon song on the opposite page was composed by one of these EcoClubs.

The BNHS runs five EcoClubs in other parts of Nagaland and has acknowledged the fact that environment education has been a key driver in the change of attitudes in the local community.

Training and awareness materials supported the 'Friends of the Amur Falcon' outreach programme. This included an activity booklet designed as a passport, which caught the imagination of the young participants. As the children complete each section they get a falcon sticker from the teacher.

When all the tasks have been successfully completed they receive a visa certificate signed by the CEO of BirdLife International confirming that they are official friends of the Amur Falcon. Posters, badges, stickers and labels were also distributed to the local community.

In 2015, adult community leaders and teachers were trained in Dimapur, the largest city in Nagaland, as these people play an important role in engaging policy makers. In addition, more than 20 teachers were trained alongside BNHS EcoClubs teachers in Dimapur in November 2015. The impact of the conservation outreach activities in Nagaland is now being positively felt in the neighbouring states of Manipur and Assam, where some of the activities are being replicated.

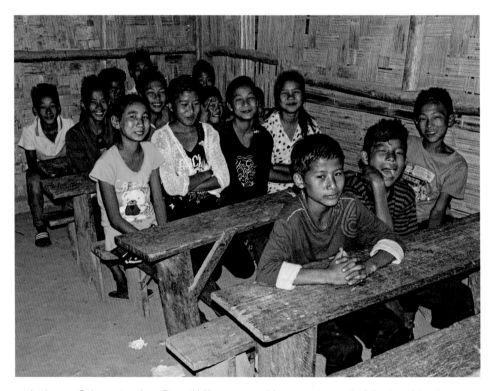

▲ *Janbemo Odyuo, teacher, Pangti Village, says, ' I am very proud of the teaching here, we have two EcoClub classes one with 15 and one with 17 students with ages from eight to 14 years. The attendance is very good, and if for any reason the students can't turn up, their parents will always inform me. I have also heard many examples that our kids go home with our conservation message and are successful in discouraging their family to hunt.'*

Prof. Bernd-Ulrich Meyburg and his team conducted one of the most comprehensive satellite tracking studies of Amur Falcons in 2010. The South African study included ten birds; eight females and two males fitted with matchbox-sized GPS transmitters to beam location data to satellites orbiting high above the earth. The minute solar-powered transmitter weighs just five grams and is gently fitted onto the bird with a harness across the bird's chest, with the antenna positioned to follow the outline of the bird's tail.

One of the female Amur Falcons, named '95773', had a particularly interesting flight. She was caught and released in Newcastle, South Africa on January 10. For the next eight weeks she was building up fat reserves feeding on insects in open grasslands, criss-crossing between different roosting sites in South Africa.

Finally, on March 21, the long journey began, when 95773 flew above the Lebombo Mountains and into Mozambique. On April 16, after a five-day stop-over in central Somalia she started on a daunting flight along the Somalia coast line, leaving the Horn of Africa to face an ocean crossing of more than 3,000 km. Two days and five hours later, she completed the oceanic passage and continued to fly on. Not until April 21, when she reached Mandalay in central Myanmar, did she finally touched down and took a rest. This astonishing non-stop flight lasted 5 days taking her 5,912 km at just under 50 km/h.

After a six-day refuelling stop, she continued flying slowly north-east and finally, on May 8, she reached her destination in Inner Mongolia about 450 km north of Beijing. This is the core of the Amur Falcon's breeding grounds, 14,560 km away from the winter roosting site outside the town of Newcastle in South Africa.

Shortly after the arrival at Inner Mongolia, Prof. Bernd-Ulrich Meyburg and his wife lost contact with Amur Falcon 95773; nobody knows what she did for the next few months. The big question was: would she return to South Africa?

Then suddenly, in late October, the network of satellites started to pick up signals again. On October 28, the female falcon passed over Assam in north-eastern India and continued over Nagpur, Mumbai and the Indian Ocean. This time her oceanic passage was shorter, at just over 2,500 km, and she covered this distance in a non-stop flight of just two days. A month later, on November 27, she stopped over in southern Zimbabwe, just 75 km from South Africa. On December 13, the satellites recorded her presence near Volkrust, a mere 50 km away from her roost the previous winter in Newcastle.

Three days later, on December 16, her GPS coordinates confirmed her roosting in a pine tree in Newcastle only two kilometres away from the roost where, 11 months earlier, 95773 had been released with a solar-powered transmitter.

The female Amur Falcon 95773 had come a full circle, and for the first time the epic journey of an Amur Falcon had been documented (Smillie 2011).

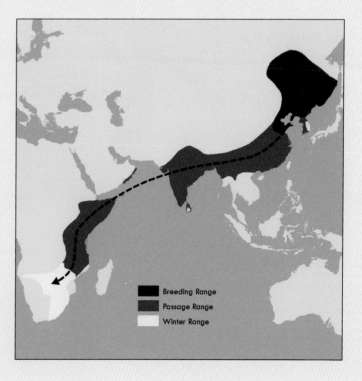

Breeding Range
Passage Range
Winter Range

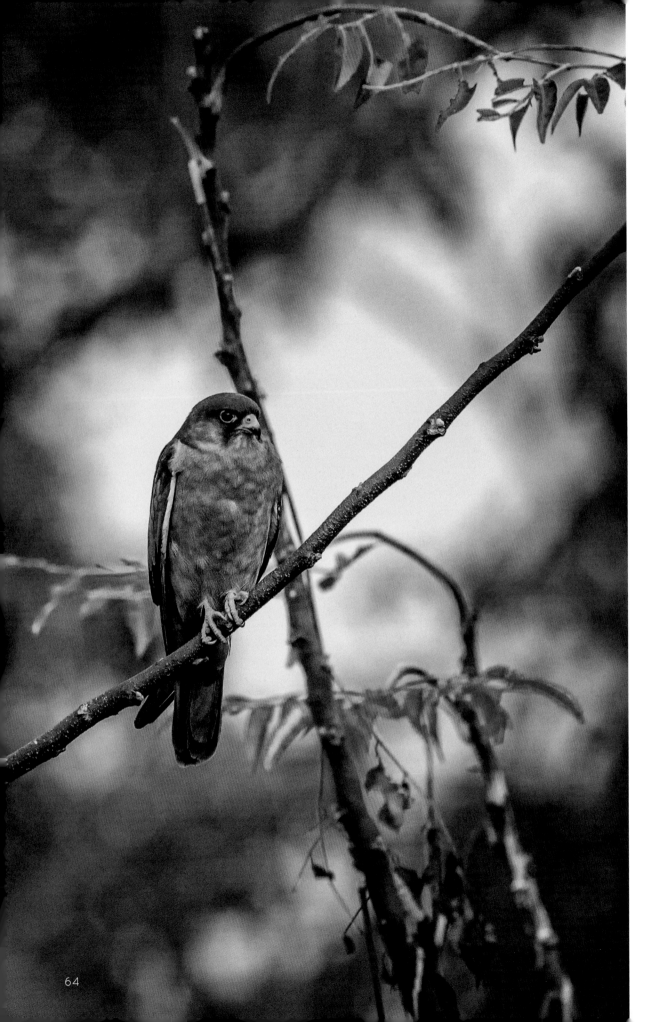

◀ During their winter months in Africa, the entire Amur Falcon population is estimated to consume 1,800 tons of invertebrates, including agricultural pests such as African bollworms, locusts, grasshoppers and termites. Big reductions in falcon numbers could therefore have far reaching impacts on agricultural areas and habitats in general. Their conservation is for this reason critical both for the ecosystems in the breeding and non-breeding grounds, and likely also for the stopover sites.

# The Results

In the 2015 migratory season, the numbers of Amur Falcons were at record levels and, just as in 2013 and 2014, there were no more killings. One of the contributing factors for this development is the locally managed Amur Falcon Roosting Area Union (AFRAU), which has checkpoints and keeps up patrolling throughout the season. Some of their members are ex-hunters from Pangti village.

Most of the 200 odd hunters around the Doyang Lake are now engaged full time in fishing. Phandeo Kithan, Chairman of the Co-operative Fisherman's Society added, 'Fortunately fishing can be done throughout the year, but the most favourable time is from June to August. Today, almost 300 fishermen from half a dozen villages are dependent on fishing with nets'. The most common fish caught in the Doyang Lake is the Indian Carp (*Catla catla*), which is collected from nets in the morning and distributed fresh locally and across Nagaland every day.

One of the other benefits of the project has been the strong involvement and leadership of the Nagaland forest department. After some initial reluctance, the department has taken ownership of this project, which signals an important mindset change within the government.

Testimony from an ex-hunter: '*I have learnt and understood that this hunting is not good, because so many birds and animals are going to be extinct in our place. Like my children, they may not know what is the name of that bird, that animal. After all, if you go on continuing like this they will not even see the small, small birds in our place.*' (Flight To Freedom – The Amur Falcon Story)

The multi-pronged approach of providing alternative livelihoods such a fishing and eco-tourism, effective public education and enforcement of wildlife protection laws have contributed to the success of this campaign. It is encouraging to see that more than 1,500 tourists visited the area in 2015.

The future survival of these amazing long distance aviators finally looks bright.

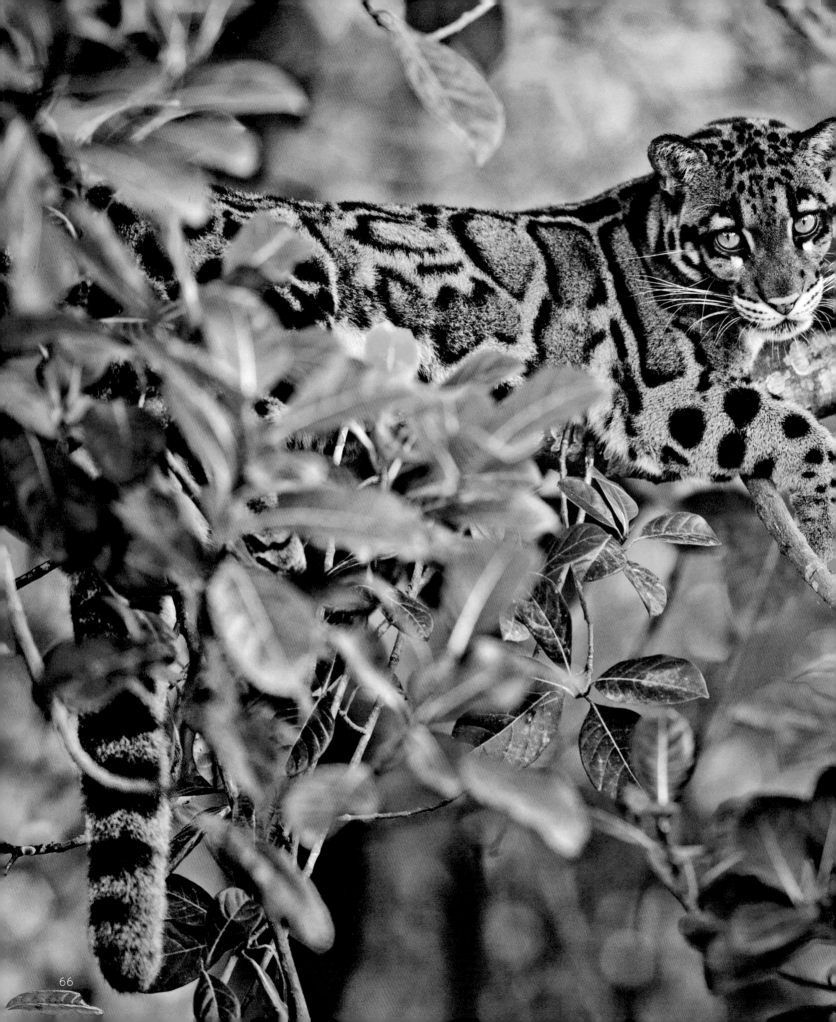

◄ The **Clouded Leopard** (Neofelis nebulosa) *can be found from the Himalayan foothills in Nepal through the north-eastern states of India, Bangladesh and Southeast Asia to southern China. It is extinct in Taiwan. In Nagaland, the Clouded Leopards are thinly distributed. It is one of three big cats occurring in the state, the others being the tiger and leopard.*

*The Clouded Leopard is well adapted for forest habitats with its stout legs and broad paws making it an excellent climber of trees. It has been observed clambering on the underside of big branches and hanging upside down by its hind feet, using the long tail for balance. Another remarkable feature is its canines, which in proportion to its body size are the largest canines of all cats. This shy and elusive animal leads a solitary lifestyle, resting in trees during the day and hunting at night. The Clouded Leopard is known to feed on a variety of prey, including langurs, large birds, pangolins, porcupines and small deer.*

*The main threats to the Clouded Leopard is habitat loss driven by logging and slash-and-burn (jhum) agriculture, which also reduces the number of prey species. In addition, it is also widely hunted for its meat and its attractive pelt which is prized by local people in Nagaland, as well as the neighbouring states.*

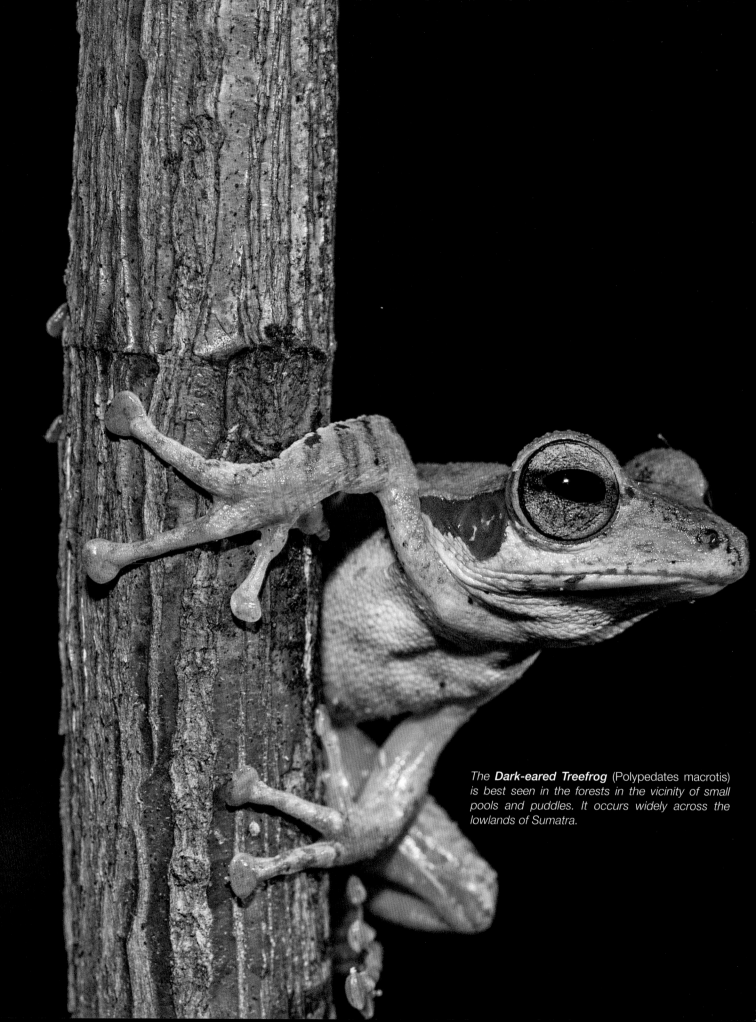

The **Dark-eared Treefrog** (Polypedates macrotis) is best seen in the forests in the vicinity of small pools and puddles. It occurs widely across the lowlands of Sumatra.

# The Forests of Harapan, Indonesia

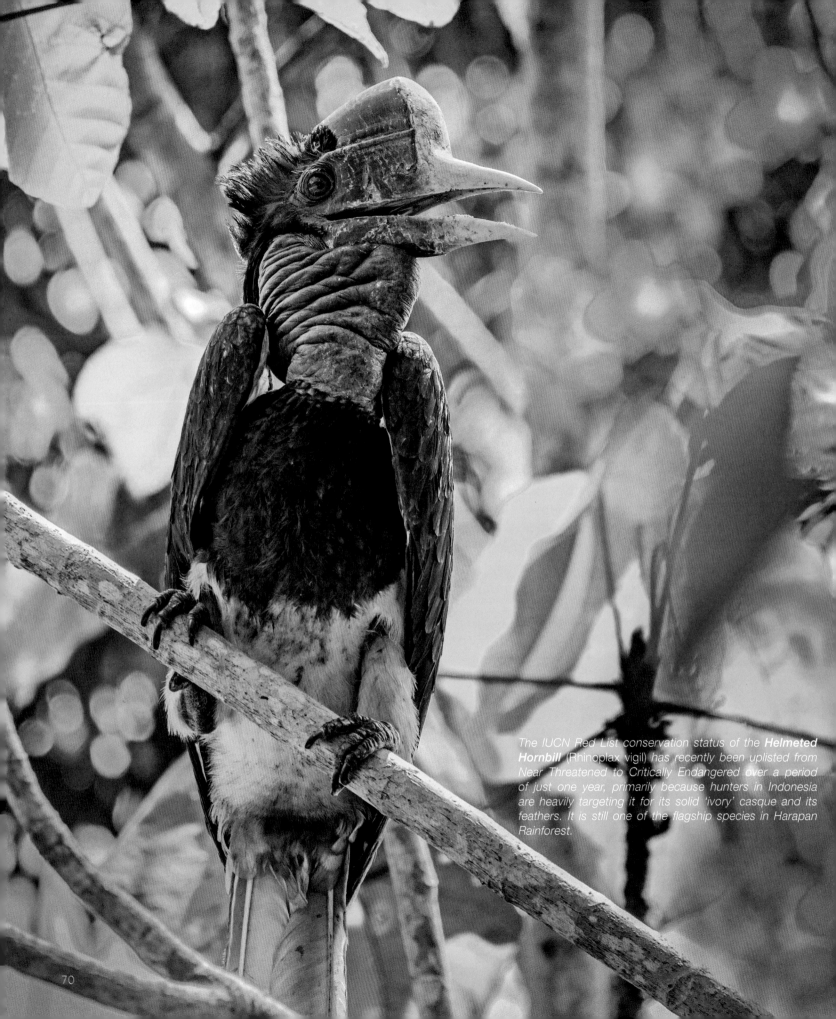

The IUCN Red List conservation status of the **Helmeted Hornbill** (Rhinoplax vigil) has recently been uplisted from Near Threatened to Critically Endangered over a period of just one year, primarily because hunters in Indonesia are heavily targeting it for its solid 'ivory' casque and its feathers. It is still one of the flagship species in Harapan Rainforest.

## Introduction

Sumatra is the sixth largest island in the world and third largest in the vast Indonesian Archipelago after Borneo and New Guinea. The forests of Sumatra contain exceptionally high levels of species diversity, comparable to, and in some cases higher than, the more well known rainforests of Borneo and the Malay Peninsula.

However, as in other parts of tropical Asia, lowland rainforests have been decimated and fragmented by timber extraction, clearance for agriculture and regular forest fires. In 1900, Sumatra's natural forests covered much of the island but today only about 8 per cent of the island (3.79 million ha) remains covered with primary forests, the majority in the rugged mountains of the Barisan range.

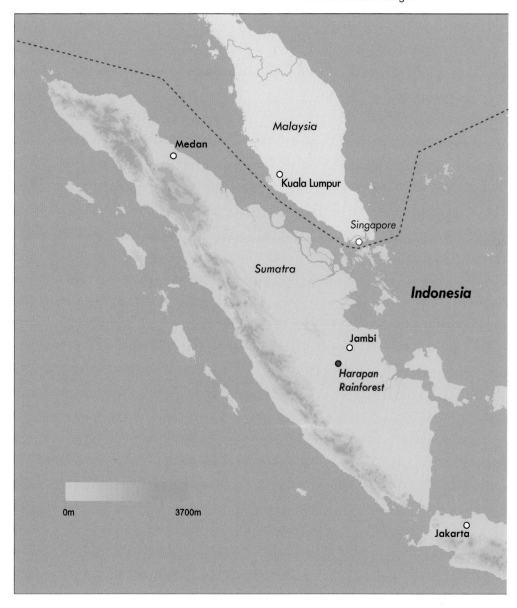

The Harapan Rainforest lies on the border of Jambi and South Sumatra provinces. In the past, it was managed under two different concessions, each with a different logging history. After the logging companies left, some of the areas were affected by severe illegal logging and forest fires.

In 2004, Burung Indonesia, supported by BirdLife International, convinced Indonesia's Ministry of Forestry to permit private organisations to manage 'production forests' to be restored and managed for conservation.

The first licence was approved in 2007 for a 52,170 ha Ecosystem Restoration Concession (ERC) in South Sumatra to a group consisting of Burung Indonesia, BirdLife International and the Royal Society for the Protection of Birds (RSPB). In 2010, the group received a second ERC licence for an adjacent 46,170 ha in the province of Jambi. Both Ecosystem Restoration Concessions are now collectively known as Harapan Rainforest, or Hutan Harapan in the Indonesian language, and run for a period of 100 years in South Sumatra and 60 years in Jambi. Hutan Harapan now represents a significant portion of remaining tropical lowland forests in Sumatra, and stands out as a rainforest island surrounded by palm oil, rubber and pulp wood plantations.

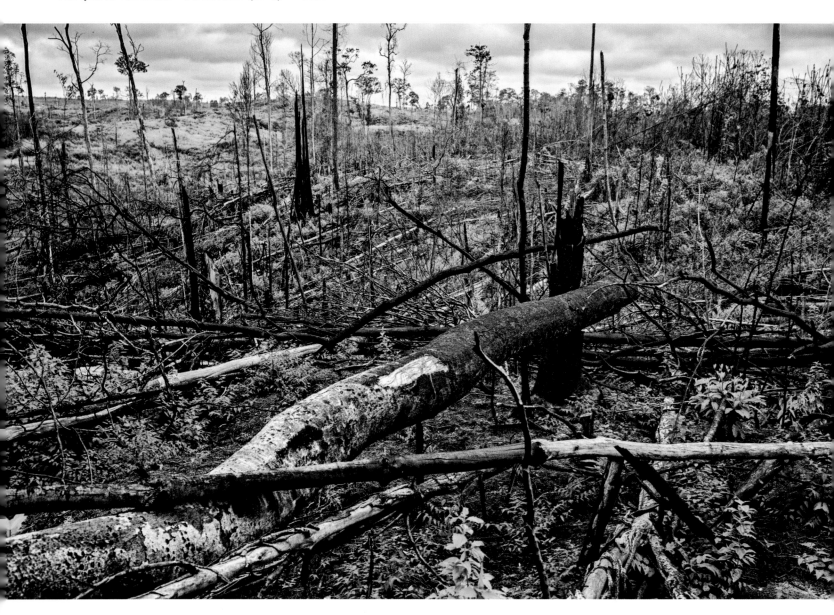

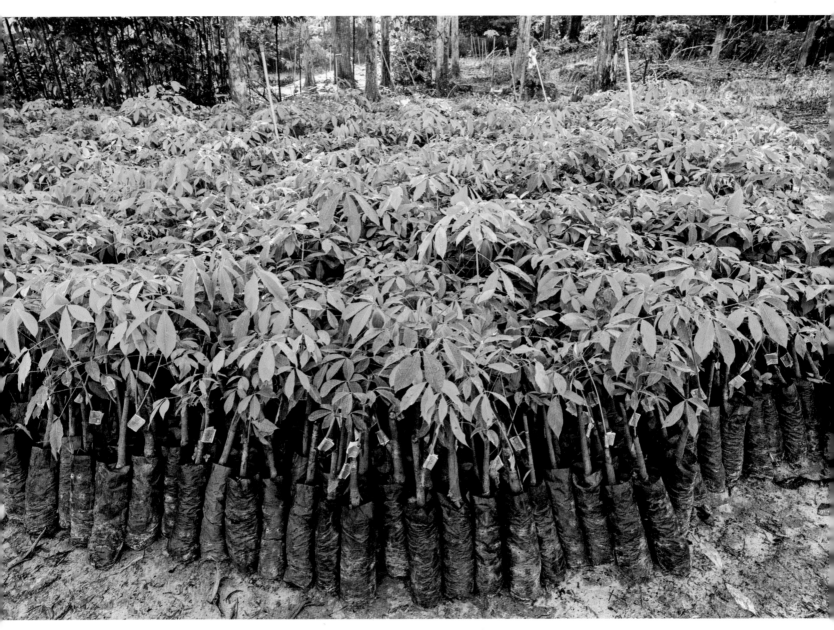

▲ As an important part of Harapan Rainforest's ecosystem restoration strategy, tree nurseries have been established to quicken the ecological rehabilitation of the area while providing a source of income for the local communities. A total of 107 households participate in the management of three nurseries, which helps to regenerate forest with native plant species.

The indigenous Batin Sembilan people know where to find the 'mother' trees and what time of year it is best to collect the seeds. The first nursery was started in 2010 and in the first two years a remarkable 900,000 seedlings of 176 native tree species were planted.

◄ Encroachment into the Harapan Rainforest poses a major challenge to the integrity of the concession. Problems of trespassing started even before the Jambi license was granted in 2010. In the transition period from 2008 to 2010, there was no concession holder and people living nearby considered the forest as 'free land'. By the time the Jambi license was issued an area of 13,000 ha had already been logged, burned down and converted to palm oil and other agricultural crops with little effort by the local government to intervene in the situation.

Harapan Rainforest forms a new approach to tropical forest restoration in Indonesia. It is the first rehabilitation forest of its kind in Indonesia, and the legal framework created for Harapan makes it possible for other organisations to secure a production forest licence for forest restoration, wildlife conservation and sustainable development.

'The benefits of the tree nursery include jobs, money, and new experience. Tree nurseries are new to us. We thought seedlings from the forest could not survive in a nursery as we have tried this before. Now we take the seedlings from the forest when they are very tiny; after we take care of them they grow naturally without using fertilisers': Ibu Teguh, Batin Sembilan housewife.

The settlers in Harapan mostly come from outside of Jambi and South Sumatra Province; many come from Java Island and North Sumatra Province. Only around 20 per cent of the encroachers can be classified as poor. Many non-government organisations (NGOs), local government officials, influential local leaders and business people supported the migrants, who may later sell their land for a profit.

After Harapan took over the management of the concession in 2010, the encroachment continued and in 2012 well organised groups were cutting down the forest at a rate of 1.5 square km every month. At this point the local authorities finally responded and the police arrested some of the settlers who

▲ **Light Red Meranti** (Shorea leprosula), *Endangered. More than 700 species of trees have been identified in Harapan, a number of which are listed as globally threatened by IUCN. A growing amount of dipterocarp species are threatened by deforestation for timber harvest, including* Hopea mengarawan. *The tree assemblage here is dominated by* Meranti, Shorea *spp.,* Litsea *spp., and* Palaquium *spp. The plant species list is growing as more surveys are carried out.*

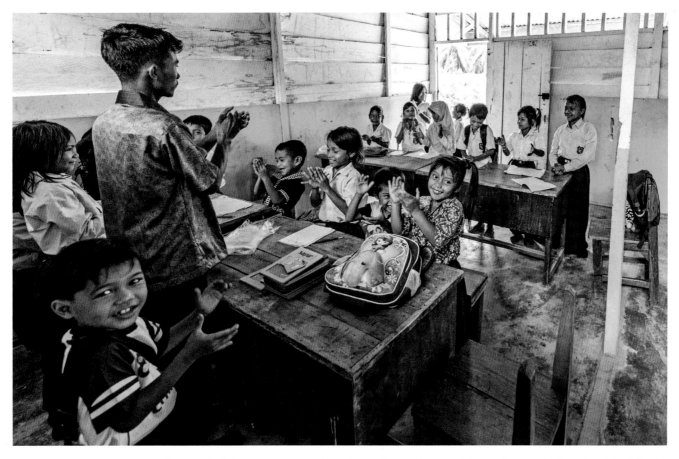

▲ *Under the management of Harapan Rainforest, resources have been allocated to provide teachers and educational facilities for an elementary school with two classrooms for children of Batin Sembilan background.*

*Harapan is home to more than 200 indigenous Batin Sembilan families living inside the forest depending on small scale slash-and-burn agriculture and gathering of non-timber forest products (NTFPs). The Batin Sembilan community's presence in the area can be traced back for centuries. Many Batin Sembilan people cannot access government education or health facilities because they do not have an identity card.*

had penetrated deeper into the forest. This further aggravated the situation and a group of immigrants kidnapped and held two Harapan guards until all the settlers had been released along with their chainsaws. Unsuccessful attempts to evict these settlers followed.

The conflict in Harapan Rainforest is complex as local business people and government officials are involved together with various NGOs, which with their respective interests have created a delicate, systemic problem. In addition, it involves many other stakeholders at the international, national and local levels. With such diverse and sometimes conflicting interests and agendas it is often challenging to form partnerships at the village level. Many newcomers get identity cards and buy the land from local business people to try to prove that they are legitimate community members.

The encroachment affects over 20 per cent of the concession area, primarily in Jambi province. It is the belief of Harapan's management that a more pragmatic and collaborative approach to resolve conflicts between different stakeholders will improve the situation.

In the past, the experience with stricter law enforcement is that it can potentially escalate the conflict: the litigation process increases animosity between the parties and makes future co-operation impossible. Ultimately, a court decision may not be enforceable in the field. Law enforcement is still weak, as the authorities often do not have the resources to administer the law in a consistent manner.

While the encroachment situation is far from satisfactory on the ground, there is little doubt that without the Harapan Rainforest project most of this lowland rainforest would already have been logged and cleared for palm oil or acacia plantations. Thanks to the project, an estimated 80,000 ha of rainforest are still intact, supporting a significant amount of biodiversity.

It is encouraging to note that a total of 16 Ecosystem Restoration Concession (ERC) licenses have been issued in Indonesia, covering a total area of more than 500,000 ha, with the possibility of more such licenses being issued in future. The ERC concept still faces serious challenges and needs more political support from the local and central government to control encroachment; moreover, to develop a business model that is financially sustainable is also essential.

▸ *A specialist of lowland forests, the Near Threatened **Garnet Pitta** (Pitta granatina) is one of the four pitta species resident in Harapan. It can survive in logged forests as long as much of the forest canopy remains intact. It takes mainly soft bodied invertebrates, particularly worms and snails.*

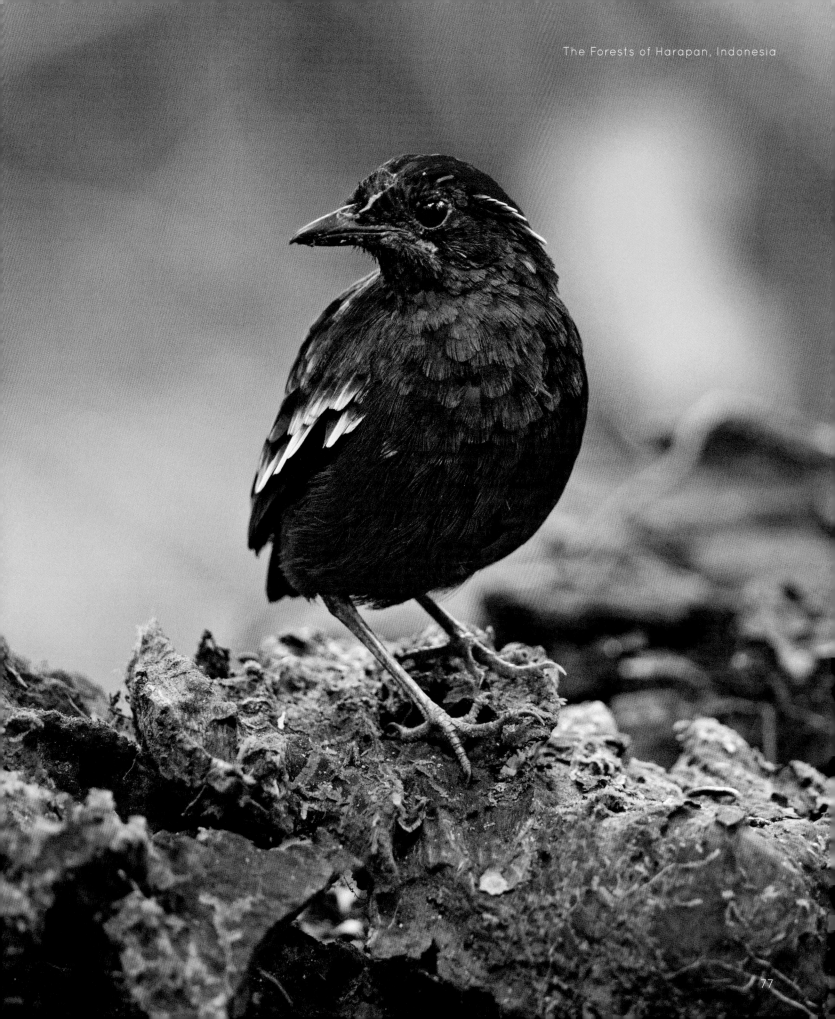

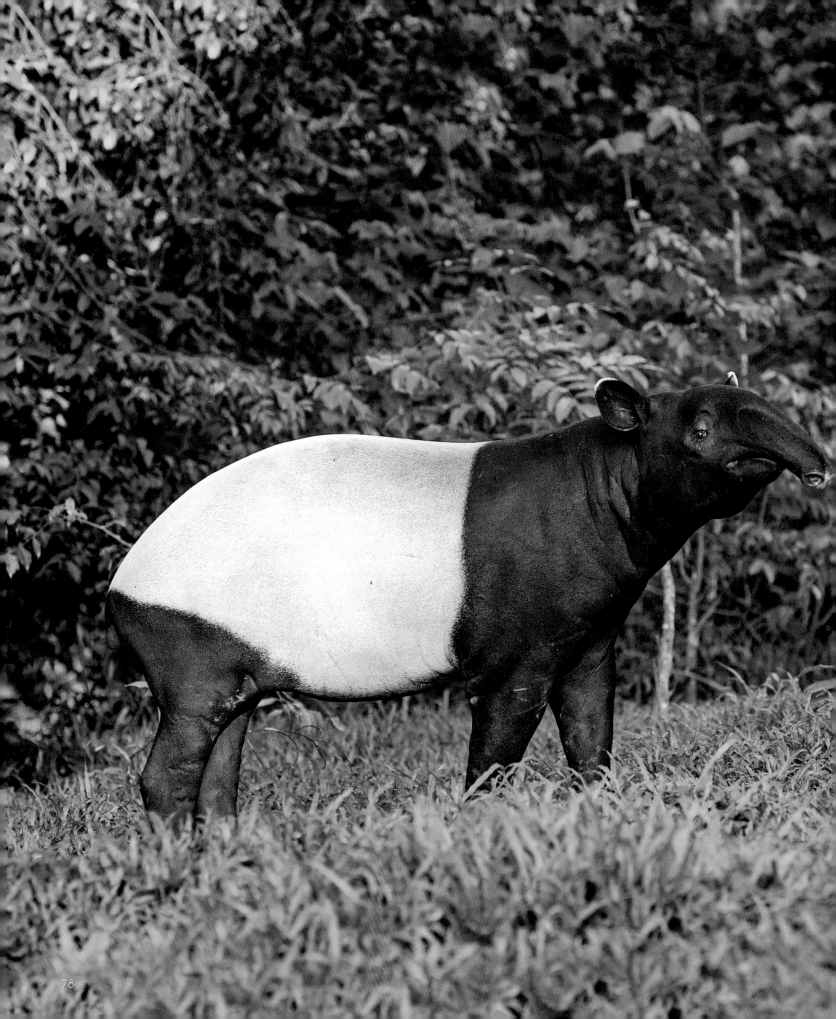

## Hutan Harapan Wildlife

The conservation significance of the Harapan Rainforest is recognised internationally. Harapan Rainforest sits within the Sundaland hotspot, a region of exceptional biodiversity recognised by Conservation International (one of 35 Biodiversity Hotspots in the world). It is also one of BirdLife International's Important Bird and Biodiversity Areas (IBAs) in Indonesia. The lowland forests of the Harapan landscape protect the watersheds of rivers, including two major tributaries (Meranti, Batang Kapas) of the important Musi River.

The landscape is home to more than 50 amphibian, 70 reptile, 300 bird and 60 mammal species. The forest supports 26 Endangered and Critically Endangered species, including the Sumatran Tiger *(Panthera tigris sumatrae)* that is still regularly seen in camera trap photos; the population in Harapan Rainforest is estimated at around 25 individuals.

The Critically Endangered Sumatran Elephant *(Elephas maximus sumatranus)* is also active in the Harapan Rainforest with one group of about seven individuals, of which two are GPS collared to monitor their movements.

◄ *The Endangered* **Asian Tapir** (Tapirus indicus) *is undoubtedly the most recognisable of the world's four tapir species, and the only one occurring in the Old World. In Sumatra, the tapir is particularly vulnerable to hunting pressure as a large proportion of the fragmented population occurs outside protected areas.*

Indonesia has well over 750 different reptile species of which close to 300 are endemic to the country.

The herpetological fauna of Sumatra is relatively poorly studied compared with Java and Borneo; the geographic distribution of many reptiles in Sumatra remains unknown.

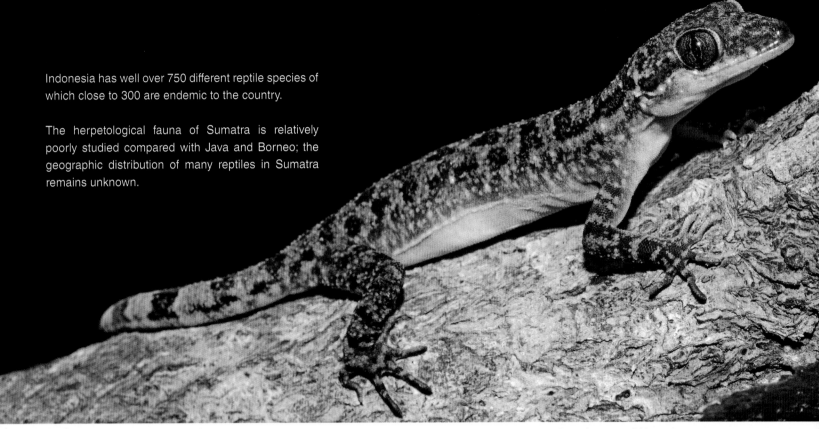

▲ *The* **Sumatran Bent-Toed Gecko** *(Cyrtodactylus lateralis) is endemic to Sumatra. Little is known about its natural history.*

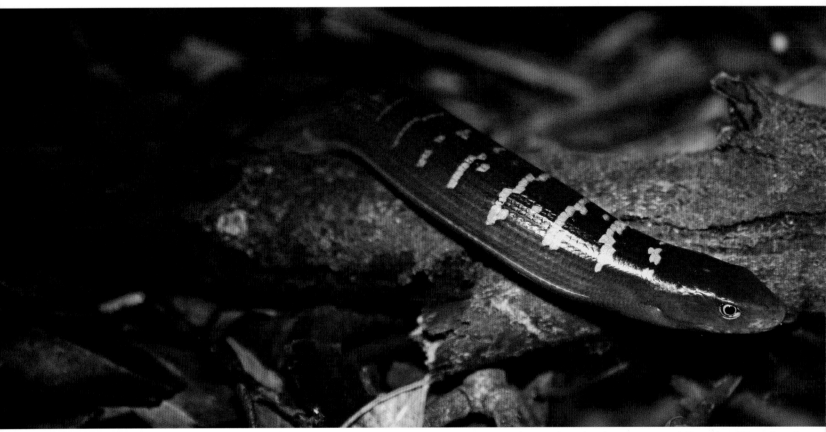

▲ *The colourful* **Sumatran Glass Lizard** *(Dopasia wegneri) is endemic and only known in one location in west-central Sumatra. Glass lizards resemble snakes, but are actually lizards. Most species, like the Sumatran Glass Lizard, have no legs. Their diet includes invertebrates, small reptiles and rodents.*

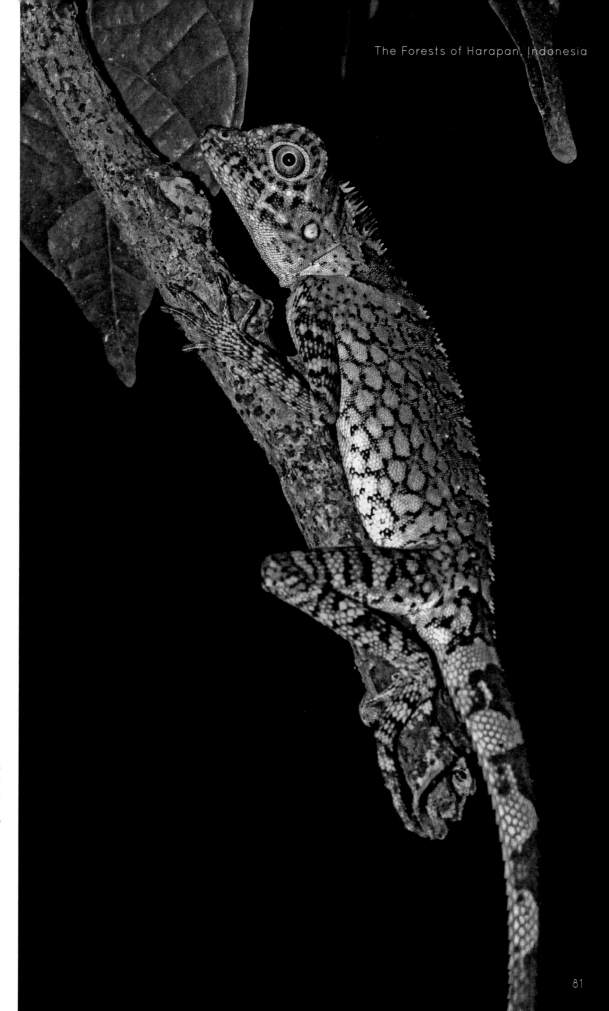

▶ Female **Beyschlag's Angle-headed Lizard**, *(*Gonocephalus beyschalgi*). It is endemic to Sumatra and can be found in lowland dipterocarp forests. Little is known about its diet and reproductive habits.*

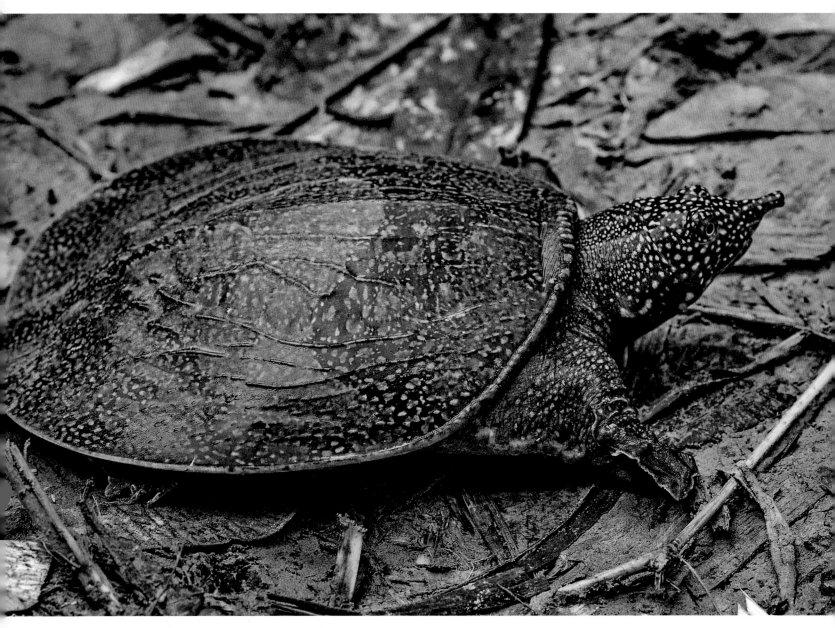

▲ As is the case with most turtle species in Asia, the Vulnerable **Southeast Asian Softshell Turtle** (Amyda cartilaginea) *is hunted for its meat both for local consumption and for export to restaurants in the region. This turtle is also harvested for traditional medicines and for its eggs. It is widely distributed from India in the west to Sumatra and Java in the east; with luck, it may be observed in Harapan's streams.*

*Most often you will only spot this turtle from its distinctive tubular snout sticking out from the water, where it spends much of it's time hidden in the muddy bottom of its aquatic habitat. During the night it may also feed on land. It is predominantly a carnivore, feeding on fish, amphibians and invertebrates.*

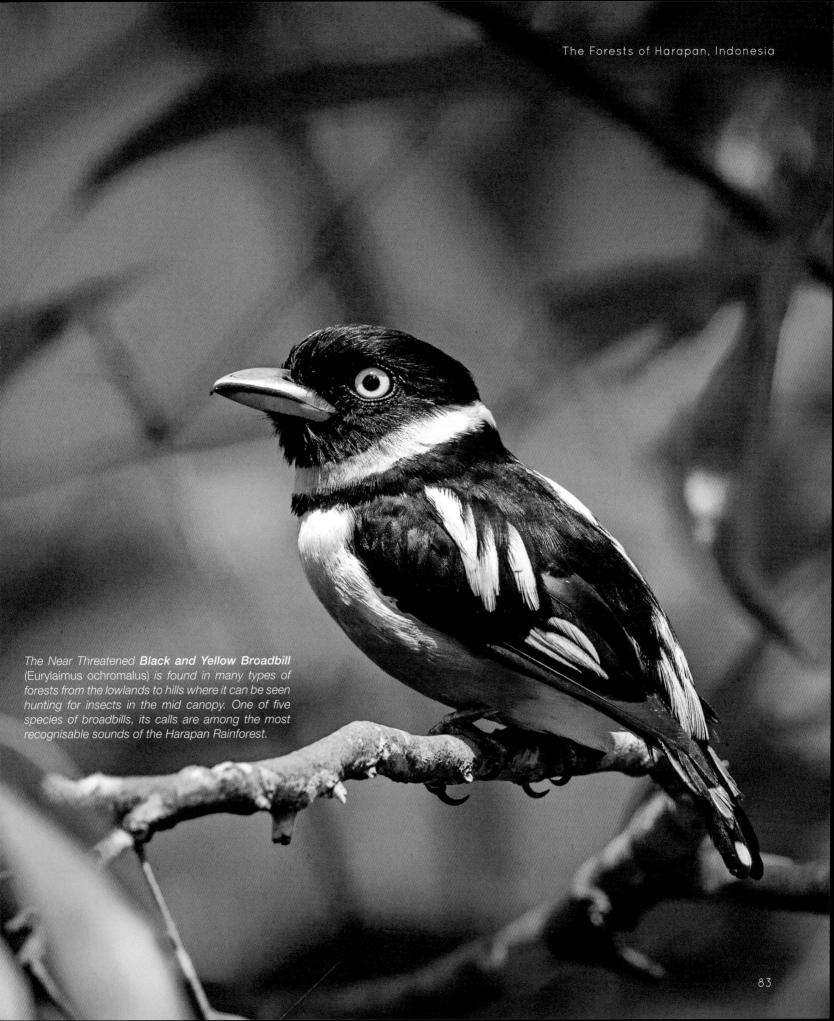

The Near Threatened **Black and Yellow Broadbill** (Eurylaimus ochromalus) *is found in many types of forests from the lowlands to hills where it can be seen hunting for insects in the mid canopy. One of five species of broadbills, its calls are among the most recognisable sounds of the Harapan Rainforest.*

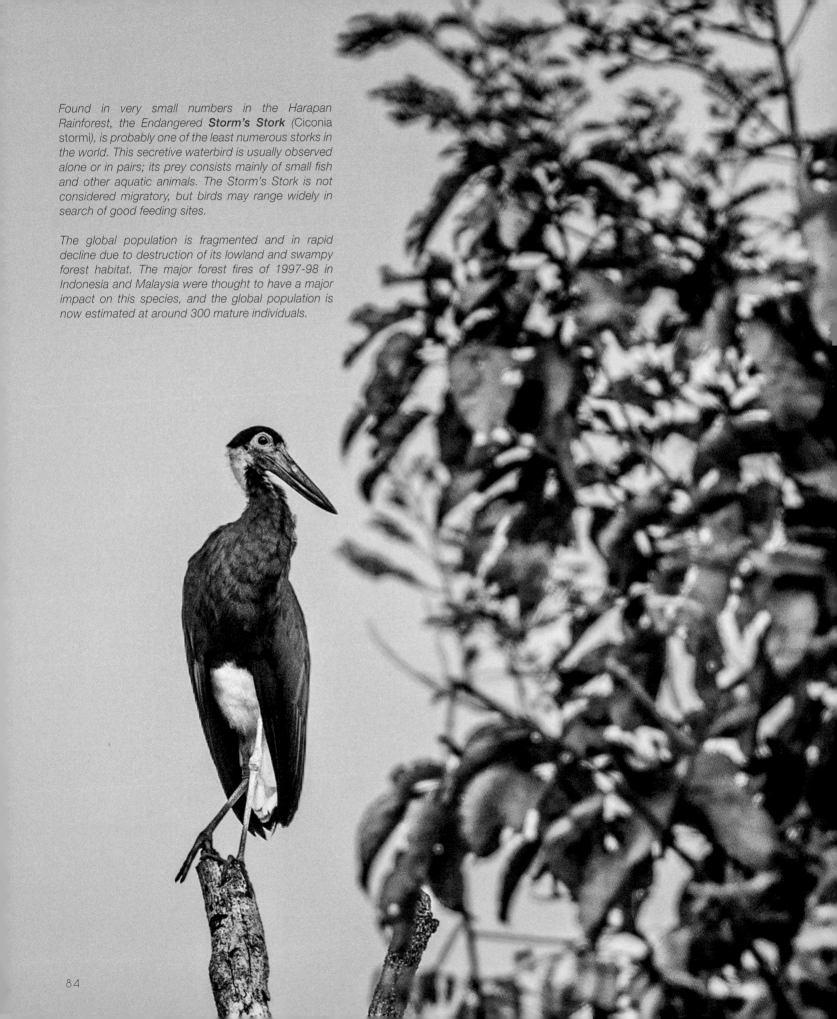

Found in very small numbers in the Harapan Rainforest, the Endangered **Storm's Stork** *(Ciconia stormi), is probably one of the least numerous storks in the world. This secretive waterbird is usually observed alone or in pairs; its prey consists mainly of small fish and other aquatic animals. The Storm's Stork is not considered migratory, but birds may range widely in search of good feeding sites.*

*The global population is fragmented and in rapid decline due to destruction of its lowland and swampy forest habitat. The major forest fires of 1997-98 in Indonesia and Malaysia were thought to have a major impact on this species, and the global population is now estimated at around 300 mature individuals.*

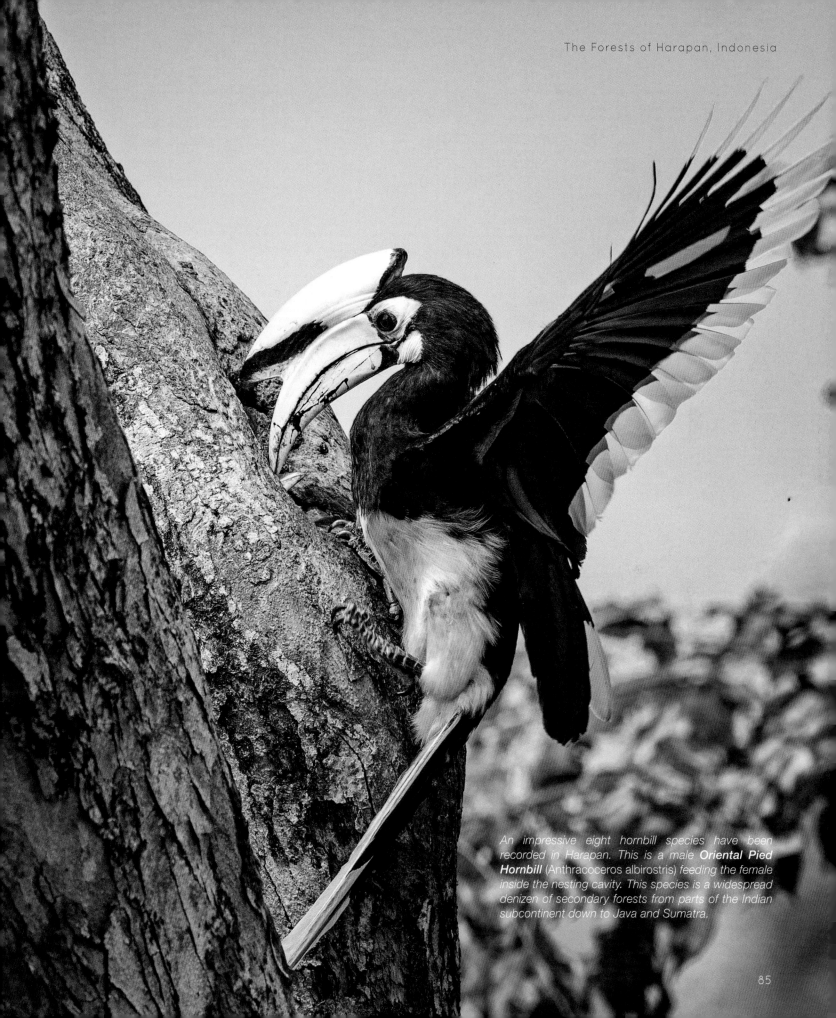

An impressive eight hornbill species have been recorded in Harapan. This is a male **Oriental Pied Hornbill** (Anthracoceros albirostris) *feeding the female inside the nesting cavity. This species is a widespread denizen of secondary forests from parts of the Indian subcontinent down to Java and Sumatra.*

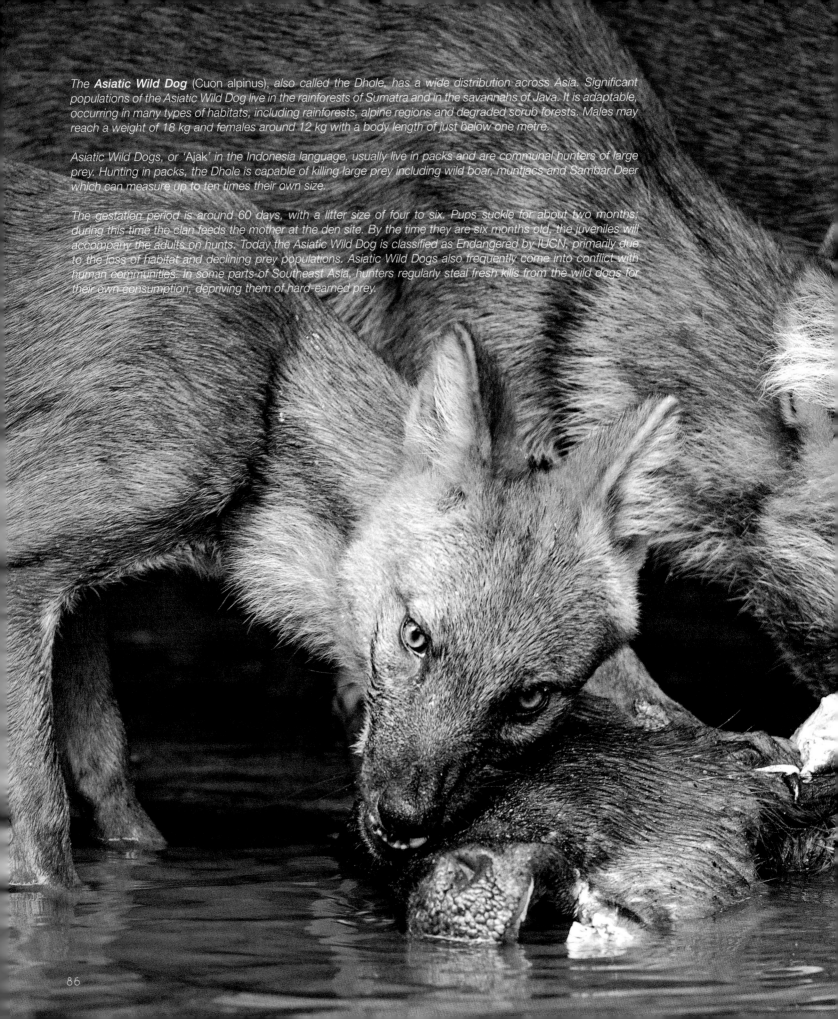

The **Asiatic Wild Dog** (Cuon alpinus), also called the Dhole, has a wide distribution across Asia. Significant populations of the Asiatic Wild Dog live in the rainforests of Sumatra and in the savannahs of Java. It is adaptable, occurring in many types of habitats, including rainforests, alpine regions and degraded scrub forests. Males may reach a weight of 18 kg and females around 12 kg with a body length of just below one metre.

Asiatic Wild Dogs, or 'Ajak' in the Indonesia language, usually live in packs and are communal hunters of large prey. Hunting in packs, the Dhole is capable of killing large prey including wild boar, muntjacs and Sambar Deer which can measure up to ten times their own size.

The gestation period is around 60 days, with a litter size of four to six. Pups suckle for about two months; during this time the clan feeds the mother at the den site. By the time they are six months old, the juveniles will accompany the adults on hunts. Today the Asiatic Wild Dog is classified as Endangered by IUCN, primarily due to the loss of habitat and declining prey populations. Asiatic Wild Dogs also frequently come into conflict with human communities. In some parts of Southeast Asia, hunters regularly steal fresh kills from the wild dogs for their own consumption, depriving them of hard-earned prey.

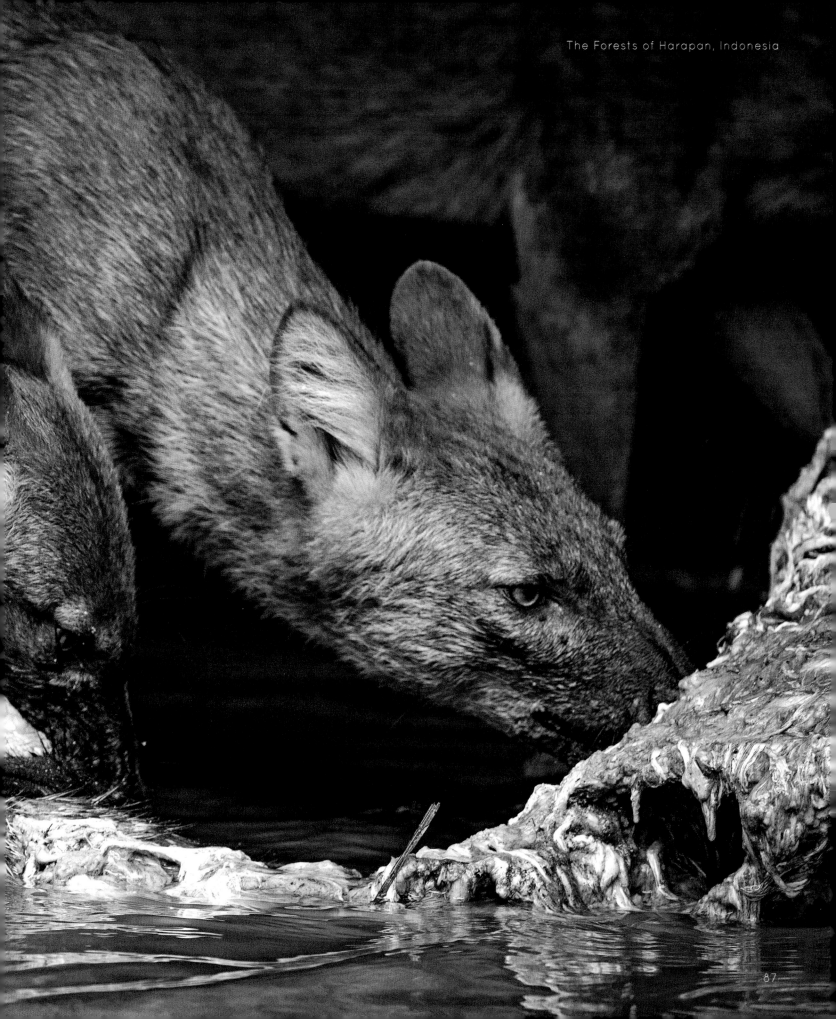

▸ The Harapan Rainforest hosts an impressive seven different species of primates, including three that are Endangered: **Siamang** (Symphalangus syndactylus), Sumatran Surili (Presbytis melalophos) *and Agile Gibbon* (Hylobates agilis). *The Orang Utan is not found here, as is the case for much of the southern half of Sumatra.*

The Siamang is the biggest of the primates here, and it may grow up to double the size of other gibbon species. Despite not having a tail, the Siamang does not lack a sense of balance and can sometimes be observed walking on its hind legs on branches in the forest canopy high above the ground. It has extremely long arms and fingers which aid it when swinging from branch to branch.

Siamangs live in both secondary and primary tropical rainforests and prefer areas with fig trees, which provide one of its favourite foods. The Siamang forages at all levels of the canopy and uses the tallest trees for resting and sleeping. Both male and female Siamangs have a large, inflatable throat pouch allowing them to project their loud, haunting calls which often can be heard early in the morning.

Every two to three years the Siamang give birth to a single offspring. For the first 12 months, the young animal stays with its mother after which the male takes over most of the duty of care. At around six years of age the young Siamang separates from its family group to look for a mate.

In Sumatra the primary threats to the Siamang are fragmentation and destruction of its forest habitat, and capture for the pet trade. It is one of the most popular gibbon species in the illegal pet trade. The mother is often killed during attempts to capture the young Siamang.

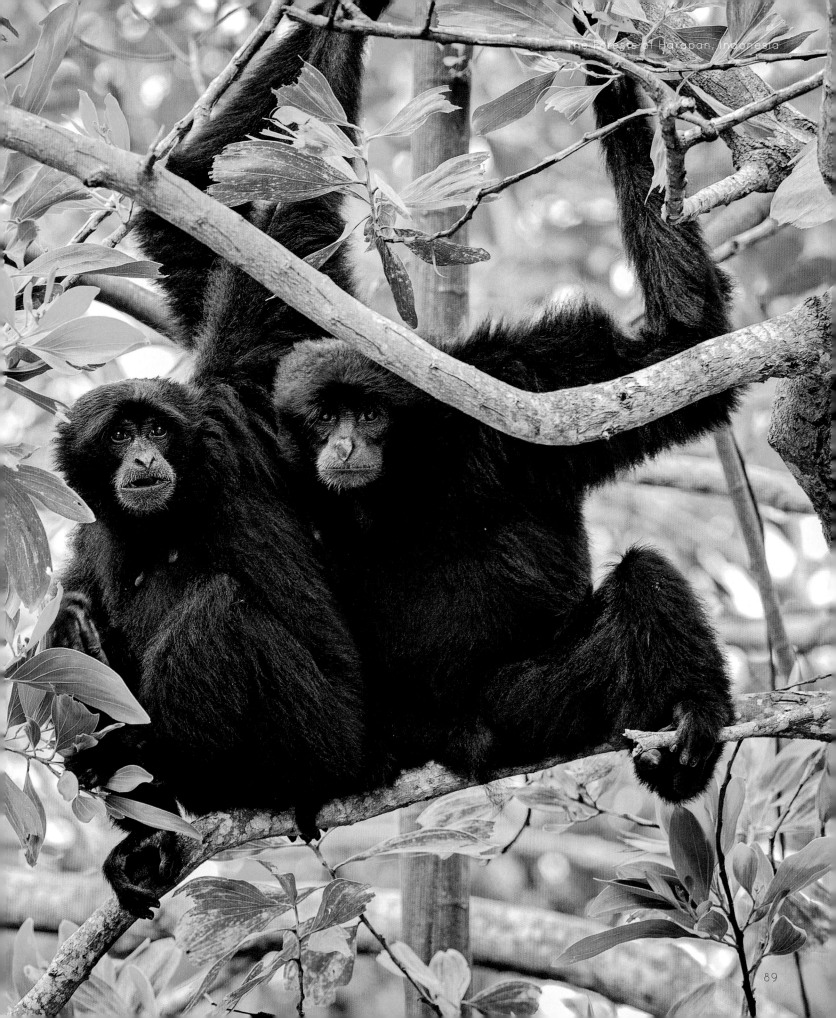

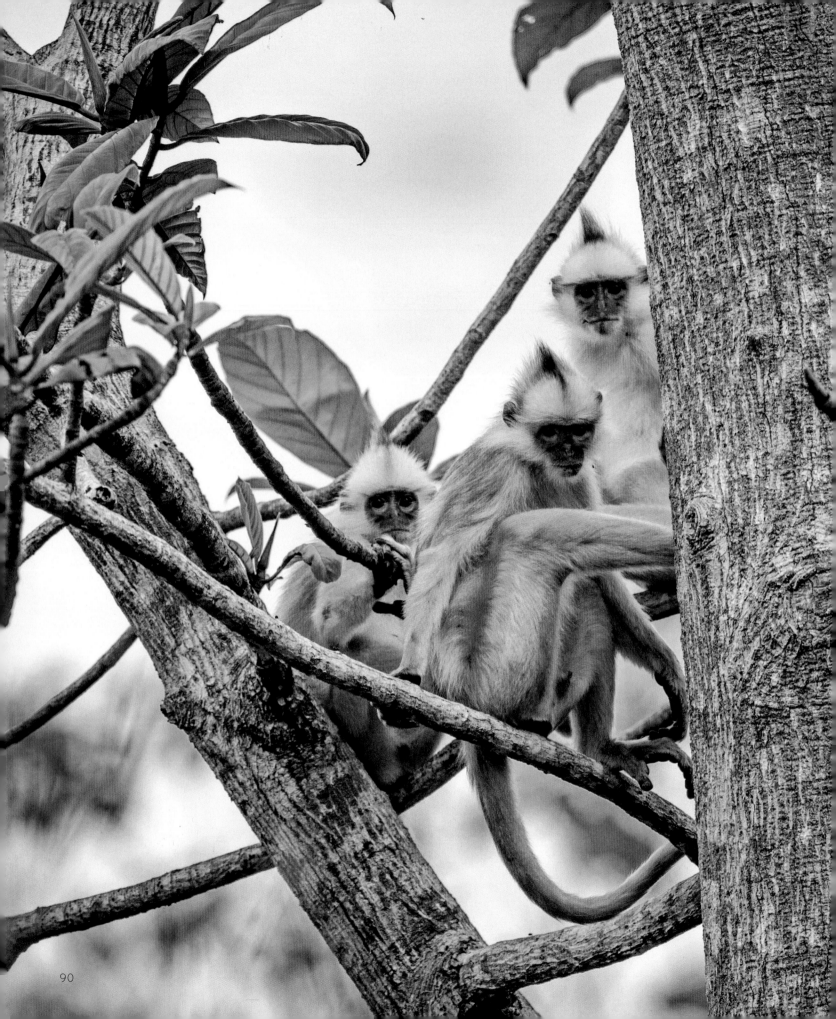

◀ *The Endangered* **Sumatran Surili** *(Presbytis melalophos) is endemic to Sumatra and Pulau Pini in the Batu Archipelago. It is active during daylight hours and the early evening and lives in troops of up to 18 individuals. This troop was encountered in the early evening when they were settling in at their roosting site for the night.*

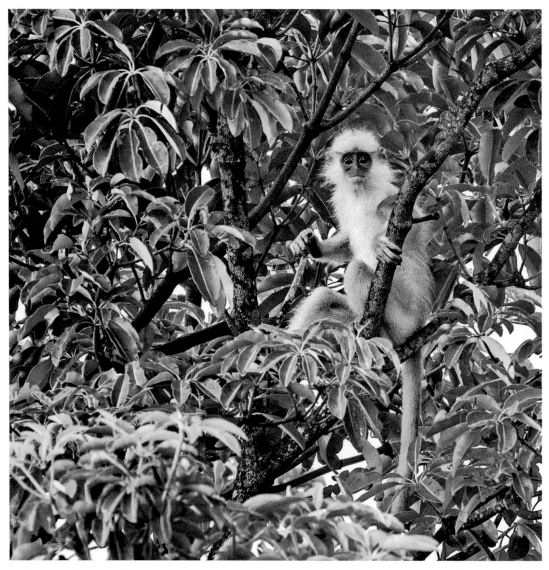

▲ The **Sumatran Surili** is quite adaptable and can also be seen in disturbed and secondary forest areas. This handsome primate gets its water through its diet or from dew and rainwater in tree holes. It is mainly folivorous but the diet includes other plant parts such as fruits, flowers, seeds and roots as well.

▶ The **Agile Gibbon** (Hylobates agilis) can be found in tropical forests in the Thai-Malay Peninsula and Sumatra. It is one of two species of gibbons found in the Harapan Rainforest. Agile Gibbons range widely across the southern two thirds of Sumatra, while in the north (north of Lake Toba) they are replaced by the White-handed Gibbon.

Agile Gibbons form territorial and monogamous family groups, usually consisting of one adult pair and one to three juveniles. Like many other gibbon species, the Agile Gibbon stakes its territory through loud early morning vocalisations. If calling and singing is not enough to keep trespassers out, the male and female will attempt to chase the intruder away.

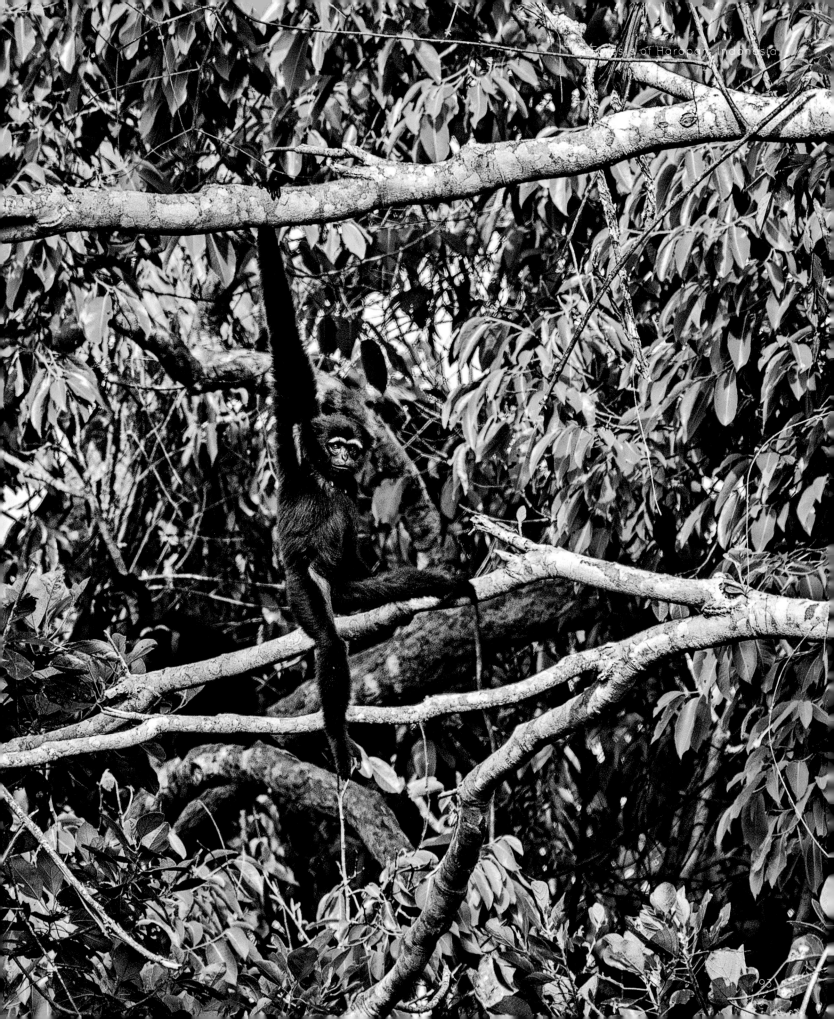

▶ The Vulnerable **Malayan Sun Bear** (Helarctos malayanus) *is locally common in Harapan with an estimated population of several hundred individuals according to field data collected by Burung Indonesia.*

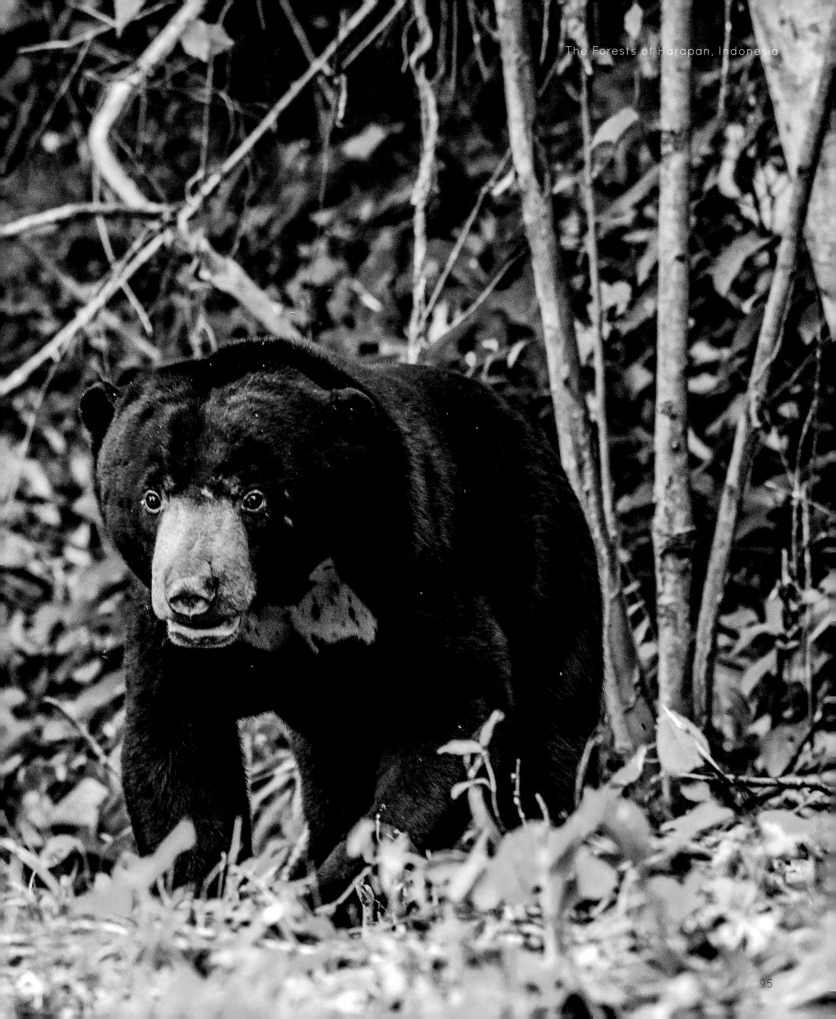

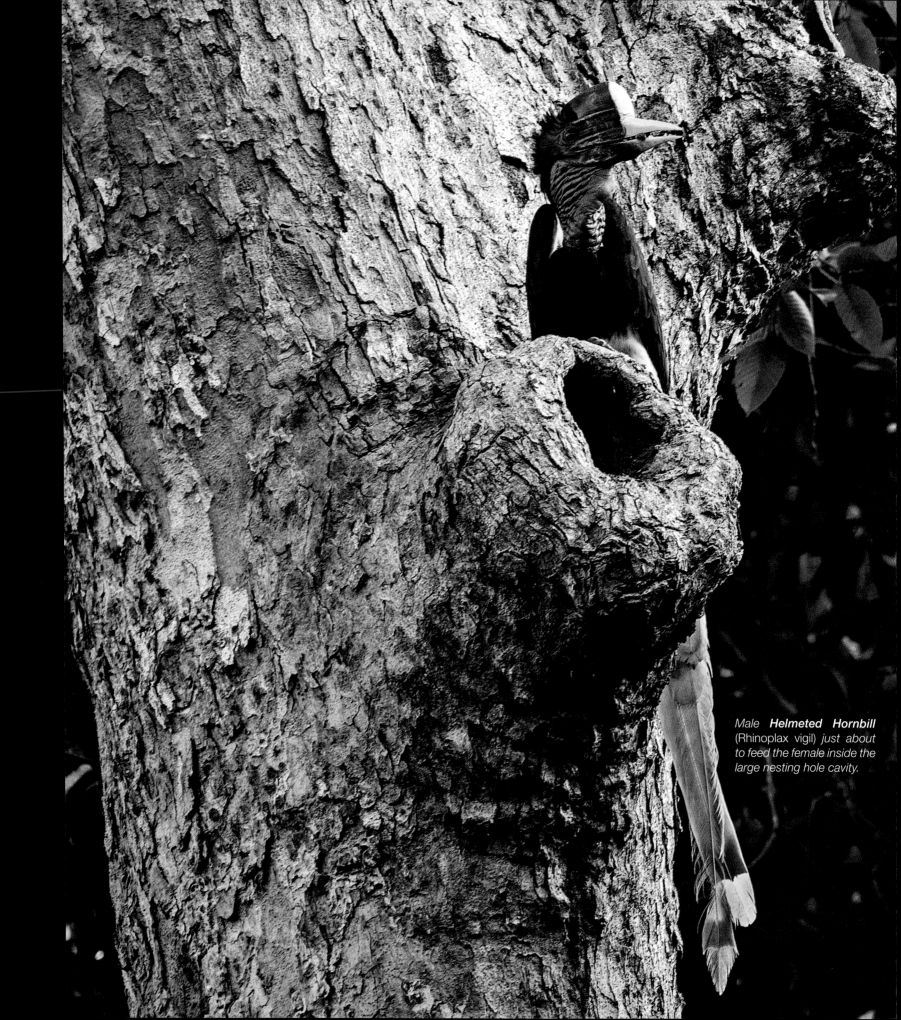

Male **Helmeted Hornbill**
(Rhinoplax vigil) *just about
to feed the female inside the
large nesting hole cavity.*

# The Forests of Belum-Temengor, Peninsular Malaysia

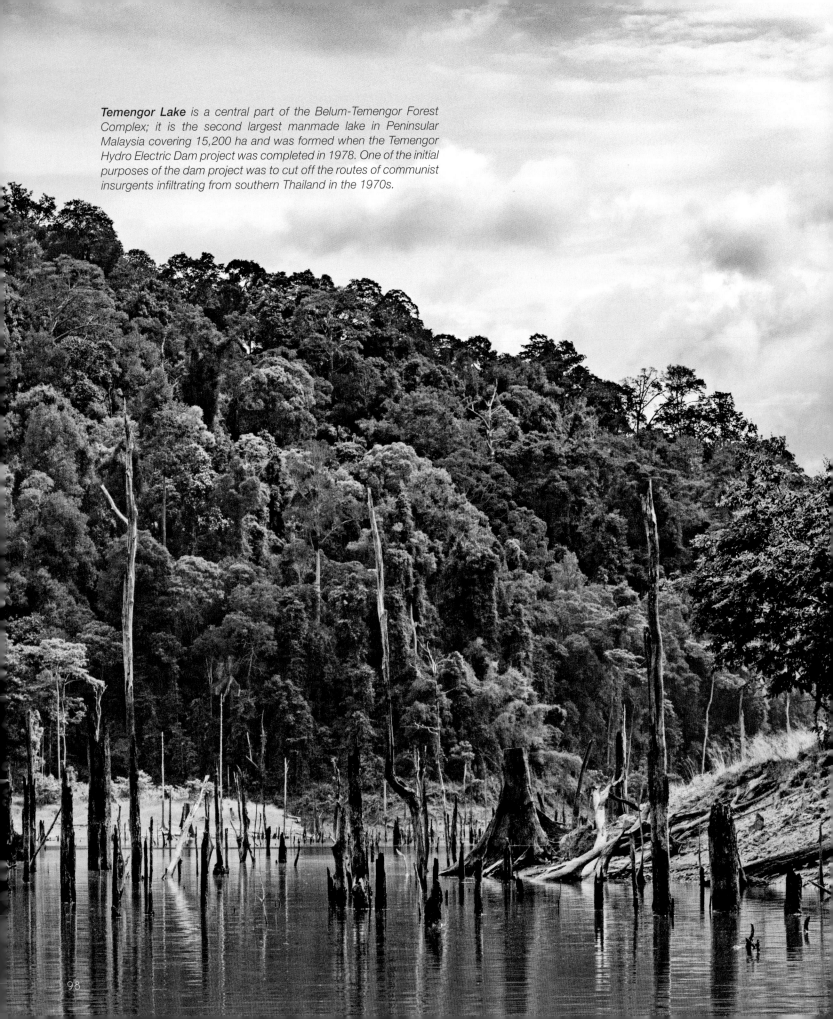

**Temengor Lake** is a central part of the Belum-Temengor Forest Complex; it is the second largest manmade lake in Peninsular Malaysia covering 15,200 ha and was formed when the Temengor Hydro Electric Dam project was completed in 1978. One of the initial purposes of the dam project was to cut off the routes of communist insurgents infiltrating from southern Thailand in the 1970s.

## Introduction

The Belum-Temengor Forest Complex, or Belum-Temengor for short, spans over a wide area of about 320,000 ha of Sundaic lowland tropical rainforest in the far north of Peninsular Malaysia. It consists of Royal Belum State Park, Temengor, Gerik, Amanjaya and Banding Forest Reserves, which sprawl over a hilly and mountainous landscape with altitudes ranging from 130 m to 1,500 m. It is recognised as a Forests of Hope site by BirdLife International.

Within the centre of the forest complex lies the extensive Temengor Lake with its many islands that were low-lying hilltops and ridges in the past.

The lake was created from the damming of the Perak River for water catchment and hydroelectric power generation. The major rivers in the area are the Sungai Belum, which joins the Sungai Temengor, both upper tributaries of the mighty Perak River.

Besides wildlife, these forests are home to some 2,000 indigenous Orang Asli of the Jahai and Temiar tribes. They make a living mainly from collecting non-timber forest produce (wild honey, agarwood, rattan, medicinal plants), fishing, planting rubber and working for the tourism industry as porters or guides.

*▸ The forest complex is contiguous with the Bang Lang National Park and Hala-Bala Wildlife Sanctuary in southern Thailand, which covers an additional area of 130,000 ha. Together these trans-boundary forest areas form an important stronghold for flora and fauna in the Thai-Malay Peninsula.*

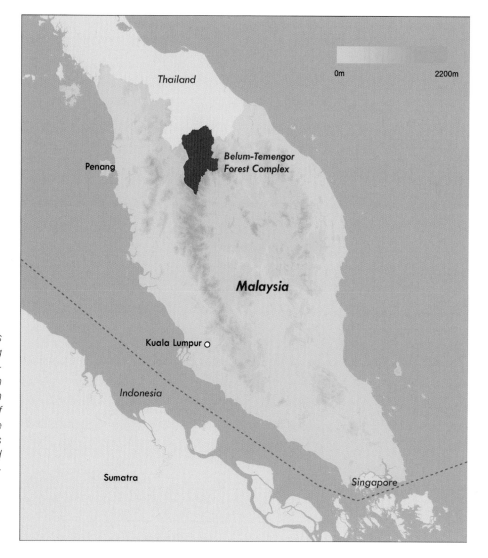

99

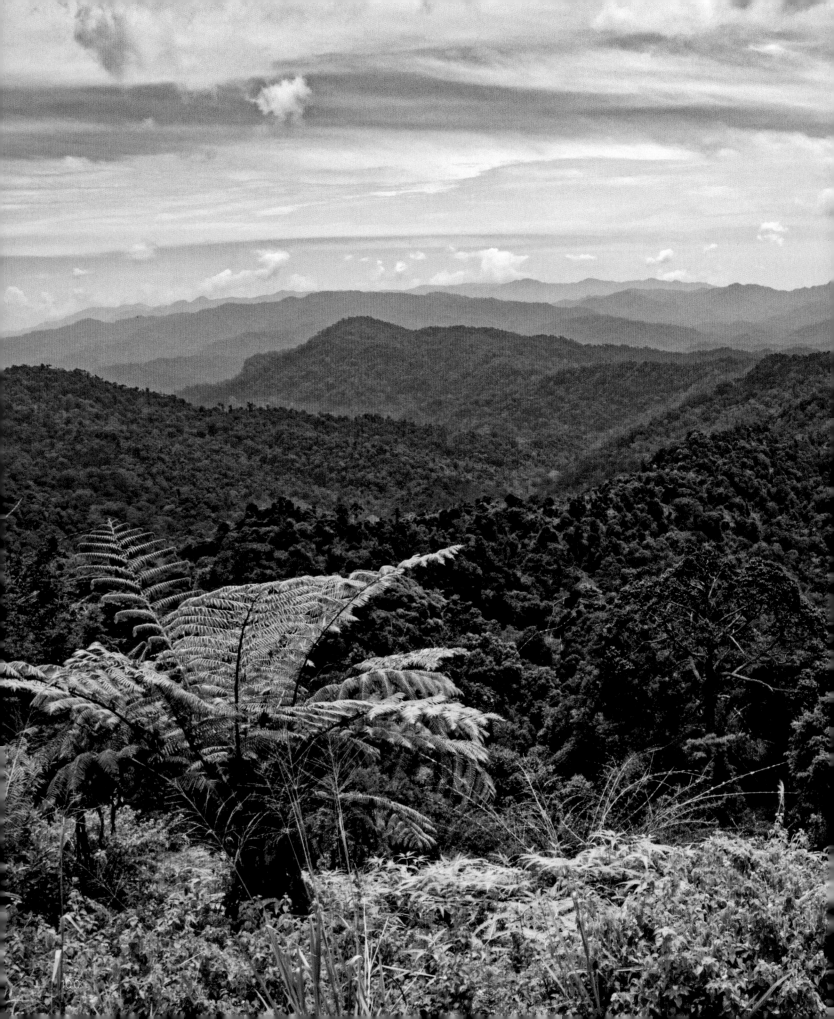

Belum-Temengor holds a range of different types of hill and montane forests, which contain more than 3,000 species of flowering plants, many of which are endemic to the region or Peninsular Malaysia. For example, out of 46 species of palms, 15 are endemic; over 30 ginger species have been found here so far.

These forests support an astonishing diversity of megafauna, with more than 125 mammal species including the Malayan Tiger *(Panthera tigris jacksoni)*, Malayan Tapir *(Tapirus indicus)*, Asian Elephant *(Elephas maximus)* and Malayan Sun Bear *(Helarctos malayanus)*. A remarkable feature of Belum-Temengor is the presence of several salt licks, which attract big mammals.

Belum-Temengor is one of the most outstanding Important Bird and Biodiversity Areas (IBAs) in northern Peninsular Malaysia, with more than 300 bird species. Host to all of 10 magnificent hornbill species, it is quite possibly the richest site for hornbill species in the world. The amphibian and reptile fauna are equally noteworthy.

Poaching has been, and remains, a serious threat to the wildlife of this exceptional area. In 2011, WWF Malaysia and TRAFFIC Southeast Asia produced a documentary entitled *'On borrowed time: Belum-Temengor Poaching Crisis'*, highlighting the seriousness of the poaching problem in the Belum landscape. The East-West Highway, which cuts through the middle part of the forest complex, has increased accessibility, thereby facilitating poaching in the forest.

*The East-West Highway connects settlements in Perak and Kelantan states, and was completed in 1982. It bisects the Belum-Temengor Forest Complex, offering scenic views of the forests and the Titiwangsa mountain range that begins in southern Thailand and snakes down Peninsular Malaysia, reaching as far south as Melaka.*

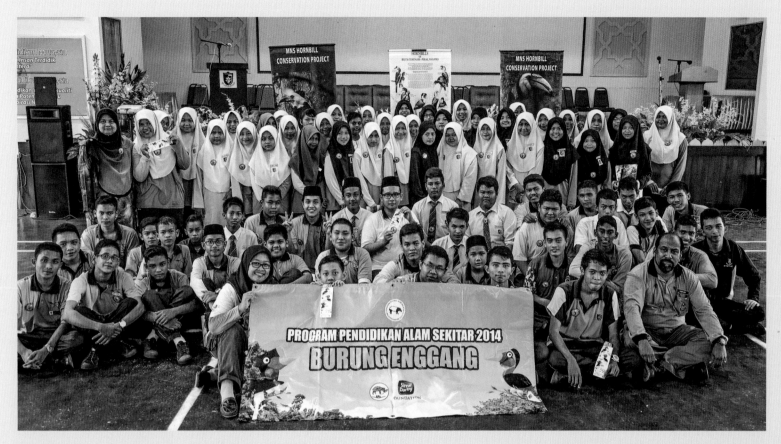

▲ *The Malaysian Nature Society's Hornbill Conservation Project has organised outreach programmes targeting more than 1,700 students and educators from 130 schools.*

*The Malaysian Nature Society (MNS) is the oldest and largest conservation NGO in Malaysia, and it is the national partner of BirdLife International. Belum-Temengor and MNS share a long history together. In 1974, MNS presented a paper 'A Blueprint for Conservation in Peninsular Malaysia', following which the Society embarked on the long journey to advocate for the gazettement of the whole forest complex as a protected area.*

*As much of the biodiversity in the area was little known, MNS initiated and led the year long Malaysian Heritage and Scientific Expedition in 1993. This was followed up with a second expedition in the Belum*

*Forest Reserve in 1998. The resulting plethora of findings included endemic flora and fauna, species new to science as well as new country records. These were documented in the MNS's Malayan Nature Journal and a major publication, 'Belum: A Rainforest in Malaysia'.*

*In 2000, MNS submitted a proposal to the Perak State Government to conserve the Belum Nature Park's rich biodiversity and ecosystem. Three years later, the Sultan of Perak declared 117,500 ha of the Belum Forest Reserve as the Royal Belum State Park. Finally, in 2007, the state park was officially gazetted as a protected area, making it the second largest in Peninsular Malaysia after Taman Negara National Park.*

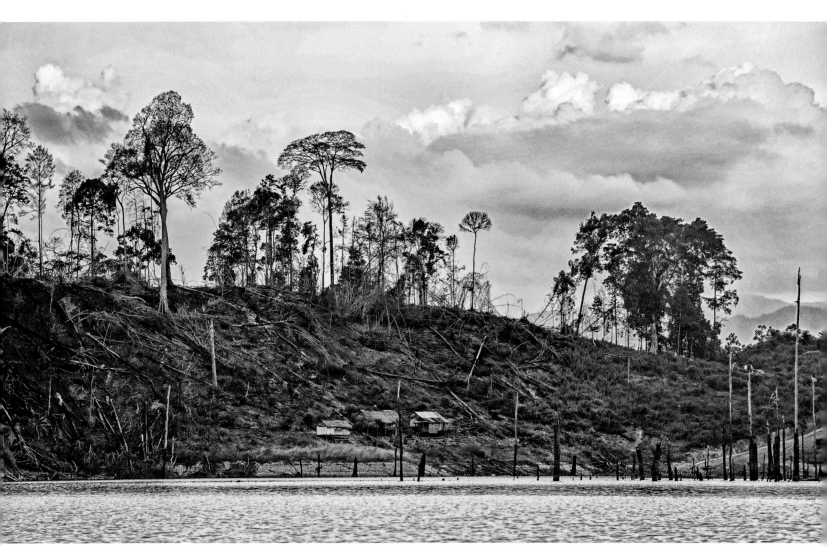

▲ This area was previously logged and subsequently cleared by the Orang Asli for planting rubber. Other parts of the Temengor Forest Reserve have been earmarked for timber production, which poses a major threat to the integrity of the forest.

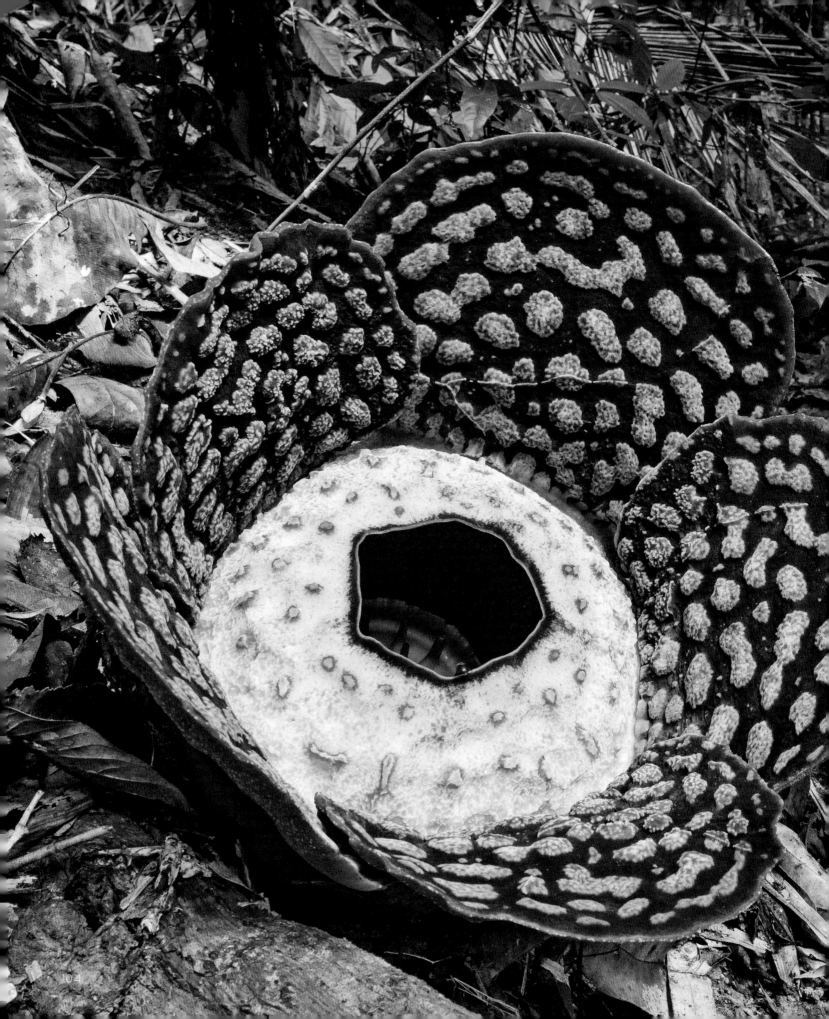

◀ **Rafflesia cantleyi** *is endemic to Peninsular Malaysia, and is one of the three species of* Rafflesia *that can be found in Belum-Temengor, where this specimen was spotted. It was named after Nathaniel Cantley, an influential curator of the Singapore Botanic Gardens, who collected the type specimen in the hills of Perak in 1881.*

The *Rafflesia* is an entirely parasitic plant. Over millenia, it has evolved to become so ecologically specialised that most of the plant grows as fine filaments in the lianas of the host plant *Tetrastigma rafflesiae*, and remains in this state for a long time. The *Rafflesia* is fully dependent on the host liana for water and nutrients. In this evolutionary ancient association, parts of the *Tetrastigma's* genome have even been transferred to that of the *Rafflesia* plant.

Members of the *Rafflesia* hold the record for producing the largest flowers of any plant in terms of mass, with individuals of the largest species, *Rafflesia arnoldii*, tipping the scale at up to 10 kg. It is massive and unusual in so many ways. The good news is, with a nickname of 'corpse flower' and the huge bloom, it is hard to miss it when you are near.

The **MNS Hornbill Conservation Project** was initiated in 2004 to conserve hornbills in the wild through strengthening field research, advocacy, education and public awareness. The project was inspired by Dr. Pilai Poonswad's groundbreaking research and work on hornbills in Thailand.

Prior to the start of the Hornbill Project, not much was known about the biology, ecology and conservation status of hornbills in Peninsular Malaysia.

Since its inception, the project has discovered:

- More than 80 hornbill nests of eight species, with the exception of Wrinkled (Aceros corrugatus) and Plain-pouched (Rhyticeros subruficollis) Hornbills;
- Most common hornbills are the Oriental Pied and Rhinoceros Hornbills;
- Hornbill nests are limited to eight tree species from four families to date;
- Some of their preferred food are figs, the favourites being Ficus dubia, F. sundaica, F. annulata and F. caulocarpa;
- Helmeted Hornbill nests are located only in Tualang (Koompassia excelsa) and Merbau (Intsia palembanica) trees with protruding branch knobs.

The Orang Asli community form an integral part of the MNS Hornbill Project team in Belum-Temengor. They share an intimate relationship with this unique forest landscape and their understanding of its fauna and flora is important to efforts to conserve the area. According to a 2011 census, the Orang Asli population in Belum-Temengor is around 2,400 individuals in 18 villages. MNS has trained several Orang Asli as field assistants, guides and 'hornbill guardians'. Each team is equipped with GPS units, binoculars, notebook and compact cameras to document hornbill nesting behaviour and the Plain-pouched Hornbill population. Thus far, good progress has been made in understanding the local biology of hornbills (Yeap, C. A. pers. comm. 2016).

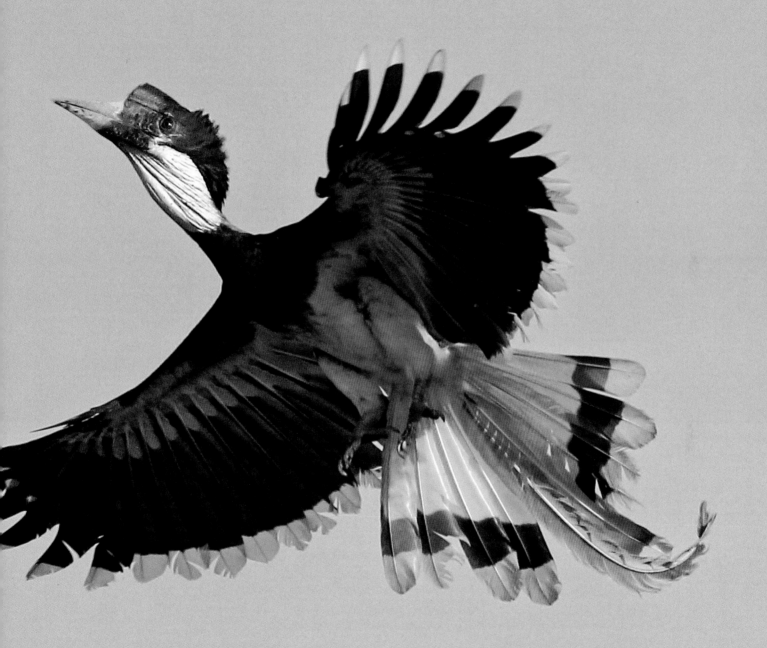

*Female* **Helmeted Hornbill** (Rhinoplax vigil)

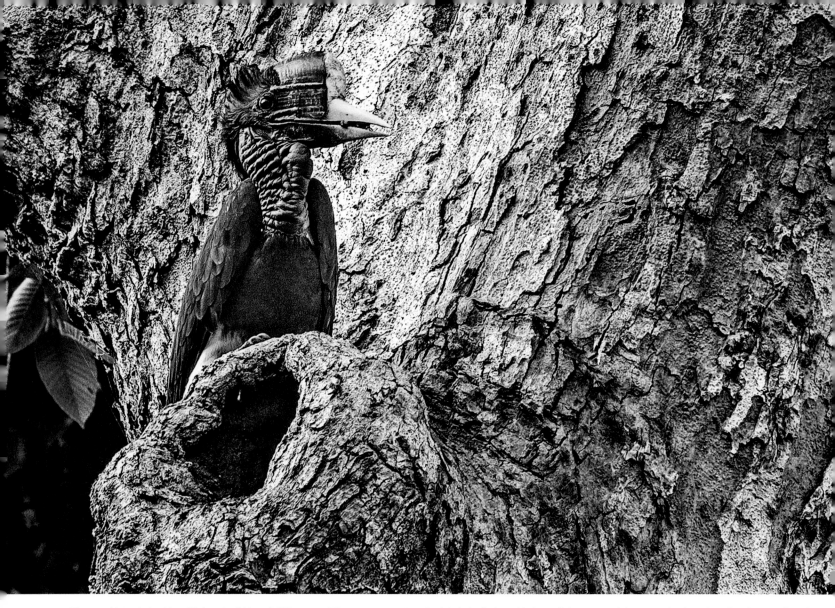

▲ *The prehistoric looking* **Helmeted Hornbill** *is one of the most spectacular birds in Asia, with its solid casque rising over its head and a short pointed bill. The featherless, leathery skin on the neck is red in males and turquoise in females.*

*Little is known of its breeding biology; in Belum-Temengor it has been seen nesting in natural cavities of the Merbau (Intsia palembanica) and Tualang (Koompassia excelsa) trees. The Helmeted Hornbill mates for life. When the time is right to lay its one or two eggs every year, the female seals herself into the nesting cavity for around 150-160 days.*

The Helmeted Hornbill *(Rhinoplax vigil)* can be found in lowland and montane forest up to an altitude of 1,500 m. It favours rugged country such as the forested foothills across the region. While it can settle in selectively logged forests, its survival depends on large forest trees with trunk cavities for nesting and where the male can perch. One of its favourite foods is large figs, but it also takes rodents, snakes and birds.

Helmeted Hornbills have one of the most distinctive calls among hornbills. It starts with a number of high-pitched 'pooh' calls, slowly progressing to several 'poohooh' calls, before ending in maniacal laughter that can be heard several kilometers away.

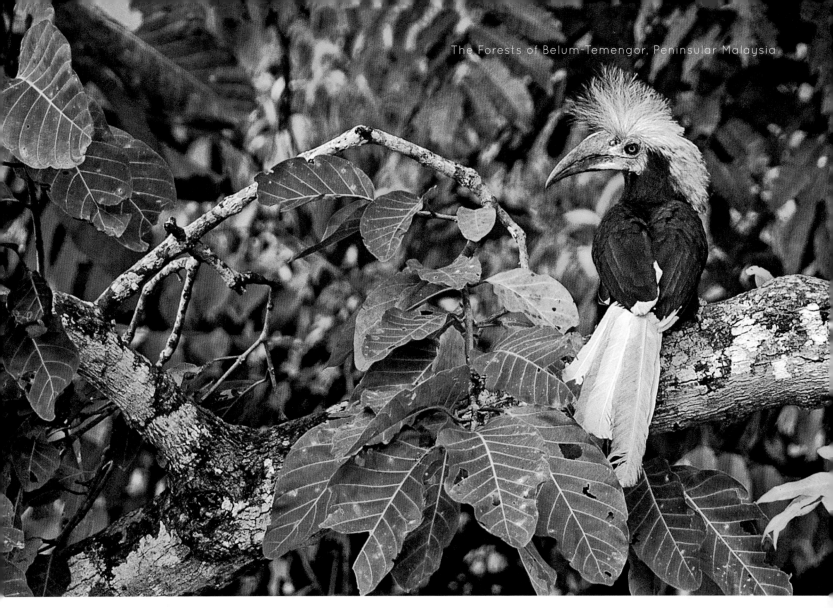

▲ *Female* **White-crowned Hornbill** (Aceros comatus) *with its unusual crown feathers in a ragged crest. It is an unobtrusive and shy bird that is normally spotted in the rainforest canopy, and occasionally venturing to the ground. The diet of the White-crowned Hornbill consists mainly of lizards, snakes, birds and insects, occasionally including fruits.*

In 2012, the Indonesian hornbill researcher Yokyok Hadiprakarsa started to collect evidence showing that the species was the target of a massive illegal trade network for its solid 'red ivory' casques, which are selling at up to five times the price of elephant ivory on the black market in China.

Later, based on reports of confiscations and Asian trading websites between 2012 and 2013, it emerged that large numbers of Helmeted Hornbills were killed every month in the province of West Kalimantan alone. The heads of the Helmeted Hornbills were subsequently smuggled out via Sumatra and Java to Hong Kong, China and Taiwan. Separate figures from TRAFFIC Southeast Asia later confirmed the scale of this carnage. Based on these findings, the classification of the species was uplisted three levels from Near Threatened to Critically Endangered in November 2015 by the IUCN. A working group represented by multiple stakeholders and coordinated by BirdLife International is working hard to develop a conservation strategy for the species.

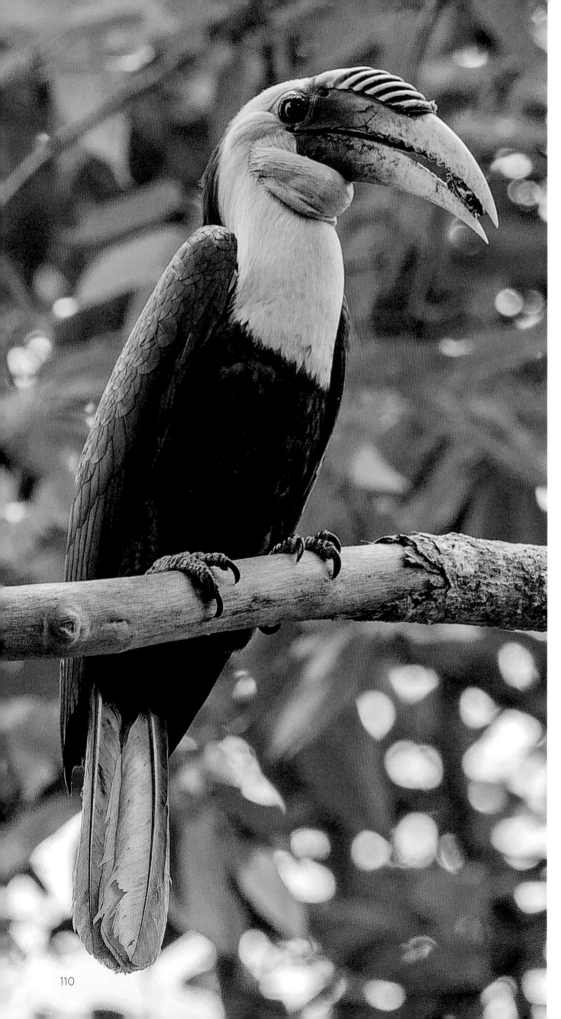

◄ The **Plain-pouched Hornbill** (Rhyticeros subruficollis) *looks similar to the Wreathed Hornbill (refer to opposite page) but is smaller and lacks the ridges on the bill.*

This species lives in rainforests and mixed deciduous hill forests up to 1,000 m elevation, and often feeds on fruits in the high crowns of forest trees. Since 2004, MNS has monitored the seasonal population of the Plain-pouched Hornbill in Belum-Temengor, which is one of the strongholds of this species, but its behavioural ecology is not well studied.

Astounding movements of thousands of Plain-pouched Hornbills have been observed between feeding and roosting areas in August and September. Some of the hornbills have migrated from as far as Myanmar. In this period, they move north-east at dawn to feed and southwest at dusk to roost. However, the exact location of the roosting sites deep inside the forests of Temengor remains unknown. In the past, flocks of the Plain-pouched Hornbills have been reported from the mangrove forests on the Selangor coast.

The annual mating and nesting timing of the species is believed to coincide with the fruiting season. These hornbills have also been seen collectively engaged in aerial hunting of newly emerged mayflies. The highest single count of the Plain-pouched Hornbill was 3,261 individuals in September 2008, although subsequent counts have been much lower. The main nesting areas for the hornbills observed in Malaysia are yet to be established (Kaur, R. and colleagues 2011).

▶ Male **Wreathed Hornbill** (Rhyticeros undulatus) *feeding the female entrapped inside the nesting cavity.*

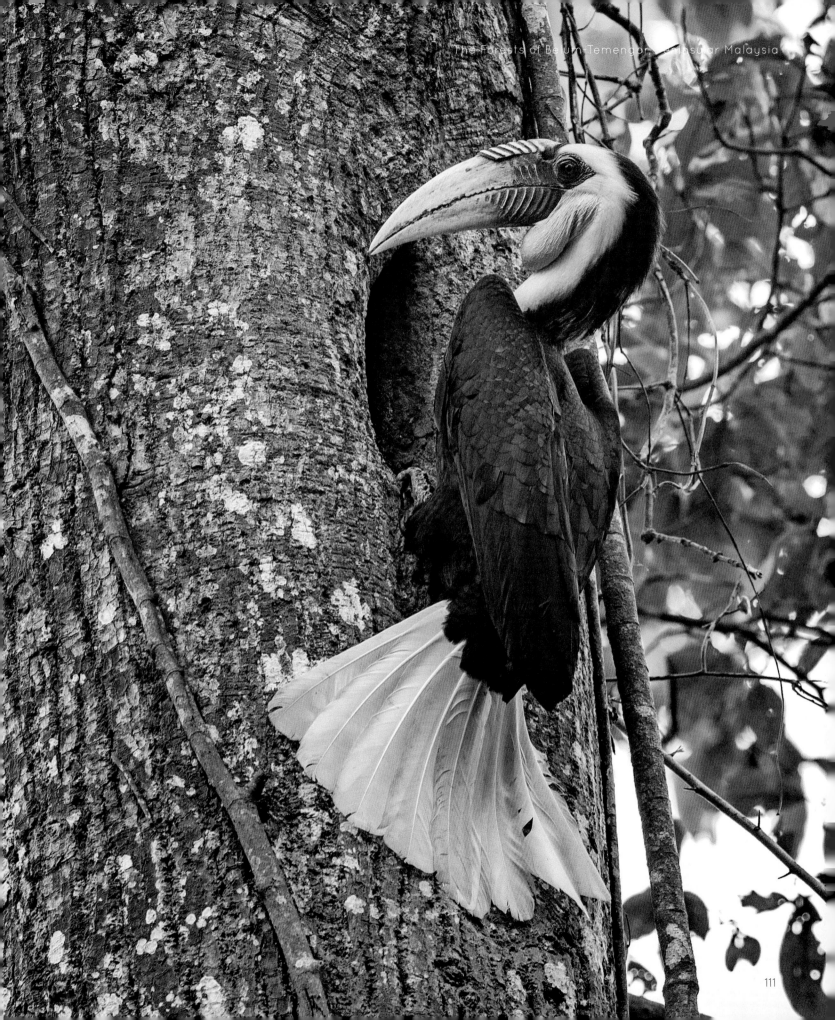

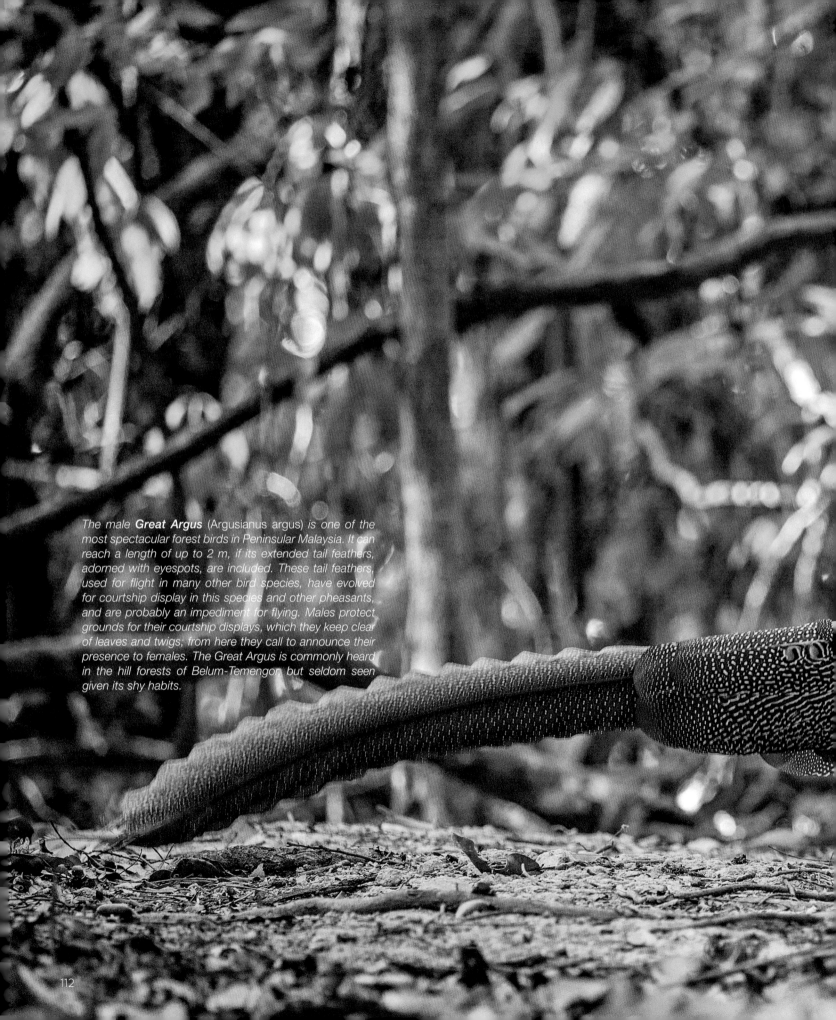

The male **Great Argus** (Argusianus argus) is one of the most spectacular forest birds in Peninsular Malaysia. It can reach a length of up to 2 m, if its extended tail feathers, adorned with eyespots, are included. These tail feathers, used for flight in many other bird species, have evolved for courtship display in this species and other pheasants, and are probably an impediment for flying. Males protect grounds for their courtship displays, which they keep clear of leaves and twigs; from here they call to announce their presence to females. The Great Argus is commonly heard in the hill forests of Belum-Temengor, but seldom seen given its shy habits.

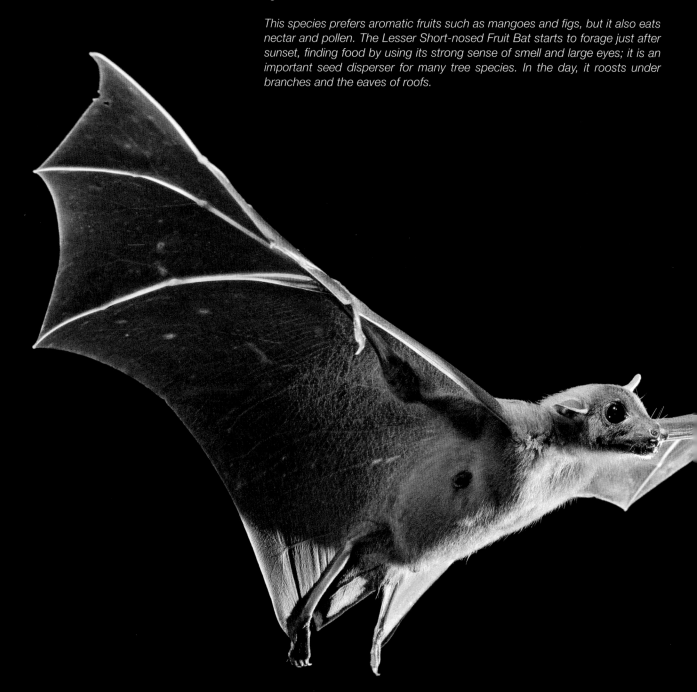

The **Lesser Short-nosed Fruit Bat** (Cynopterus brachyotis) *is one of the commonest bats in Southeast Asia. It is one of more than 40 bat species found in Belum-Temengor. This individual was just about to land on a fig tree* (Ficus fistulosa) *on its nightly forays. The long finger bones clearly stand out against the membranes.*

*This species prefers aromatic fruits such as mangoes and figs, but it also eats nectar and pollen. The Lesser Short-nosed Fruit Bat starts to forage just after sunset, finding food by using its strong sense of smell and large eyes; it is an important seed disperser for many tree species. In the day, it roosts under branches and the eaves of roofs.*

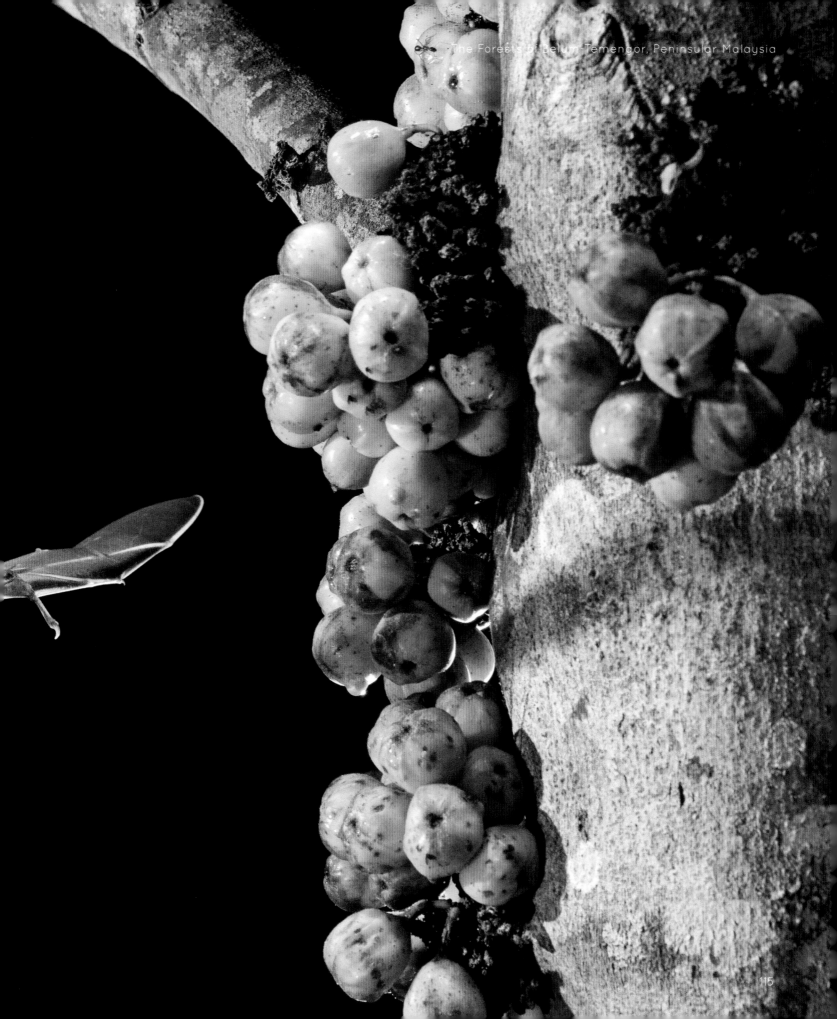

▲ The **Lesser Mouse Deer** (Tragulus kanchil) *is less than half the size of the Greater Mouse Deer* (Tragulus napu), *which is also found in Belum-Temengor. It is one of the smallest known hoofed mammals in the world. It measures less than 50 cm in length and weighs a mere two kilograms. Lesser Mouse Deers are most active in the early morning and late afternoon, while spending most of the night resting.*

◄ *The* **Yellow-throated Marten** (Martes flavigula) *can be found in a wide range of forested habitats in Peninsular Malaysia, sometimes relatively close to human habitation. It is a fearless animal with few natural predators. Its varied diet includes rodents, birds, snakes, lizards, eggs and fruits.*

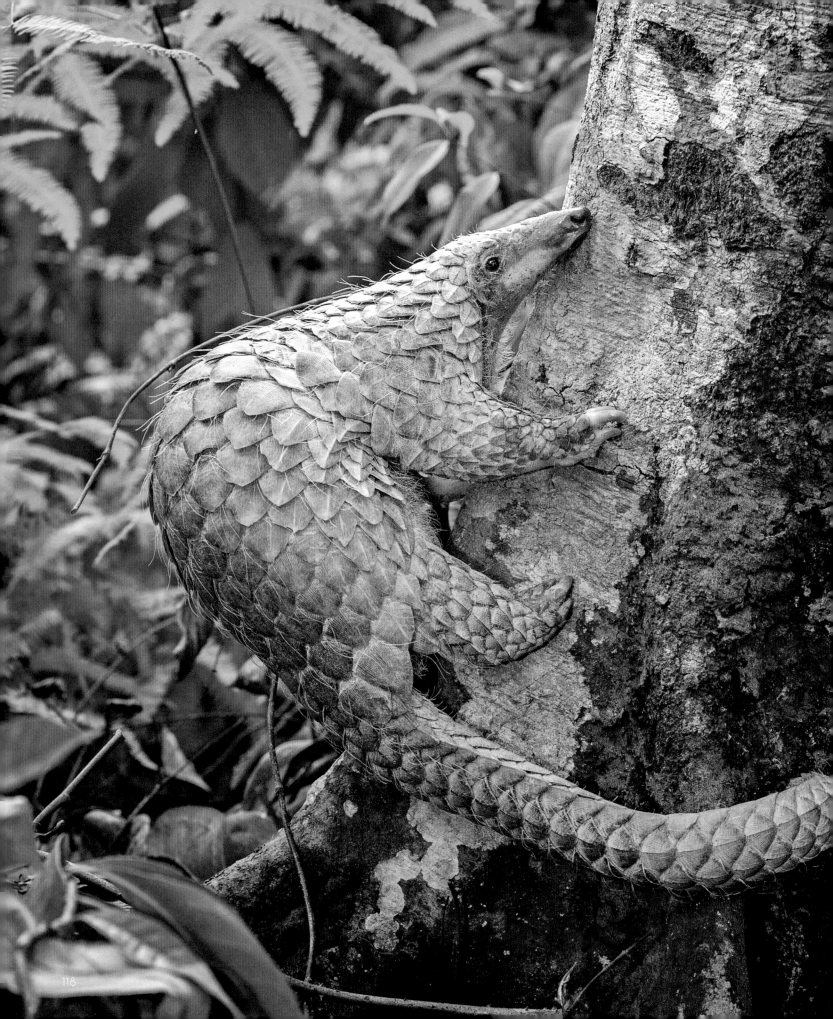

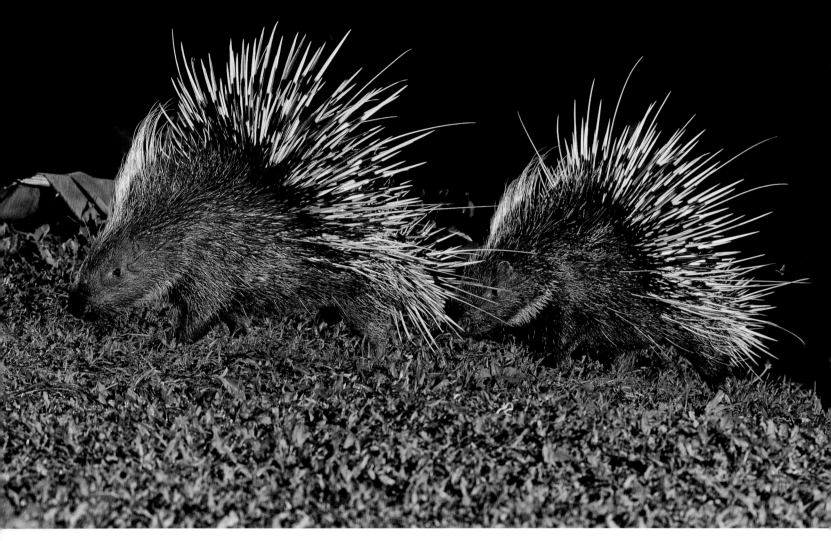

▲ The **Malayan Porcupine** (Hystrix brachyura) *forages mostly at night and rests during the day. It lives in large burrows excavated with their powerful front feet and claws. The same burrows may be used for many generations. The Orang Asli hunt the species by smoking the burrows with burning vegetation and capturing them when they come to the surface. The Malayan Porcupine is found in many types of forest habitats and cleared areas near forests. It has a varied diet of fallen fruits, roots, tubers but also takes carrion and insects.*

◄ *The peculiar-looking* **Sunda Pangolin** (Manis javanica) *is found in a great variety of habitats from primary and secondary forests to cultivated areas and plantations. All pangolins are specialised feeders of termites and ants. It is rarely seen due to its nocturnal and shy habits.*

The pangolin is considered the most heavily trafficked mammal in the world and is classified as Critically Endangered by the IUCN. Particularly in China and Vietnam, the Sunda Pangolin is consumed in urban restaurants as a luxury bushmeat and a delicacy. However, the greatest demand is for their scales in traditional Chinese medicine where they are considered to cure ailments ranging from skin diseases to cancer, even though there is no scientific evidence for this. In recent years, foreign hunters have been apprehended in the Belum-Temengor area for poaching pangolins.

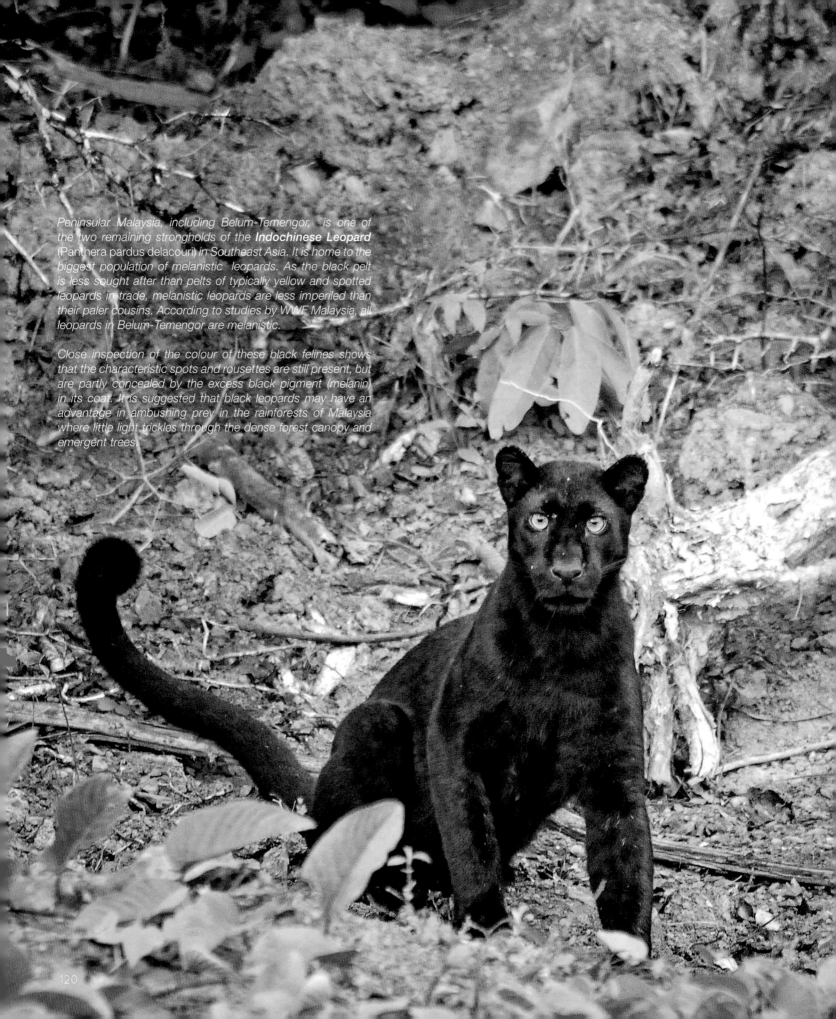

Peninsular Malaysia, including Belum-Temengor, is one of the two remaining strongholds of the **Indochinese Leopard** (Panthera pardus delacouri) in Southeast Asia. It is home to the biggest population of melanistic leopards. As the black pelt is less sought after than pelts of typically yellow and spotted leopards in trade, melanistic leopards are less imperiled than their paler cousins. According to studies by WWF Malaysia, all leopards in Belum-Temengor are melanistic.

Close inspection of the colour of these black felines shows that the characteristic spots and rousettes are still present, but are partly concealed by the excess black pigment (melanin) in its coat. It is suggested that black leopards may have an advantage in ambushing prey in the rainforests of Malaysia where little light trickles through the dense forest canopy and emergent trees.

120

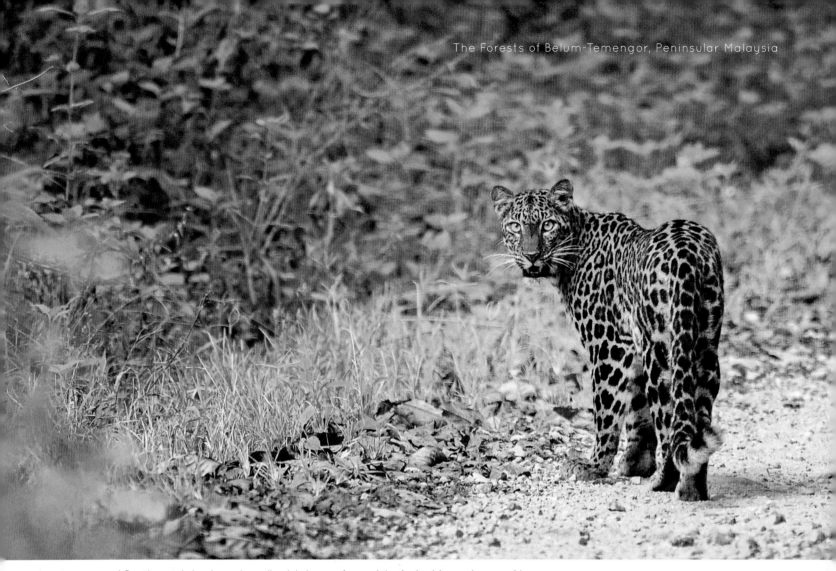

▲ In other parts of Southeast Asia, the paler yellowish-brown form of the **Indochinese Leopard** is more common.

Comparatively little is known about the leopard population in Southeast Asia. The Indochinese Leopard *(Panthera pardus delacouri)* is a distinctive subspecies which historically could be found throughout mainland Southeast Asia. It is adaptable and can survive in areas where other large carnivores have been extirpated.

The diet of the Indochinese Leopard varies with prey availability. In general, it prefers small- to medium-sized ungulate prey where available. However, it is highly flexible in what it hunts and has one of the broadest diets of the larger carnivores. Male Indochinese Leopards have been known to kill the Banteng *(Bos javanicus)* which is ten times heavier. When necessary, it will also take small mammals, birds, reptiles and insects.

According to a recent study, the Indochinese Leopard has suffered a major range contraction in Southeast Asia; the total breeding population is now estimated at only between 400 and 1050 individuals. Poaching for the illegal wildlife trade, combined with the collapse of prey populations and habitat destruction have all played a part in its decline. It has also been recommended that the IUCN threat status of the Indochinese Leopard be uplisted from Vulnerable to Endangered (Rostro-Garcia, S. and colleagues 2016). Habitat fragmentation and loss are also major threats to the Indochinese Leopard, as these are linked to eventual prey depletion and human disturbance.

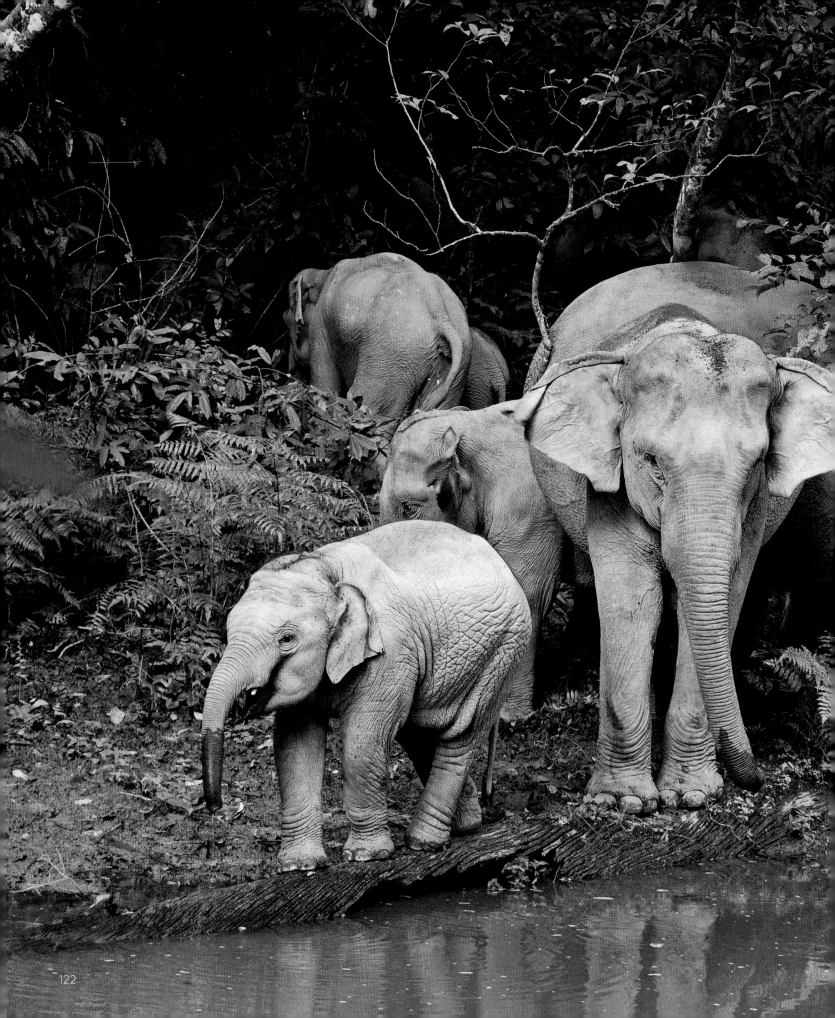

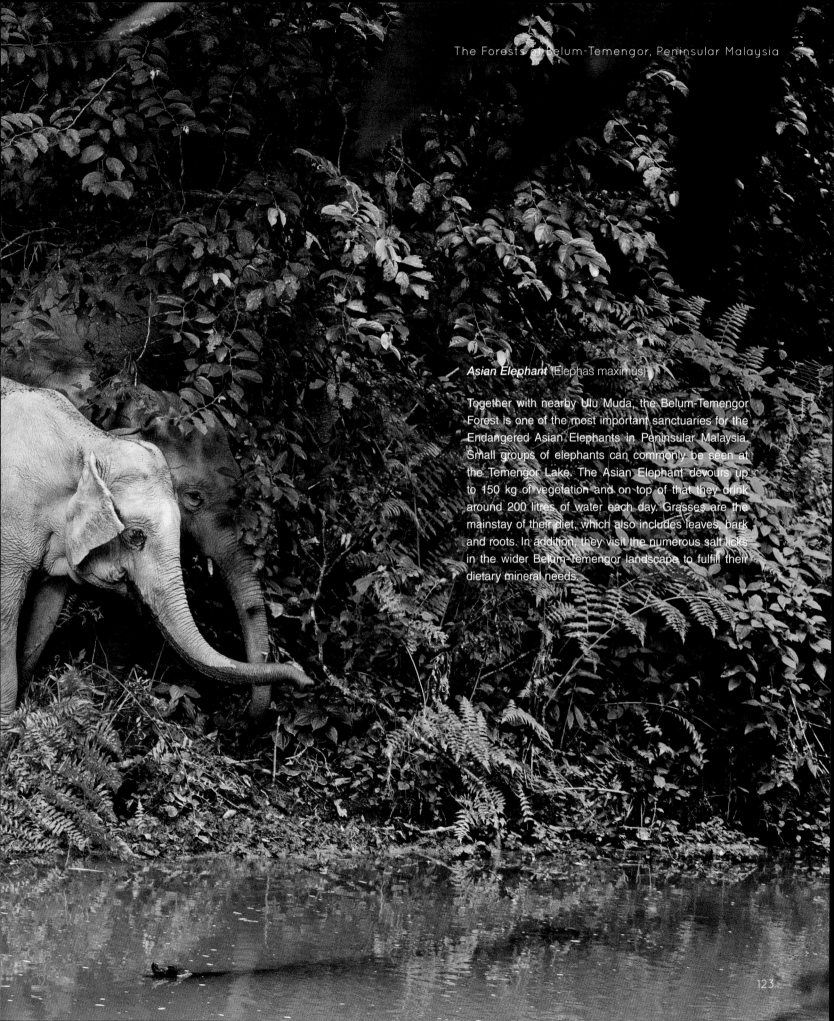

*Asian Elephant* (Elephas maximus)

Together with nearby Ulu Muda, the Belum-Temengor Forest is one of the most important sanctuaries for the Endangered Asian Elephants in Peninsular Malaysia. Small groups of elephants can commonly be seen at the Temengor Lake. The Asian Elephant devours up to 150 kg of vegetation and on top of that they drink around 200 litres of water each day. Grasses are the mainstay of their diet, which also includes leaves, bark and roots. In addition, they visit the numerous salt licks in the wider Belum-Temengor landscape to fulfill their dietary mineral needs.

◀ The forests of Belum-Temengor are rich in small carnivores such as civets, including the nocturnal **Large Indian Civet** (Viverra zibetha). Although it is an agile climber, it spends most of the time on the ground. It is a generalist carnivore, consuming anything from birds and eggs to frogs and insects. It is reported to breed throughout the year, with two litters, each consisting of up to four young.

◀ A rare encounter with a young Together with nearby Ulu Muda, the Belum-Temengor **Sumatran Serow** (Capricornis sumatraensis) which took close to 30 minutes to cross the Temengor Lake. The Vulnerable Serows are sturdy, dark coloured ungulates with a shoulder height of around one metre, and weighing up to 120 kg. It is usually solitary except for females with young. The Sumatran Serow prefers hill slopes with primary or secondary forests and is only observed infrequently as it feeds in the early hours of the morning and in late evenings; it is generally not encountered for the rest of the day. Threats to the Serow population in Peninsular Malaysia come from habitat destruction and poaching for local consumption of the meat and for the use of body parts in traditional medicines.

This is what Sir George Maxwell, the thirteenth British Resident of Perak, wrote about the Serow in his book 'In Malay Forests' in 1907:

In the Malay Peninsula, Sir Frank Swettenham, the late High Commissioner for the Federated Malay States, is so far as I know, the only European who has shot one. Very few white men have ever set eyes on a living specimen, or even come across the animal's tracks, and a considerable proportion of the European community is unaware of the animal's existence in the country. The limestone hills that are studded over the alluvial plain of Kinta, in the State of Perak, are the home of a considerable number of these goats..... It is now some years since I was stationed in Kinta, and I am prepared to tell the world the locality of Gunung Kroh. On those limestone heights, isolated in a little world of their own, far apart from the animals and life of the wild plain below, the goats are still to be found. The little goat I saw is now, if it is still alive, a patriarch of the herd, but in my thoughts it always remains the kid that I saw. Mine are the only eyes that have seen it – for no one, except an occasional woodcutter, has climbed the hill since our last drive, and for all that the rest of the world knows, it and its brethren may be some of Monsieur Huc's unicorns.

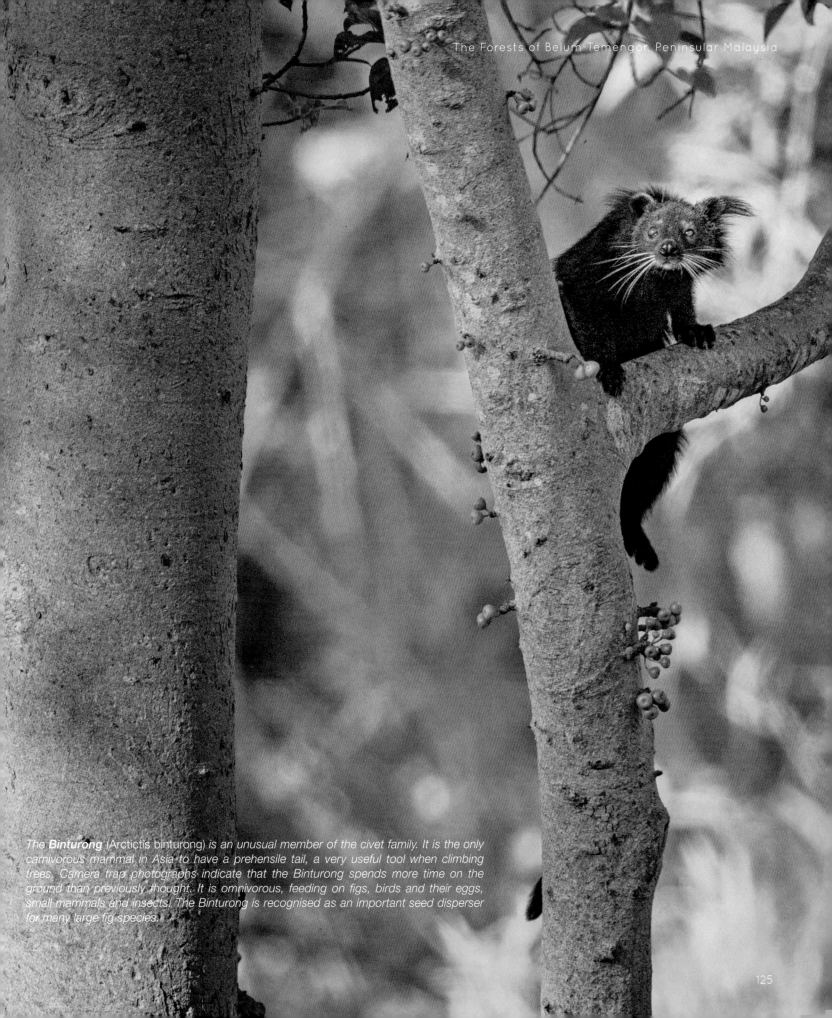

The **Binturong** (Arctictis binturong) is an unusual member of the civet family. It is the only carnivorous mammal in Asia to have a prehensile tail, a very useful tool when climbing trees. Camera trap photographs indicate that the Binturong spends more time on the ground than previously thought. It is omnivorous, feeding on figs, birds and their eggs, small mammals and insects. The Binturong is recognised as an important seed disperser for many large fig species.

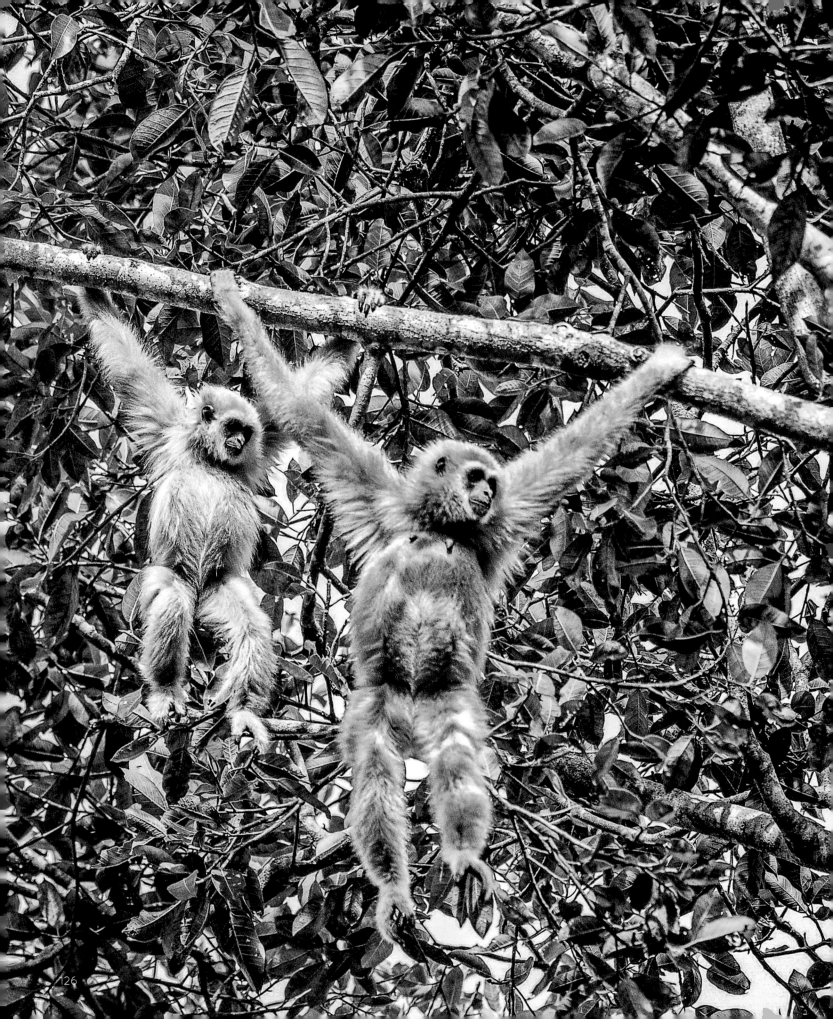

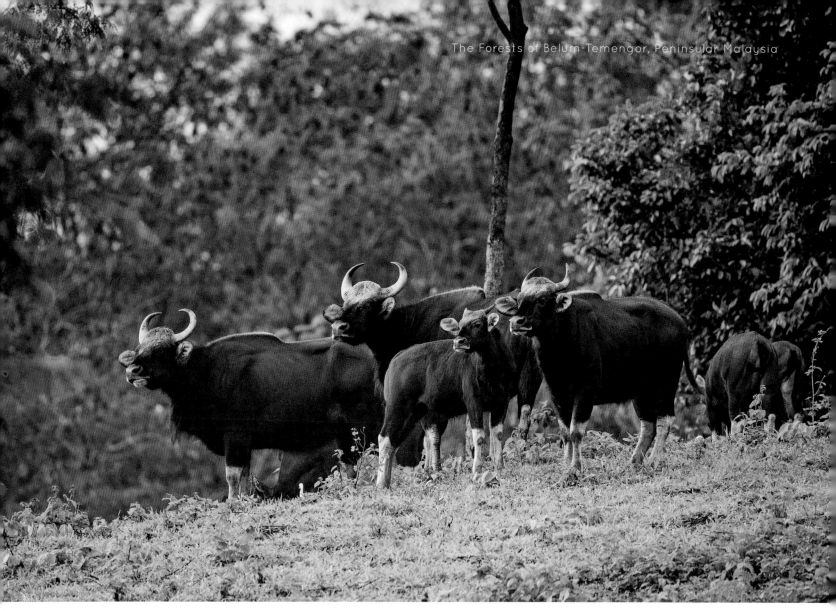

▲ *The **Gaur** (Bos gaurus) is by most measurements the largest of the nine wild bovines in Asia. It is a strong and robustly built species with a prominent ridge on the back. In the Malay language, it is referred to as the Seladang.*

*It is now rare in most sites in Peninsular Malaysia, because of hunting pressure even within protected areas. According to the IUCN, in Belum-Temengor, the population has been decimated by poaching teams that have slipped across the international border. These illegal activities have been encouraged by a thriving international trade in Gaur parts, such as horns for trophies and internal organs for traditional medicine.*

◀ *Three species of gibbons can be found in the Belum-Temengor landscape, most prominently the Endangered **White-handed Gibbon** (Hylobates lar), also known as the Lar Gibbon. It varies in the colour of its coat from beige and dark brown to black, but always with white upper sides of the hands and a white fringe around the blackish face. Female Gibbons reach sexual maturity at 8-10 years and males at 8-12 years. White-handed Gibbons normally produce one offspring every four years.*

*Gibbons are masters of agility, perfectly built with their long arms to swing from branch to branch with little effort. Small family units mark their territory with their loud whooping calls. Like other gibbons, they eat a lot of fruits, as well as young leaves, flowers and insects. Gibbons swallow nearly all the seeds that they eat and subsequently pass it out in their droppings, making them valuable seed dispersers.*

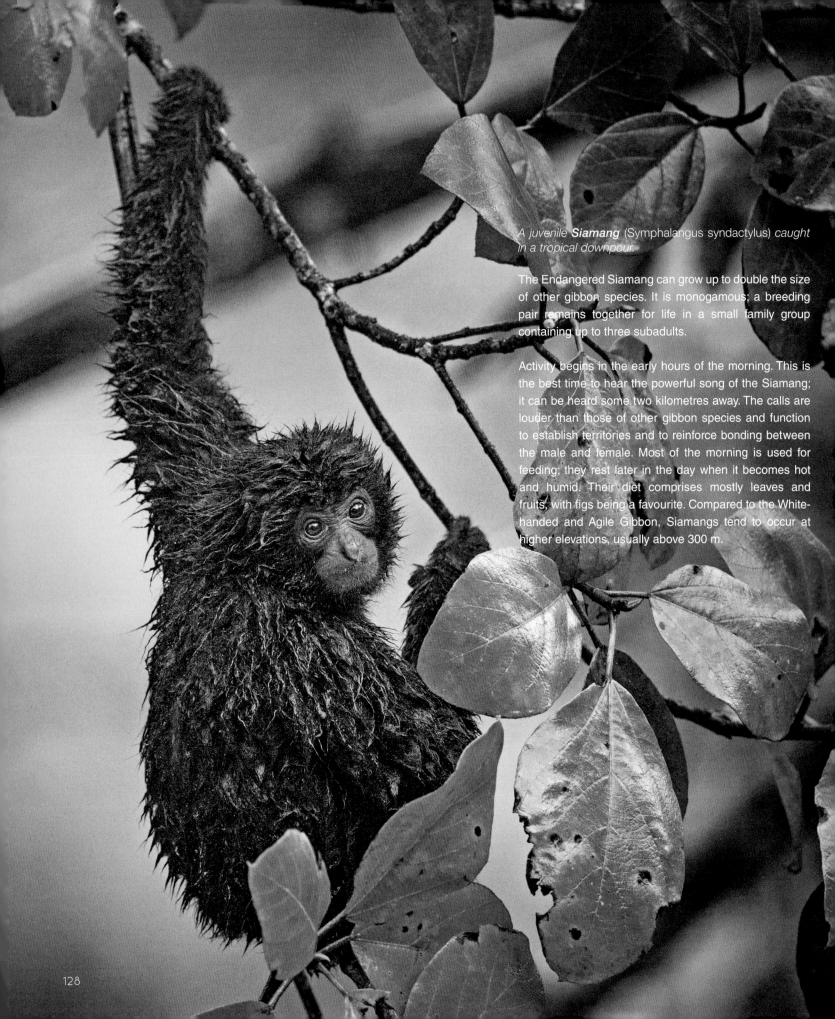

*A juvenile **Siamang** (Symphalangus syndactylus) caught in a tropical downpour.*

The Endangered Siamang can grow up to double the size of other gibbon species. It is monogamous; a breeding pair remains together for life in a small family group containing up to three subadults.

Activity begins in the early hours of the morning. This is the best time to hear the powerful song of the Siamang; it can be heard some two kilometres away. The calls are louder than those of other gibbon species and function to establish territories and to reinforce bonding between the male and female. Most of the morning is used for feeding; they rest later in the day when it becomes hot and humid. Their diet comprises mostly leaves and fruits, with figs being a favourite. Compared to the White-handed and Agile Gibbon, Siamangs tend to occur at higher elevations, usually above 300 m.

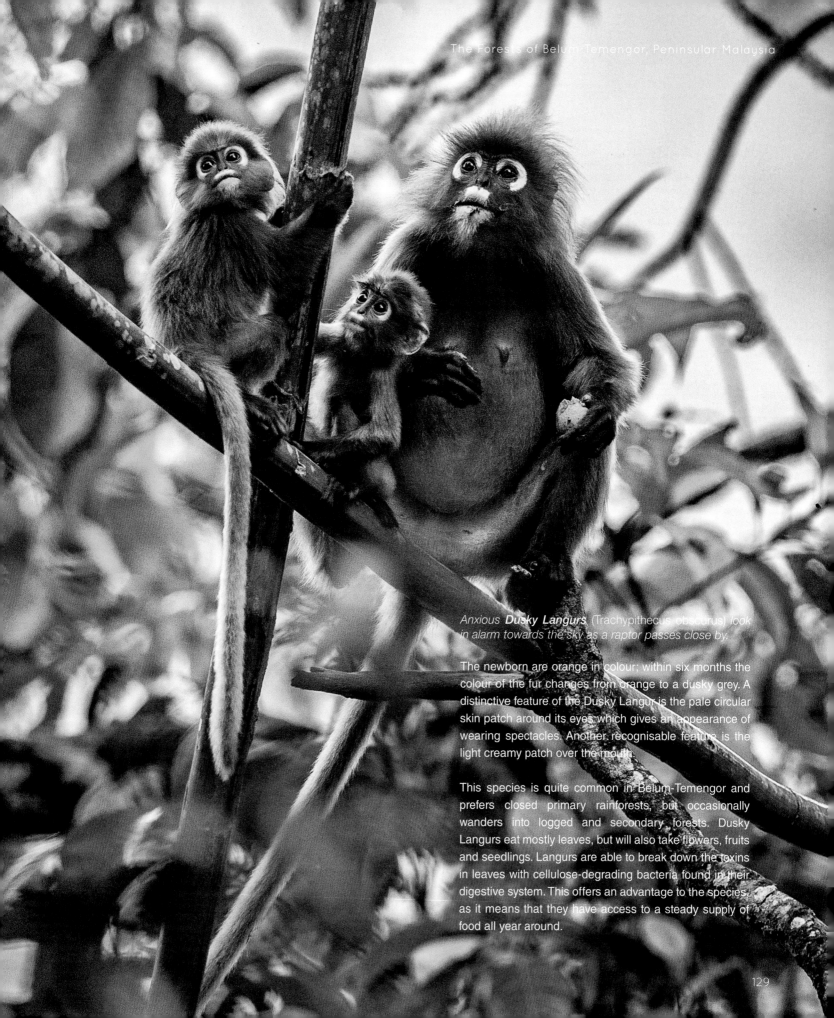

*Anxious **Dusky Langurs** (Trachypithecus obscurus) look in alarm towards the sky as a raptor passes close by.*

The newborn are orange in colour; within six months the colour of the fur changes from orange to a dusky grey. A distinctive feature of the Dusky Langur is the pale circular skin patch around its eyes which gives an appearance of wearing spectacles. Another recognisable feature is the light creamy patch over the mouth.

This species is quite common in Belum-Temengor and prefers closed primary rainforests, but occasionally wanders into logged and secondary forests. Dusky Langurs eat mostly leaves, but will also take flowers, fruits and seedlings. Langurs are able to break down the toxins in leaves with cellulose-degrading bacteria found in their digestive system. This offers an advantage to the species, as it means that they have access to a steady supply of food all year around.

129

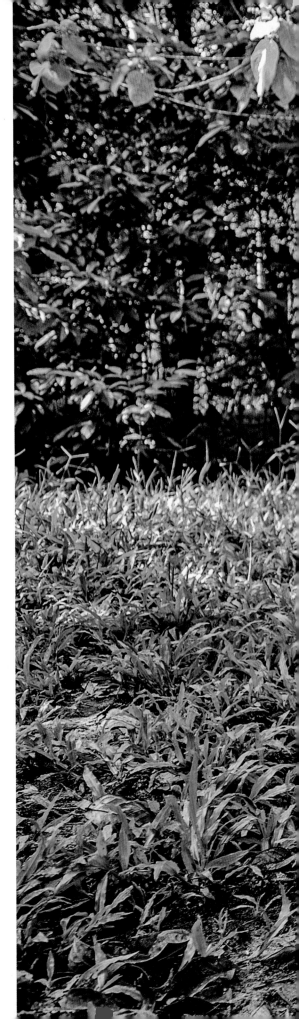

▸ *The Endangered **Malayan Tapir** (Tapirus indicus) is the only tapir species in Asia and is one of Peninsular Malaysia's most iconic large mammals, also featuring on the logo of Malaysian Nature Society. At well over one meter tall at shoulder height and with a weight of up to 350 kg, it is the world's largest tapir. This ungulate feeds on more than 380 different plant species and usually forages at night. Some camera trap studies suggest that Malayan Tapirs visit salt licks more frequently compared with other species. They are known regularly to visit salt licks more than 15 km apart.*

*The Malayan Tapir gives birth to a single calf after a gestation period of around 12 months. The calf has a brown patterned coat with white spots and stripes, somewhat similar to that of wild boar piglets – an adaptation for forest camouflage. It stays with the mother for up to two years. With its short trunk-like nose, and its curious feet structure, the pied Malayan Tapir is one of the most recognisable creatures of the Malayan rainforest.*

The Royal Belum State Park offers protection to about one third of the total forest complex, leaving the remaining two thirds vulnerable to future exploitation. The Malaysian Nature Society and other NGOs have made significant efforts to push for the inclusion of the Temengor Forest Reserve into the protected area. This included a campaign that has secured 80,000 signatures and an award-winning documentary *'Temengor-Biodiversity in the Face of Danger'* to educate the public and create better awareness.

With the support of the MNS, in 2013, the Perak State government gazetted the Amanjaya Forest Reserve, covering an additional 18,866 ha and securing the protection of an important forest strip on both sides of the East-West Highway.

However, about two-thirds of the Belum-Temengor forest complex remains unprotected. For example, large parcels of forest, including about half of the Temengor Forest Reserve is classified as 'production forest', which renders it vulnerable to future logging activities. Logging activities target the commercially valuable large trees, which are the main nesting trees for hornbills. Moreover, it threatens the survival of mature fruit trees, especially strangler figs, which are a main food source of the majestic hornbills and many other megafauna.

Recognising the significance of Belum-Temengor, MNS continues, through long term conservation programmes, to use hornbills as flagship species. Research, education and awareness activities are being planned to push for a more comprehensive protection for the whole Belum-Temengor Forest Complex (Yeap, C. A. pers. comm. 2016).

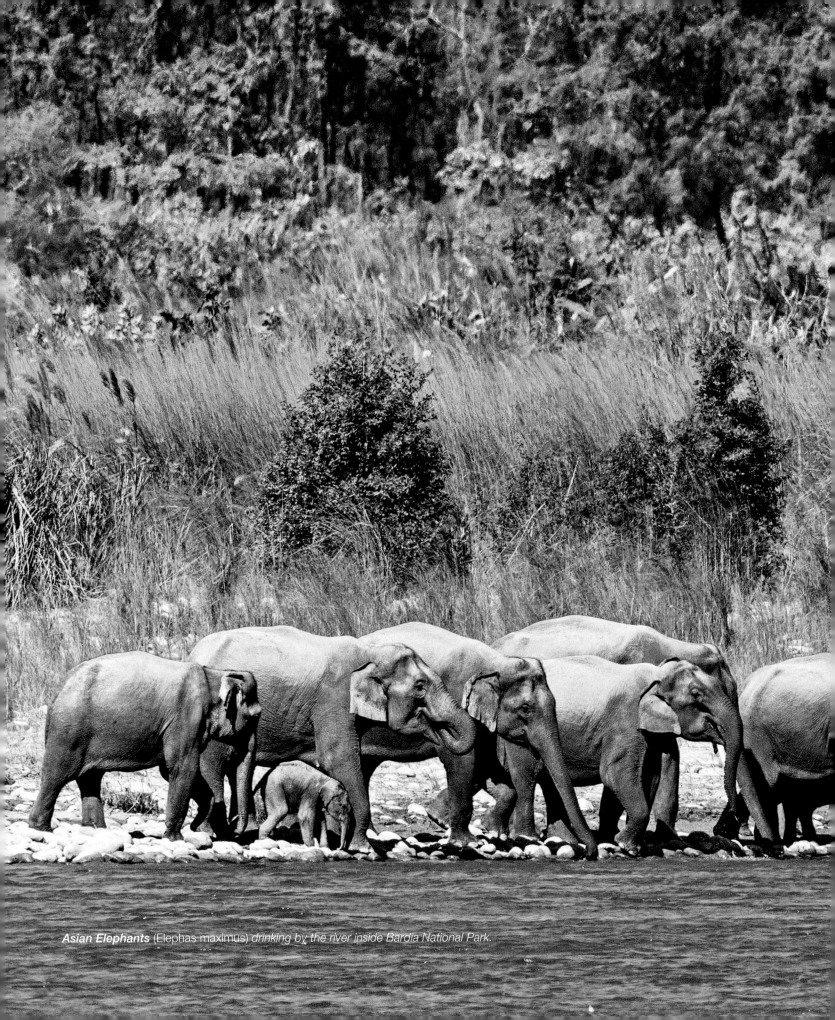

*Asian Elephants* (Elephas maximus) *drinking by the river inside Bardia National Park.*

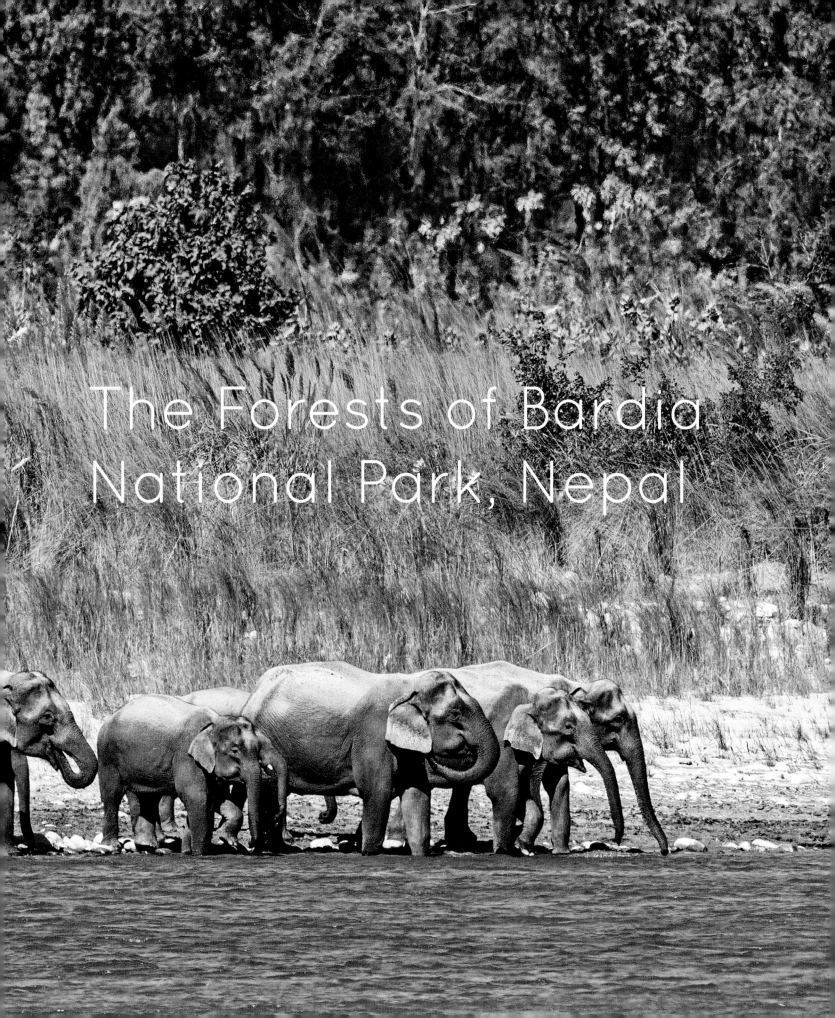

The Forests of Bardia
National Park, Nepal

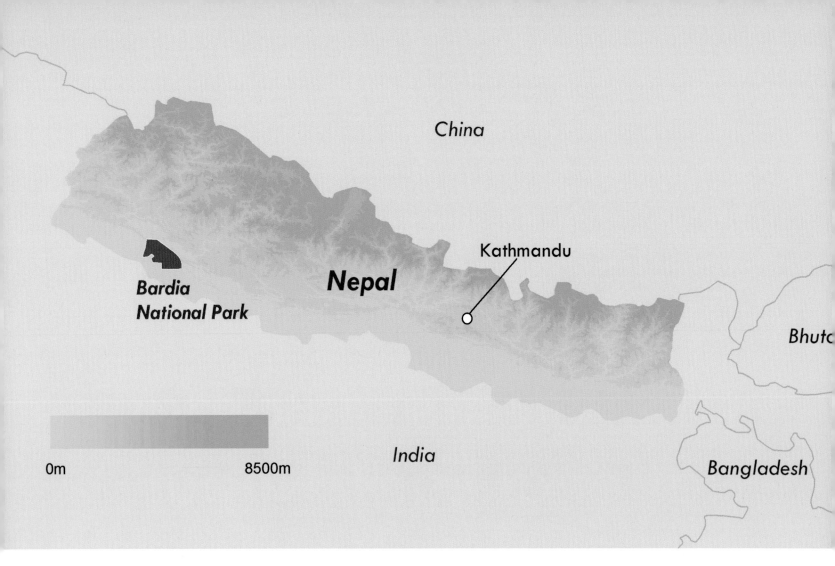

China

Kathmandu

Bardia
National Park

Nepal

Bhutc

India

Bangladesh

0m                              8500m

## Introduction

Nepal is a remarkably diverse and distinctive country sandwiched between China and India. It is roughly 800 km long and 200 km wide, occupying around 147,000 square km, making it slightly bigger than England. For such a comparatively small country, Nepal exhibits remarkable geographic diversity, ranging from the southern subtropical plains of the Terai region bordering the foothills of the Himalayas to the highest place on Earth, Mount Everest, or Sagarmatha as the mountain is known to the Nepalese people. It is home to more than 800 species of birds and 200 species of mammals.

About 25 per cent of the country falls within protected areas, representing different ecosystems across various elevations. However, beyond the protected areas, wildlife suffer from the conversion of grassland and forests to farmland, overgrazing, poaching and overexploitation of forest resources.

In the remote west of Nepal, the wilderness of Bardia National Park is one of the country's many hidden jewels. Although access has improved significantly, visitor numbers here are still only a fraction of Nepal's most well known National Park, the Chitwan.

Until now Bardia has suffered little impact from tourism. It protects 968 square km of wilderness, which was unaffected by the 2015 earthquake. The buffer zone around the national park consists of an extensive area of 507 square km. The mosaic landscape of forest, grassland and riverine habitats in Bardia provides excellent habitat for a wide range of fauna and flora.

About 70 per cent of the park is covered in dense deciduous forests dominated by Sal (Shorea robusta) while other parts are covered with grassland. The northern parts of Bardia are comprised of undulating terrain and the southern parts are almost flat.

Bardia National Park is one of 36 Important Bird and Biodiversity Areas (IBAs) in Nepal. More than 500 bird species have been recorded in Bardia, including threatened flagship species such as Bengal Florican (Houbaropsis bengalensis), White-rumped Vulture (Gyps bengalensis), Slender-billed Vulture (Gyps tenuirostris), Sarus Crane (Grus antigone) and Pallas's Fish Eagle (Haliaeetus leucoryphus).

Bardia also supports significant populations of four globally threatened species: wintering Steppe Eagle (Aquila nipalensis); Great Slaty Woodpecker (Mulleripicus pulverulentus); Asian Woollyneck (Ciconia episcopus) and Lesser Adjutant (Leptoptilos javanicus). Due to widespread poaching during the Maoist insurgency from 1996 to 2006, the populations of many larger wildlife species suffered, but are now recovering from this difficult period.

▲ Nepal is one of the least developed countries in Asia. At present, the rapidly increasing population is putting immense pressure on the country's natural environment.

Bird Conservation Nepal (BCN) was founded in 1982. It is Nepal's national partner of BirdLife International and is the leading organisation on the conservation of birds and their habitats in the country. BCN published 'The State of Nepal's Birds 2010, Indicators for our changing world', a scientific report highlighting the status of Nepal's birds, the key protection challenges as well as the best responses to tackle the latest issues. BCN has carried out numerous scientific studies that will guide the conservation of many bird species.

Conservation and awareness training workshops and events are organised regularly for stakeholders, including government policy makers, school leaders and students, local conservation partners and community groups. Bird counts and surveys are some of the popular activities.

In Nepal, common land is owned by the state. However, there is limited capacity to monitor and manage forest areas; this often results in overharvesting of firewood by local people. Over the past few years, a network of community forests has been established through the formation of 'Forest User Groups', which play an important role in forest management and land use decisions. Together with the government and international partners, BCN has implemented several programmes to ensure that community forests are conserved and managed sustainably.

Rural poverty is one of the primary drivers for unsustainable use of forest resources. For this reason, Bird Conservation Nepal (BCN) has initiated several projects to generate sustainable incomes for local people and provide alternative livelihoods. To this end, BCN has supported training programmes for various cottage industries, especially those involved in the production of weaved craft items, natural juice processing, vegetable growing and the production of food plates using Sal leaves. Several hundred households have benefited from these activities. BCN has also provided support for two biogas plants used by 62 households around Bardia National Park, thus reducing the use and collection of firewood for cooking by 50 per cent.

▲ BCN seedling reforestation programme at the Shital Buffer Zone of Bardia National Park.

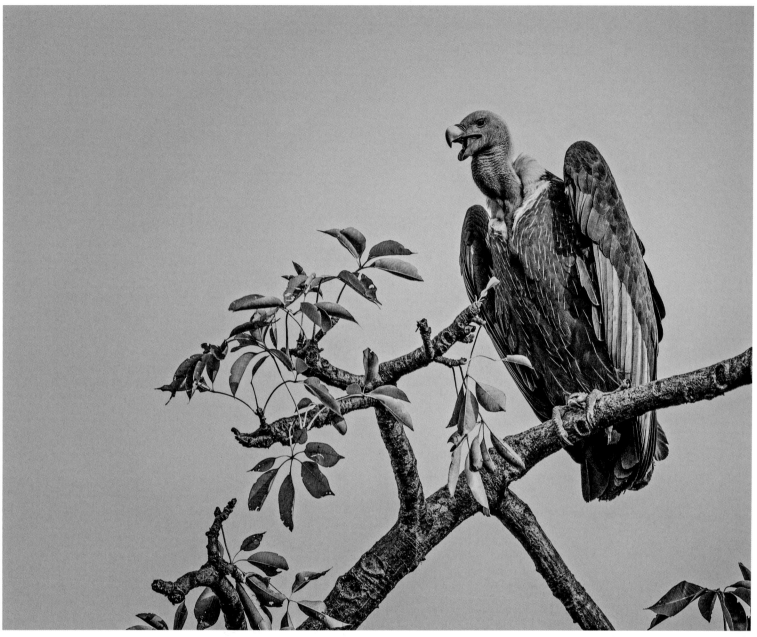

▲ *White-rumped Vulture* (Gyps bengalensis), *Critically Endangered.*

Nine species of vultures can be found in Nepal, four of which reside in Bardia National Park. Vultures provide an essential ecosystem service by maintaining an environment free of animal carcasses, thus returning vital nutrients into the ecosystem. As one of the primary consumers of carrion, vultures ensure quick and efficient removal of dead animals. In Nepal, vultures rely mostly on carcasses of domestic animals as a food source. More than 80 per cent of the country's population are Hindu, for whom the slaughter of cattle and beef consumption is taboo. When cattle die, their carcasses are typically left to the vultures.

Over the past few decades, there has been a catastrophic decline of all vulture species in South Asia. The main culprit is use of the anti-inflammatory drug diclofenac to treat livestock. The Government of Nepal banned production and veterinary use of diclofenac in 2006. However, the ban is not 100 per cent effective and vultures continue to be killed from ingesting this deadly drug.

◀ *The Vulnerable* **Great Slaty Woodpecker** (Mulleripicus pulverulentus) *is considered the largest extant woodpecker in the world, reaching a length of close to 60 cm. It is a resident in the forests of Bardia. This is a male, which is recognised by its reddish cheek patch.*

*Great Slaty Woodpeckers are often seen foraging in family groups of three to five members consisting of a breeding pair and their offspring from previous years. Ants are an important part of their diet, together with termites, beetle larvae and stingless bees.*

*The* **Sarus Crane** (Grus Antigone), *a rare visitor in Bardia, is the only breeding crane in Nepal. Local religious traditions have played an important role in protecting the species in both Nepal and India, where they are regarded as sacred birds. They are, however, vulnerable to various threats as more than 90 per cent of the population is found outside protected areas. In spite of this, an increase in population has been reported in the latest study on the species (Hem, B.K. 2016).*

*The species breeds in the June-July monsoon season. In Nepal, the Sarus Crane commonly uses farmland for nesting and roosting, perhaps in response to the scarcity of natural wetlands. Usually two eggs are laid, with both sexes sharing the incubation duties; the chicks fledge after approximately two months.*

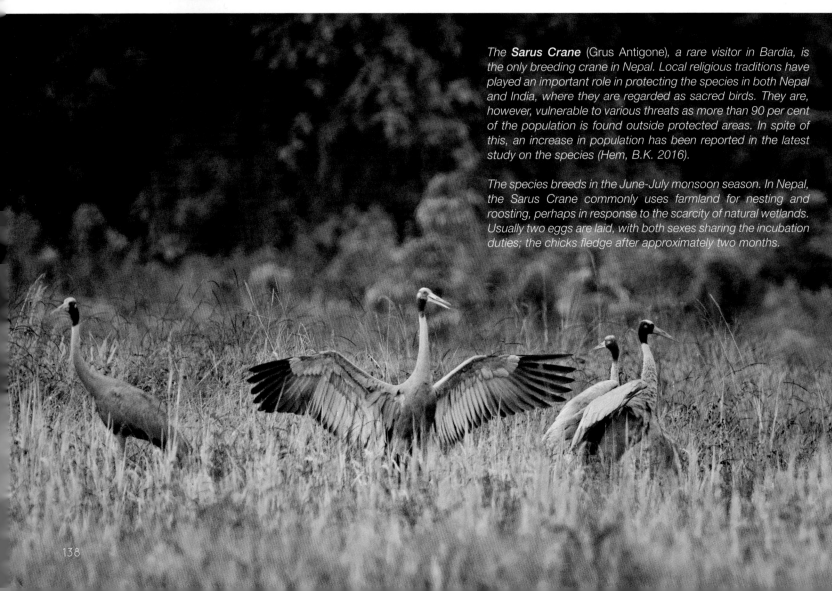

▲ The **Spiny Babbler** (Turdoides nipalensis) *is Nepal's only endemic bird species. Although a rarity in Bardia, it has been recorded inside the park on hill slopes with thick scrub and scattered trees.*

The Bengal Florican *(Houbaropsis bengalensis bengalensis)* is one of three bustards that breed on the Indian subcontinent. It is one of the rarest bustards in the world with a global population of less than 1,000 individuals, the majority of which remains in Cambodia and eastern India. This rare bird is Critically Endangered; it is probably best known for its elaborate courtship display during the breeding season from April to May. During these months, the black and white plumage of the male is showcased in short aerial sorties to capture the attention of females.

The larger buff-brown females are far more secretive. They are thought to spend most of their time in tall, dense grassland. One or two olive green eggs are laid on the ground. The incubation duties of the female lasts up to 28 days; the chicks are capable of looking after themselves shortly after hatching.

The Bengal Florican has a small and fragmented population limited to a handful of locations in Nepal. Regular sightings are from only four protected areas: Koshi Tappu and Suklaphanta Wildlife Reserves; Chitwan and Bardia National Parks. Surveys conducted in 2007 point to a dramatically declining population in Bardia National Park, currently down to two individual birds.

Koshi Tappu Wildlife Reserve in north-eastern Nepal was largely neglected by researchers until 2012, when a comprehensive survey was conducted. The total estimated population of 60 birds here represents by far the largest known population in Nepal (Baral, H.S. and colleagues 2013).

In Nepal, the key threats to the Bengal Florican are human disturbance and suboptimal grassland management activities such as grass burning and cutting. During the breeding season, burned and relatively open grassland is often selected by males, whereas females prefer unburned areas that provide better cover. In Bardia, predators such as jackals may also be a threat to floricans.

▸ *The male* **Bengal Florican** *in his domain. It is a grassland specialist favouring habitat with a mixture of short and long grasses. This flagship species is most often seen stalking dense grasses as it forages for beetles, grasshoppers and small vertebrates. Seeds, berries and flowers are also consumed, especially during winter and spring.*

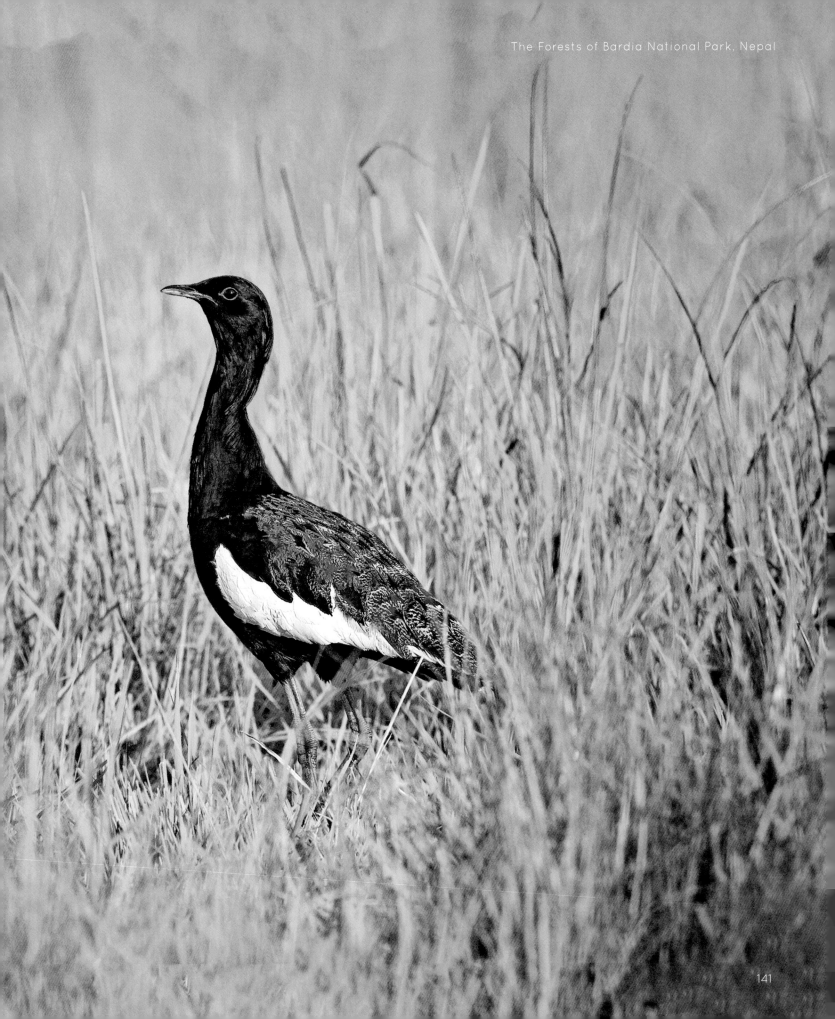

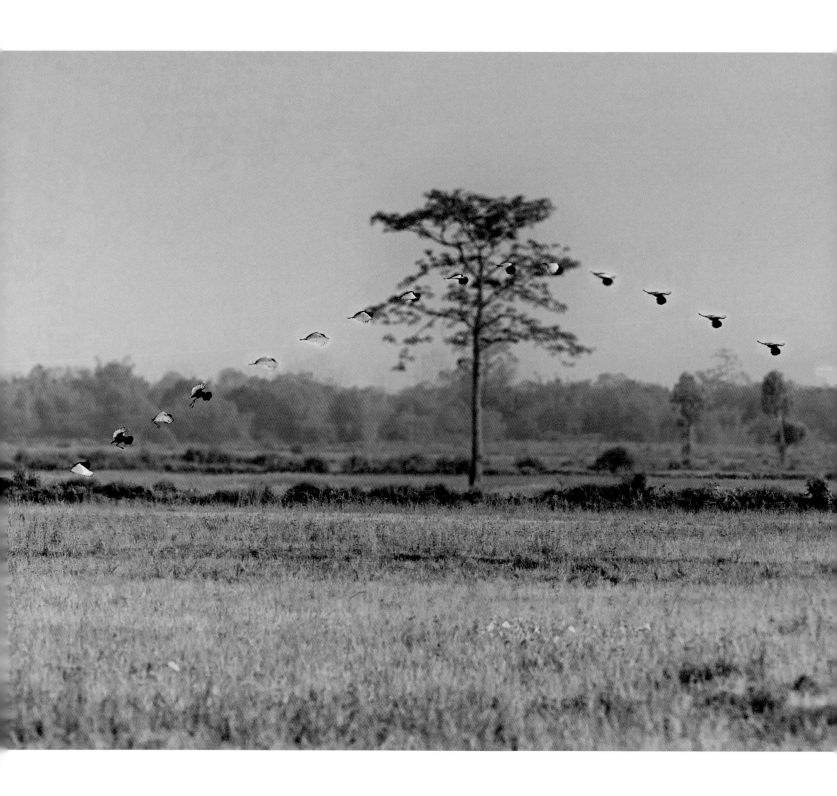

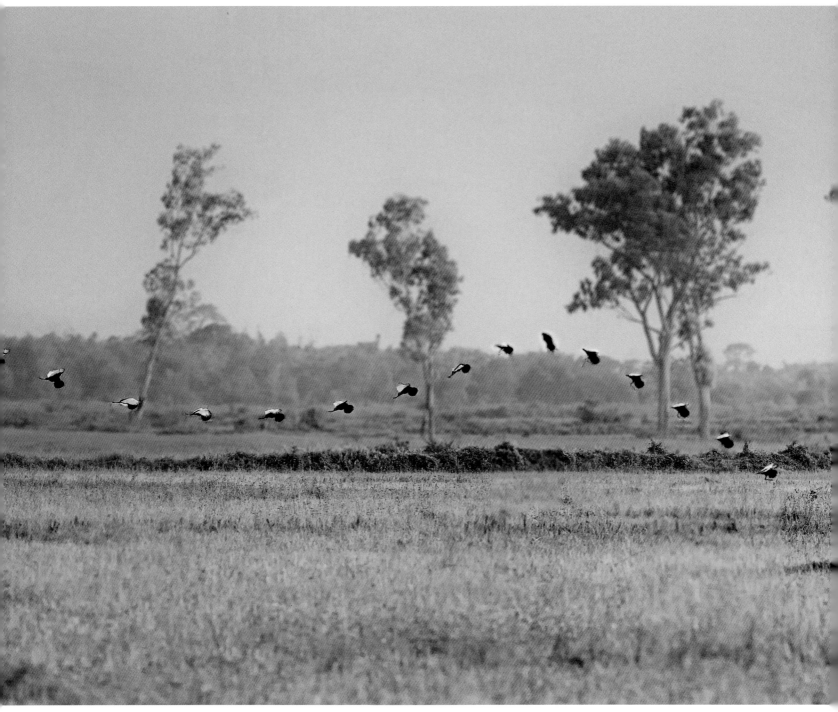

▲ Composite photo showing the aerial flight sequence of a male **Bengal Florican**. The species is best seen during the spring-summer period from March to August in the early morning or late afternoon.

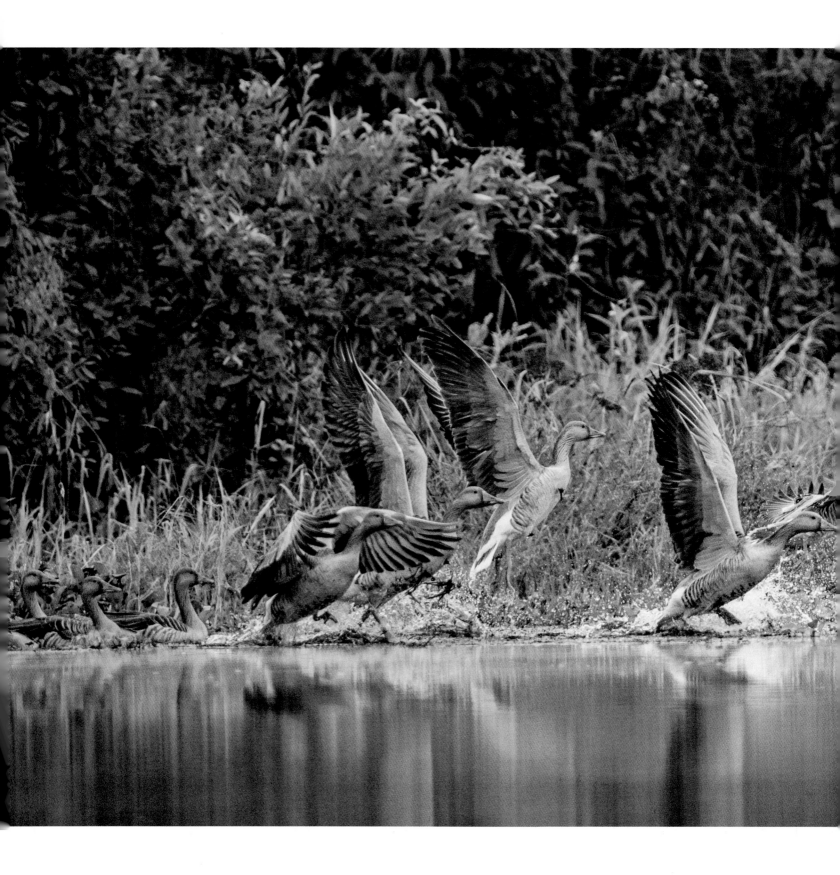

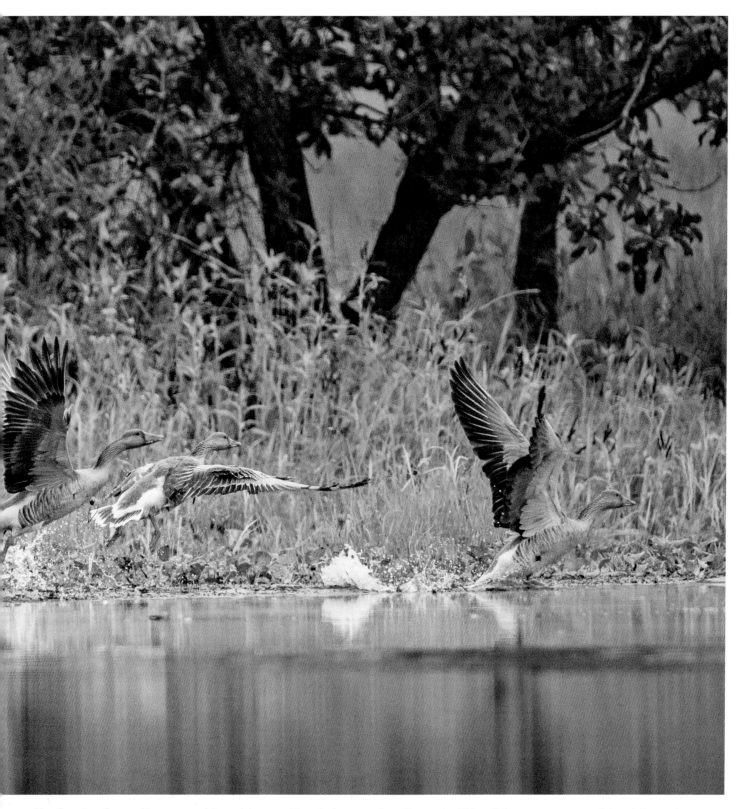

▲ The **Greylag Goose** (Anser anser) *breeds across Eurasia from western Europe to China. It is an uncommon winter visitor and passage migrant in Nepal, with many birds seen here on their way to India. Greylag Geese primarily feed on grass, but also take leafy vegetation, grain and root crops. As these preferred foods are not high in nutrients, the geese have to graze for extended hours to get enough nourishment. These heavy birds digest their food at a remarkable speed.*

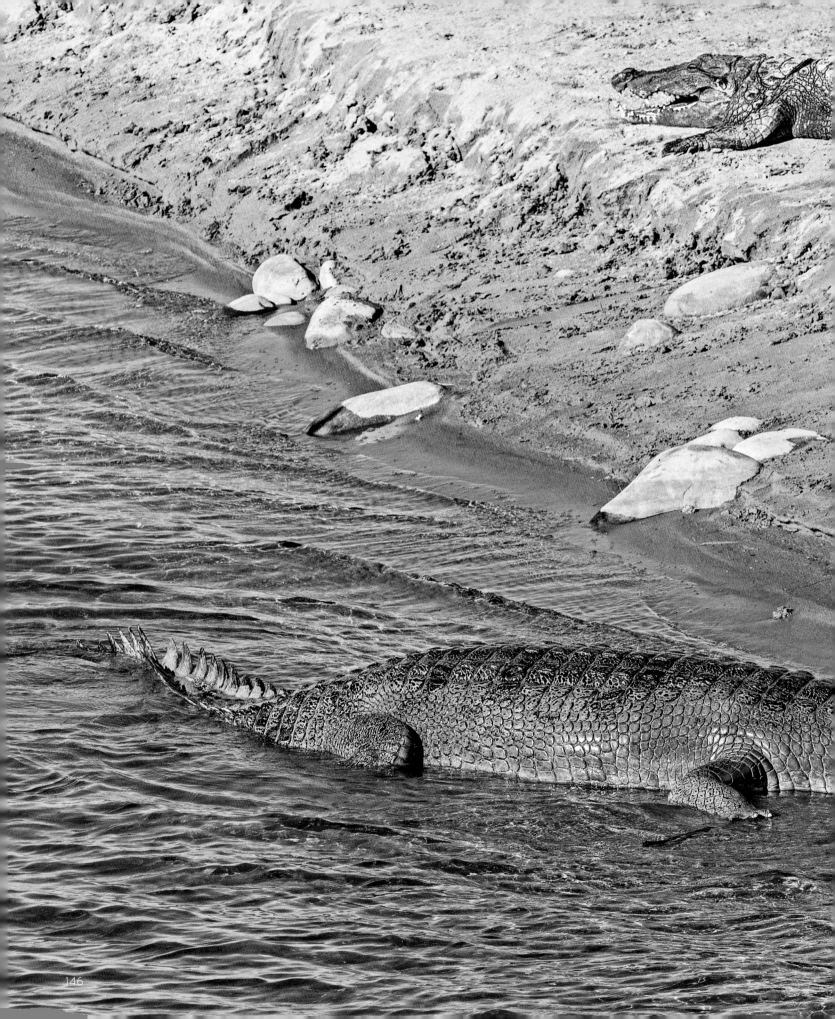

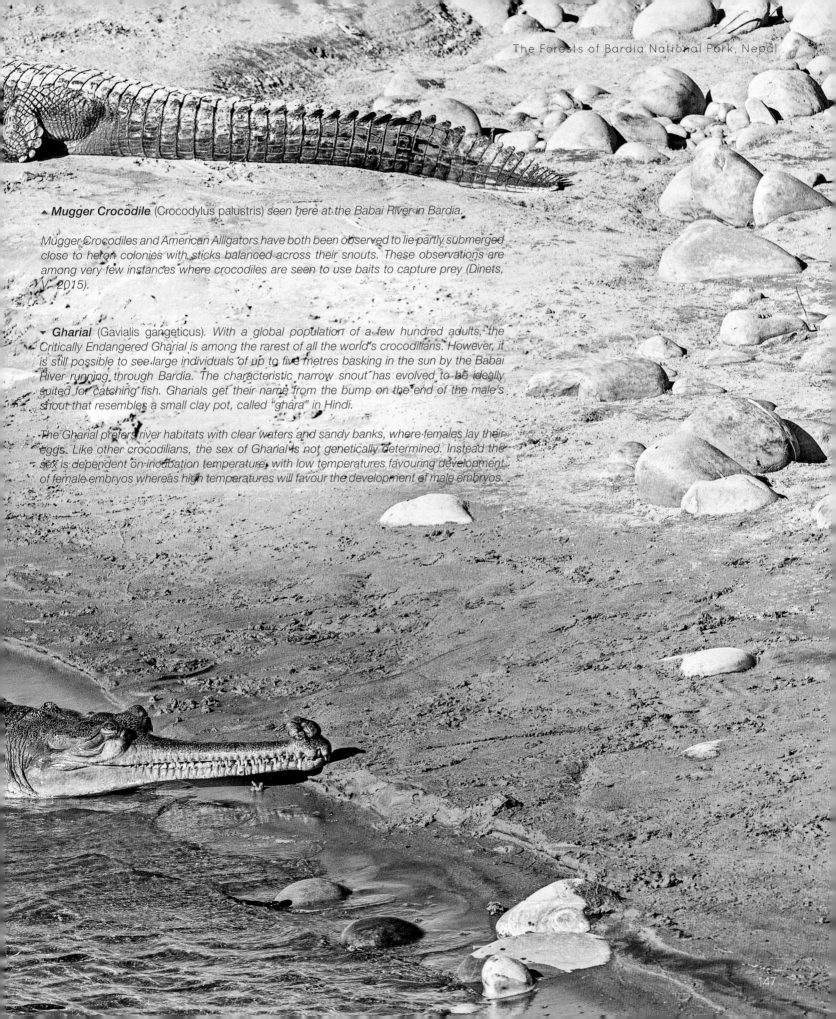

▲ **Mugger Crocodile** (Crocodylus palustris) seen here at the Babai River in Bardia.

Mugger Crocodiles and American Alligators have both been observed to lie partly submerged close to heron colonies with sticks balanced across their snouts. These observations are among very few instances where crocodiles are seen to use baits to capture prey (Dinets, V. 2015).

▼ **Gharial** (Gavialis gangeticus). With a global population of a few hundred adults, the Critically Endangered Gharial is among the rarest of all the world's crocodilians. However, it is still possible to see large individuals of up to five metres basking in the sun by the Babai River running through Bardia. The characteristic narrow snout has evolved to be ideally suited for catching fish. Gharials get their name from the bump on the end of the male's snout that resembles a small clay pot, called "ghara" in Hindi.

The Gharial prefers river habitats with clear waters and sandy banks, where females lay their eggs. Like other crocodilians, the sex of Gharial is not genetically determined. Instead the sex is dependent on incubation temperature, with low temperatures favouring development of female embryos whereas high temperatures will favour the development of male embryos.

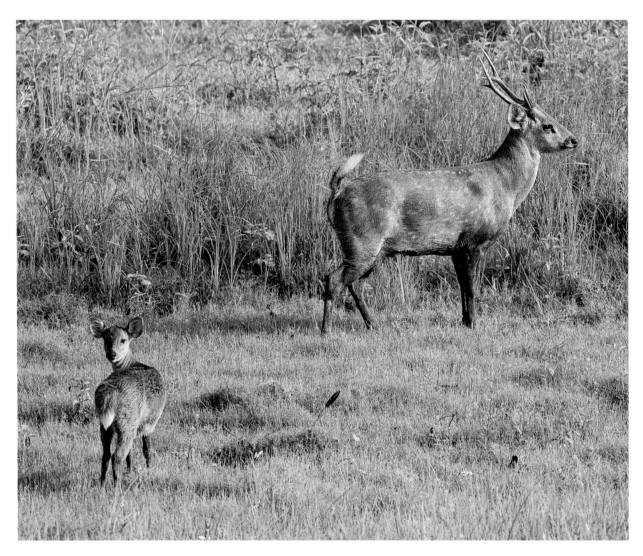

▲ *The Endangered **Hog Deer** (Axis porcinus) can be found in low-lying grassland on floodplains. In Nepal, most populations remain inside protected areas including Bardia National Park, where numbers are comparatively stable. Outside protected areas, few viable populations remain and these are subjected to severe hunting pressures.*

*In September and October, males compete vigorously for the attention of females. The victorious male expels his opponent from the territory and mates with the watching female. Females give birth to a single fawn after a gestation period of around seven months; the young are weaned after six months. Their main predators are tigers, leopards and Asiatic Wild Dogs.*

▶ *In the past, the spiral horns of the male **Blackbuck** (Antilope cervicapra) made it a popular hunting target. By the mid-1970s, the species was on the brink of extinction in Nepal. The population was down to less than a dozen before concerted conservation efforts were commenced. Today, the main population of around 200 individuals is increasing but remains vulnerable as it is restricted to the Blackbuck Conservation Area in the Bardia district.*

*Inside Bardia National Park there are small groups of reintroduced Blackbuck in the open country on the south-eastern parts of the park. Blackbucks need water on a daily basis; this restricts their distribution to areas where surface water is available for most of the year. They are primarily grazers and prefer open and short grasslands. In the dry summer season they may move long distances in search of food and water.*

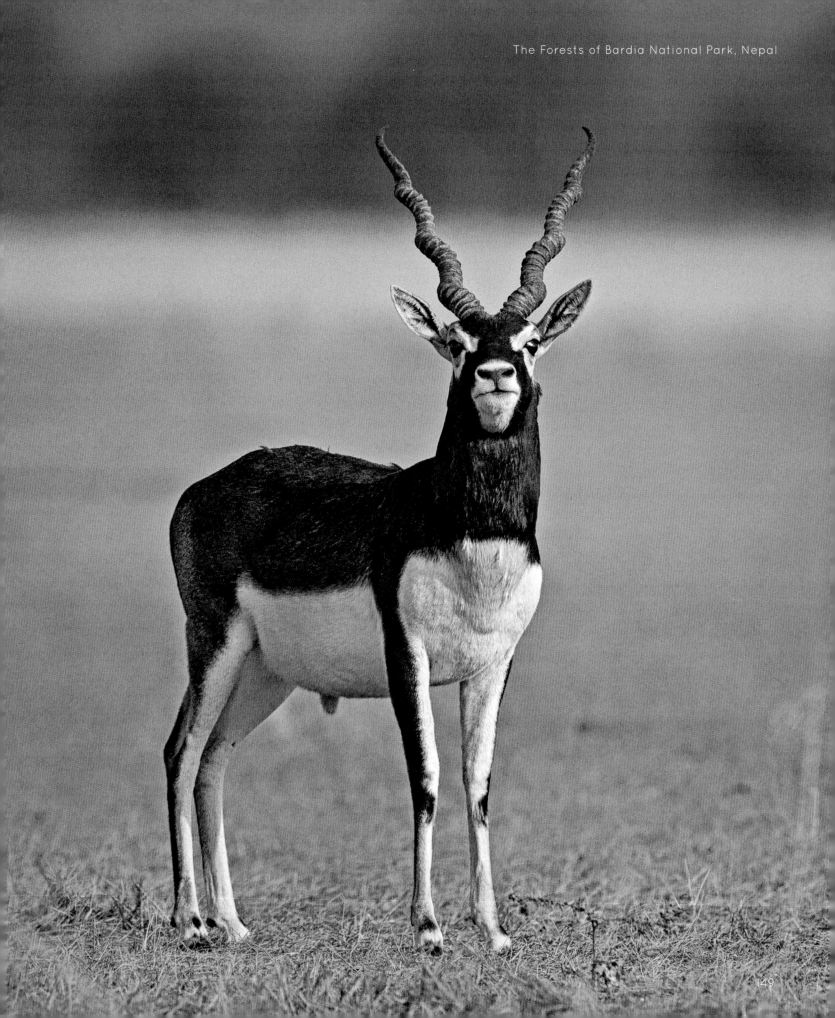

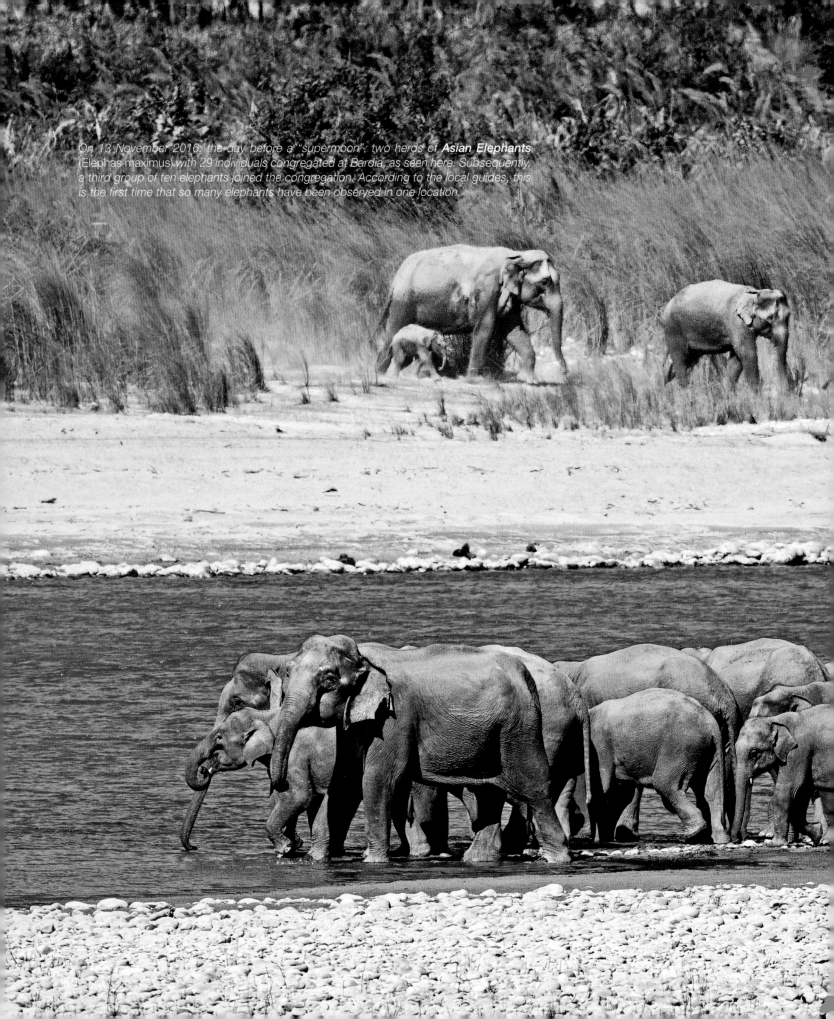

On 13 November 2016, the day before a "supermoon", two herds of **Asian Elephants** (Elephas maximus) with 29 individuals congregated at Bardia, as seen here. Subsequently, a third group of ten elephants joined the congregation. According to the local guides, this is the first time that so many elephants have been observed in one location.

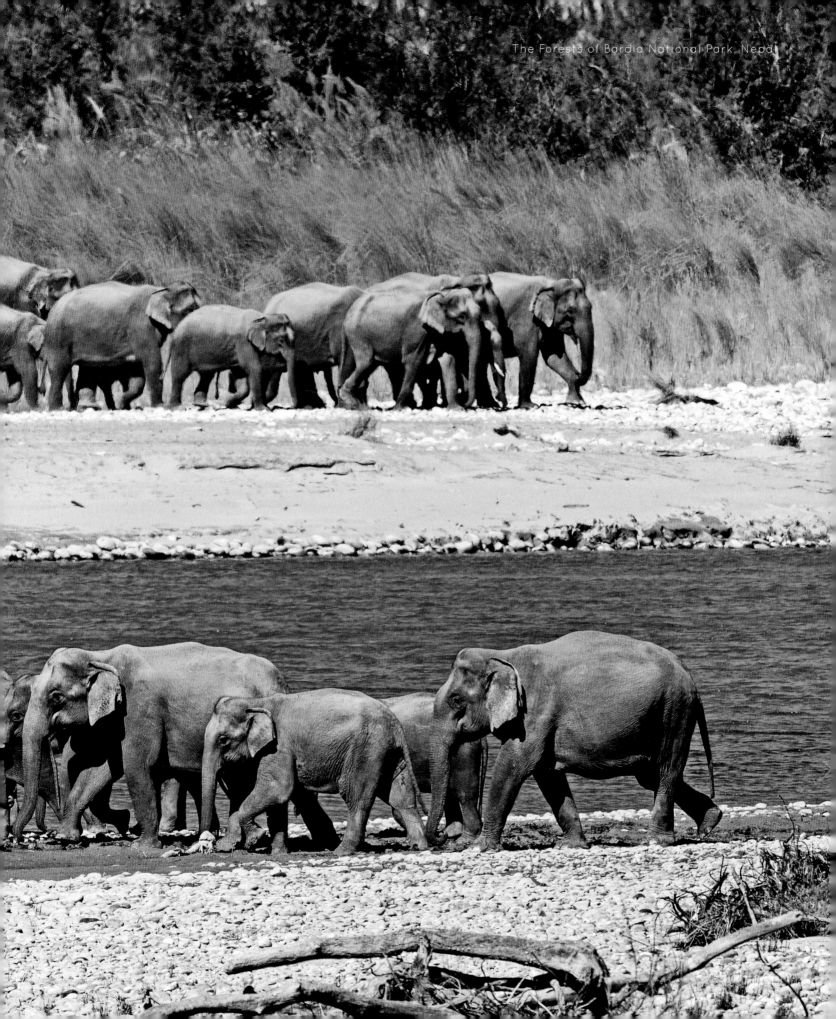

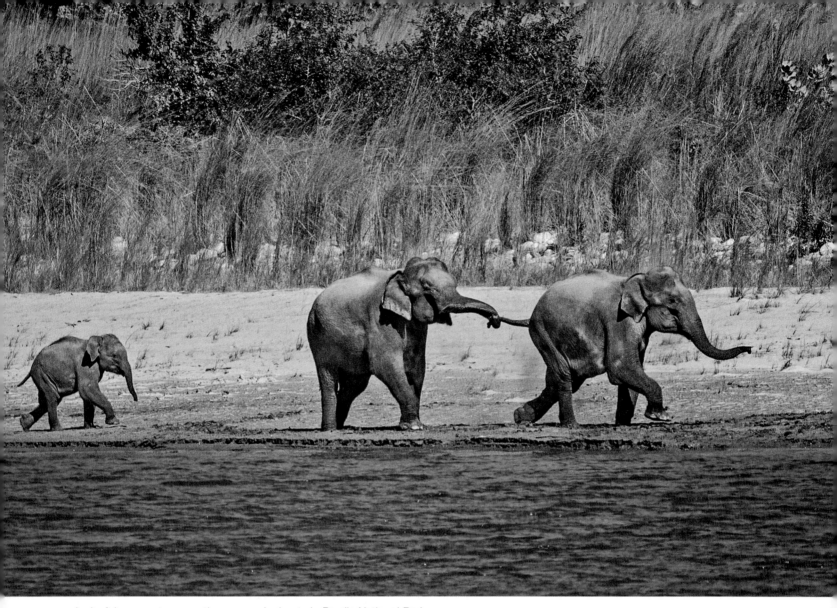

▲ A playful moment among the young elephants in Bardia National Park.

Because of habitat destruction in the western parts of Nepal there were no wild herds of elephants there in the mid and late 1970s. Subsequently, two large bulls took up residence in Bardia. The situation changed dramatically in the early 1990s. By 1995, the population of elephants counted in Bardia National Park had increased to 41. By that time, it is believed that the elephants were already breeding in the park (ten Velde, R.F. 1996).

The main migration of wildlife between Bardia National Park and the Katarniaghat Wildlife Sanctuary in India is through the Khata corridor, which connects the two protected areas. Transboundary conservation efforts in Nepal and India have played an important role in maintaining the Khata corridor, allowing elephants, tigers, rhinoceros and other keystone species to migrate.

There are about 260 wild elephants in Nepal and almost half of them occur in Bardia, which makes the park the single highest priority for elephant conservation in the country.

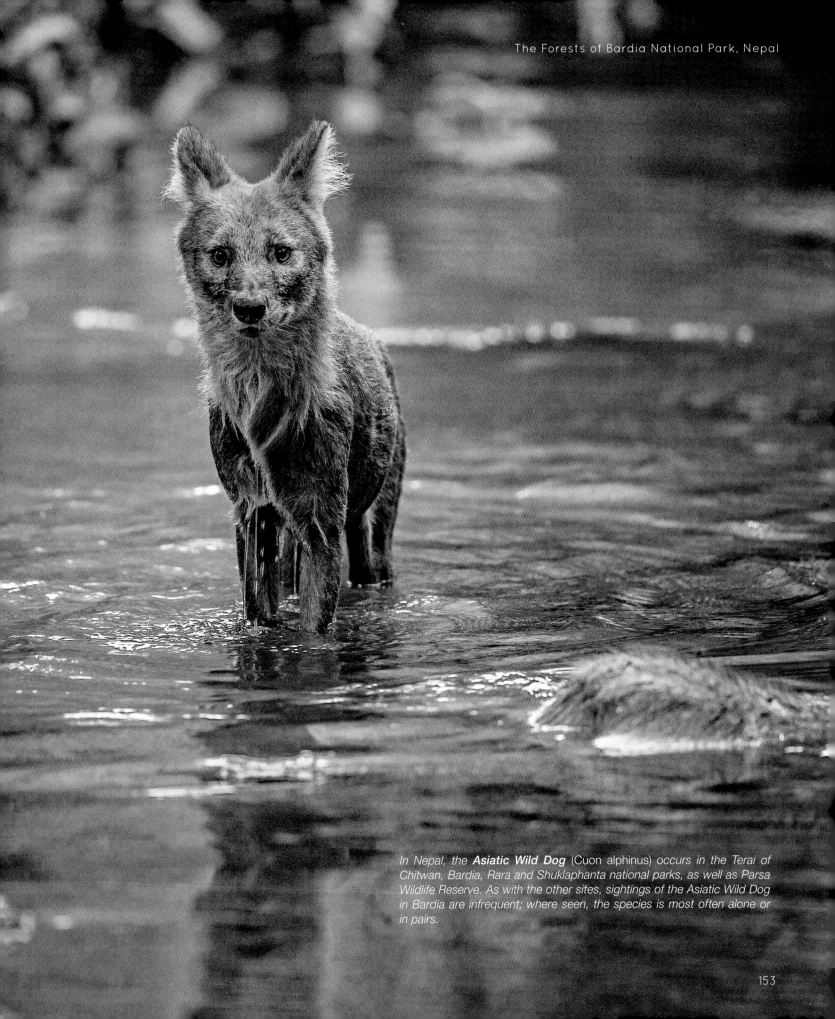

In Nepal, the **Asiatic Wild Dog** (Cuon alphinus) *occurs in the Terai of Chitwan, Bardia, Rara and Shuklaphanta national parks, as well as Parsa Wildlife Reserve. As with the other sites, sightings of the Asiatic Wild Dog in Bardia are infrequent; where seen, the species is most often alone or in pairs.*

The **Rhesus Macaques** (Macaca mulatta) have one of the most extensive geographic ranges of any primate, apart from humans. They occur from Afghanistan in the west to China in the east and occupy a considerable range of habitats including man-made landscapes. They are the most commonly encountered primate in Bardia.

Both male and female Rhesus Macaques engage in promiscuous sexual behaviour. They move in groups of up to 150 individuals. Separate, and defined hierarchies for males and females exist in Rhesus Macaque societies. Social grooming for pleasure is common; it is also a form of submission and appeasement. The diet of Rhesus Macaques is varied, consisting of roots, insects, crop plants and small animals.

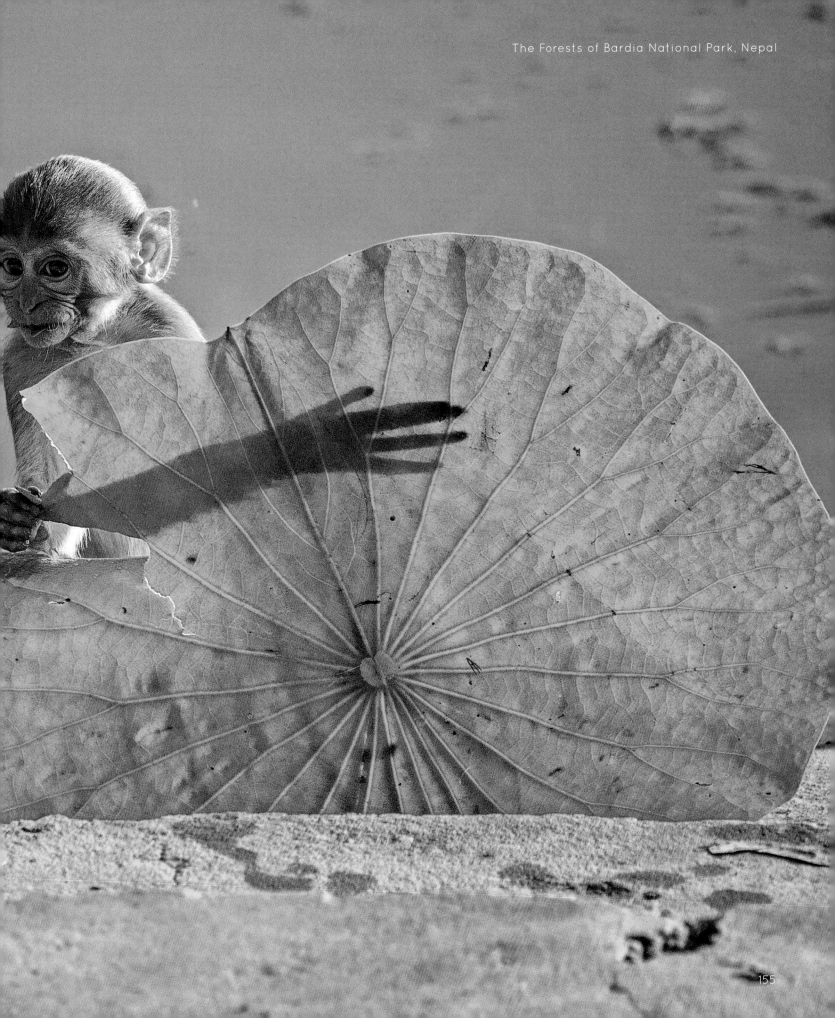

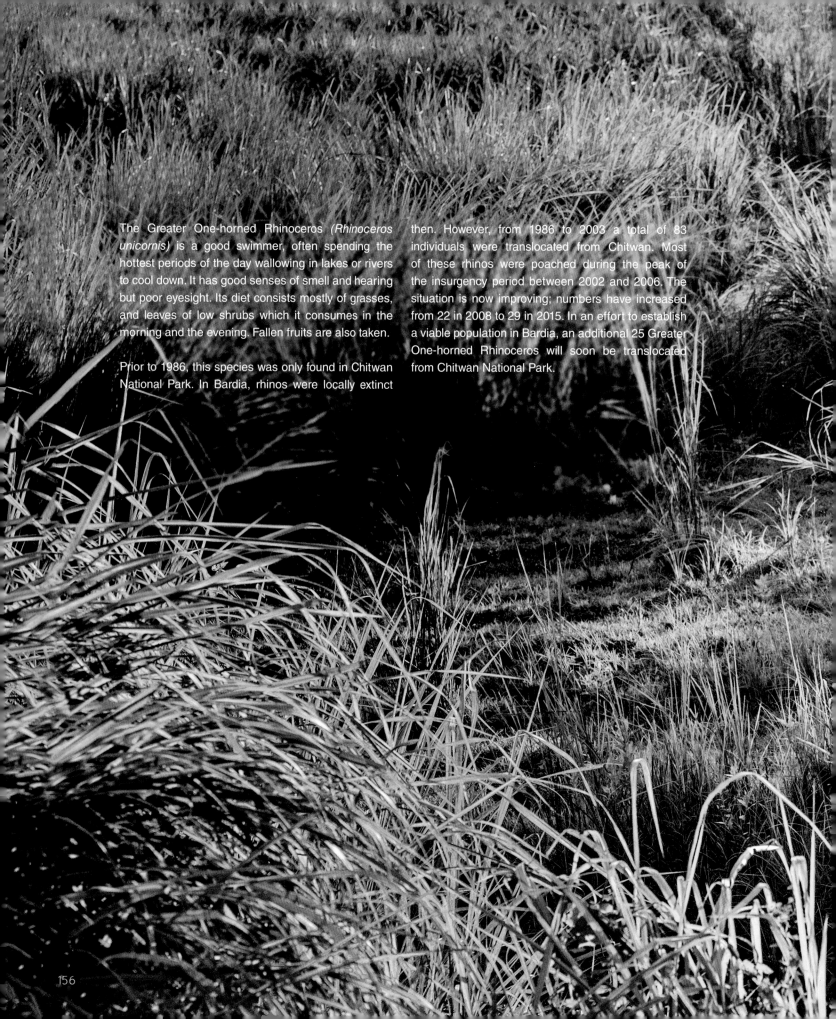

The Greater One-horned Rhinoceros (*Rhinoceros unicornis*) is a good swimmer, often spending the hottest periods of the day wallowing in lakes or rivers to cool down. It has good senses of smell and hearing but poor eyesight. Its diet consists mostly of grasses, and leaves of low shrubs which it consumes in the morning and the evening. Fallen fruits are also taken.

Prior to 1986, this species was only found in Chitwan National Park. In Bardia, rhinos were locally extinct then. However, from 1986 to 2003 a total of 83 individuals were translocated from Chitwan. Most of these rhinos were poached during the peak of the insurgency period between 2002 and 2006. The situation is now improving; numbers have increased from 22 in 2008 to 29 in 2015. In an effort to establish a viable population in Bardia, an additional 25 Greater One-horned Rhinoceros will soon be translocated from Chitwan National Park.

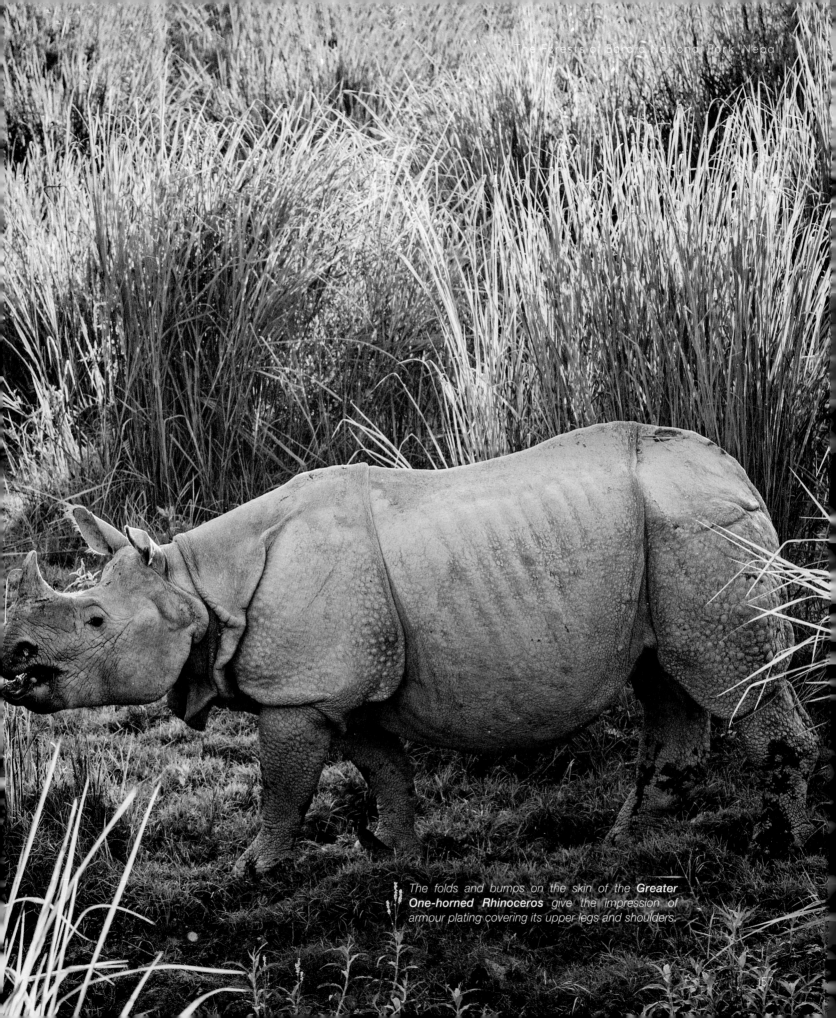

The folds and bumps on the skin of the **Greater One-horned Rhinoceros** give the impression of armour plating covering its upper legs and shoulders.

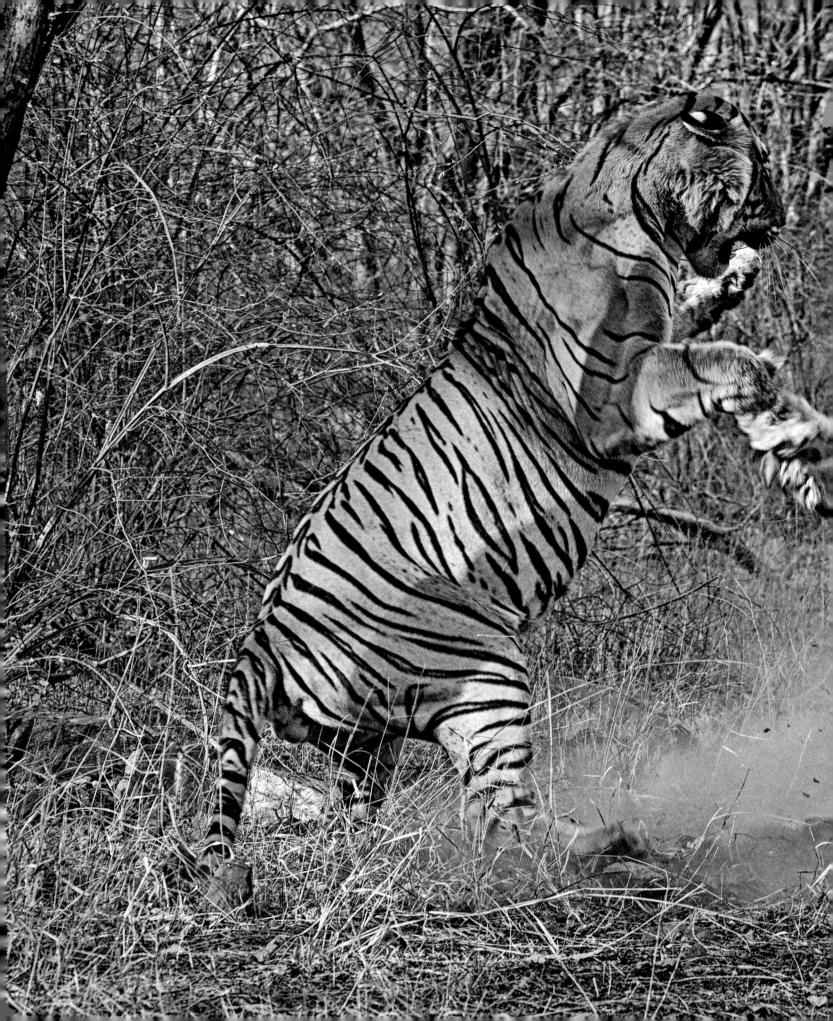

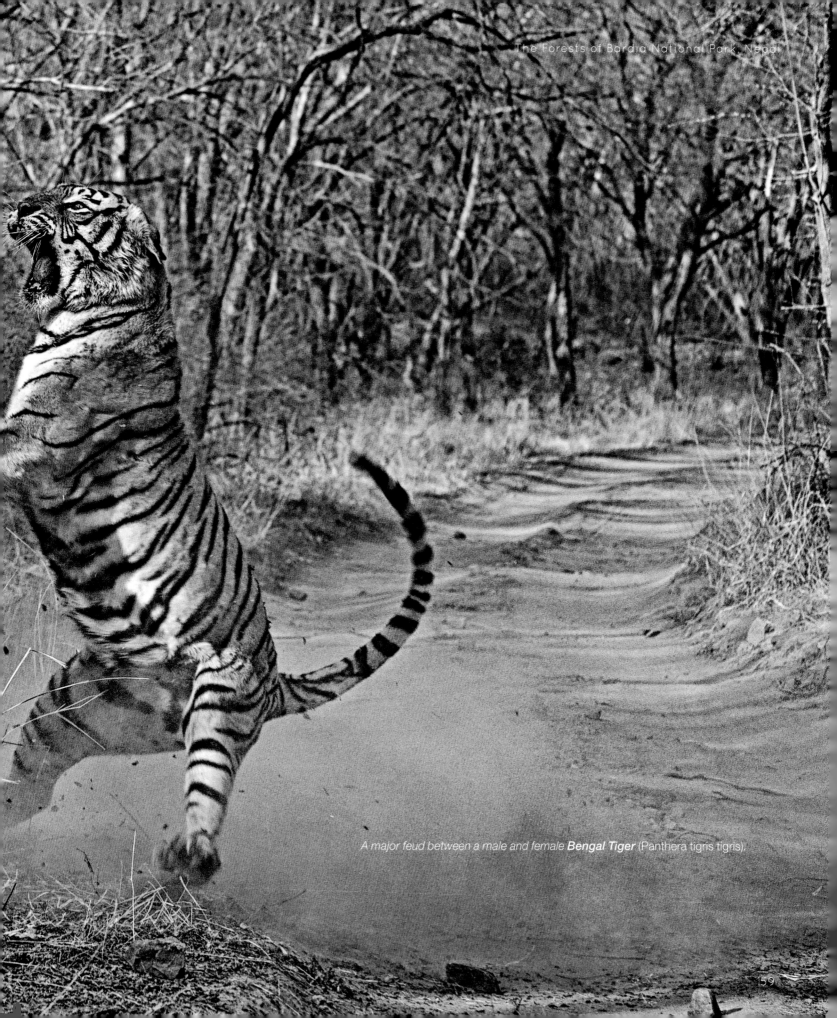

*A major feud between a male and female* **Bengal Tiger** (Panthera tigris tigris).

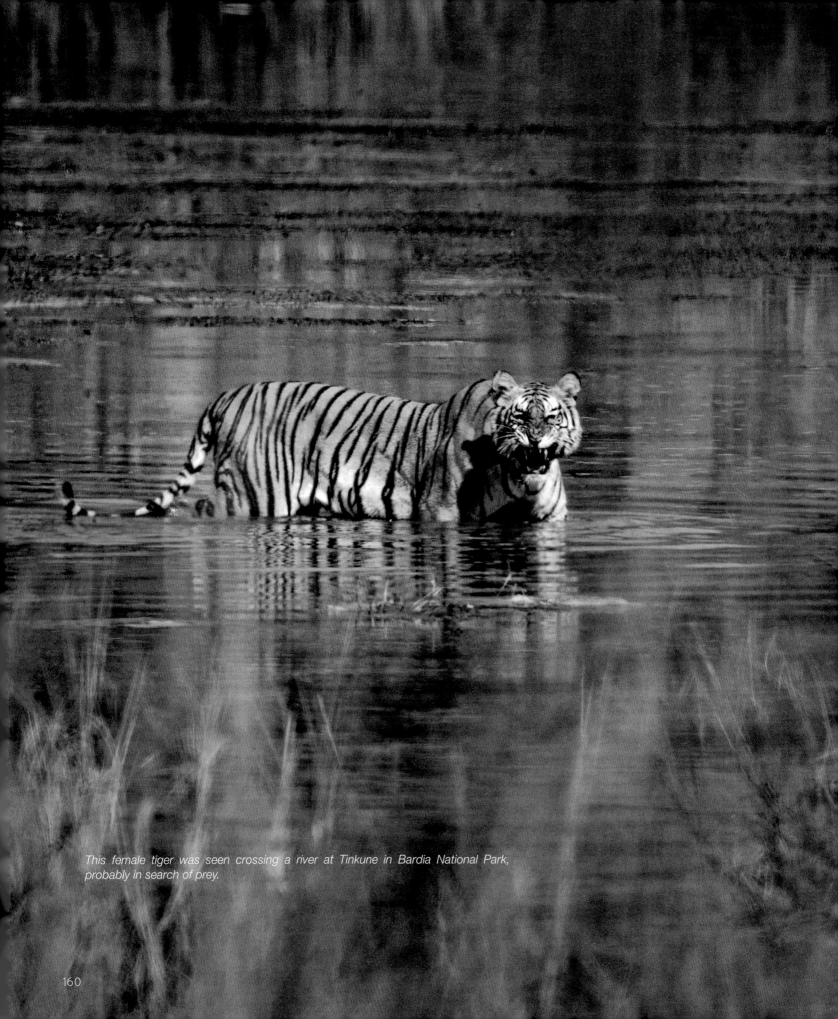

*This female tiger was seen crossing a river at Tinkune in Bardia National Park, probably in search of prey.*

The Endangered Bengal Tiger *(Panthera tigris tigris)* is among the largest of all cats, with some males weighing well over 200 kg. It is normally seen alone, except for females with their cubs. The litter size is usually between two and five. Tigers usually take large deer and wild boar, but they are opportunistic and will also hunt primates, reptiles, birds, fish and livestock.

There has been a noteworthy increase in the tiger population in Bardia, which is now home to the second largest number of tigers in Nepal. From around 20 individuals in 2009, the population now stands at 56 in 2016.

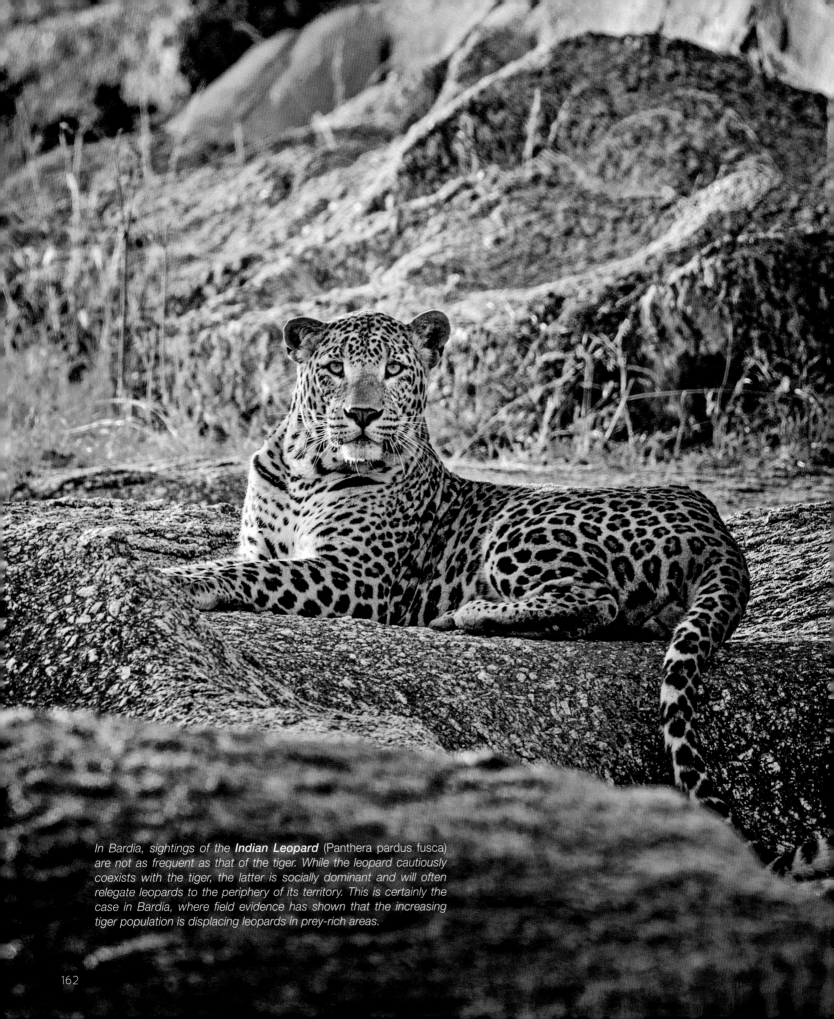

In Bardia, sightings of the **Indian Leopard** (Panthera pardus fusca) are not as frequent as that of the tiger. While the leopard cautiously coexists with the tiger, the latter is socially dominant and will often relegate leopards to the periphery of its territory. This is certainly the case in Bardia, where field evidence has shown that the increasing tiger population is displacing leopards in prey-rich areas.

## Nature Conservation

With Nepal's proximity to China, and recognising that Chinese demand is one of the main drivers of the global trade in endangered species, it is remarkable that Nepal has been able to achieve a number of conservation successes over the past decade.

While good progress has been made on the front line of wildlife protection, illegal hunting for commercial purposes or subsistence use remains a significant threat to many species. The Bengal Tiger and the Greater One-horned Rhinoceros are among the most affected species, as their body parts are often used in traditional medicine in many parts of east Asia.

Presently, conversion of grassland and forests to agricultural land and unsustainable harvesting of plants and animals threaten species across Nepal. To address these issues, Bird Conservation Nepal has invested significant resources to work together with government agencies and local stakeholders to conserve biodiversity. The aim is to improve and secure local livelihoods in and around protected areas such as Bardia National Park. This work of mobilising local people and other grassroots organisations to improve livelihoods of local communities is key to conservation in developing countries such as Nepal.

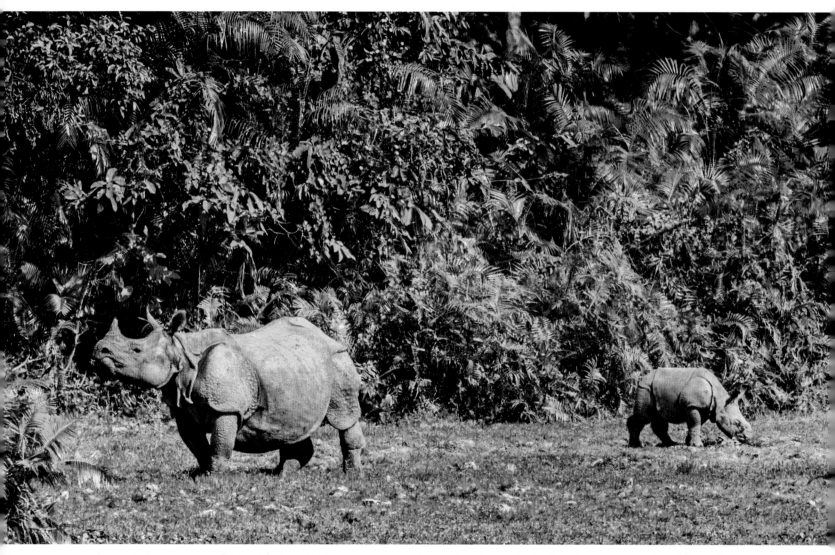

▲ Apart from females with young, the **Greater One-horned Rhinoceros** are generally solitary animals. Females reach sexual maturity at five to seven years and will give birth to a single calf after a gestation period of approximately 16 months. The calf will remain with its mother until just before the birth of the next offspring.

Bird Conservation Nepal has also played a vital role in conserving declining vulture populations in the country. BCN's work includes activities such as nest guarding schemes, scientific surveys and monitoring work on the use of diclofenac. Most importantly, local communities have been involved in creating Vulture Safe Zones, completely free from diclofenac usage. Seven vulture safe feeding sites, called vulture restaurants, have also been established. Here local inhabitants are encouraged to collect old cows from villages and keep them for at least seven days to ensure that no residual drugs remain. After their natural death, the cows are then fed to the vultures.

The results have so far been encouraging. According to the latest survey, the population of the Critically Endangered White-rumped Vulture, whilst still small, has remained stable for the last few years.

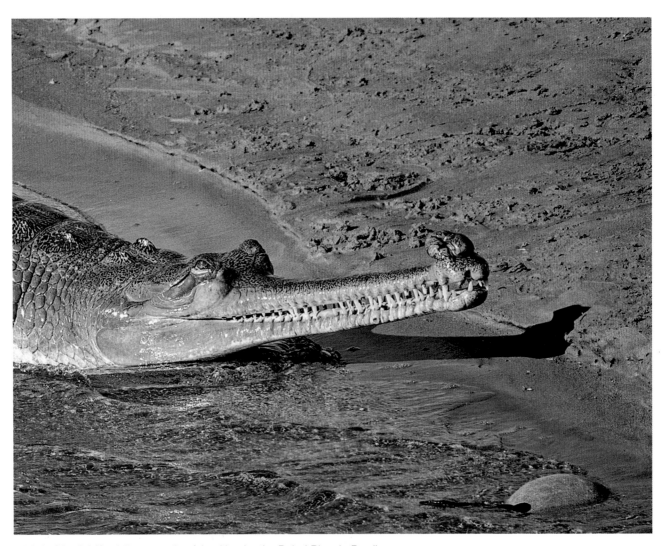

▲ *Male **Gharial** (Gavialis gangeticus) basking by the Babai River in Bardia.*

The population of the Critically Endangered Gharial is also showing signs of recovery. According to a census carried out in March and April 2016, the number of Gharials has now increased to 198 compared with 124 individuals counted in Nepal's rivers in 2013.

One of the main reasons for this encouraging news is the captive breeding programme established in Chitwan National Park. This programme has been extended to Bardia, where, in 2016, for the first time, more than 30 hatchlings were raised.

Staff from the two breeding centres search for Gharial eggs buried in seasonally exposed riverbanks, bringing them back to the centre for safe incubation. The Gharial hatchlings are generally kept in captivity for around three years and released into the wild when they reach an average length of one meter. In the past, the reintroduction scheme seemed to be ineffective in reducing the decline of Gharials; it was suspected that young Gharials were flushed out of protected areas during the annual monsoon. However, it appears that the slightly older Gharials stand better chances of survival after their release.

Human activities, including fishing with the use of gill nets and the extraction of sand and stones from riverbanks, remain an issue impeding the conservation of this impressive reptile. In other areas, dams and barrages have further degraded the Gharial's riverine habitat.

Effective conservation programmes have enabled tiger numbers to increase in Nepal's national parks. In 2010, according to the Global Tiger Recovery Plan, Nepal committed to double its tiger population from 121 to more than 250 by 2022.

A comprehensive census in 2016 concluded that the tiger population in Nepal has now increased to 198 individuals. Poaching of tigers now appears largely under control, thanks to good coordination between government and non-government agencies as well as security forces.

Against all odds, Nepal has made itself a world leader in rhino conservation. In the ten years up to 2015, the number of Greater One-horned Rhinoceros in Nepal has increased by a remarkable 58 per cent to 645 individuals.

Apart from one tragic poaching incident in September 2016, not a single Greater One-horned Rhinoceros has been poached in the last two years. The commitment to wildlife conservation is not just benefitting rhinos, according to Krishna P. Acharya of Nepal's Ministry of Forest and Soil Conservation. In fact, not a single elephant or tiger was poached anywhere in the country in the year of 2014.

An exceptional factor about Nepal's commitment to wildlife protection is the involvement of its army, park rangers, local communities and domestic and foreign conservation groups in a collaborative system. Even the highest levels of government are involved. As an example, the Prime Minister himself chairs the National Tiger Conservation Committee. Extraordinary legal powers are granted to the heads of protected areas; in other words, the head of Bardia National Park has authority to fine and to jail those who commit crimes within the boundaries of the park.

With continued investment of resources in nature conservation in Nepal, the respectable progress made over the past decade can be further enhanced, in particular within the protected areas. However, with increasing population pressures and a growing need for economic development, sustaining such conservation work outside protected areas may remain a challenge.

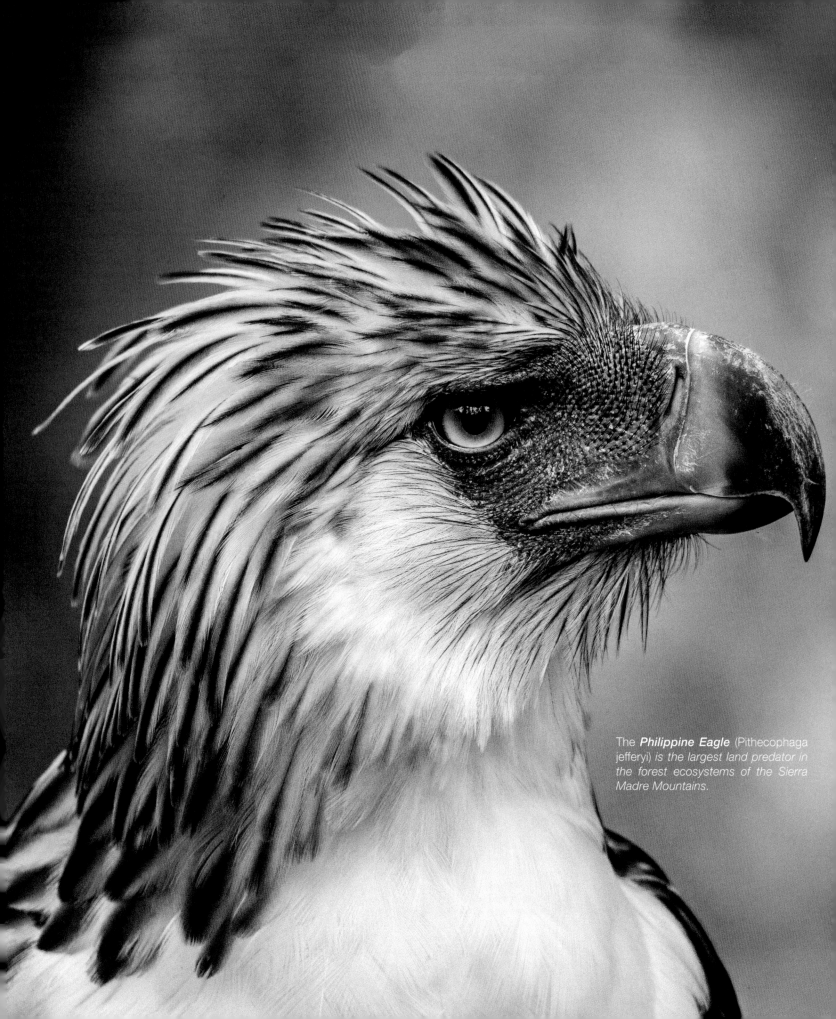

The **Philippine Eagle** (Pithecophaga jefferyi) *is the largest land predator in the forest ecosystems of the Sierra Madre Mountains.*

# The Forests of Mount Irid-Angelo, Philippines

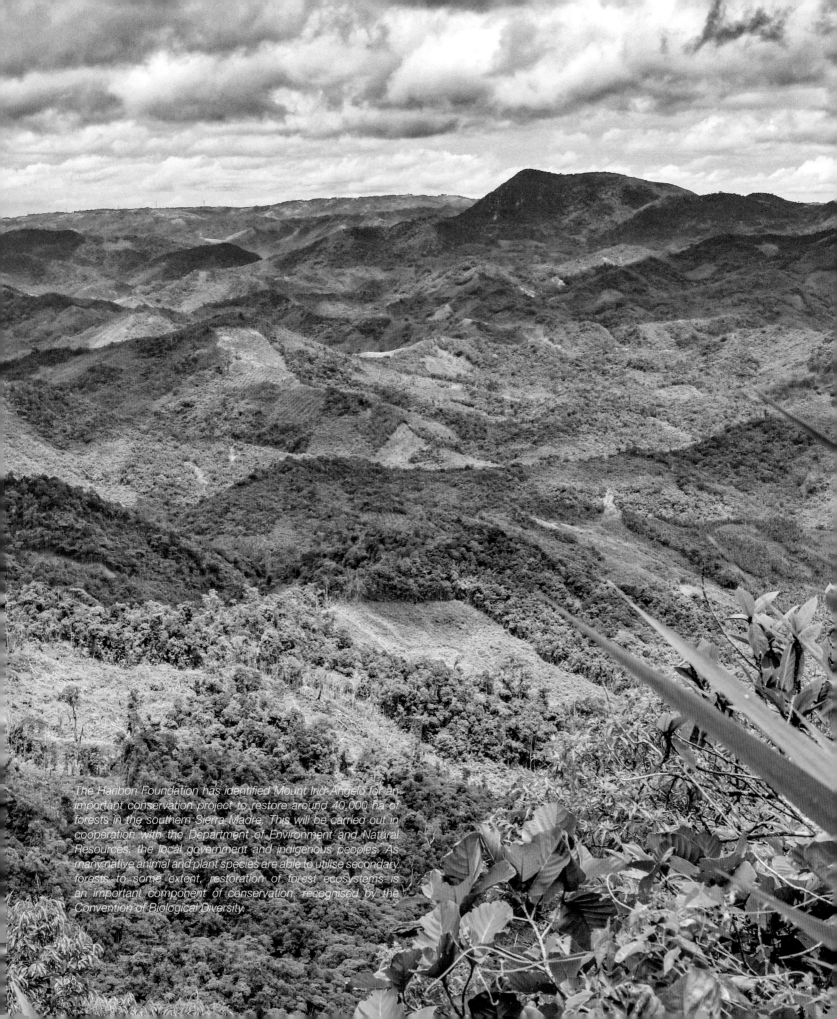

The Haribon Foundation has identified Mount Irid-Angelo for an important conservation project to restore around 40,000 ha of forests in the southern Sierra Madre. This will be carried out in cooperation with the Department of Environment and Natural Resources, the local government and indigenous peoples. As many native animal and plant species are able to utilise secondary forests to some extent, restoration of forest ecosystems is an important component of conservation, recognised by the Convention of Biological Diversity.

## Introduction

Luzon is the largest island in the Philippines and lies at the northern end of the Philippine archipelago. Unlike the adjacent islands of Taiwan and Japan to the north, Luzon has never been connected to continental Asia. As a result of its isolation, the island has seen the evolution and radiation of unique animal and plant species that can be found nowhere else in the world. As a whole, Luzon is so biologically distinct that BirdLife has classified it as an Endemic Bird Area in its own right.

The Sierra Madre is one of the three major mountain ranges on Luzon, which are collectively the most important areas for Luzon's endemic wildlife. Luzon also contains some of the most extensive areas of forests left in the Philippines, and is home to the Critically Endangered Philippine Eagle (Pithecophaga jefferyi).

Mount Irid and Mount Angelo are two mountains in the southern Sierra Madre inhabited by indigenous peoples of the Dumagat-Remontado tribe. The Dumagat make their living from subsistence agriculture and harvesting of forest products. Mount Irid-Angelo is located on the boundaries between the provinces of Bulacan, Quezon and Rizal, about 40 km north-east of Manila, the capital of Philippines. In spite of its proximity to the city, there are few roads going into these weathered mountains, which remain sparsely populated.

The forests of the Sierra Madre provide major ecosystem services for the fast increasing human population of Luzon Island. The southern Sierra Madre provides electricity through hydropower and forms an important water catchment area for Manila. A series of devastating landslides and floods in the past has convinced Filipinos that the loss of forest cover affects not just wildlife but also impacts people and infrastructure; hence, awareness of forest conservation is rising in Philippines.

▸ *The Philippines is an archipelago that consists of more than 7,000 islands with a land area of around 300,000 square km. Luzon is the largest of these islands with an area of about 105,000 square km.*

The mountains of Irid-Angelo consist of limestone rock covered with volcanic soil. Up to around 750 m above sea level, the forest has been widely logged and cleared for subsistence agriculture. There are some areas of regenerating lowland forest with a canopy height of up to 30 m. In these forests, canopy vines are common, including jade vines; *Rafflesia* sp. is common among ground vegetation in some locations. At around 1,100 m, the canopy is lower, at around 20 m, and limestone outcrops become extensive; lichens, ferns and orchids are also abundant. At 1,300 m, the canopy of the montane forest is low, averaging at 10 m. On the ground, ferns, sedges and ground orchids are commonly seen, while *Rafflesia* sp. can also be found at this elevation. Near the peak, at 1,469 m, one will find a sparsely vegetated karst landscape (Balete, D.S. and colleagues 2013).

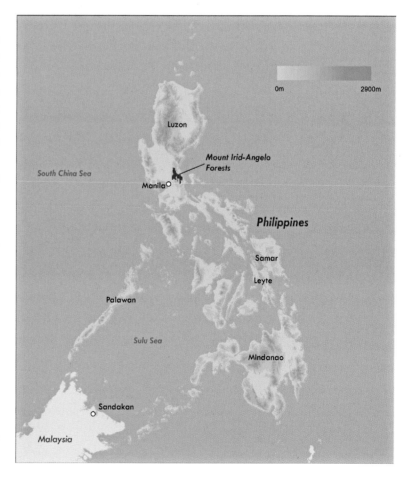

The Haribon Foundation is BirdLife International's partner in the Philippines. Haribon has been working on a major conservation project in the Mount Irid-Angelo Mountains Important Bird and Biodiversity Area (IBA), targeting an area of around 40,000 ha. This area has been legally gazetted under a special category promoting the restoration of degraded forest areas. Haribon has successfully assisted three local municipalities within the IBA to plan their land and water usage in a comprehensive and environmentally friendly manner.

Haribon has also partnered with local schools to strengthen public awareness on biodiversity conservation vis-à-vis local conservation policies. An IBA Monitoring System will be established in coordination with the local government and other key stakeholders. Thus far, there has been is strong local government support for biodiversity conservation, including forest restoration, and protection.

To engage local communities in conservation, educational activities have been planned, including a nature camp for high school students to learn about forest conservation. Indigenous communities have started to implement forest restoration practices, environmentally friendly vegetable gardens, organic farming and agroforestry activities.

Moving forward, the Haribon Foundation is developing a detailed conservation plan for the Mount Irid-Angelo area. This will involve an extensive process of environmental and socio-economic research, capacity building and participatory planning involving all the 19 districts in the municipality. The programme will also include forest management capacity enhancement of government staff and personnel of the Department of Environment and Natural Resources. Work to enhance the livelihoods of indigenous people will be undertaken at the same time.

The combination of high biodiversity in the area and domestic backing for sustainable forest management makes the project particularly exciting.

◀ *Keeping wild birds as pets is common in the rural areas; this juvenile* **Northern Rufous Hornbill** *(Buceros hydrocorax) was taken from the nesting hole two weeks before this photo was taken. Mortality is high and one of its siblings had already died.*

The forests of Mount Irid-Angelo are inhabited by the indigenous Dumagat people, who belong to the Agta-Negrito group. In the past, they lived in coastal areas. However, they were later pushed by development and Spanish colonisation of the Philippines from the lowlands into the mountains to live a semi-nomadic lifestyle. These days, they live in permanent settlements and make a living from hunting and gathering of forest products as well as subsistence farming, cultivating crops like cassava and in some cases rice. Some work as unskilled labourers for lowland farmers.

Deforestation, mining and illegal timber harvesting have marginalised the native Dumagat people. Hydro-electric dam projects have also displaced indigenous communities without providing equitable compensation and legal recognition of their ancestral land rights.

▸ *Many indigenous* **Dumagats** *have never attended school, but this is slowly changing and some of the younger generation are starting to get a formal education.*

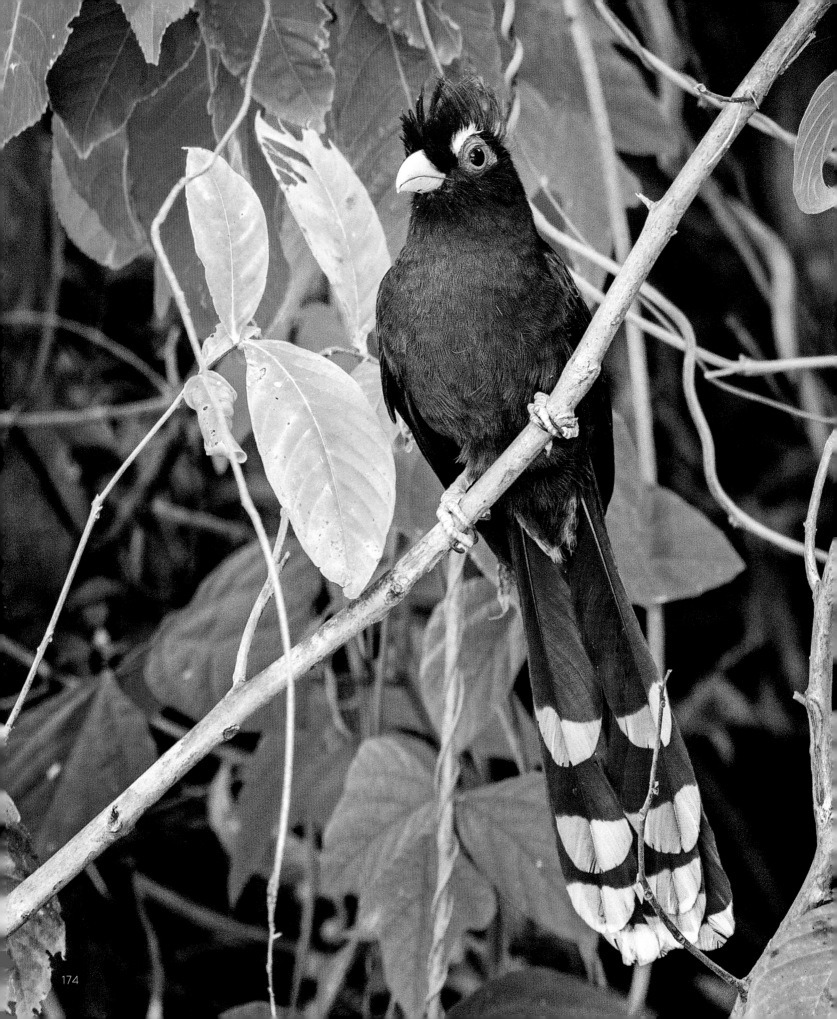

# Wildlife

The forests of Mount Irid-Angelo are not well surveyed and only a couple of studies on the area have been published. The Haribon Foundation conducted a preliminary survey of the area's biodiversity in 2007 and recorded 126 species of terrestrial vertebrates. Of these, 17 species are mammals, 88 species are birds and 21 species are reptiles and amphibians. Endemic species accounted for 54 per cent of the overall total. The floral survey identified 172 species of trees belonging to 52 families; 39 species were endemic to the Philippines.

The Field Museum of Natural History, Chicago and the National Museum of the Philippines conducted another survey in 2009. This study sampled the mammals of Mount Irid and documented 16 species of bats and eight species of non-volant small mammals. On top of that, some larger mammals were recorded, including the Philippine Brown Deer *(Cervus mariannus)*, Asian Palm Civet *(Paradoxurus hermaphroditus)*, Malay Civet *(Viverra tangalunga)*, Long-tailed Macaque *(Macaca fascicularis)* and Philippine Warty Pig *(Sus philippensis)*. All of these larger mammals are reported to be heavily hunted, resulting in low populations in the area (Balete, D.S. and colleagues 2013).

Interestingly, research suggests that biological diversity is not always richest in the tropical lowlands. This study concluded that, at least for mammals, species richness can increase with elevation. The diverse habitats on mountains along an elevational gradient allow for species radiation, leading to different co-occurring species on montane forests. For instance, Mount Irid (1,469 m) is home to five native species, whereas Mount Amuyao in the Central Cordilleras, at 2,710 m, is home to an impressive 13 mammal species (Heaney, L.R. and colleagues 2016).

◀ *The **Red-crested Malkoha** (Phaenicophaeus superciliosus) is common in the forests of Mount Irid-Angelo and is endemic to Luzon and a few adjoining islands (e.g. Polillo). It is most often seen singly or in small groups, foraging in dense foliage and making short flights from tree to tree.*

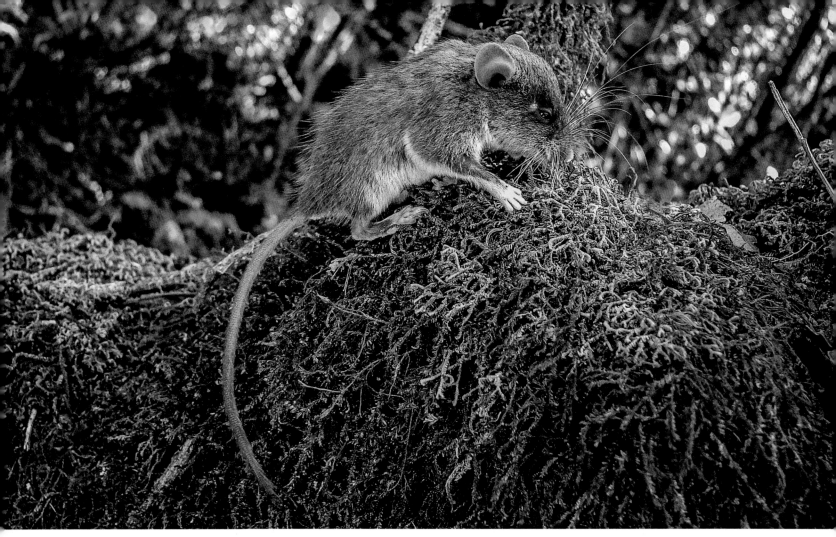

▲ The **Philippine Tree Mouse** (Musseromys inopinatus) was discovered at 2,300 m on Mount Amuyao in Luzon's Central Cordillera and only described for science in 2014. Specimens of this rodent were captured in different forest habitats at altitudes from 1,650m to 2,300 m. All individuals were trapped on branches from 0.5 m to 5 m above ground. The discovery of the Philippine tree mouse, among many other new mammal species is a testament to how poorly studied Luzon's mammals are (Heaney, L.R. and colleagues 2014).

### Luzon Island is a top hotspots for endemic mammals

The astonishing levels of endemism in the Philippine mammal fauna is further demonstrated by the recent discoveries of new species, predominantly from the island of Luzon. The majority of endemic small mammals on Luzon come from two rodent groups, one comprising mainly of ground-dwelling species called earthworm mice, and the second consisting of arboreal rodents known as cloud rats which feed on leaves and seeds.

According to a study of Luzon's biodiversity stretching 12 years, 52 out of 56 non-flying mammals are unique to the island and can be found nowhere else in the world: in other words, 93 per cent of all non-volant mammals are endemic. Out of the 56 species, half were discovered in the cloud forests of Luzon's mountains during the extended project. The study suggests that small mammal diversity in the Philippines is the result of speciation within the island from a few ancestral species, and not driven by repeated colonisation of Asian mainland species (Heaney, L.R. and colleagues 2016).

On isolated islands, where animals interact with few predators or competing species, they are eventually able to colonise new environments and over time evolve into distinct species. Luzon's mountainous areas and high mountain peaks are essentially 'sky island' habitats where isolation has promoted speciation over millenia.

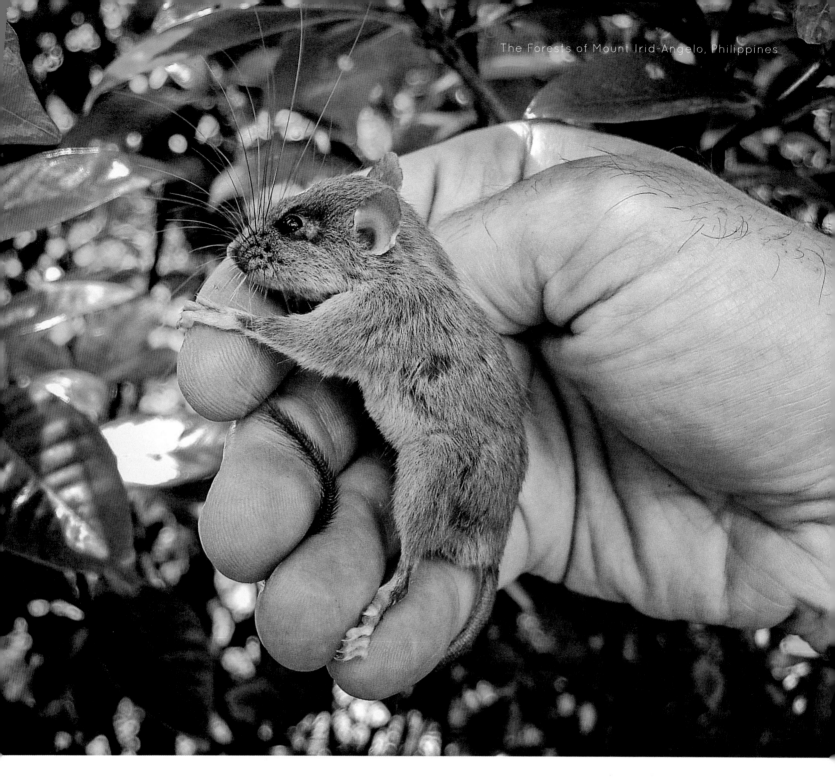

In 2014 the first mammal species endemic to Mount Irid, an earthworm mouse *(Apomys iridensis)* was discovered. This establishes the area as a localised centre of mammalian endemism. Only a few mountains on Luzon with an elevation below 1,600 m are known to support an endemic non-flying mammal. Mount Irid is isolated from other mountainous areas on Luzon by lowlands under 200 m elevation, which poses a substantial barrier to the movement of many non-flying mammals (Heaney, L.R. and colleagues 2014)

▲ *This is the holotype of the tiny* **Banahaw Tree-mouse**, *(Musseromys gulantang), which occurs only on Luzon and weighs a miniscule 15 g. It is related to the better known 'giant cloud rats', which can weigh up to 2.6 kg. This adult male was captured on 12 May in 2004 in regenerating lowland rainforest on the southern lower slopes of Mount Banahaw, which is located only 80 km southwest of Manila.*

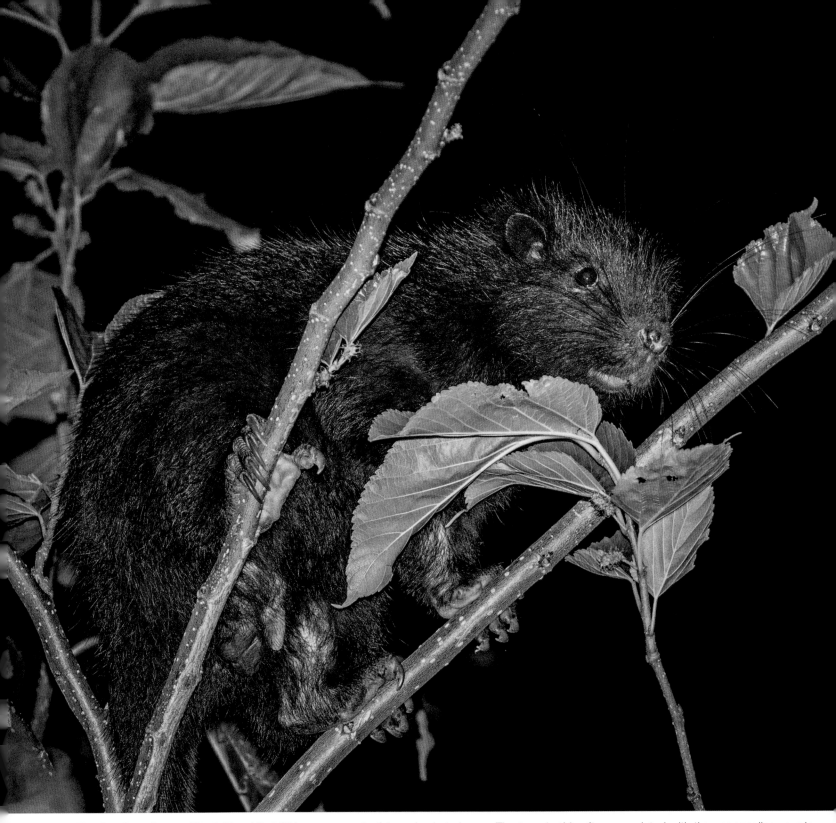

▲ The **Southern Luzon Giant Cloud Rat** (Phloeomys cumingi) *is endemic to Luzon. The term 'rat' is often associated with the unappealing vermin in the genus* Rattus. *However, this giant cloud rat sports an endearing look with its chubby face, beady eyes and thick dark brown fur. This very large cloud rat grows up to a total length of 75 cm and can weigh up 2.1 kg. It is nocturnal and nests in hollow trees such as strangler figs. The Southern Luzon Giant Cloud Rat forages mostly in trees for flowers and young leaves.*

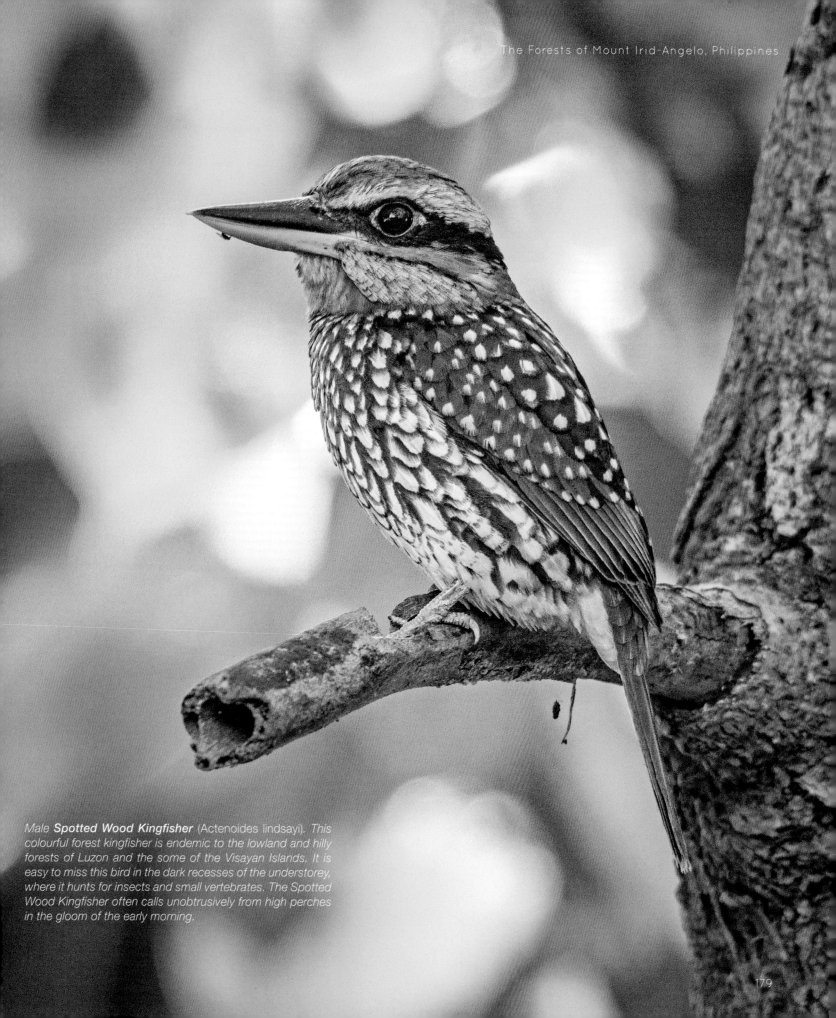

Male **Spotted Wood Kingfisher** (Actenoides lindsayi). This colourful forest kingfisher is endemic to the lowland and hilly forests of Luzon and the some of the Visayan Islands. It is easy to miss this bird in the dark recesses of the understorey, where it hunts for insects and small vertebrates. The Spotted Wood Kingfisher often calls unobtrusively from high perches in the gloom of the early morning.

▶ The **Whiskered Pitta** (Pitta kochi) *is the largest pitta occurring in the Philippines. It is classified as Near Threatened and is endemic to Luzon, where it can be found across much of the Sierra Madre mountains, including Irid-Angelo. It inhabits montane and sub-montane evergreen forests, often in areas with dense undergrowth mostly above 1,000 m. It has been observed to feed on invertebrates in areas where the soil has been disturbed by wild pigs. The Whiskered Pitta spends much of its life on the forest floor, only flying up to low branches to roost at night.*

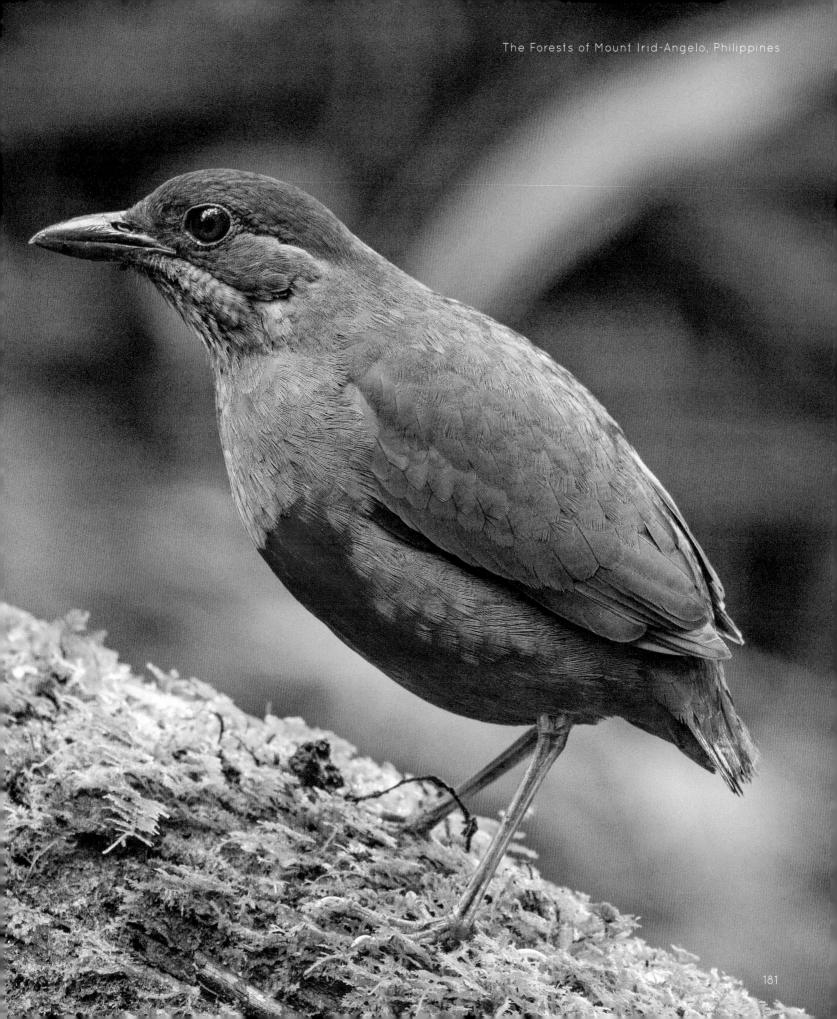

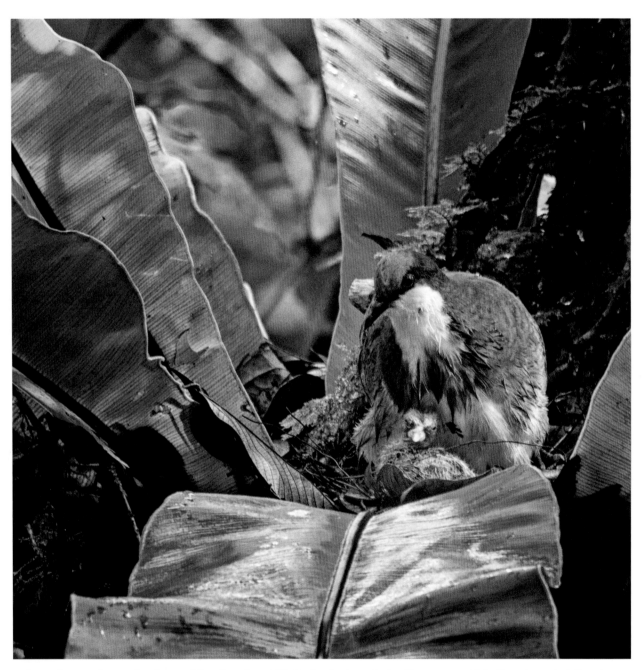

▲ *A rare image of a nesting **Luzon Bleeding-heart** (Gallicolumba luzonica) with a young chick. The characteristic crimson red spot on the breast which resembles a bloodstain is striking. This species is endemic to the island of Luzon and some smaller neighbouring islands. It can be found in virgin or secondary forests at altitudes of up to 1,400 m above sea level. It is often observed walking on the forest floor where it forages quietly for seeds, fruits and larvae in the leaf litter. The Luzon Bleeding-heart is enigmatic and hard to find in its natural habitat, but is sought after by the pet trade because of its plumage. It is classified as Near Threatened by the IUCN.*

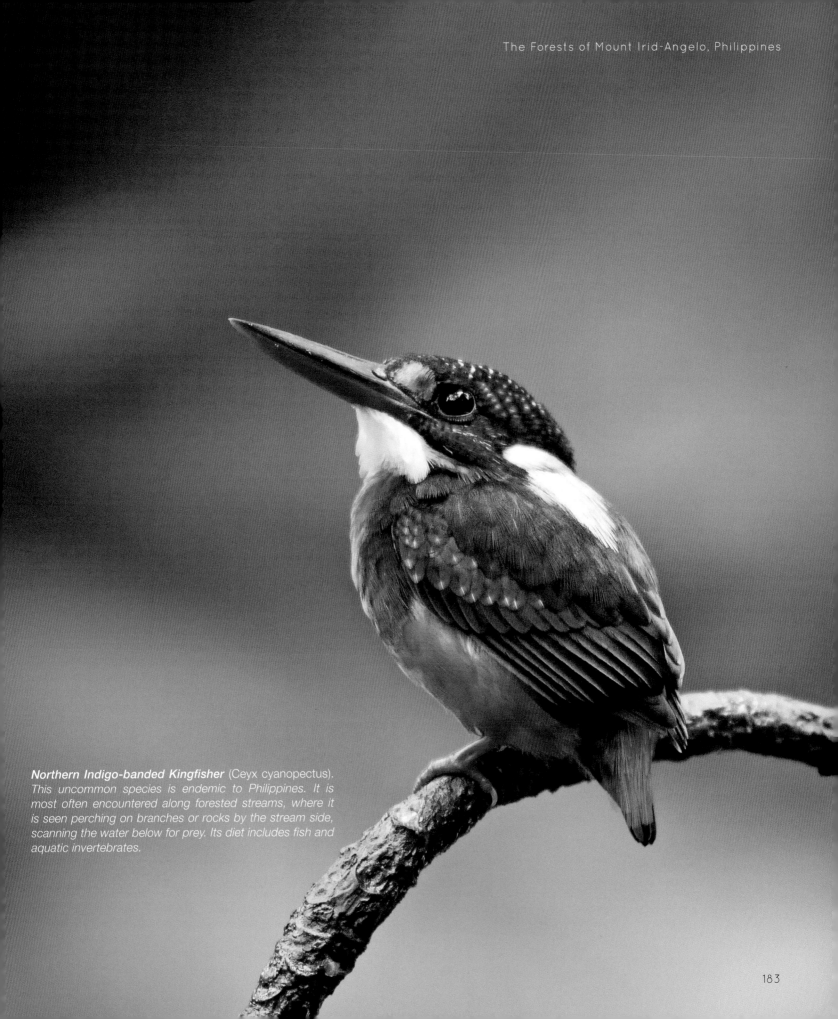

**Northern Indigo-banded Kingfisher** (Ceyx cyanopectus). *This uncommon species is endemic to Philippines. It is most often encountered along forested streams, where it is seen perching on branches or rocks by the stream side, scanning the water below for prey. Its diet includes fish and aquatic invertebrates.*

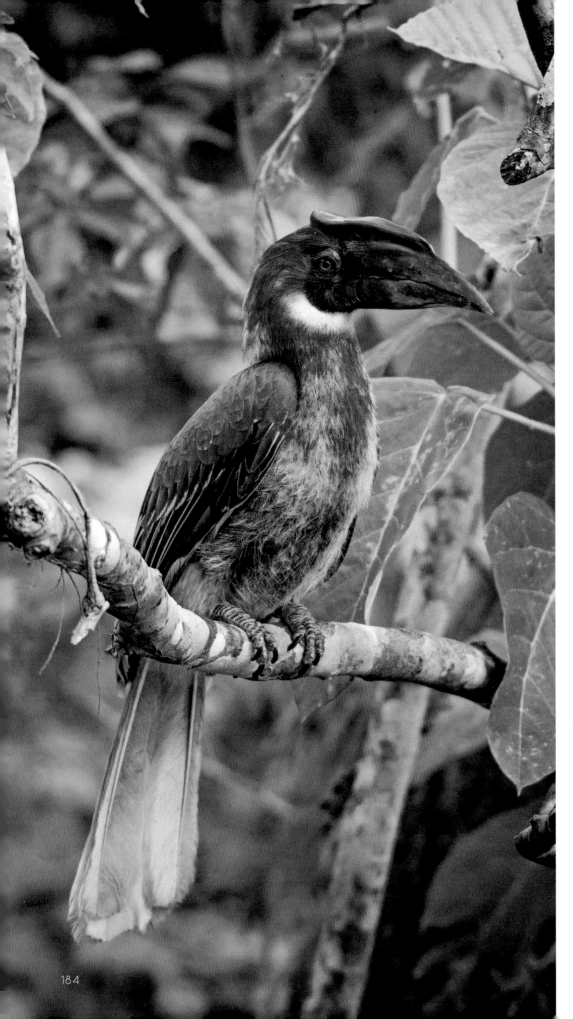

◀ Juvenile **Northern Rufous Hornbill** (Buceros hydrocorax). *This species is the largest of the hornbills in Philippines, with a total length of up to 100 cm. It is found in large tracts of primary forest and mature secondary forest up to 2,100 m in elevation. The Northern Rufous Hornbill forages in the canopy of tall trees, where it feeds on fruits, seeds and figs and occasionally invertebrates.*

*Classified as Vulnerable, the Northern Rufous Hornbill is dependent on large forest trees for nesting, which in turn are particularly vulnerable to loggers. It is also hunted for food and for the ornamental use of its feathers and casques.*

▲ The **Lowland White-eye** (Zosterops meyeni) *is endemic to the northern islands of the Philippines. Common in the lowlands, it can be found in secondary forests, scrubland and even suburban gardens. It is often noisy and conspicuous, and seen in groups or mixed flocks.*

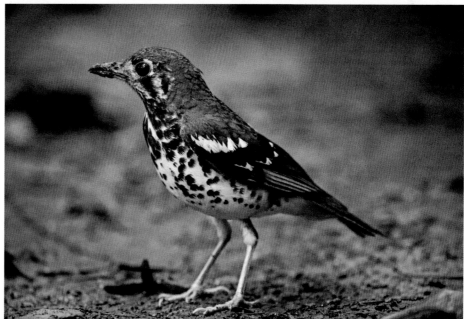

▶ **Ashy Thrush** (Geokichla cinerea). *This secretive species is best seen in the early morning working the leaf litter for invertebrates in the dim areas of the forest. It occurs in secondary and primary forests from the lowlands to up to 1,100 m in the Sierra Madre, where the population may suffer from localised hunting pressures. An endemic to Luzon and Mindoro, the Ashy Thrush is classified as Vulnerable and considered an uncommon species by ornithologists.*

185

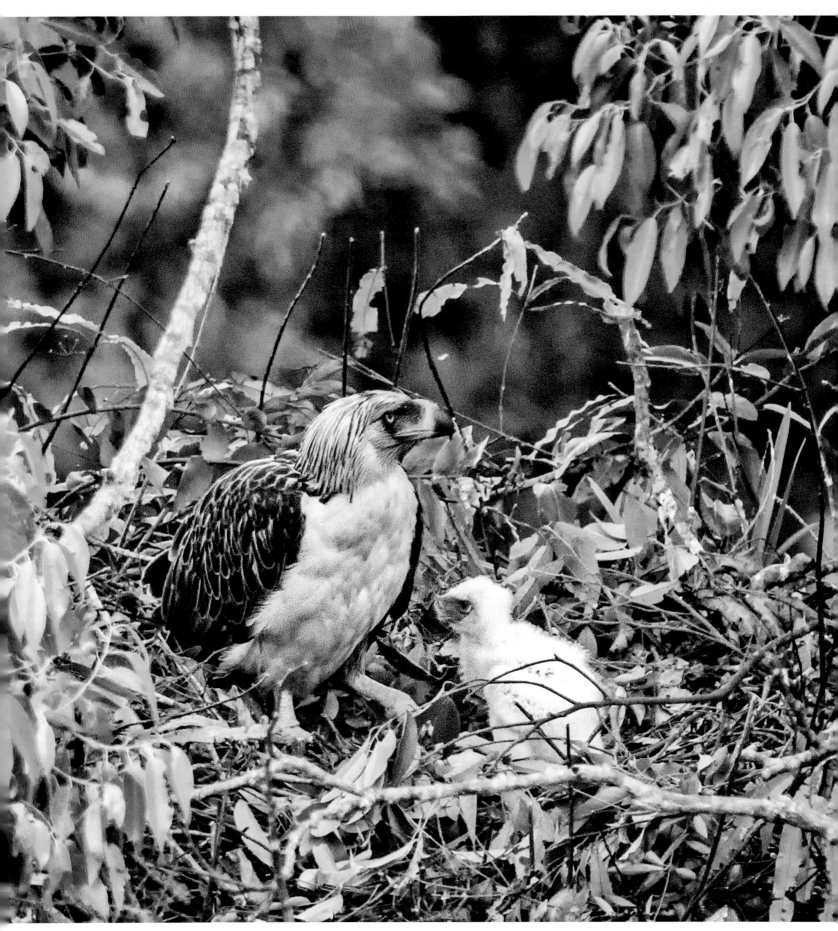

# Philippine Eagle (Pithecophaga jefferyi)

The English naturalist and explorer John Whitehead is frequently associated with Borneo and less so with the Philippines despite his many scientific discoveries there. In May 1896, soon after his arrival at Bonga in the mountainous interior of Samar Island, Whitehead saw a massive eagle which he had not seen during his previous visit. A couple of weeks later, his servant Juan brought him a male specimen.

William R. Ogilvie-Grant, who described the species in December 1896, declared the discovery of the Philippine Eagle as 'the most remarkable of Mr. Whitehead's achievements in the Philippine Islands'. In the description of the species, Ogilvie-Grant named this massive eagle as Pithecophaga jefferyi. Whitehead, whose name at the time had been honoured in bird names some nine times, requested that this magnificent bird be named after his father, Jeffery, who had bankrolled his explorations (Collar 1996).

The Critically Endangered Philippine Eagle is the national bird of Philippines and the top predator of the archipelago. With a total length of just over 100 cm, it is one of the largest eagles in the world. It is also one of the most threatened birds of prey. This eagle is endemic to the Philippines and can be found on the islands of Luzon, Samar, Leyte and Mindanao. Although it has been regularly observed in the Sierra Madre mountains, it has only been recently discovered in Luzon's Central Cordilleras. Most of the scientific studies have been conducted on the island of Mindanao where the highest number of eagles resides. According to the IUCN, no more than 250 pairs are left in the wild.

Like many predators, the Philippine Eagle is an opportunistic hunter, taking prey based on its local level of abundance and ease of being caught. Mammals dominate the diet. Some of the top prey items based on studies in Mindanao are the Philippine Flying Lemur (Cynocephalus volans), the Common Palm Civet (Paradoxurus hermaphroditus) and the Mindanao Flying Squirrel (Petinomys crinitus). All of these mammals are arboreal and nocturnal; they are thus more vulnerable to predation by the eagle when they rest in the day. The diet of the Philippine Eagle remains poorly known in Luzon, but may include the large cloud-rats.

In terms of body mass, the Long-tailed Macaque (Macaca fascicularis) is among the largest prey item in the diet of the eagle, which may differ from island to island. Eagle pairs have been observed hunting together when targeting monkeys, with one bird perching nearby to attract the attention of the primates, allowing the other one to go in for the kill from a different direction. This is why it is also known as the Monkey-eating Eagle.

Rainforest destruction and fragmentation is the primary threat to the eagle. However, the increasing human population of the Philippines is also putting pressure on many remaining forested areas through slash-and-burn cultivation activities pursued by landless migrants.

◄ The **Philippine Eagle** lays only one egg every second year, mostly between September and November. The bulky nest is normally built high in the canopy of the largest trees on big horizontal branches. On the island of Mindanao, which supports the largest populations of Philippine Eagles, nesting sites are sometimes in the vicinity of settlements indicating some tolerance of human presence.

The male and the female share duties in incubating the egg and caring for the chick. The female spends more time incubating the egg while the male does the majority of the hunting during the nesting period. The chick is closely guarded and looked after for up to 50 days. From then on, the male and female search for food, sharing it with the eaglet. It takes two years for the parent birds to raise the chick to adulthood.

The Philippine Eagle Foundation in Davao City, Mindanao manages an important captive breeding programme for the species. The aim is to establish a reintroduction programme, while simultaneously monitoring the wild population. An impressive 27 captive bred eagles have been raised up to now. These eagles will either be released in the wild or retained at the centre for breeding purposes.

In the central Sierra Madre, the Haribon Foundation is working together with indigenous people, local and national government units for the establishment of protected areas for the Philippine Eagle in Mount Mingan, Luzon Island.

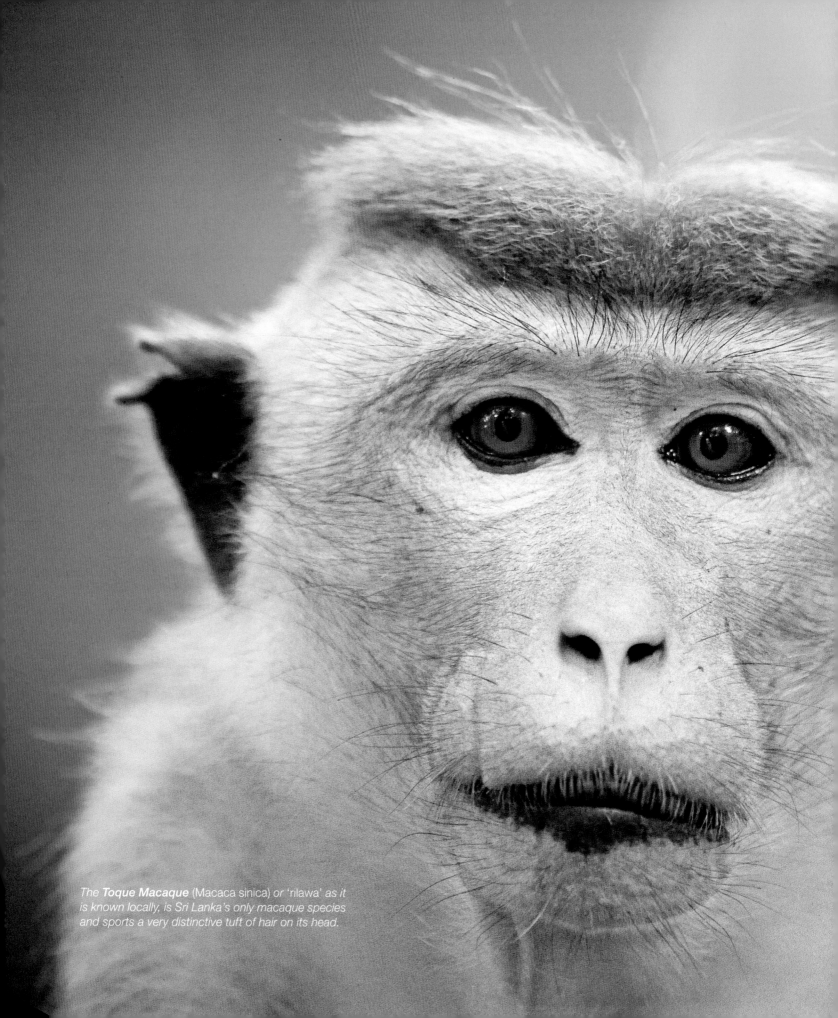

The **Toque Macaque** (Macaca sinica) or 'rilawa' as it is known locally, is Sri Lanka's only macaque species and sports a very distinctive tuft of hair on its head.

# The Forests of
# Sinharaja, Sri Lanka

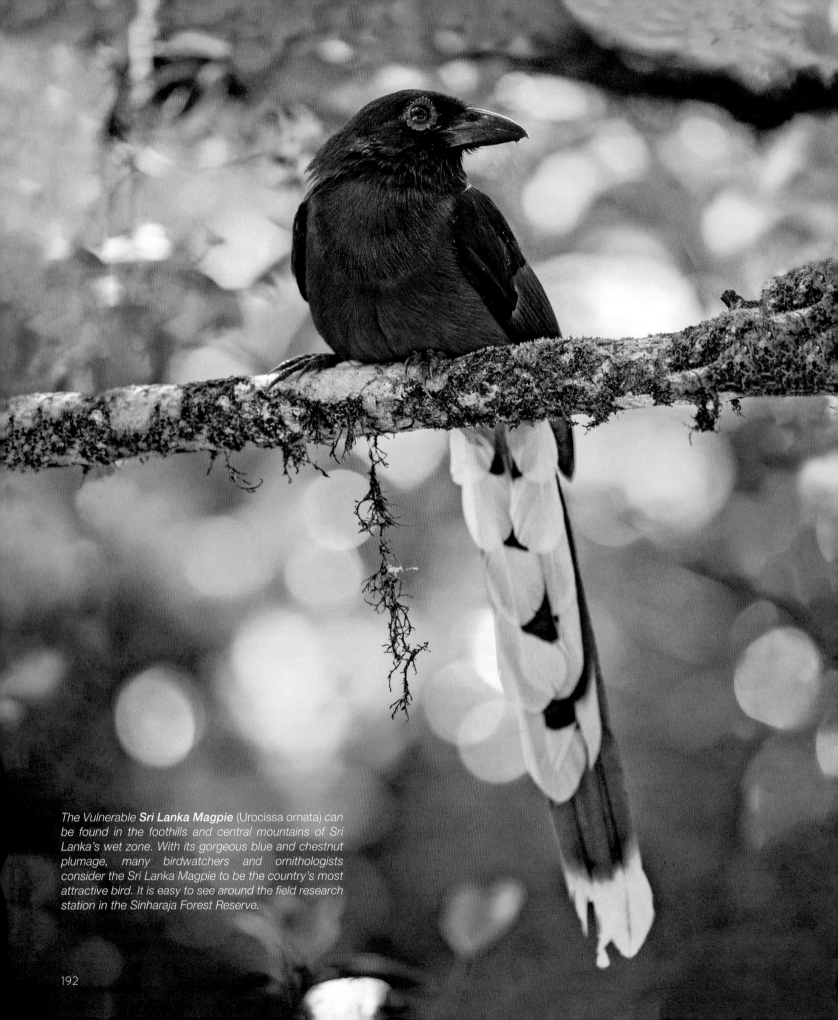

The Vulnerable **Sri Lanka Magpie** (Urocissa ornata) *can be found in the foothills and central mountains of Sri Lanka's wet zone. With its gorgeous blue and chestnut plumage, many birdwatchers and ornithologists consider the Sri Lanka Magpie to be the country's most attractive bird. It is easy to see around the field research station in the Sinharaja Forest Reserve.*

## Introduction

Sri Lanka, formally called Ceylon, is located southeast of India. This small island nation has a land area of 65,525 square km and a population of just over 20 million. Much of the island is low lying and flat apart from the south-central hill country. There are three topographic zones, the central highlands, the plains, and the coastal belt, which are distinguished by elevation. Sri Lanka's plains are characterised by its dissected appearance created by the Uva Basin with rolling hills, traversed by deep valleys and gorges in the east. The ridges and valleys that rise here gradually merge to form the Central Highlands in the south-west.

Two centuries ago, virtually the whole island was covered by natural vegetation. However, conversion to tea, coconut and rubber plantations, rice paddies and human settlements has decimated the Sri Lankan forests, which now cover less that 30 per cent of the land area.

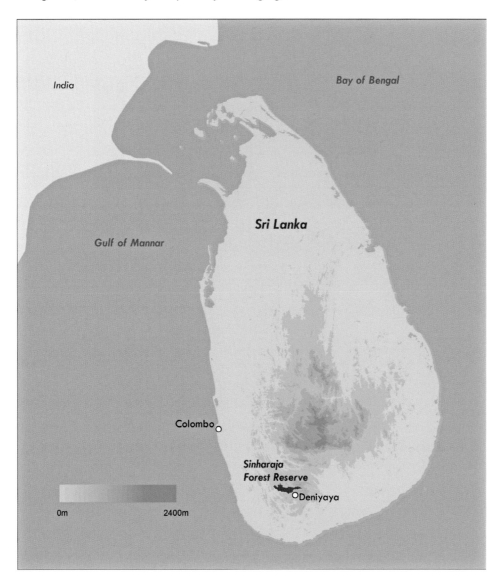

The wet zone forests of Sri Lanka, more specifically those in the hill country, provide a distant link between the rainforests of Asia and Africa, because of their origins in the ancient supercontinent of Gondwanaland. The later connection with the Asian mainland enabled Eurasian species to colonise the island during periods when land bridges exposed during lower sea levels linked Sri Lanka with the rest of India.

Fossil evidence of Asiatic Lions has been found in Sri Lanka, suggesting that lions once roamed the landscape, but disappeared before modern humans arrived. However, despite the many subsequent land connections with India since the original split, the rainforest and its biota became increasingly isolated. As climatic conditions changed and species were marooned on this island, new species gradually evolved.

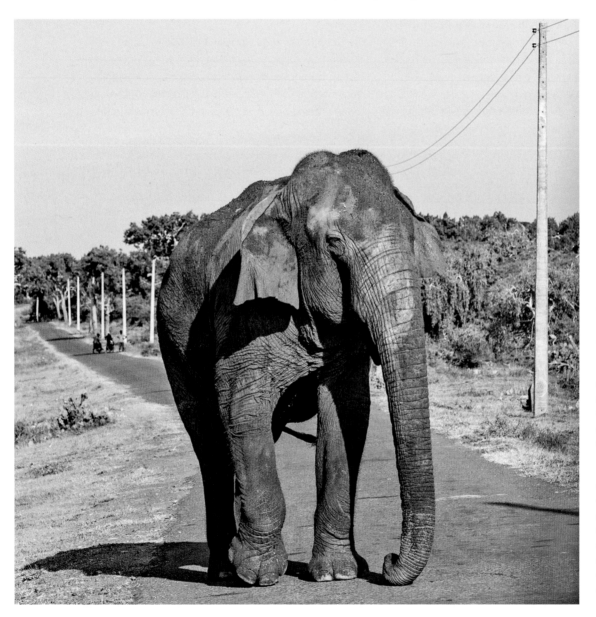

◄ *Sri Lanka is the range country with the highest density of the Endangered* **Asian Elephants** *(Elephas maximus maximus). The island supports a relatively dense human population, which has driven the conversion of elephant habitat to human landscapes, thus sowing the seeds of human-animal conflicts.*

*Of the approximately 6,000 elephants in Sri Lanka, around 4,000 are found within protected areas leaving 2,000 individuals outside of national parks. Only a handful of elephants are left in the inaccessible eastern parts of the Sinharaja rainforest (Fernando, P. pers. comm. 2016).*

Sri Lanka's lowland rainforests are found in the southwestern parts of the island, where the warm tropical climate provides optimal growth conditions for many species of plants. The soil in rainforests often contains little accumulation of organic matter. In most cases, this can be attributed to climate and an efficient microflora in the soil breaking down the organic matter into nutrients which are then quickly reabsorbed by the rainforest trees. This is why, when converted to agriculture, the soil on former rainforest areas becomes impoverished of essential nutrients within a very short period.

Interestingly, the trees in the rainforest often have very shallow roots running close to the ground surface, where much of the nutrients are concentrated. The tree trunks are therefore supported by plank buttress roots, a characteristic of large rainforest trees. In Sinharaja, however, buttresses are relatively scarce in comparison to Southeast Asian rainforests.

According to Conservation International, India's Western Ghats and Sri Lanka form one of the planet's 35 Biodiversity Hot Spots.

Conserving the island's tropical rainforests is vital for preserving its biodiversity. Unfortunately, only a small fraction of Sri Lanka's lowland rainforest is left. Some estimates are as low as 750 square km, even when badly logged areas are included. Today, the Sinharaja Forest Reserve represents the most intact lowland rainforest left in Sri Lanka in the southwest wet zone (Wijeyeratne, G.S. 2007).

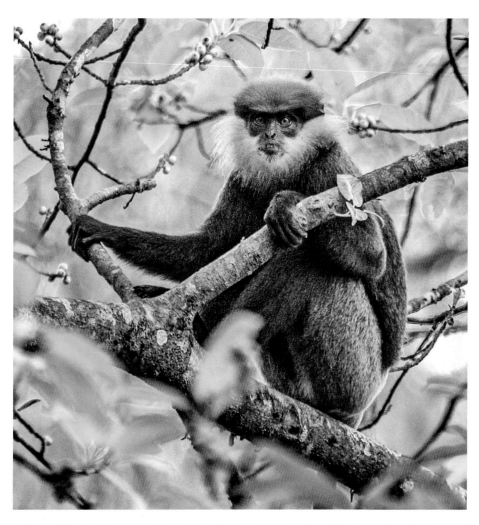

▲ *One of the iconic mammal species which can be found in Sinharaja is the Endangered* **Purple-faced Leaf Monkey** (Semnopithecus vetulus)*, which is endemic to Sri Lanka. One of the island's four subspecies of this langur, the Western Purple-faced Leaf Monkey (ssp.* nestor) *is on the list of the world's 25 most endangered primates.*

*The Purple-faced Leaf Monkey is a predominantly folivorous species, but at the same time it will also consume fruits and flowers; it prefers immature leaves because of the higher protein content, but its dietary composition is highly dependent on the seasonal availability of food plants.*

# Sinharaja Forest Reserve

In the 1970s, Sinharaja was rescued from a controversial logging project mainly aimed at the commercial production of plywood for furniture. This conservation victory was attributed to a group of local and overseas-based environmentalists, local non-government organisations and scientists. They were able to convince the government that the benefits of protecting this remarkable rainforest far outweighed the short term commercial gains.

In 1978, part of Sinharaja was declared a Man and Biosphere Reserve (MAB) and ten years later it was finally inscribed on the UNESCO'S World Heritage list. It is estimated that more than half of Sinharaja's tree species are endemic; among the *Dipterocarpaceae*, the trees dominating the Sinharaja forest canopy, endemism reaches more than 90 per cent. Around 80 orchid species have been recorded from Sinharaja, of which 40 per cent are endemic to the country.

The majority of Sri Lanka's 30-odd endemic bird species can be found here; the protected area is arguably one of the best places in Sri Lanka for birdwatching. The tropical rainforests of Sinharaja are also home to more than half of Sri Lanka's endemic mammal species, and many of its herpetofauna species are highly localised endemics.

Sinharaja is probably the most thoroughly explored site for biodiversity in Sri Lanka: several long and short term studies have been conducted on plants, several species of birds, butterflies, dung beetles, amphibians and small mammals. Some of the best known studies on the phenomena of mixed foraging bird flocks are based on research carried out in Sinharaja.

◄ *The last major remnant of **Sri Lanka's lowland rainforest**, Sinharaja, is home to at least 139 endemic plant species within two main types of forest:* Dipterocarpus-*dominated forest in the valleys and on the lower slopes, and secondary forest and scrub where the original forest cover has been removed.*

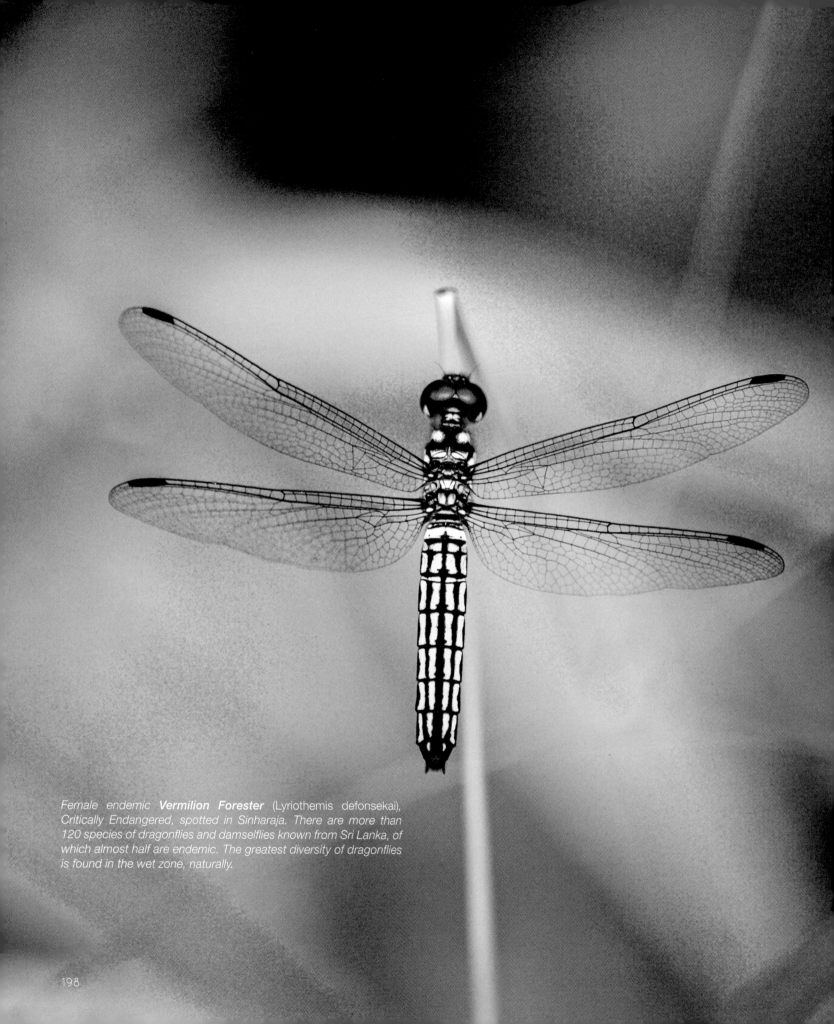

*Female endemic **Vermilion Forester** (Lyriothemis defonsekai), Critically Endangered, spotted in Sinharaja. There are more than 120 species of dragonflies and damselflies known from Sri Lanka, of which almost half are endemic. The greatest diversity of dragonflies is found in the wet zone, naturally.*

◀ The endemic **Sri Lanka Two-spotted Threadtail** (Elattoneura oculata) *is classified as Endangered. It is only known from a few locations in the southwestern and central parts of the island, where it is restricted to small streams and springs in the rainforest. This specimen was seen in Sinharaja.*

◀ *The Vulnerable* **Nepenthes distillatoria** *is endemic to the island and the only* Nepenthes *species in Sri Lanka. It was the second* Nepenthes *species to be formally described, and was designated the type species of the genus. This upper pitcher was seen in a mess of ferns on the roadside in Sinharaja.*

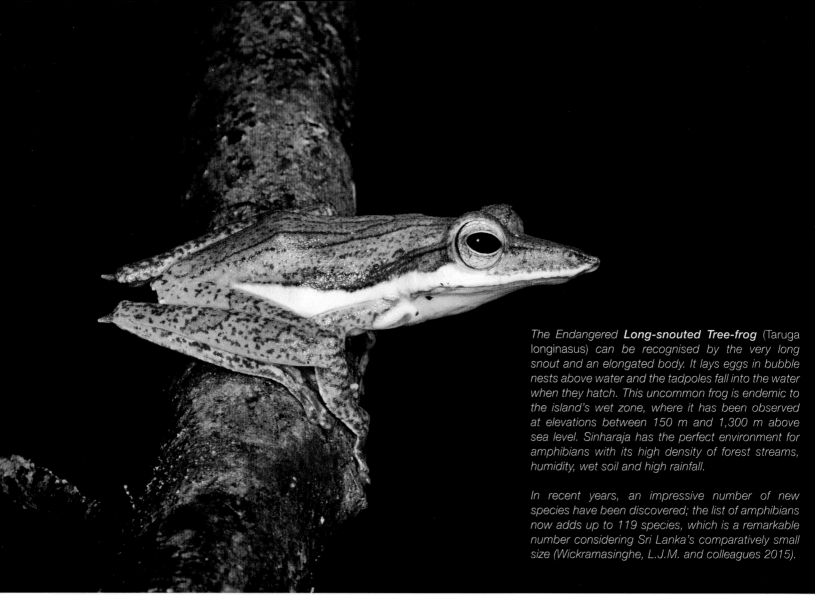

The Endangered **Long-snouted Tree-frog** (Taruga longinasus) *can be recognised by the very long snout and an elongated body. It lays eggs in bubble nests above water and the tadpoles fall into the water when they hatch. This uncommon frog is endemic to the island's wet zone, where it has been observed at elevations between 150 m and 1,300 m above sea level. Sinharaja has the perfect environment for amphibians with its high density of forest streams, humidity, wet soil and high rainfall.*

*In recent years, an impressive number of new species have been discovered; the list of amphibians now adds up to 119 species, which is a remarkable number considering Sri Lanka's comparatively small size (Wickramasinghe, L.J.M. and colleagues 2015).*

◀ *The endemic* **Sri Lankan Kangaroo Lizard** (Otocryptis weigmanni) *is most often seen in the leaf litter feeding on insects and grubs. When threatened, it will rise on its well-developed hind legs and run for cover; this unique ability is also the reason for its common name. The Kangaroo Lizard was described by the noted German herpetologist Johann Wagler, and named for his colleague, Arend F. Weigmann.*

▶ *Like other malkoha species, the distinctive* **Red-faced Malkoha** (Phaenicophaeus pyrrhocephalus) *favours the upper canopy in undisturbed forests. It is endemic to Sri Lanka and found mainly in the forests of the wet zone. Red-faced Malkohas usually forage in pairs, but are also regular participants in mixed-species flocks. Its diet consists primarily of large insects such as grasshoppers and cicadas, but also includes berries and fruits. It is classified as Vulnerable by the IUCN.*

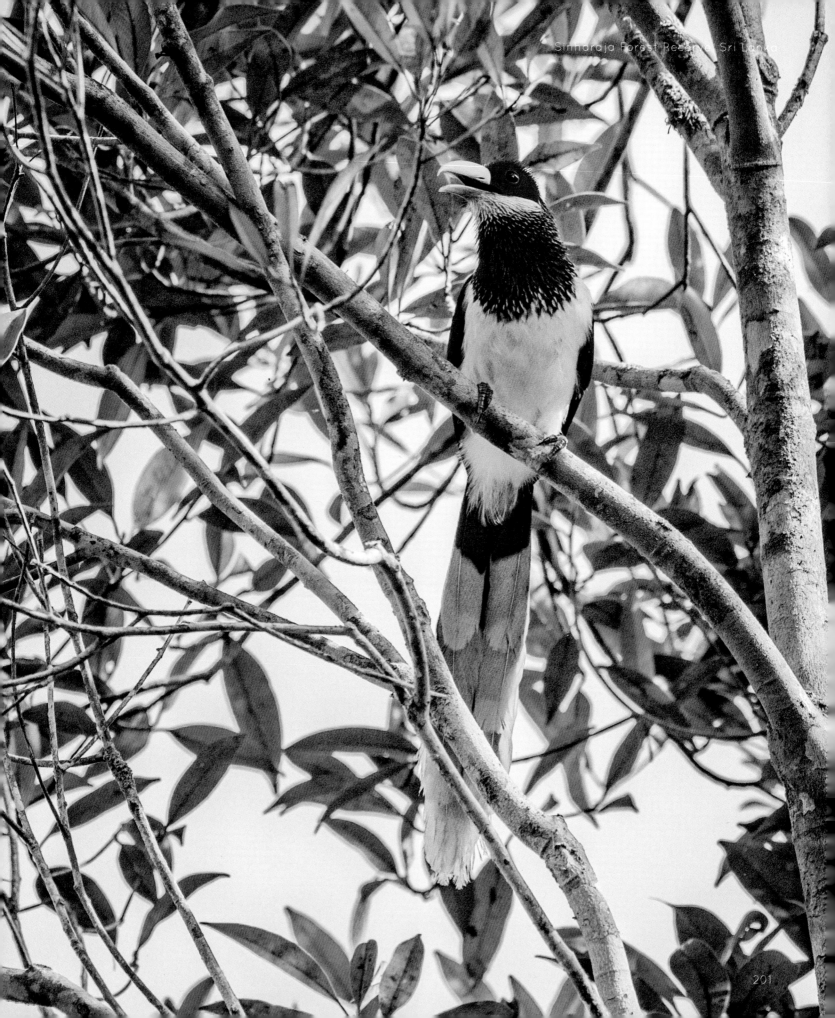

▶ *The Vulnerable* **Green-billed Coucal** *(Centropus chlororhynchos) is endemic to Sri Lanka and restricted to the lowland forests of the wet zone. It is associated with forests with dense undergrowth and stands of the bamboo Ochlandra stridula. BirdLife International estimates that the population is no more than a few thousand individuals.*

*This elusive bird forages for frogs, lizards, snails, worms and fruits on the ground and low trees, making short flights as it moves from point to point in low, dense vegetation. Both parents participate in the nest building and feeding of the chick. The nest is roughly 60 cm tall and 45 cm wide with a entrance hole on the side (Wijesinghe, M. 1999).*

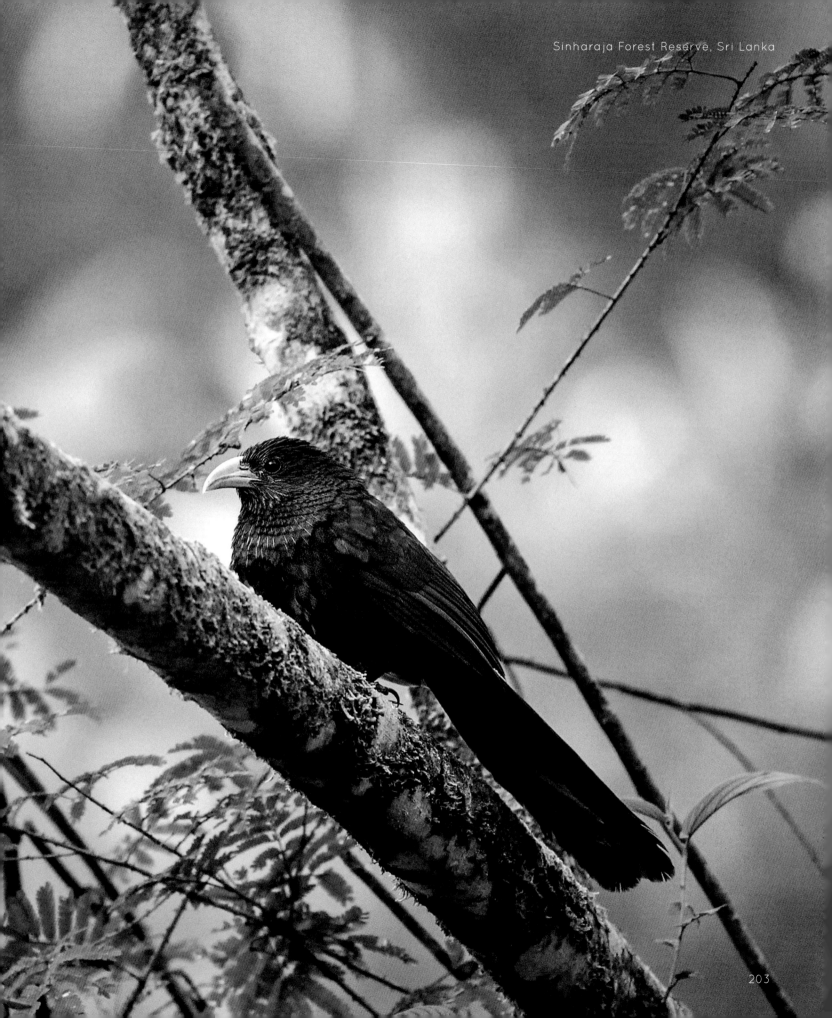

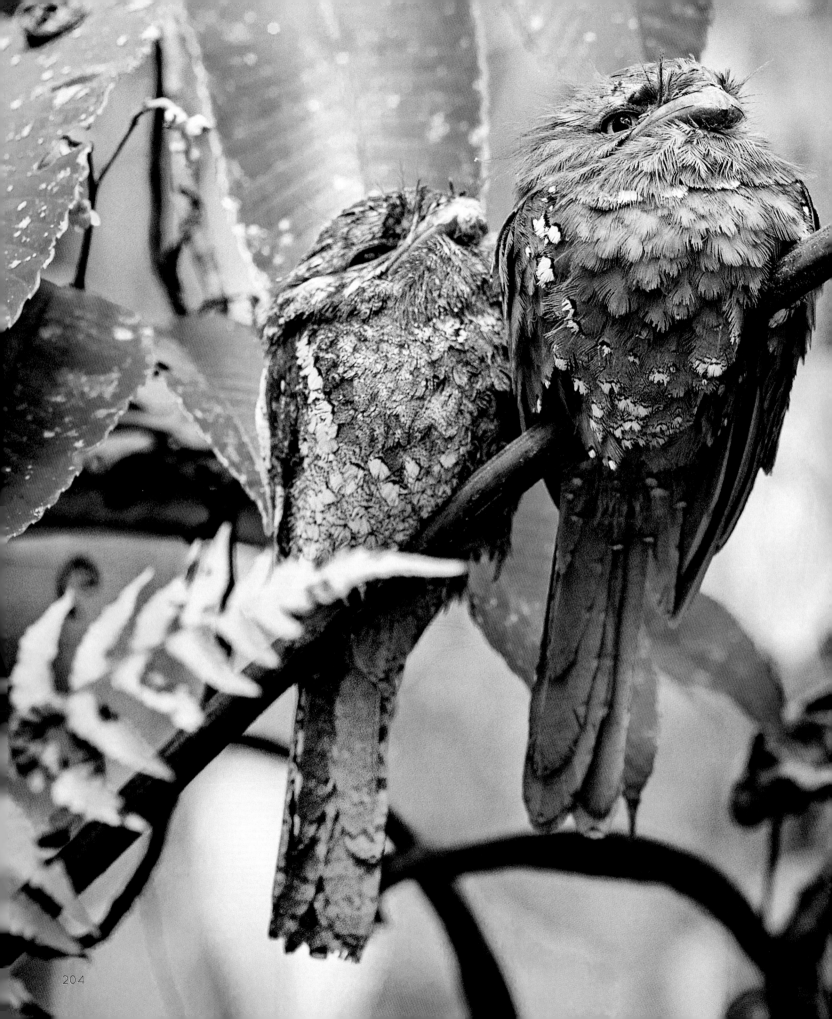

◀ *Shown here is a pair of **Sri Lanka Frogmouth*** (Batrachostomus moniliger). *This small and distinctive frogmouth grows to about 23 cm in length, and is endemic to Sri Lanka and the Western Ghats of peninsular India. It inhabits wet tropical forests, often in areas with dense undergrowth. A nocturnal species, it hunts insects with its broad hooked bill. The Sri Lanka Frogmouth is the only frogmouth in the Indian subcontinent outside of north-east India.*

205

▲ The Vulnerable **Sri Lanka White-faced Starling** (Sturnus albofrontatus) *is endemic to the wet zone forests. The fragmented population is declining and numbers no more than a few thousand mature individuals. The high-pitched whistles alerted us to this pair feeding in an African Tulip Tree* (Spathodea campanulata), *an invasive species native to the tropical forests of Africa.*

▸ *This group of young* **Ashy-headed Laughingthrush** (Garrulax cinereifrons) *was observed in the buffer zone of Sinharaja Forest Reserve, which is one of their strongholds.*

*The species is found in higher densities in selectively logged forests than in the unlogged forest. It usually forages for insects in flocks, sometimes mixed with other species. Ashy-headed Laughingthrushes are noisy birds, and their laughing calls are the best indicator of their presence, as they are difficult to see in the dense rainforests. According to the IUCN, it appears never to have been abundant and current numbers are probably not more than a few thousand mature individuals, restricted to the forests of the wet zone. It is currently classified as Vulnerable.*

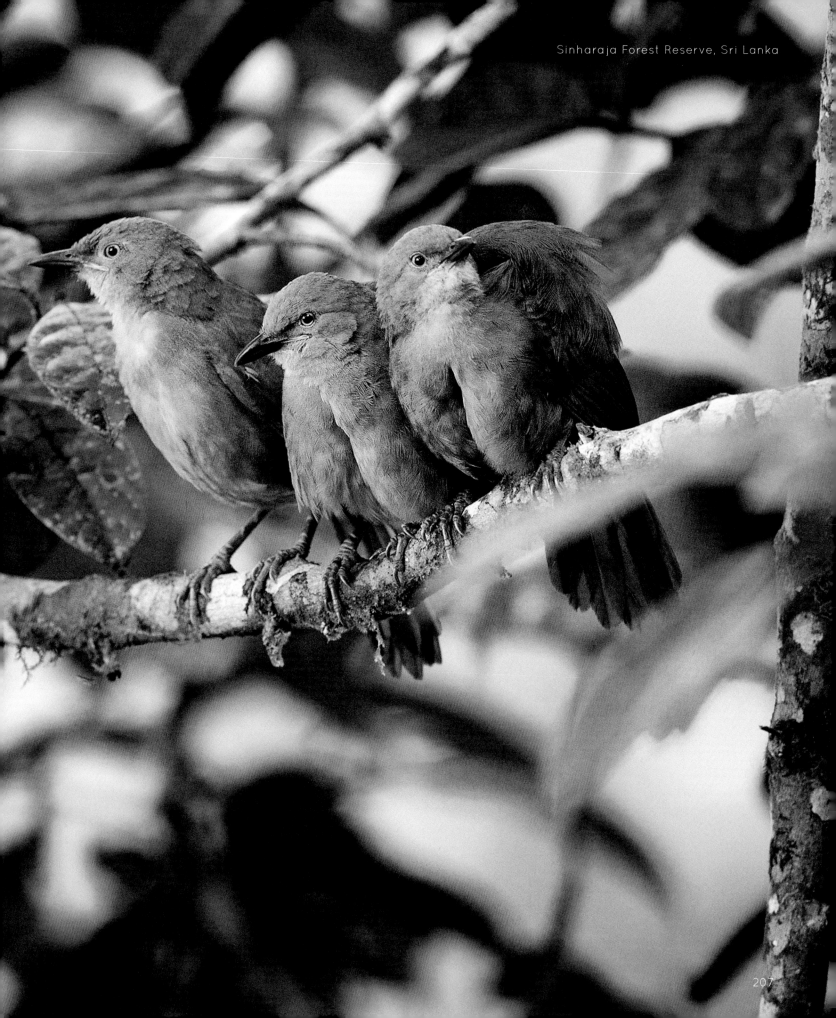

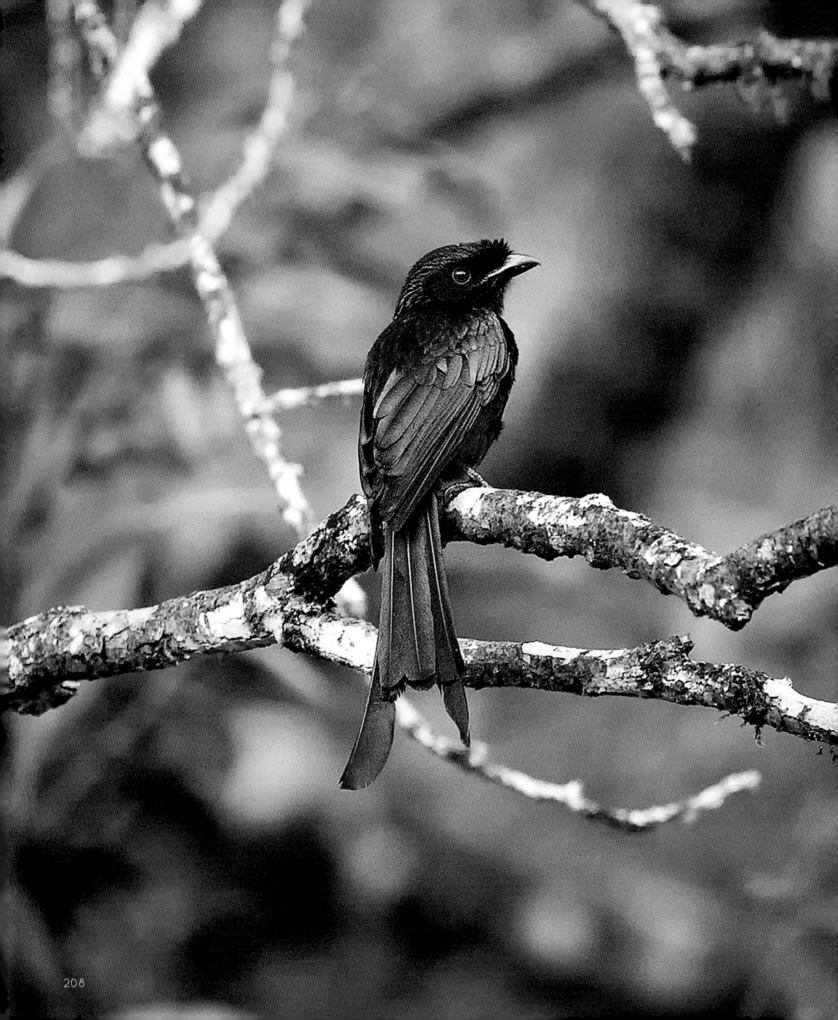

## The Sinharaja Bird Wave

Ask any person if he knows what a 'bird wave' is and he will most likely shake his head. However, if one puts the same question to a birdwatcher, his face will most probably light up; you may even get a couple of bird wave stories at the same time.

A bird wave, more accurately known as a mixed feeding flock, consists of two or more species feeding and moving through the forest together; these bird waves are a common phenomenon in many parts of the world. In the Sinharaja rainforest, bird waves can be a spectacular sight, as they can include up to a dozen different species; many flocks consist of more than 35 birds. In some cases, researchers have observed groups of over one hundred individuals.

In many situations, birds waves may only last for a few minutes. In Sinharaja, the duration of a bird wave may last up to half an hour or even longer. Sinharaja's feeding parties of birds have been the focus of one of the longest running ornithological studies. Research dating back to 1981 has examined the behaviour of bird flocks, with much of the work led by Sarath Kotagama and members of the Field Ornithology Group of Sri Lanka (FOGSL) and the noted bird ecologist Eben Goodale. This pioneering work helped further convince the Sri Lankan government of the importance of protecting the Sinharaja rainforest.

◄ *The endemic* **Sri Lanka Crested Drongo** *(Dicrurus lophorinus) seen at Sinharaja Forest Reserve. Drongos are well known for their ability to mimic the songs and contact calls of other bird species. Studies in Sri Lanka suggest that this vocal mimicry is a way for drongos to manage the behaviour of other bird species in what appears to be a symbiotic relationship.*

*Through vocal mimicry, drongos can attract birds that disturb insects, which the drongos can then catch. In other cases, territorial species attracted to the drongos' vocalisations catch insects themselves, but all these species are smaller than drongos, and thus potential targets of kleptoparasitism (Goodale, E. and Kotagama S.W. 2006).*

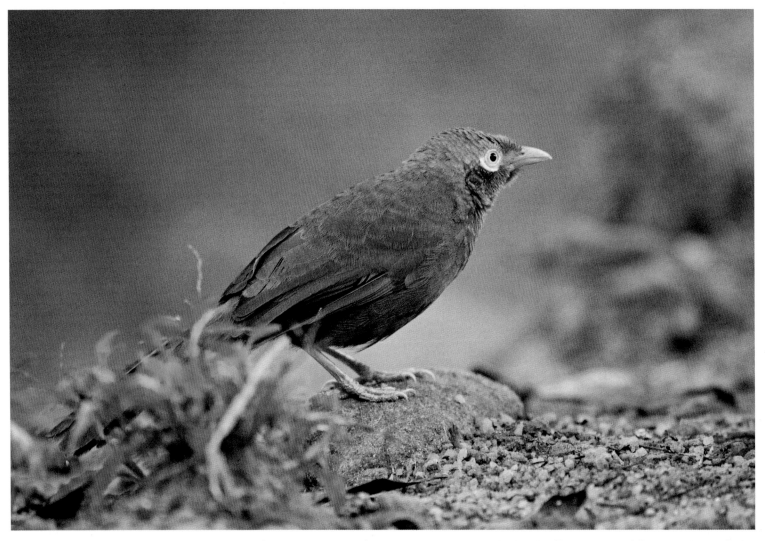

▲ *The Near Threatened* **Orange-Billed Babbler** (Turdoides rufescens) *is clearly a nuclear species for the Sinharaja mixed flocks, as it contributes appreciably to maintaining the cohesion of flocks. This endemic species shows all the characteristics of a nuclear species, as they are present in most flocks, are highly sociable and vocal, and active in leading the flocks (Kotagama, S.W. and Goodale, E. 2004).*

The flocks usually form in the morning with the Orange-billed Babblers the primary flock-leading species, while the Sri Lanka Crested Drongo *(Dicrurus lophorinus)* plays a somewhat less prominent role. The far-carrying, bell-like call of the drongo is believed to be a signal to other participating birds. Within minutes, dozens of birds are attracted and the Orange-billed Babblers then start leading the flock forward. The Crested Drongo is also known to sound alarm calls to warn the flock of approaching danger, and sometimes to make distracting alarm calls to steal food.

Other species often join the mixed foraging party as it passes through their territories; these groups sometimes offer birdwatchers the opportunity to observe more than half a dozen endemic species.

Mixed flocks only occur among insect-eating birds. Often, flocks move along an established route, but may shift in response to changing environmental conditions. Birds move about within the flock but always travelling in the same direction, occasionally dropping in and out of the group.

It is believed that flock formation increases the feeding efficiency of the member species in the flock. The preferred prey of one species may not appeal to another; thus, the participating species do not necessarily compete with each other. Different species specialise in feeding at different levels of the rainforest. As the babblers forage on the understorey, they disturb insects which then take flight and become easy targets for the birds overhead, especially for the Sri Lanka Crested Drongo.

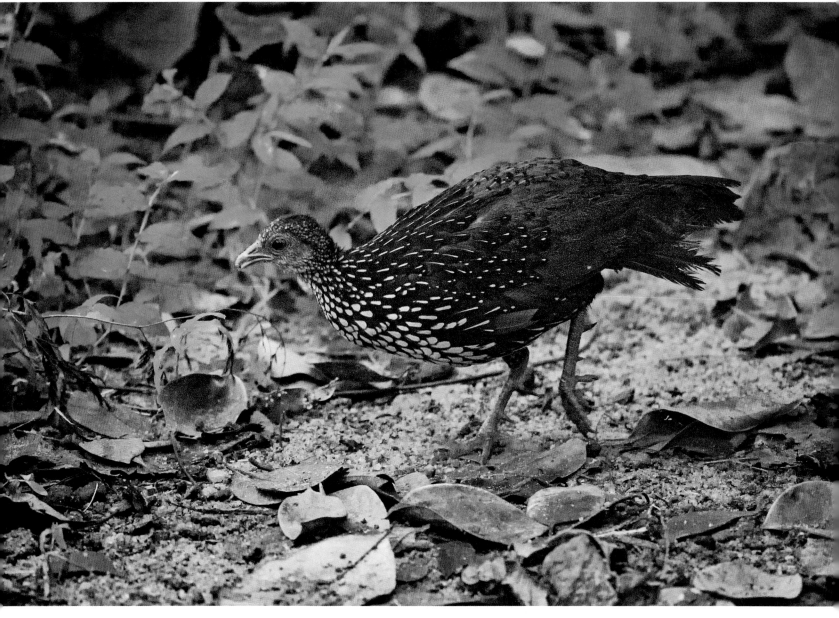

▲ The shy **Sri Lanka Spurfowl** (Galloperdix bicalcarata) *is more often heard than seen in the deep forests of the wet zone. It is one of the most elusive of Sri Lanka's endemics. If disturbed, the spurfowls will immediately run for cover. This male was seen in the early morning at Sinharaja.*

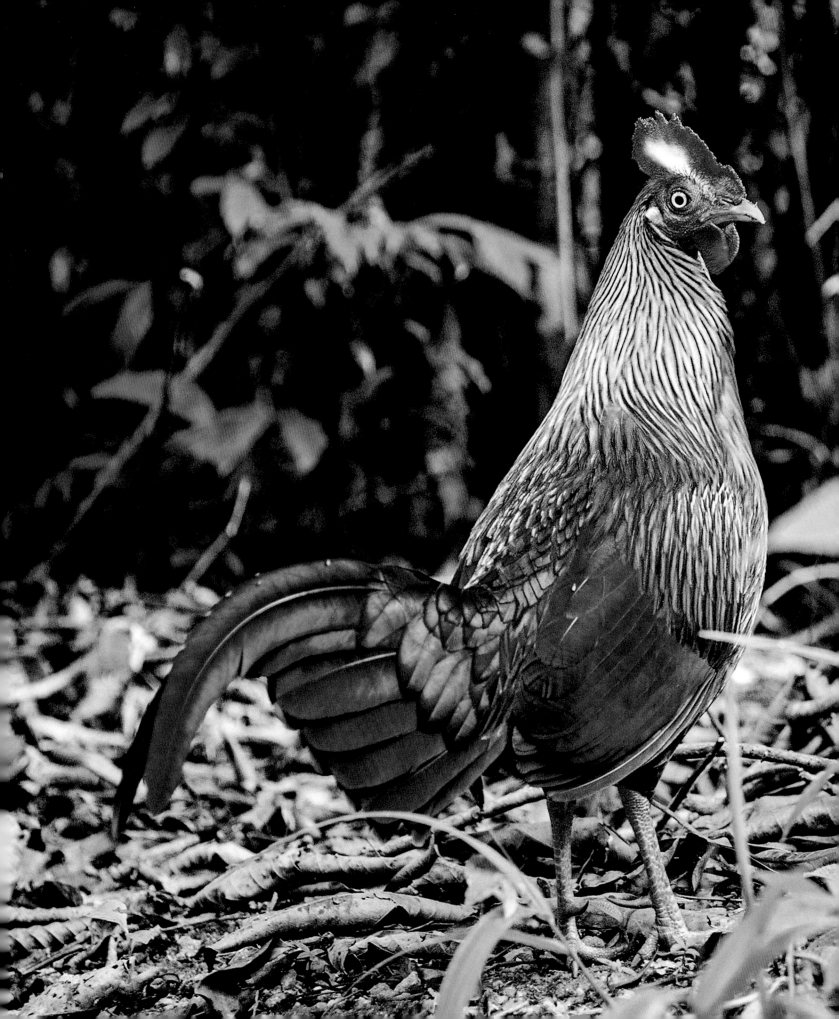

◀ The **Sri Lanka Junglefowl** (Gallus lafayettii) *is the national bird of Sri Lanka. Sinharaja forest reserve is one of the best places to see this colourful species with it vivid plumage and yellow-centred red comb.*

▲ The endemic **Spot-winged Thrush** (Geokichla spiloptera) *is comparatively easy to see in Sinharaja. It is a ground-feeder and the diet includes a high proportion of soft-bodied invertebrates such as this fleshy caterpillar.*

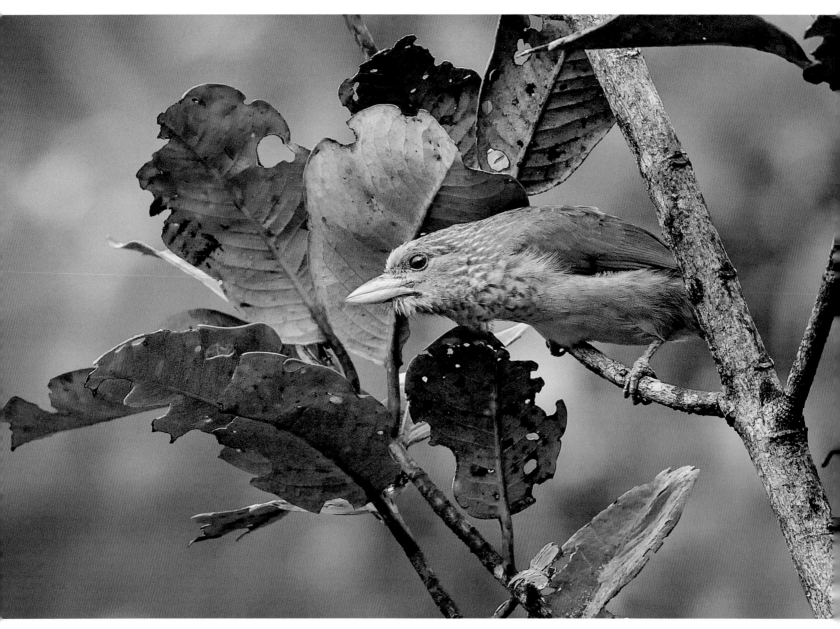

▲ The **Sri Lanka Yellow-fronted Barbet** (Psilopogon flavifrons) *is common in the southwestern hill forests and is quite adaptable, occurring regularly in disturbed forests. Its preferred diet includes various berries and fruits including figs, guavas and papayas, but it takes invertebrates and small lizards if the opportunity arises.*

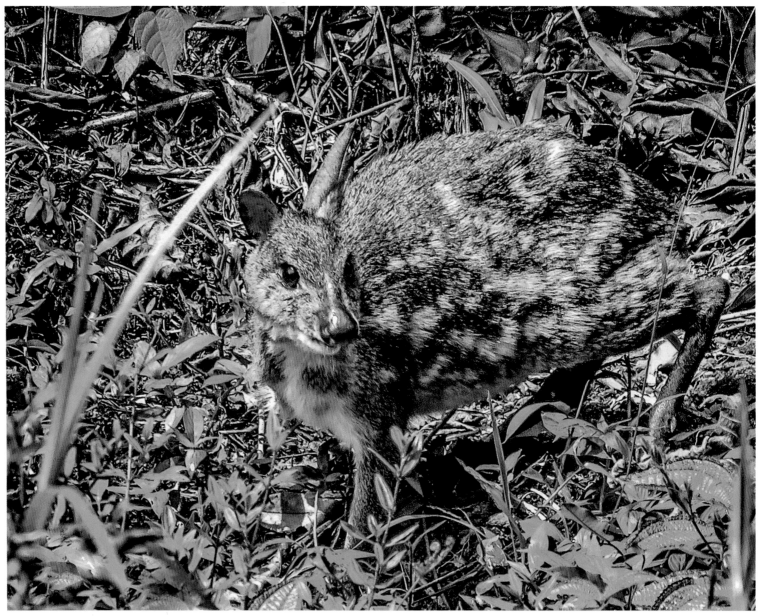

▲ The **Yellow-striped Chevrotain** (Moschiola kathygre) *is a newly described species. Among the world's smallest hoofed mammals, this chevrotain seldom exceed 50 cm in length. While locally common in Sinharaja, it appears more abundant in secondary than in primary forests.*

▶ *The endemic* **Layard's Palm Squirrel** *(Funambulus layardi) is classified as Vulnerable and can be found in the central and southwestern parts (including Sinharaja) of Sri Lanka. This attractive squirrel is named for the noted British diplomat Edgar Layard, who was very much an ardent naturalist when he was based in Sri Lanka.*

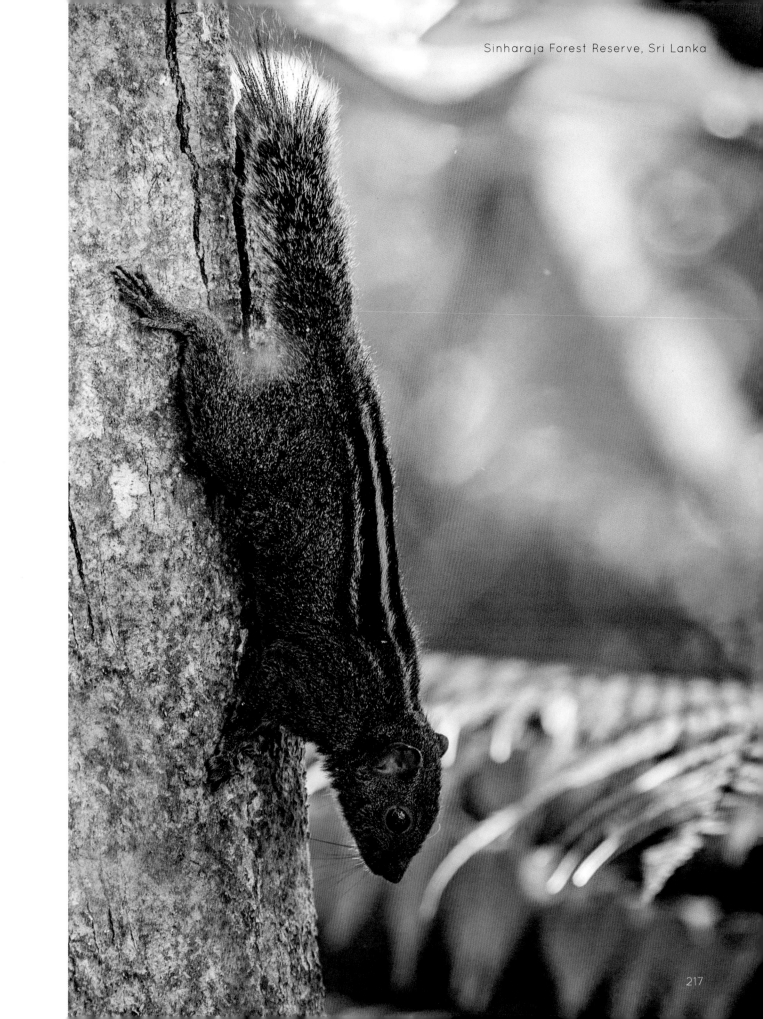

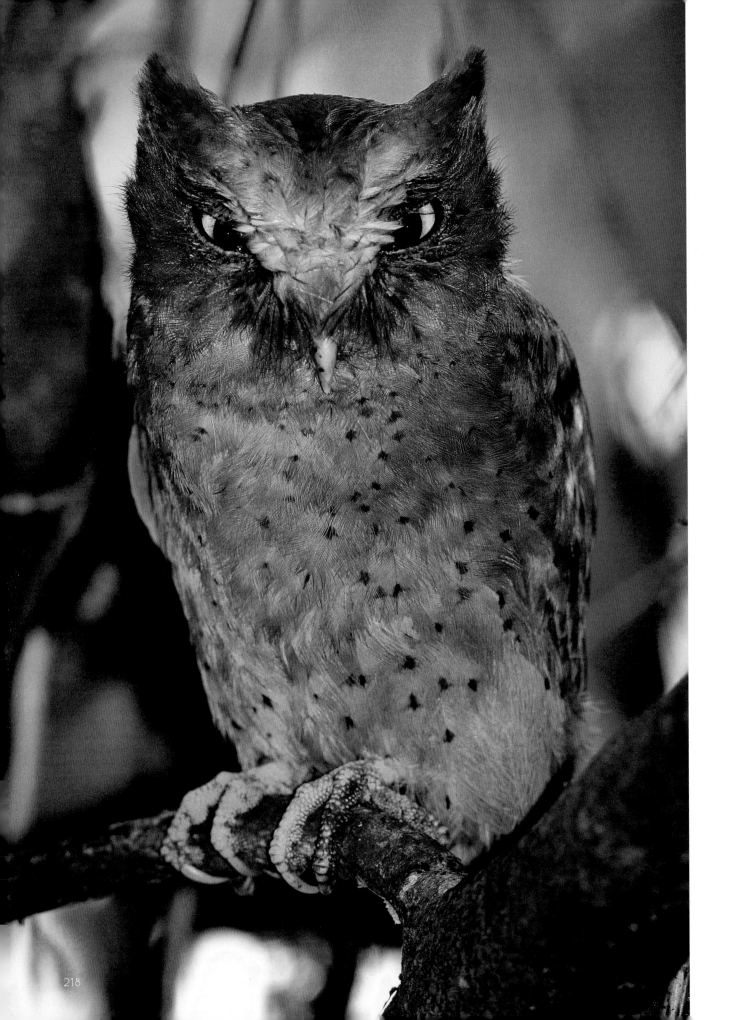

The amazing discovery of the petite Serendib Scops Owl in Sinharaja in 2001 stunned ornithologists around the world. It was the first new bird species to be discovered in Sri Lanka since 1868. Later, in 2007, the Endangered Sinharaja Shrew *(Crocidure hikmiya)* was discovered. This has underscored Sinharaja's importance as a World Heritage Site. Some of the latest discoveries from Sinharaja include several species of amphibians that can only been found in the eastern parts of the reserve.

These and other well published discoveries are the result of research work done in Sinharaja stretching over 25 years. In addition, several universities and NGOs have carried out effective education programmes on site, leading to a significant increase in conservation understanding and awareness among Sri Lanka's population. Research on forest restoration has also yielded a wealth of information on the state of regeneration of the rainforests.

The core forest area of Sinharaja appears well protected under the Forest Department of Sri Lanka. However, the overall implementation of legislation to conserve Sinharaja needs to be improved to safeguard the value and integrity of the site. Special attention should be paid to the the buffer zone occupied by local people. Many of them arrived as workers during the period when the reserve was being logged. Also, boundary demarcations will need to be clearly defined, monitored and enforced. A key issue is the encroachment of the forest for tea and cardamom cultivation.

The current construction of small scale, mini hydropower projects in the buffer zone is another formidable threat to the freshwater stream ecosystem and its endemic flora and fauna.

The lack of control on the use of agrochemicals for pest and weed management in the surrounding tea plantations has led to contamination of streams, resulting in damage to the forest ecosystem. Illegal poaching of Sambar, both chevrotains as well as wild pigs has been reported. In addition, road developments near Sinharaja may impact the site by opening up entry points that facilitate illegal logging and gem mining.

◄ *Serendib Scops Owl* (Otus thilohoffmanni)
*In 1995, ornithologist Deepal Warakagoda heard and recorded an excitingly unfamiliar owl call. Later, after playing the recording among some of his colleagues, there was a general agreement that this could be an entirely new owl species.*

*It took him another six years of tracking this mysterious bird before he made the first observation of the species at the Sinharaja rainforest with a birdwatcher he was guiding. It was photographed for the first time some three weeks later, and described as a species new to science in 2004. The new owl species was given the scientific name* Otus thilohoffmanni, *after Thilo W. Hoffmann, one of Sri Lanka's most renowned conservationists, well known for his work in saving Sinharaja from further logging.*

*The species is endemic to the wet zone of Sri Lanka and currently only known from five sites where the population is estimated at 200-250 individuals. It has been classified as Endangered by the IUCN.*

'The current destruction of our forests will lead to serious effects on climate, productivity and life. The forest is gold. If we know how to conserve and manage it well, it will be very valuable'. Ho Chi Minh

# The Forests of
# Khe Nuoc Trong,
# Quang Binh, Vietnam

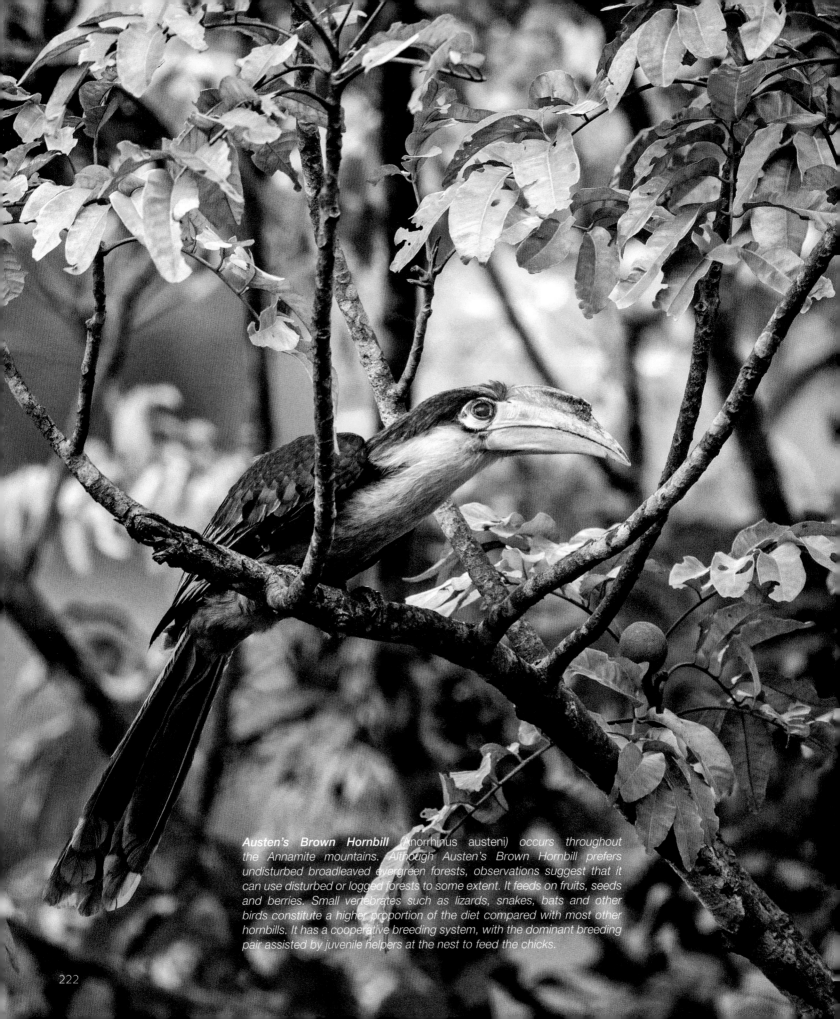

**Austen's Brown Hornbill** (*Anorrhinus austeni*) *occurs throughout the Annamite mountains. Although Austen's Brown Hornbill prefers undisturbed broadleaved evergreen forests, observations suggest that it can use disturbed or logged forests to some extent. It feeds on fruits, seeds and berries. Small vertebrates such as lizards, snakes, bats and other birds constitute a higher proportion of the diet compared with most other hornbills. It has a cooperative breeding system, with the dominant breeding pair assisted by juvenile helpers at the nest to feed the chicks.*

# The Forests of Khe Nuoc Trong

The remote Annamite or Truong Son mountain range and its foothills run along the borders of Vietnam and Laos. This wild and rugged landscape nurtures a remarkable diversity of species and is as yet very poorly explored. Since the 1990s, scientists have described an unexpectedly high number of new species, many of which are endemic to the Annamites, such as the Annamite Muntjac (*Muntiacus truongsonensis*), the Annamite Striped Rabbit (*Nesolagus timminsi*) and the Truong Son Pit Viper (*Viridovipera truongsonensis*).

The Annamese lowland forests of Khe Nuoc Trong are also home to a variety of rare wildlife such as the Saola (*Pseudoryx nghetinhensis*), Edwards's Pheasant (*Lophura edwardsi*), Large-antlered Muntjac (*Muntiacus vuquangensis*), Sunda Pangolin (*Manis javanica*) and Chinese Three-striped Box Turtle (*Cuora trifasciata*); all five are listed in the IUCN Red List as Critically Endangered.

Also present in these forests are the Red-shanked Douc Langur (*Pygathrix nemaeus*) and Hatinh Langur (*Trachypithecus hatinhensis*) both listed as Endangered, along with the Crested Argus (*Rheinardia ocellata*).

The lowland forests of Quang Binh Province face major challenges in the form of degradation, fragmentation and constant encroachment. These species rich lowlands are particularly vulnerable to exploitation and clearance, as well as conversion to other land uses, because of their easy accessibility. In addition, the area overlaps with both the former Demilitarised Zone and the Ho Chi Minh Trail and was greatly affected by the war in the 1960s. Forest areas degraded with the defoliant 'Agent Orange' are still recovering after more than 45 years.

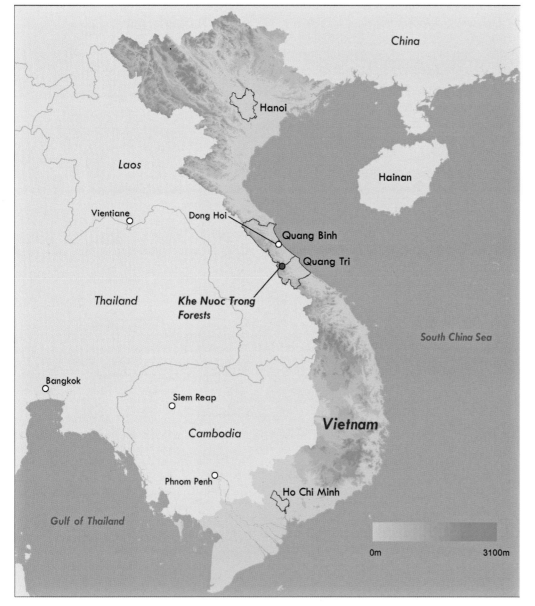

With support from the World Land Trust (WLT), Viet Nature Conservation Centre (Viet Nature) signed a 30 year forest environmental lease contract with the local government authorities of Quang Binh Province in north central Vietnam. Viet Nature is an independent nature conservation NGO and the affiliate of BirdLife International in Vietnam.

This is the first time a conservation partnership of this nature has been implemented in Vietnam. Khe Nuoc Trong is part of BirdLife International's Forests of Hope programme, which is designed to achieve large scale forest conservation and restoration for the benefit of people and nature.

Out of the total area of 20,000 ha, the environmental lease will cover 768 ha of Khe Nuoc Trong, which will be the base for scientific research and biodiversity conservation activities led by Viet Nature. At the same time, a five year action plan is being implemented by Viet Nature. This will act as a catalyst to raise management standards for the rest of the site. Activities under the action plan include increased patrolling frequency, building of five more field camps, regular removal of snares and procurement of additional motorcycles, equipment and smart apps for processing collected data in a timely manner. The immediate objective is to monitor biodiversity in the landscape and to identify and respond more effectively to threats such as logging and hunting. Viet Nature is also working with donors to implement sustainable natural resource management practices at Khe Nuoc Trong that improve livelihoods for the local communities.

It is important not to forget that Khe Nuoc Trong is one of the best remaining tracts of Annamite lowland forest retaining a diverse biodiversity despite outside pressures. Camera trap images gathered by Viet Nature since 2011 in the Khe Nuoc Trong forest have confirmed the continued presence of many threatened mammal and bird species. However, there has been no recent evidence of the Saola's occurrence, the last being that of skulls and horns of hunted animals from 2002.

◀ **Oriental Whip Snake** (Ahaetulla prasina). *Spotted over a stream at night in Khe Nuoc Trong. It is a common snake in many parts of tropical Asia, and is harvested for use in traditional medicines such as snake wine. It is a rear-fanged and mildly venomous snake, but not known to be dangerous to humans. Its diet includes small amphibians and reptiles. Adult individuals may grow up to 1.8 m in length.*

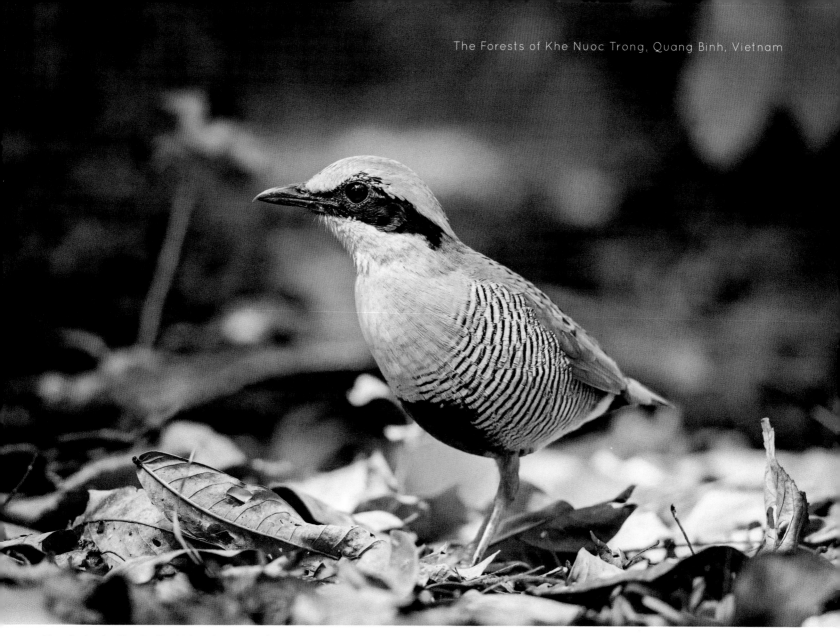

▲ *The distinctive* **Bar-bellied Pitta** *(Pitta elliotii) inhabits broadleaf and mixed deciduous forests up to an altitude of 800 m across much of Vietnam. Bar-bellied Pittas are most often encountered foraging quietly on the forest floor for earthworms and other invertebrates. The species breeds mostly between April and June.*

In the past decades, the growing affluence of the middle classes in Vietnam and China have created a surging demand for exotic bushmeat. Traders and hunters have frequently tempted indigenous people to trap wildlife illegally to satisfy the national and international demand for bushmeat.

While all hunting in forests is illegal, local government agencies are underresourced and lack the capacity to enforce wildlife protection laws effectively without outside support. Collection of non-timber forest products for subsistence use is permitted in some cases, but is also very poorly regulated.

Through improved enforcement by working with local authorities and supporting the livelihoods of local communities, Viet Nature has taken the first steps to make Khe Nuoc Trong a safe haven for wildlife for the long term.

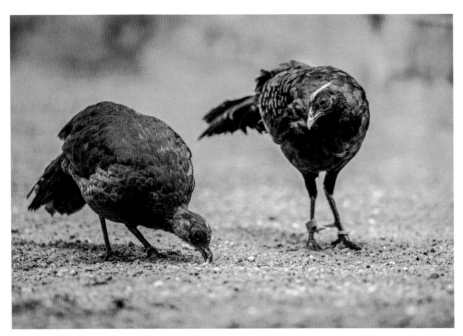

▲ *Female (left) and male (right)* **Edwards's Pheasant**

The Edwards's Pheasant (*Lophura edwardsi*) was first described in 1896 by the renowned French ornithologist Jean-Frédéric Oustalet. However, 120 years on, little is known about its biology, ecology, habitat needs, or diet in the wild. Most historical sightings have been made in lowland evergreen forests at an altitude of less than 300 m above sea level. Field surveys suggest that the species inhabits wet evergreen forests with dense vegetation and it may tolerate some habitat degradation.

Any possibly remaining populations of Edwards's Pheasant in the wild are threatened by poachers using wire snares to catch terrestrial animals for food and traditional medicine. Indiscriminate snaring by hunters results in depletion of many ground-dwelling species.

The species breeds well in captivity. Zoos and private breeders in Europe, Japan and the USA now have a captive-bred stock of approximately 1,000 individuals.

This captive population is thought to originate from very few founder birds collected before 1930 and is therefore inbred and vulnerable to disease.

Since 2011, camera trap programmes have found no traces of the Edwards's Pheasant, even in the most suitable habitats in Quang Binh and neighbouring Quang Tri provinces. In 2013, local and international stakeholders came together to develop an Edwards's Pheasant conservation strategy focused on site protection, conservation breeding, research, and co-ordinated resource mobilisation for a sustainable Edwards's Pheasant population in the wild by 2030.

Since 2012, Viet Nature has been actively involved in the long term protection of Khe Nuoc Trong, which is viewed as potentially the most suitable site for the reintroduction of Edwards's Pheasant and may offer the best hope of its long term survival in the wild.

▶ *Male* **Edwards's Pheasant**. *It is endemic to four provinces in central Vietnam. However, the last recorded sighting was in 2000. It is now possibly extinct in the wild, hence its global conservation status was raised to Critically Endangered in 2012.*

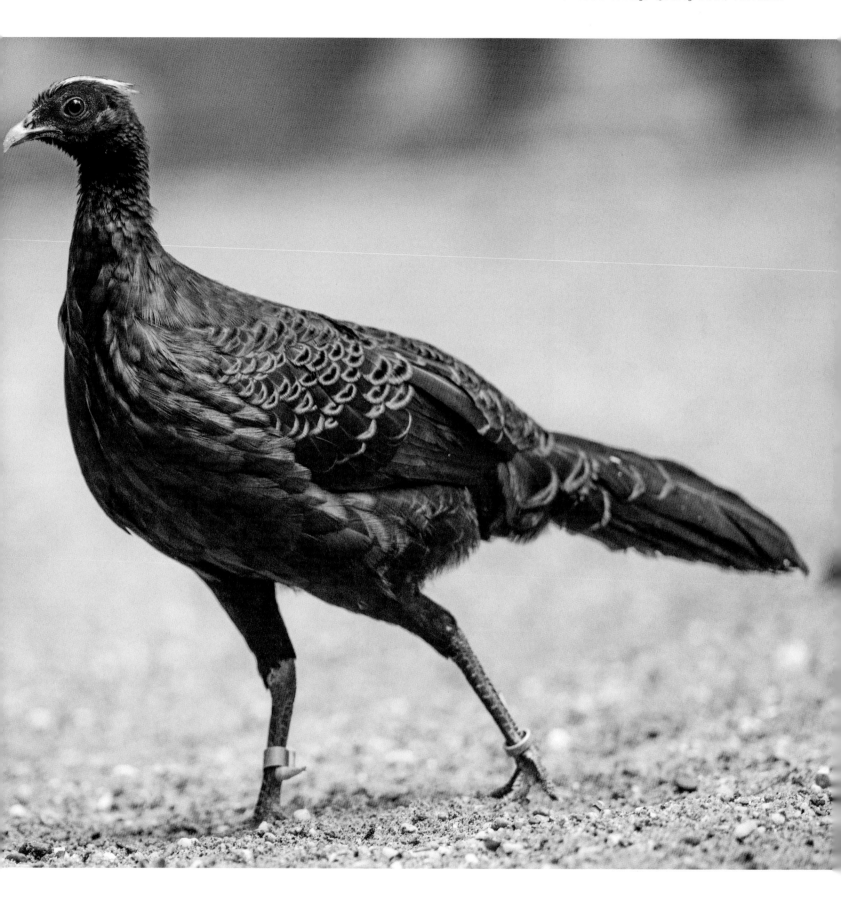

▶ Male **Silver Pheasant** (Lophura nycthemera). *This striking pheasant can be found in evergreen and mixed deciduous forests across eastern Southeast Asia. It lives in small groups and has been observed foraging under fig trees with feeding monkeys and Emerald Doves.*

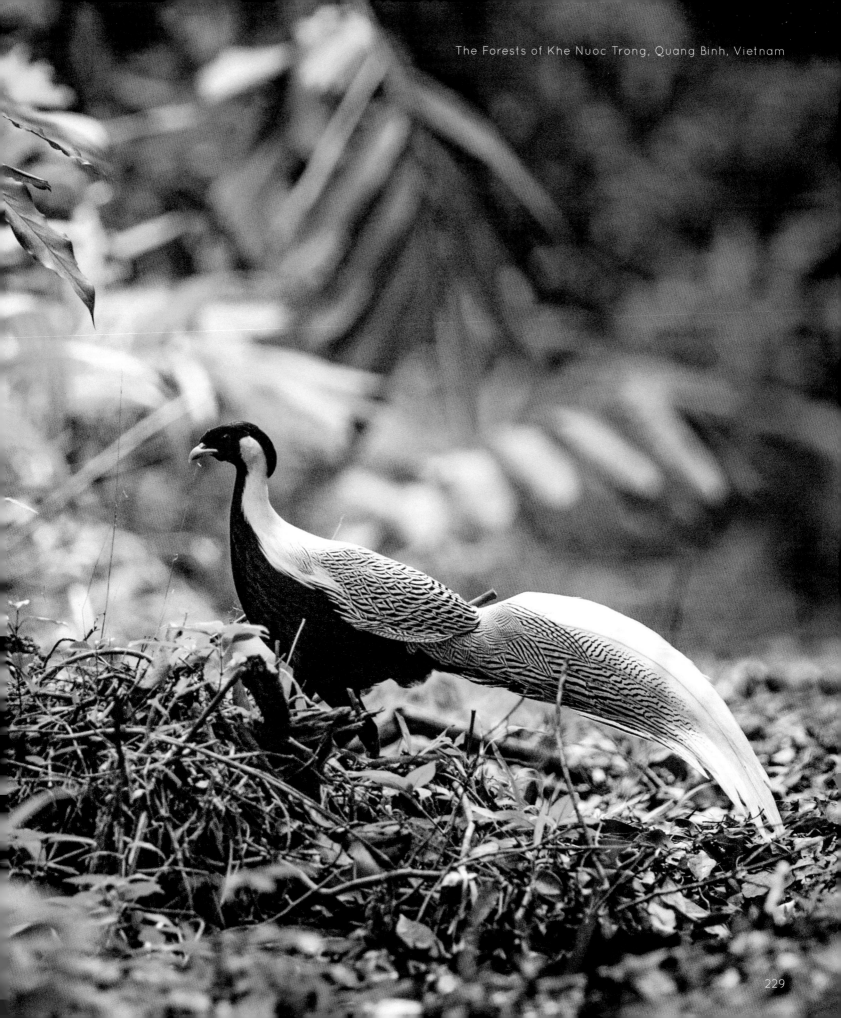

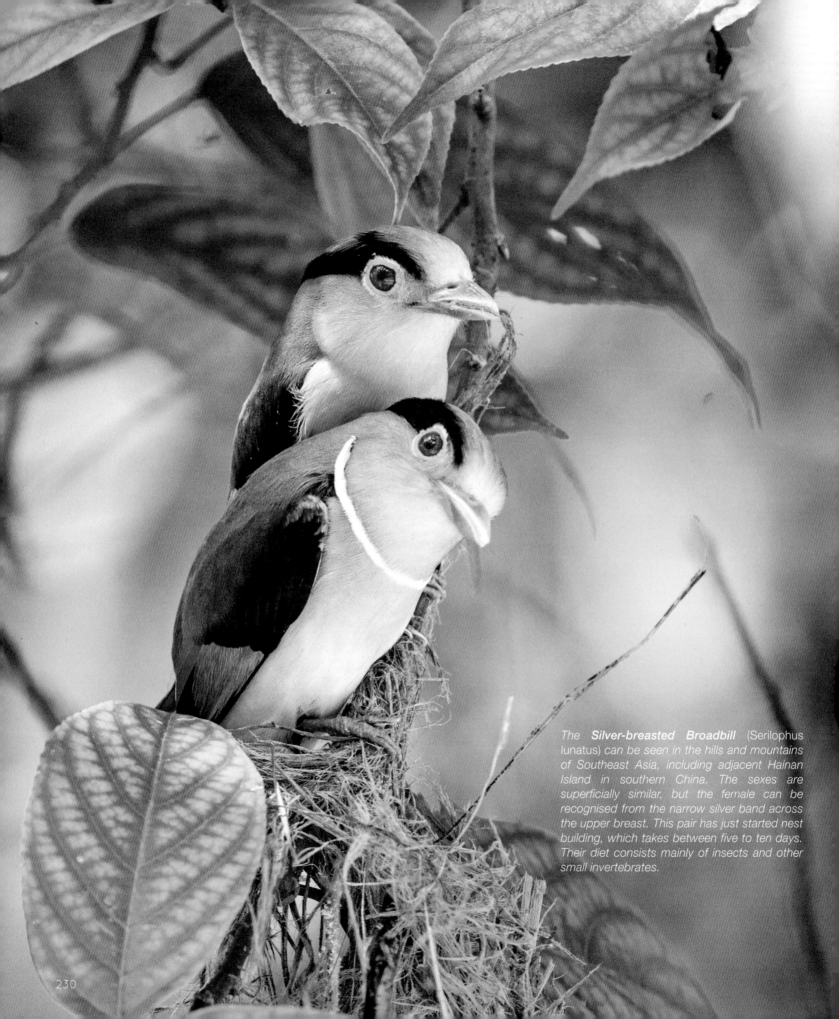

The **Silver-breasted Broadbill** (Serilophus lunatus) can be seen in the hills and mountains of Southeast Asia, including adjacent Hainan Island in southern China. The sexes are superficially similar, but the female can be recognised from the narrow silver band across the upper breast. This pair has just started nest building, which takes between five to ten days. Their diet consists mainly of insects and other small invertebrates.

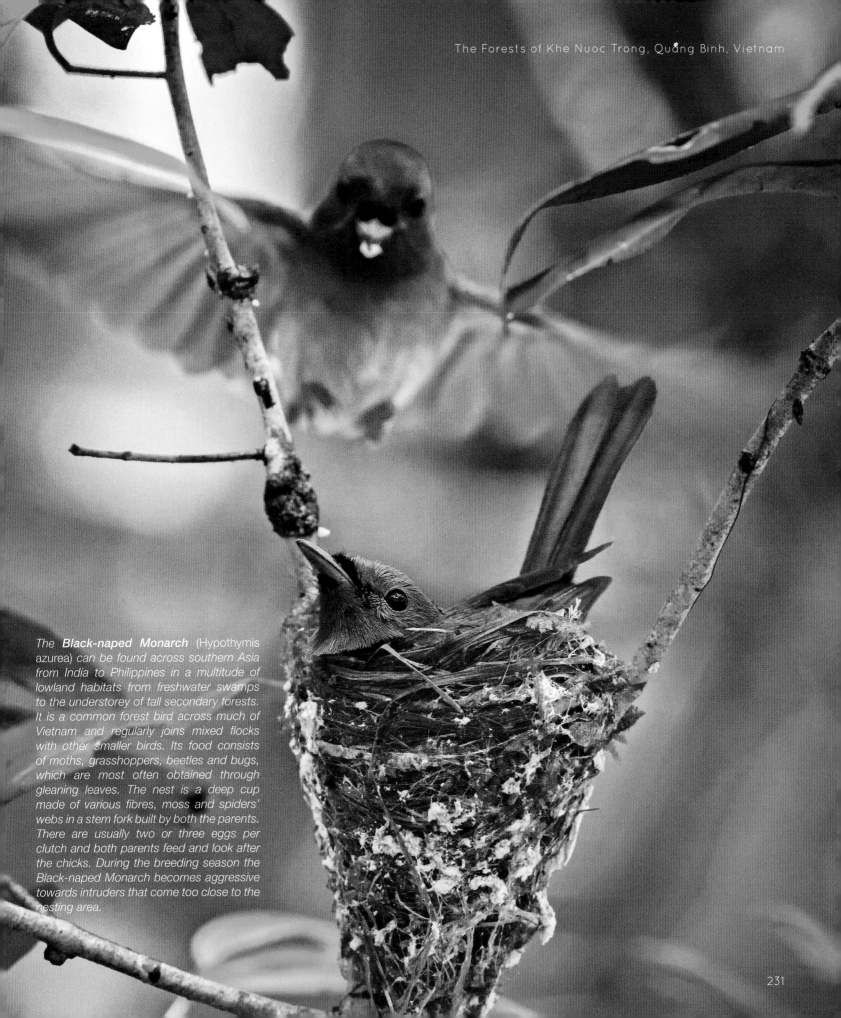

The **Black-naped Monarch** (Hypothymis azurea) *can be found across southern Asia from India to Philippines in a multitude of lowland habitats from freshwater swamps to the understorey of tall secondary forests. It is a common forest bird across much of Vietnam and regularly joins mixed flocks with other smaller birds. Its food consists of moths, grasshoppers, beetles and bugs, which are most often obtained through gleaning leaves. The nest is a deep cup made of various fibres, moss and spiders' webs in a stem fork built by both the parents. There are usually two or three eggs per clutch and both parents feed and look after the chicks. During the breeding season the Black-naped Monarch becomes aggressive towards intruders that come too close to the nesting area.*

231

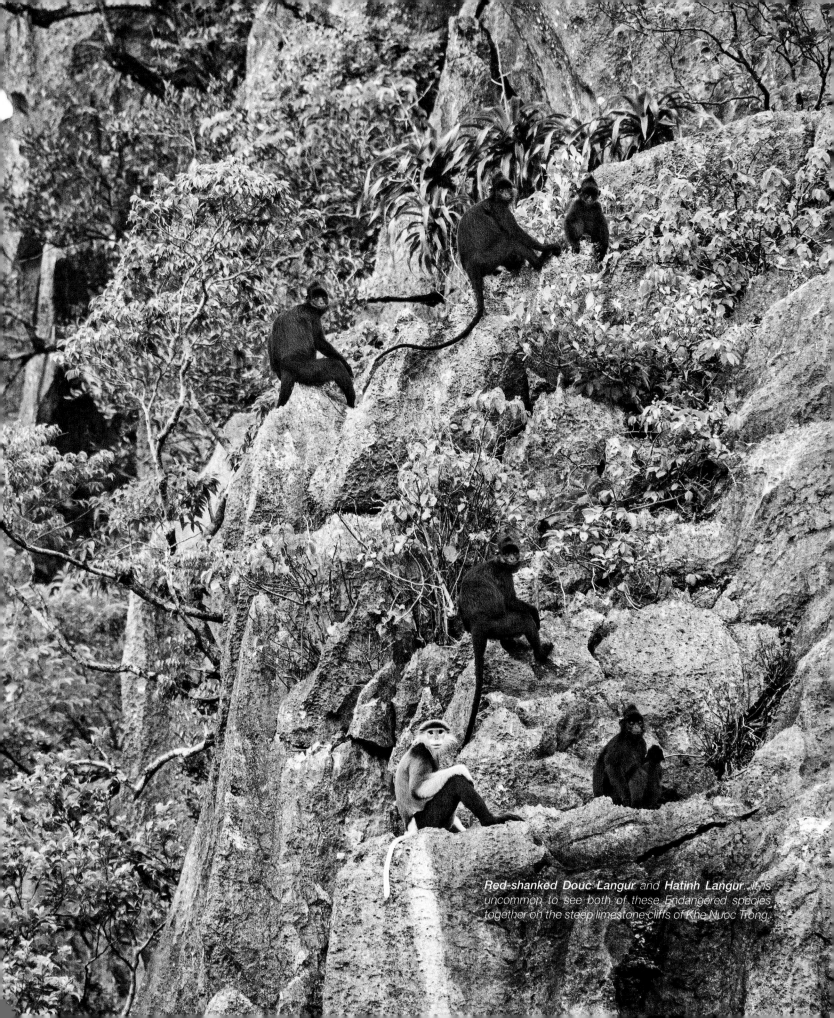

*Red-shanked Douc Langur* and *Hatinh Langur*. It is uncommon to see both of these Endangered species together on the steep limestone cliffs of Khe Nuoc Trong.

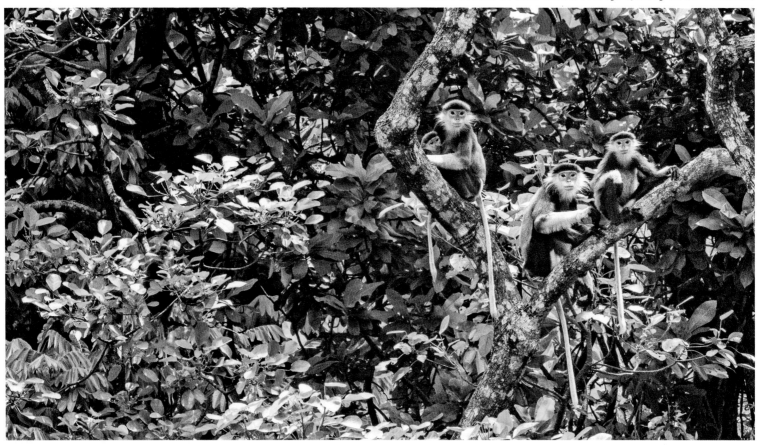

▲ *This small family group of* **Red-shanked Douc Langurs** *belong to a larger troop of around 30 members frequenting the western parts of Khe Nuoc Trong forest.*

## Primates

The forests of Khe Nuoc Trong support a striking diversity of primates, including important populations of three globally Endangered species.

The Southern White-cheeked Gibbon (*Nomascus siki*) is found in north-central Vietnam and neighbouring areas in Laos. Khe Nuoc Trong has one of the largest populations known of this species.

Gibbons spend nearly all their lives in tree canopies, very rarely, if ever, venturing to the ground. They live in small close-knit family groups, usually with two adults, which take care of their offspring for the seven or eight years before they reach maturity and leave. This low productivity of gibbons means that they are highly susceptible to hunting with guns. In Vietnam, gibbons are regularly hunted for their meat, the pet trade and in the production of medicinal 'monkey balm'. When hunted for the pet trade, mothers bearing infants are shot in the hope that the infant will survive the fall from the tree, which the mother inevitably does not.

Hatinh Langurs (*Trachypithecus hatinhensis*) are endemic to central Vietnam and southern Laos and are very closely related to the similar Laotian Langur (*T. laotum*). They inhabit the forest-covered limestone areas of the Annamite Mountains. As their habitat is difficult to access, little is known of their ecology and behaviour. Caves and crevices in the limestone used as sleeping quarters are often located on vertical cliffs, and they have been observed to arrive and depart from roosting sites in darkness.

Although the Hatinh Langur is mostly folivorous, it is also believed to play an important role in seed dispersal for many forest tree species. Groups are composed of an alpha male and multiple females; births take place throughout the year. The foremost threat to them is hunting, as primates are killed not just for meat, but also for traditional medicine.

Red-shanked Douc Langurs (*Pygathrix nemaeus*) are found mainly in evergreen and semi-deciduous forests and are locally common in Khe Nuoc Trong. These gaudy-looking primates spend most of their lives in the forest canopy, only occasionally descending to the ground for minerals and water.

Infants are born throughout the year, peaking in the January to June period. Motherhood duties are shared, allowing mothers time to feed. Bonding between different family groups are critically important and communication in these groups is done through many kinds of visual and vocal signals. The Red-shanked Douc Langur is especially vulnerable to hunters as when disturbed it remains still in the forest canopy instead of fleeing.

▸ *The **Red-shanked Douc Langur**. It is the most colourful of the flagship species in Khe Nuoc Trong with its strikingly patterned body. Up to three quarters of its diet are young, tender leaves but fruits, flowers and seeds are also consumed. This leafy diet is low on energy value and therefore large volumes are needed to be consumed daily to meet its energy needs. Adults consume an average of two kilograms of leaves per day.*

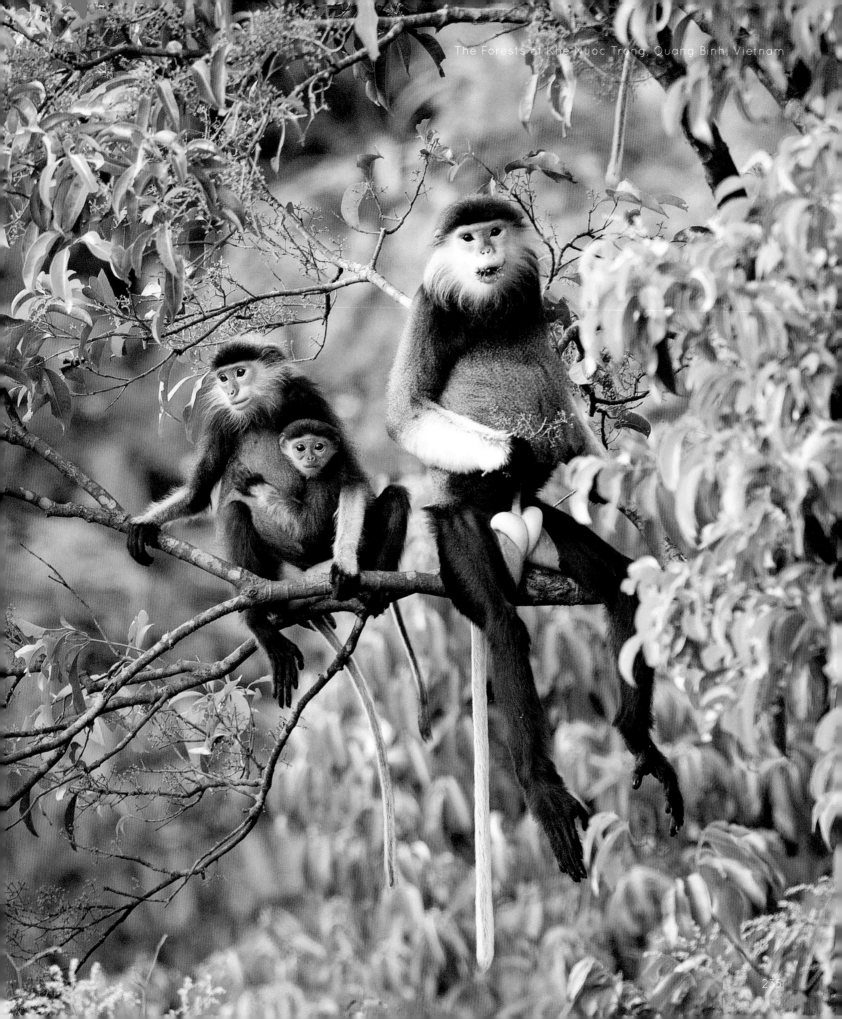

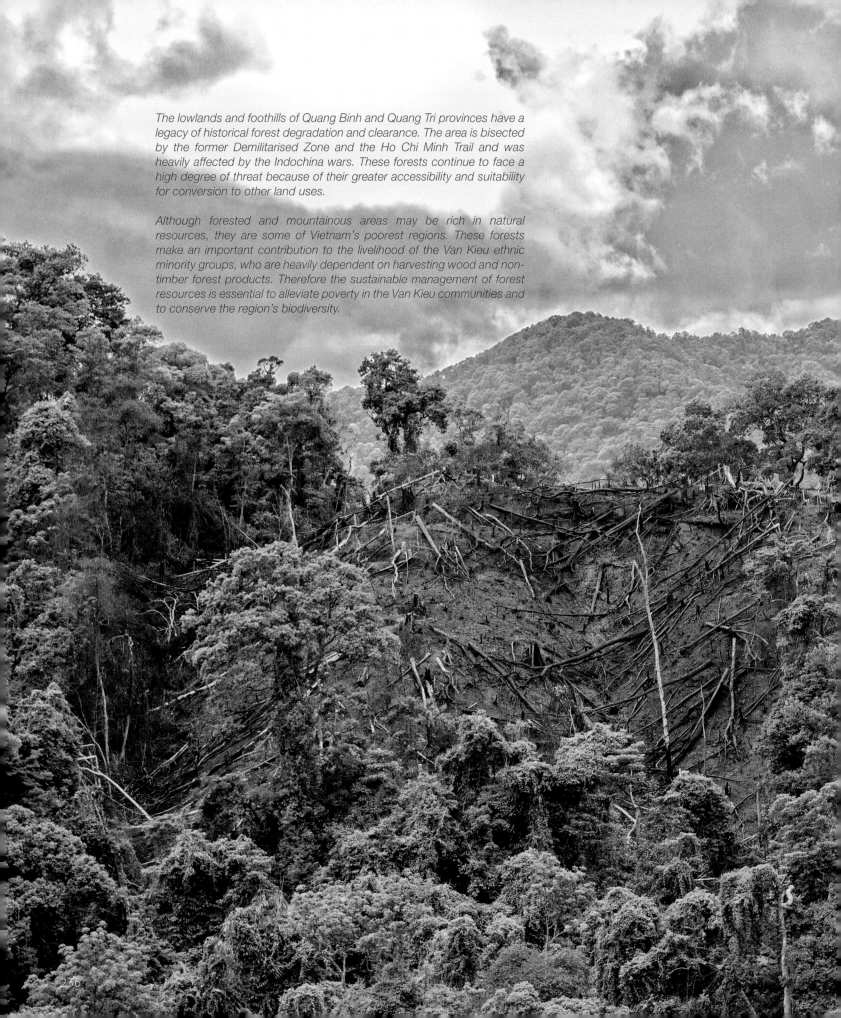

The lowlands and foothills of Quang Binh and Quang Tri provinces have a legacy of historical forest degradation and clearance. The area is bisected by the former Demilitarised Zone and the Ho Chi Minh Trail and was heavily affected by the Indochina wars. These forests continue to face a high degree of threat because of their greater accessibility and suitability for conversion to other land uses.

Although forested and mountainous areas may be rich in natural resources, they are some of Vietnam's poorest regions. These forests make an important contribution to the livelihood of the Van Kieu ethnic minority groups, who are heavily dependent on harvesting wood and non-timber forest products. Therefore the sustainable management of forest resources is essential to alleviate poverty in the Van Kieu communities and to conserve the region's biodiversity.

# Saola (*Pseudoryx nghetinhensis*)

In May 1992, one of the most remarkable zoological discoveries of the 20th century was made in Vietnam. The biologist Dr. Do Tuoc from Ministry of Forestry discovered a pair of peculiar skulls and a pair of unusual tapered horns in a hunter's hut during a survey in the Vu Quang Nature Reserve in the Annamite mountain range close to the Lao border in north-central Vietnam.

These remains turned out to belong to the Saola, which is so distinctive from other bovid species (buffalo, antelopes, sheep and goats) that it was allocated its own genus. An adult Saola is estimated to weigh between 80 to 100 kg with a shoulder height of 80 to 90 cm and a head and body length of around 150 cm. The superficial similarity of the Saola to the oryxes of Africa and the Arabian peninsula prompted the discoverers to give it the genus *Pseudoryx*. The discovery of such a striking mammal prompted biologists to regard the Saola as the greatest terrestrial mammal discovery since the Okapi, which was described in 1900 from central Africa.

As a testimony to the Saola's shy and solitary habits in remote and impenetrable forests, it is not surprising that the French colonists in Indochina never came across the Saola in spite of its size and distinctive appearance. The same goes for the Soviet biologists, who were in Vietnam in the 1980s. In the past decade, documented sightings of Saola are not counted in the hundreds, but rather in the tens.

▶ *Hunting is no doubt the gravest threat to the Saola. It is often the traditional medicine and bushmeat trade that drives hunting for specific wildlife species. However, this is not the case for the Saola because of its rarity. Instead the animals are often a by-catch in the hunt for other species for the medicine and bushmeat trade.*

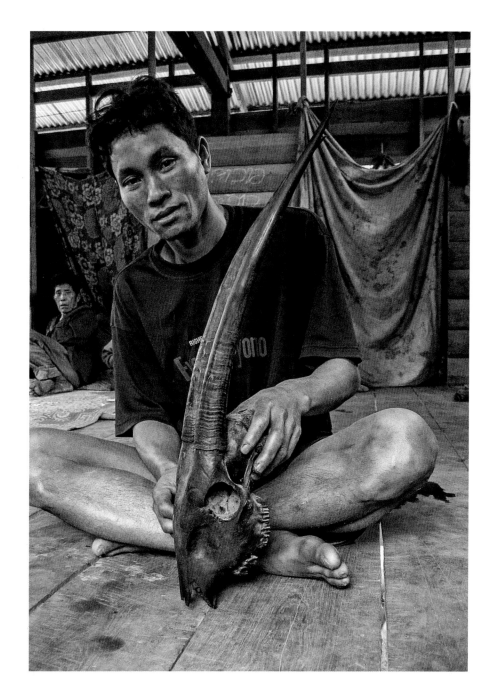

‣ 'In the late 1990s, we were operating with only about ten camera traps in the Saola study area in Bolikhamxay Province, Laos. On one of my trips to the area, I met an experienced Hmong hunter who had killed a Saola six months earlier, so I hired him to guide me in the area. During one of the first trips into the forest we found Saola tracks under a rock-overhang near a stream. This was a good place for a camera trap, but had no trees. So I just secured the camera on top of a rock, hoping for the best. Ten days later when we came back, there were, what looked like, new Saola tracks around, but the camera was knocked off the rock and when the film was developed – no Saola photos!

By early 1999, permission to enter the area had expired. So I made an agreement with two young guys, Saykham and Khambai from the Toum ethnic group, to continue the camera trapping. They had been my main assistants for the camera work.

The arrangement was to meet up with them in Lak Xao to give them fresh films and replacement batteries once a month. In addition to the modest payment for their work, the deal was that they would get US$ 100 for each photo of a Saola, and their village and a few others, in which we were working nearby, would each get US$ 200. This was based on the belief that we could later sell the images to magazines, so it was only fair to share the proceeds.

For the next three months, I met with the two young villagers in Lak Xao, which was about two day's walk from the young men's village, Ban Vangban. Some of the films showed good images of muntjacs, but still no sign of the elusive Saola.

Then in April, at the conclusion of project, when we were down to four camera traps, I met the villagers for the last time and received the cameras with four rolls of Kodak film. My hopes were not high when I returned to Vientiane. But our perseverance finally paid off.

Two of the last four rolls of film had two outstanding photographs of Saola taken in different locations, including one iconic image that today is still the best image ever taken of Saola in the wild. These were the first (and still the only) photos of a wild Saola from Laos.

We sent a message with the good news to the village, and a few weeks later we all met in Lak Xao, to hand over framed copies of the photos and the reward money, which was a big sum in those days. We did all this at a proper ceremony and celebratory party with representatives of the provincial government.'

William Robichaud, Coordinator, IUCN SSC Saola Working Group.

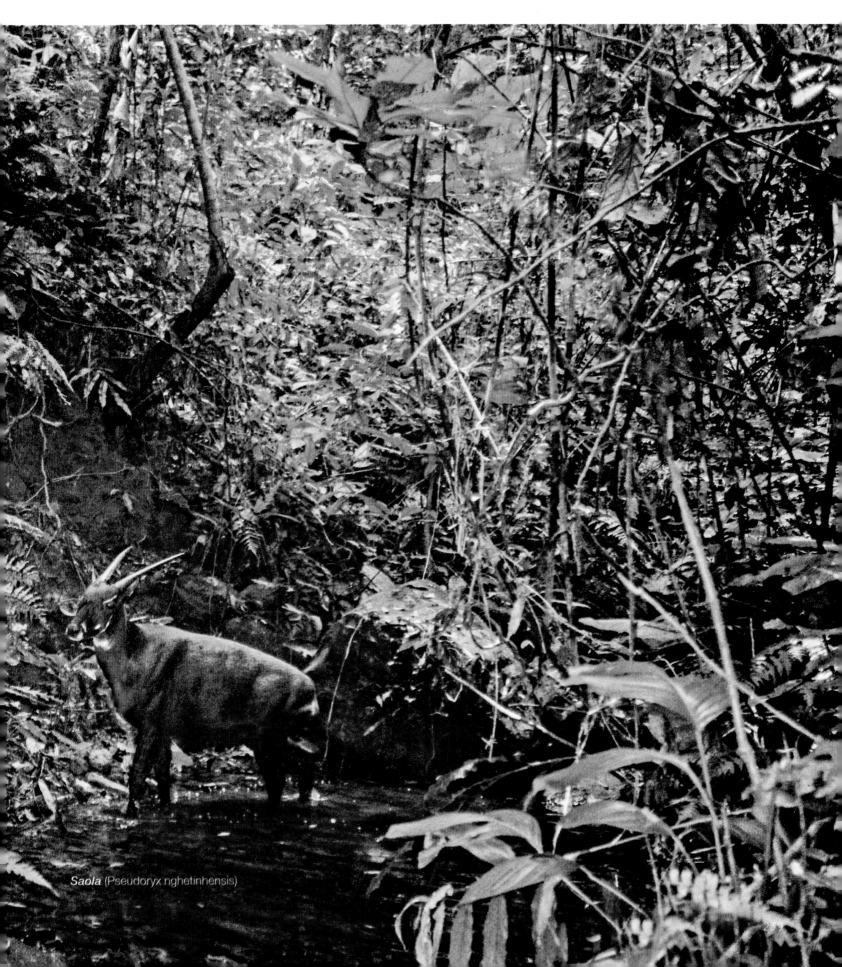

*Saola* (Pseudoryx nghetinhensis)

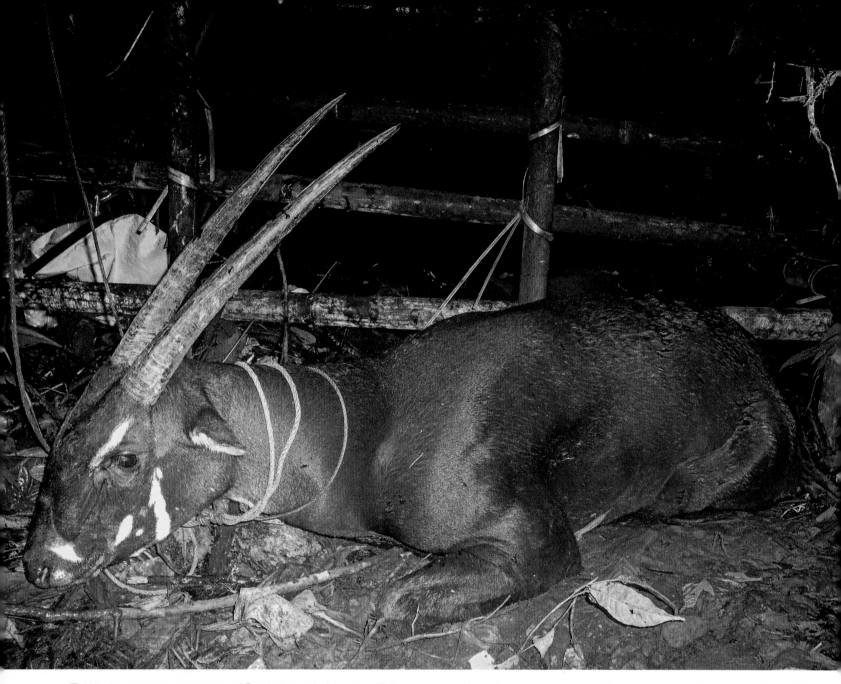

▲ *This is the most recent capture of **Saola** from 2010 in Laos. This photo was taken after villagers removed it from a snare a few days earlier, but it died hours after this photo was taken.*

*Since 1992 at least 20 individuals are known to have been in captivity, but none survived longer than five months, apart from two individuals that were eventually released into the wild.*

In January 1996, a female Saola was captured by Hmong villagers in Laos in response to a cash reward offered by a general in central Laos. William Robichaud spent three weeks studying her. He commented: '*The most remarkable thing about the animal was her calm nature… Within three days she could be touched and stroked, and would calmly feed out of my hand.*

*I measured her where she stood and checked her ears for ticks. She was more confiding than a village cow or goat.*'

The most recent confirmed capture of a Saola was a male caught in Laos in August 2010, but that individual also perished within a matter of days.

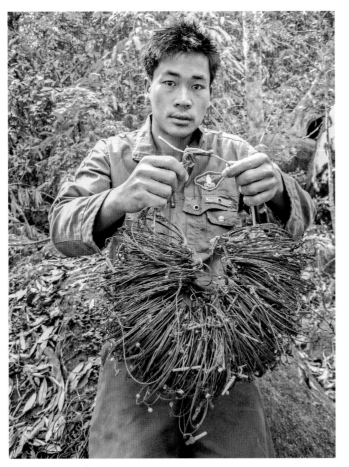

◄ According to the Saola Working Group established under the IUCN, since 2011 patrols have destroyed more than 130,000 wire snares set up to trap wildlife in just five protected areas in Vietnam and Laos.

The latest documented record is a camera trap image taken in September 2013, in a remote area in the central Annamite Mountains of Vietnam. Today, no Saolas are known to be in captivity anywhere in the world.

Almost 25 years on, little is known about the Saola's ecology or life history because of its rarity and secretive nature. In addition, it occurs only in sensitive border areas in Vietnam and Laos, and it has often been difficult or impossible for biologists to do surveys in these forests. It has only been photographed in the wild on a handful of occasions using camera traps, and, amazingly, no western scientist has ever seen the animals in the wild. Most of what we know about the Saola today comes from information given by indigenous people, as well as a single pregnant female observed in captivity for three weeks in 1996.

The Critically Endangered Saola lives in the broadleaf evergreen or semi-deciduous forests of the Annamite mountain range, which does not have a pronounced dry or rainy season. It has been reported that the Saola uses forests at different elevation according to changing seasons, normally between 400 and 800 m above sea level. In Vietnam, most hunted individuals have been killed in winter, when Saola descend into the more accessible lowland forest habitats.

Unlike rhinos and tigers, the Chinese and Vietnamese had little or no knowledge of the Saola in earlier centuries, so it is not used in their traditional medicine. Although the Saola is not specifically sought after, hunters catch them in lethal wire snares meant for other species. Unfortunately the illegal trade in wildlife is not likely to abate as long as there are wild boars, muntjacs and civets to be caught - unless effective anti-poaching measures are enforced. Sadly, the Saola will become extinct long before these more common species are hunted out.

The blame for the rising wildlife trade is moving away from poor families to the growing number of middle and high income people willing to pay large sums of money for consuming exotic wildlife products.

Hydropower projects, infrastructural developments, mining and the completion of the Ho Chi Minh highway through the Annamite Mountains continue to threaten and fragment the Saola's forest habitat. All this has accelerated access to once remote forest areas for professional trappers and loggers.

The Saola is a flagship species for the Annamite Mountains, which constitute a regional biodiversity hotspot extending along the border of Vietnam and Laos. Since the discovery of the Saola, numerous new and endemic species have been discovered, including the Large-antlered Muntjac (*Muntiacus vuquangensis*) and Annamite Muntjac (*Muntiacus truongsonensis*). In 1996, the Kha-nyou (*Laonastes aenigmamus*) was discovered in Laos by biologist Robert Timmins in a local food market, and in the same year he also discovered the Annamite Striped Rabbit (*Nesolagus timminsi*) in another market. The Annamite Mountain range is certain to contain more zoological surprises - if the professional poachers do not get there first.

In recent years, a significant amount of effort has been put into the conservation of the Saola by international and local NGOs. They are supporting the employment of additional forest guards to patrol the habitat and are building additional ranger stations to prevent illegal activities. The number of biodiversity surveys in the Annamites has also greatly increased since 1992, and partnership-building with villagers, local and central government agencies has made progress in regional conservation work.

Increasing affluence in Vietnam and China is feeding a voracious appetite for wildlife products of many kinds such as traditional medicines, which has intensified hunting pressures to levels not seen before. Conservationists have warned that people are literally eating some of the region's biodiversity into extinction. This, combined with poorly funded and badly motivated government departments results in weak law enforcement. It also means that the surviving Saola population is declining rapidly; in many areas, numbers may be so low that no viable population remains.

On a medium term basis it may be necessary to establish a captive breeding centre in Laos or Vietnam to prevent the Saola's global extinction, with a possible reintroduction release of captive bred animals. For this purpose Khe Nuoc Trong may be be one of the priority areas.

*A small window of opportunity remains open, but we must act with the greatest sense of urgency. We cannot continue to let one of the rarest and most distinctive large animals in the world slip towards extinction through complacency'.* William Robichaud

▶ **Large-antlered Muntjac** (*Muntiacus vuquangensis*).

*With the discovery of the Saola, more attention and surveys were directed at the Annamite mountain range. As a result, another large mammal entirely unknown to science was announced in 1994. The new species, found in the Vu Quang area, is a very large muntjac (barking deer), somewhat similar to the Red Muntjac (Muntiacus muntjak) but twice the size at around 55 kg. Interestingly, this was the same area where the Saola was found. Little is known about the ecology of this species, which has been classified as Endangered.*

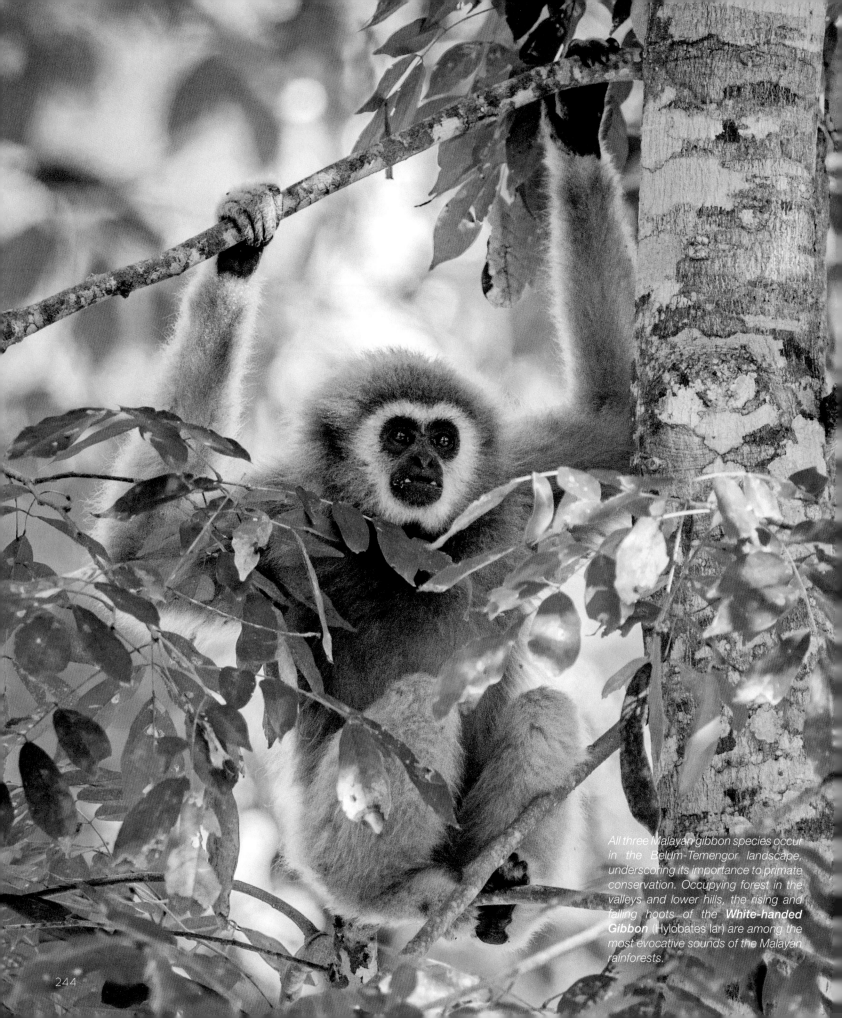

*All three Malayan gibbon species occur in the Belum-Temengor landscape, underscoring its importance to primate conservation. Occupying forest in the valleys and lower hills, the rising and falling hoots of the* **White-handed Gibbon** *(Hylobates lar) are among the most evocative sounds of the Malayan rainforests.*

# Acknowledgements

This publication would not have been possible without the support and encouragement of many conservationists and friends.

First of all a warm thank you to our editor **Yong Ding Li**, who did not think twice about accepting the task to edit this publication, in spite of his new book in the pipeline and a tight schedule. As was the case with 'A Visual Celebration of Borneo's Wildlife', Ding Li's broad knowledge and experience with the fauna and flora in Asia has been an invaluable part of this project. His many suggestions and comprehensive network have made a vast difference!

**Zinnira Bani** has expertly created the stunning design and layout of all our three publications. She diligently managed the abundant revisions and coordinated all the technical aspects of this project. **Teo Siyang** drafted all the excellent maps used in the book. **Judith Rumgay** meticulously copy-edited and proofread the manuscript to make sure that the text and style were consistent and free of inaccuracies.

The collection of more than 190 unique photographs in this publication includes works from leading local and international wildlife photographers, who have generously contributed their greatest images to help nature conservation. Their names and details appear on page 247.

A special thank you goes to **Hum Gurung**, **Felicia Wee**, **Adrian Long** and **Keiko Suzue** from BirdLife International for coordinating travelling schedules, compiling research papers and helping with many other matters.

The support from the former (**Cristi Marie C. Nozawa**) and present (**Vinayagan Dharmarajah**) directors of BirdLife International (Asia) was integral to the development of this project.

We also offer our heartfelt gratitude to:
**Jonathan Charles Eames,** OBE for his contribution of images, assistance with the manuscript, and personally accompanying us and arranging a most productive stay at Western Siem Pang, Cambodia, in addition to a well-attended vulture restaurant event.

**Chea Sophea** for expertly coordinating ground arrangements at Western Siem Pang forest, and **Mai Mem** for selecting the right sites for building multiple natural hides, helping us to get exceptional images of the five targeted Critically Endangered ibises and vultures. Also thank you to **Phan Pheara** and **Chhun Thorn** for collecting us on time at four o'clock every morning.

**Neha Sinha** for her help with the India trip schedule, Nagaland photos and going through the manuscript, and to **Lalal Khongsai** for taking care of all practical arrangements and showing us some of the memorable places of Nagaland and Assam states.

**Ria Saryanthi** for her assistance and for accompanying us throughout our stay at Harapan Rainforest, Indonesia. Also thank you to **Agis Dian Agista** and the Harapan and Burung Indonesia team for help with all the feedback and arrangements.

**Henry Goh** for personally accompanying us to Belum-Temengor Forest Complex, Peninsular Malaysia.

**Yeap Chin Aik** for organising the Belum-Temengor trip, including transport, provisions, and delicious chicken rice lunches in the field hide. Also thank you for the comprehensive assistance with research, manuscript and photos.

**Ch'ien C. Lee** for assisting and contributing several images for this new publication.

**Marisan Pandak, Razak Bin Sema, Roslan Carang, Hadi Bin Mes, Azam Carang** and **Dedi Bin Roslan** and the Orang Asli of Kampung Huweh in the Belum-Temengor forests, Malaysia for letting us document their work and facilitating some rare hornbill encounters. Also thank you for the most delicious durian.

**Narendra Man Babu Pradham, Ishana Thapa** and **Rajendra Gurung** of Bird Conservation Nepal (BCN) for coordinating our trip to Bardia National Park, going through our trip notes, as well as briefing us on the various BCN conservation activities.

**Ram Shahi, Daya Ram Chaudhary** and last but not least **Padam** for all the guiding and field arrangements in western Nepal.

**Dhritiman Mukherjee** for his contribution from his award winning image gallery.

**Noel Resurreccion** and **David Quimpo** for arranging the field and motorbike rides to visit Mount Irid-Angelo, Philippines, and for checking the manuscript. Thanks also go to the Dumagat people of Mount Irid-Angelo for letting us record their work.

**Dr. Lawrence R. Heaney** for providing research material and images of the endemic mammal hotspot of Luzon Island, Philippines.

**Prof. Sarath Kotagama** for spending time with us amidst his busy schedule, and for coordinating our Sri Lanka visit and reviewing our trip notes.

**Kusum Kumar Fernando** for taking time off to show us the spectacular nature of Sinharaja and Sri Lanka. Kusum also managed to get his 4x4 in and out of one of the deepest potholes we have seen for some time.

**Rahula Perera, Prof. Devaka Weerakoon** and **Dr. Prithiviraj Fernando** for spending time to brief us on the current conservation situation in Sinharaja and in Sri Lanka, and to **Enoka P. Kudavidanage** for helping to review the manuscript of the Sinharaja chapter and providing comprehensive notes.

**Salindra Kusum Dayananda** for checking our draft manuscript and guiding us during our productive time in the field in Sinharaja.

**Gehan de Silva Wijeyeratne** for information and numerous unique images from Sinharaja.

**Pham Tuan Anh** and **Le Trong Trai** for personally briefing us and accompanying us around the Khe Nuoc Trong Proposed Nature Reserve in central Vietnam, thanks also go to **Paul Insua-Cao** for helping to check the draft manuscript.

**Dr. William Robichaud** for taking time off to share with us his amazing story and unrivaled experience with the mysterious Saola - as well as providing iconic images.

**Dang Gia Tung** for information and assistance regarding Edwards's Pheasant. Also thank you to **Ha Van Nghia** and **Le Van Nghia** for assisting with logistics, motor bike rides, and cooking during our stay in the field in Vietnam.

Our sincere thanks and appreciation also go to the countless unnamed naturalists who have made us appreciate the spirit of 'Together we can make a difference'.

*Fanny & Bjorn*

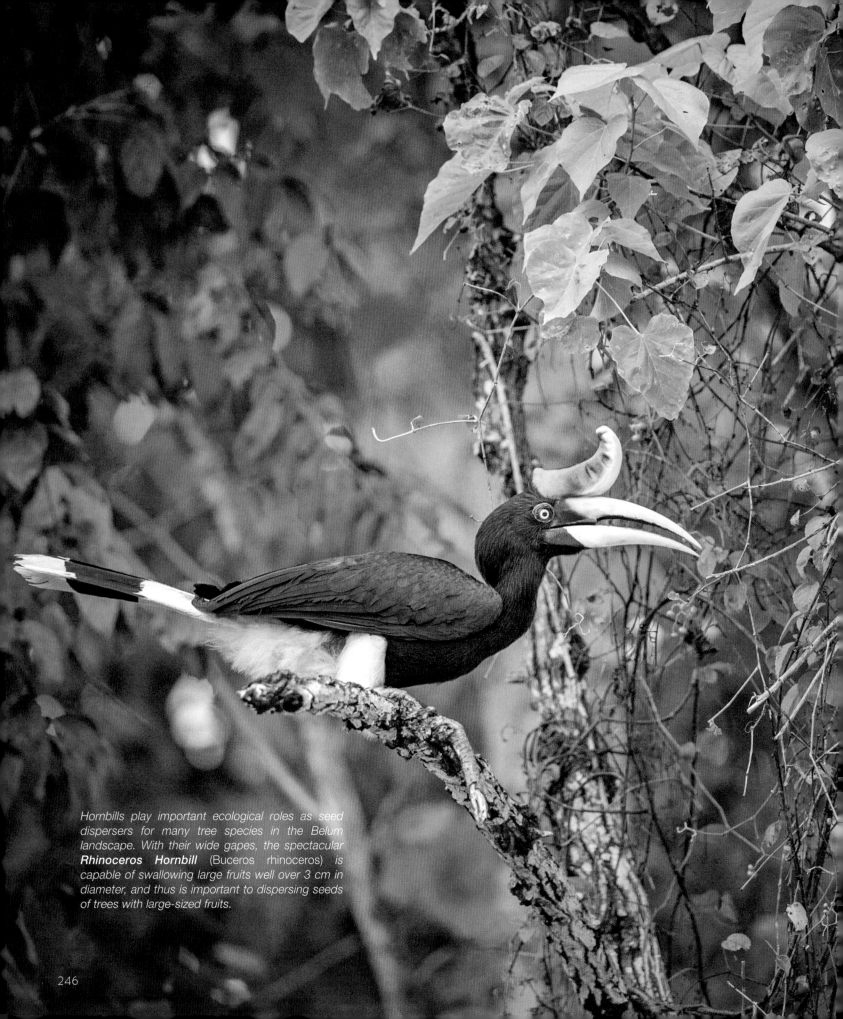

Hornbills play important ecological roles as seed dispersers for many tree species in the Belum landscape. With their wide gapes, the spectacular **Rhinoceros Hornbill** (Buceros rhinoceros) is capable of swallowing large fruits well over 3 cm in diameter, and thus is important to dispersing seeds of trees with large-sized fruits.

Editor *Yong Ding Li* • Design & Layout *Zinnira Bani* • Cartography *Teo Siyang* • Copy Editing *Judith Rumgay* • Dust Jacket *June Chong*

# Contributing Photographers

| | |
|---|---|
| Rey Sta. Ana | page 12, 166, 174, 179, 181, 182, 183, 184, 186, 188 |
| Samarn Khunkwamdee | page 95, 116, 119, 120, 121, 124, 126 |
| Arjin Sookkaseam (Guide A) | page 86, 113, 122, 125 (2nd photo), 127, 153 |
| Dhritiman Mukherjee | page 66, 141, 149, 158, 162 |
| Jonathan Charles Eames, OBE | page 20, 23, 24, 43 |
| Benjamin Schweinhart | page 48, 143, 148 |
| Ch'ien C. Lee | page 104, 110, 114 |
| Conservation India | page 55, 56, 58 |
| Gehan de Silva Wijeyeratne | page 195, 198, 199 (1st photo) |
| Chairunas Adha Putra | page 80 (2nd photo), 81 |
| Pete Morris | page 10, back of dust jacket |
| Hutan Harapan | page 80 (1st photo), 82 |
| William Robichaud | page 237, 241 |
| Ban Vangban Village/Wildlife Conservation Society | page 239 |
| Bird Conservation Nepal (BCN) | page 136 |
| BirdLife Cambodia Programme | page 25 (2nd photo) |
| Birdlife International | page 13 |
| The late Danilo S. Balete © Field Museum of Natural History | page 176 |
| Enoka P. Kudavidanage | page 216 |
| Fanny Lai | page 155 |
| Ixi Mapua | page 178 |
| Jyotendra Jyu Thakuri | page 139 |
| Lawrence R. Heaney © Field Museum of Natural History | page 177 |
| Malaysian Nature Society (MNS) | page 102 |
| Muhammad Alzahri | page 70 |
| Lee Tiah Khee | page (inner back sleeve 2nd photo) |
| Pasha Ho | page 107 |
| Uditha Hettige | page 218 |
| Wildlife Conservation Society | page 240 |
| William Robichaud/Wildlife Conservation Society | page 243 |
| Wong Wai Hang, Jason | page 258 |
| Yam Tee Yong | page 14 |
| Yann Muzika | page 225 |
| Yeap Chin Aik | page 124 (2nd photo) |

Out of the 129 animal species illustrated in this publication, we were unable to find quality images taken in the wild for five species. In these cases we have used photographs from a captive environment. The species in question are: Philippine Eagle (page 12 and 166 only), Edwards's Pheasant, Sunda Pangolin, Malayan Tapir and Large-antlered Muntjac.

# Useful Websites

| | |
|---|---|
| Arkive | http://www.arkive.org |
| Avibase – the world bird database | https://avibase.bsc-eoc.org |
| Asian Wild Cattle Specialist Group | http://www.asianwildcattle.org/ |
| Bat Conservation International | http://www.batcon.org/our-work/regions/asia |
| Bird Conservation Nepal (BCN) | http://www.birdlifenepal.org |
| BirdLife International | http://www.birdlife.org |
| Bombay Natural History Society (BNHS) | http://www.bnhs.org |
| Burung Indonesia | http://burung.org |
| Ceylon Bird Club | http://www.ceylonbirdclub.org |
| Ch'ien C. Lee | http:www.wildborneo.com.my |
| Conservation India | http://conservationindia.org/ |
| Conservation International | http://conservation.org/ |
| Darwin Online | http:www.darwin-online.org.uk |
| Dhritiman Mukherjee Images | http:www.dhritimanimages.com |
| Fauna & Flora International (FFI) | http://www.fauna-flora.org |
| Field Ornithology Group of Sri Lanka (FOGSL) | http://www.fogsl.net |
| Global Wildlife Conservation | http://globalwildlife.org/our-work/regions/asia/ |
| Harapan Rainforest | http://harapanrainforest.org |
| Haribon Foundation | http://www.haribon.org.ph |
| International Union for Conservation of Nature (IUCN) | https://iucn.org/ |
| IUCN Red List | http://www.iucnredlist.org/ |
| Key Biodiversity Areas | http://www.keybiodiversityareas.org/ |
| Malaysian Nature Society (MNS) | http://www.mns.org.my |
| Merlin Tuttle's Bat Conservation | http://www.merlintuttle.com |
| Mongabay | http://mongabay.com |
| Nagaland Wildlife & Biodiversity Conservation Trust (NWBCT) | http://www.nagalandconservation.in/ |
| Nature Society (Singapore) | http://www.nss.org.sg |
| Oriental Bird Club | http://orientalbirdclub.org |
| Panthera | http://www.panthera.org/ |
| Philippine Eagle Foundation | http://www.philippineeagle.org |
| Protected Planet | https://protectedplanet.net/ |
| Raptor Research & Conservation Foundation | http://www.raptors.net.in |
| Saola Working Group | http://www.savethesaola.org |
| The Field Museum, Chicago | https://www.fieldmuseum.org /synopsis-philippine-mammals |
| TRAFFIC | http://www.traffic.org |
| Ungulates of the World | http://ultimateungulate.com |
| Viet Nature Conservation Centre | http://thiennhienviet.org.vn |
| Wallace Online | http:www.wallace-online.org |
| Wildlife Conservation Society, India | http://www.wcsindia.org |
| Wildlife Conservation Trust | http://www.wildlifeconservationtrust.org |
| Wildlife and Travel | http:www.wildlifewithgehan.blogspot.sg |
| World Birds | http://www.worldbirds.org |
| World Wide Fund for Nature (WWF) Malaysia | http://www.wwf.org.my |
| Zoological Society of London | http://www.zsl.org |

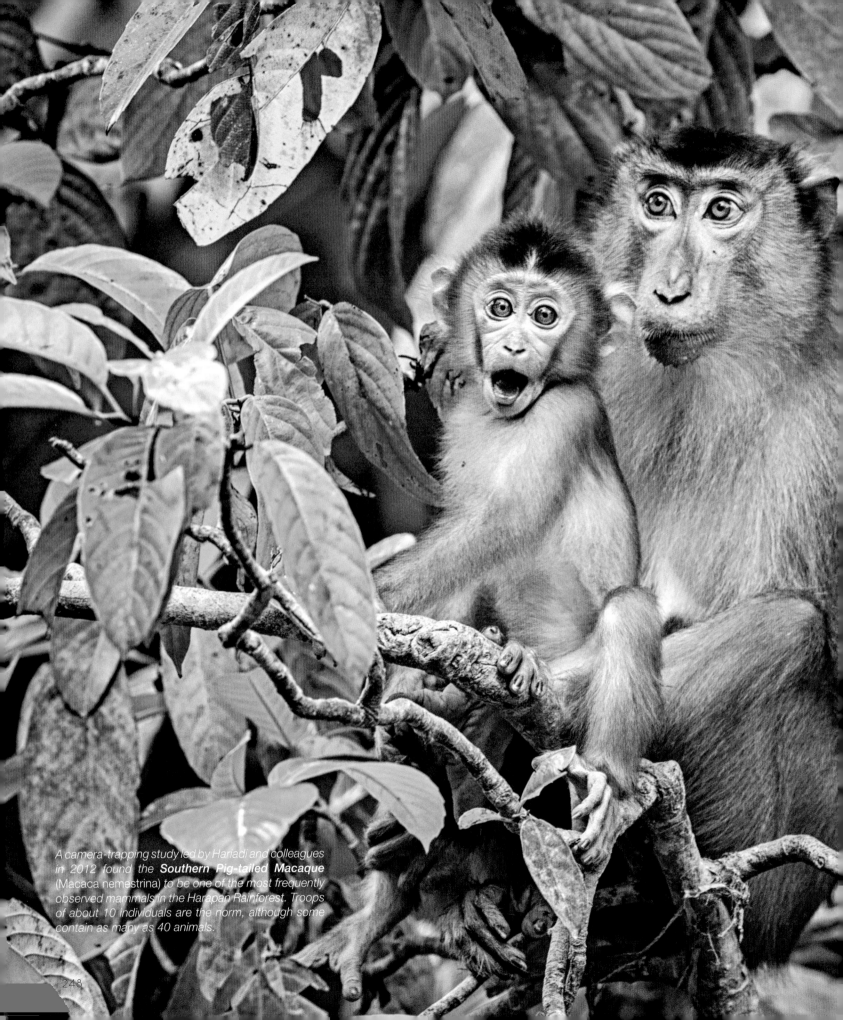

A camera-trapping study led by Hariadi and colleagues in 2012 found the **Southern Pig-tailed Macaque** (Macaca nemestrina) to be one of the most frequently observed mammals in the Harapan Rainforest. Troops of about 10 individuals are the norm, although some contain as many as 40 animals.

Sources and
References

# Sources and References

**Arlott, N.** 2015. Collins Field Guide, *Birds of India, Pakistan, Nepal, Bhutan, Bangladesh and Sri Lanka.* William Collins, London, UK.

**Balete, D.S.**, Heaney, L.R. and Rickart, E.A. 2013. *The mammals of Mt. Irid, Southern Sierra Madre, Luzon Island.* National Museum of the Philippines: Journal of Natural History *1: 15-29.*

**Baral, H.S.**, Ram, A.K., Chaudhary, D., Chaudhary, A., Timsina, A., Acharya, S., Bidari, K., Acharya, S., Acharya, B., Thulung, P., Karki, A. and Prasad Acharya, K. 2013. *Survey of Bengal Florican* Houbaropsis bengalensis bengalensis *in the Koshi Tappu Wildlife Reserve and adjoining areas, Nepal.* Journal of Threatened Taxa 5(7): 4076–4083.

**Department of National Parks and Wildlife Conservation (Nepal) (DNPWC).** 2011. *The State of Nepal's Birds 2010.* Bird Conservation Nepal and Department of National Parks and Wildlife Conservation, Kathmandu, Nepal.

**Bhattacharya, A.**, 2013. *'Campaign saves migratory falcons',* December 15, 2013. The Times of India.

**Bhupathy, S.**, Kumar, R., Thirumalainathan, P., Paramanandham, J. and Chang Lemba. 2013. *Wildlife exploitation: a market survey in Nagaland, North-eastern India.* Tropical Conservation Science 6(2): 241-253

**BirdLife International.** 2001. *Threatened Birds of Asia: the BirdLife International Red Data Book.* BirdLife International, Cambridge, UK.

**BirdLife International.** 2004. *Important Birds Areas in Asia: Key sites for conservation.* BirdLife International, Cambridge, UK.

**Birdlife International Cambodia Programme.** 2012. *The Biodiversity of the Proposed Western Siem Pang Protected Forest, Stung Treng Province, Cambodia.* BirdLife International Cambodia Programme, Phnom Penh, Cambodia.

**Bouwman, H.**, Symes, C. and du Plessis, H. *How to make 2.5 Billion Termites Disappear? A Case for Protecting the Amur Falcon Falco Amurensis.* Ornithological Observations 3:232-242.

**Bueser, G.L.L.**, Bueser, K.G., Afan, D.S., Salvador, D.I., Grier, J.W., Kennedy, R.S. and Miranda Jr, H. 2003. *Distribution and nesting density of the Philippine Eagle* Pithecophaga jefferyi *on Mindanao Island, Philippines: what do we know after 100 years?* Ibis, 145: 130-135.

**Burung Indonesia.** 2014. Fact Sheet. *Community Tree Nurseries: Engaging Communities for Ecological Restoration in Harapan Rainforest.* Burung Indonesia, Bogor, Indonesia.

**Choudhury, A.** 2005. *Significant records of birds in Nagaland, north-east India.* Forktail 21: 187.

**Collar, N.J.** 1996. *The Philippine Eagle: one hundred years of solitude.* Bulletin of the Oriental Bird Club 24:30-31.

**Collar, N.J.** 2015, *Helmeted Hornbills* Rhinoplax vigil *and the ivory trade: the crisis that came out of nowhere.* BirdingASIA 24:12-17.

**Conservation International Philippines**, Department of Environment and Natural Resources-Protected Areas and Wildlife Bureau and Haribon Foundation. 2006. *Priority Sites for Conservation in the Philippines: Key Biodiversity Areas.* Conservation International, Quezon City, Philippines.

**Das, I.** 2010. *A Field Guide to the Reptiles of South-east Asia.* New Holland Publishers, London, UK.

**Das, I.** 2012. *A Naturalist's Guide to the Snakes of South-east Asia, Malaysia, Singapore, Thailand, Myanmar, Borneo, Sumatra, Java and Bali.* John Beaufoy Publishing Limited, Oxford, UK.

**Davison, G.W.H.** 1995. *Belum: A Rainforest in Malaysia.* Malaysian Nature Society, Kuala Lumpur, Malaysia.

**Dinets, V**, Brueggen, J.C. and Brueggen, J.D. 2015. *Crocodilians use tools for hunting,* Ethology Ecology & Evolution 27: 74-78.

**Dixon, A.**, Batbayar, N. and Purev Ochir, G. 2011. *Autumn migration of an Amur Falcon* Falco amurensis, *from Mongolia to the Indian Ocean tracked by satellite.* Forktail 27. 86-89.

**de Kok, R.P.J.**, Briggs, M., Pirnada, D. and Girmansyah, D. 2015. *Identifying targets for plant conservation in Harapan rainforest, Sumatra.* Tropical Conservation Science 8(1): 28-32.

**Department of National Parks and Wildlife Conservation (Nepal).** 2015. *Vulture Conservation Action Plan for Nepal (2015—2019).* Department of National Parks and Wildlife Conservation, Ministry of Forests and Soil Conservation, Government of Nepal, Kathmandu.

**Eames, J.C.** 2015. *Western Siem Pang Hidden Natural Wonder of Cambodia.* Privately published.

**Fernando, P.**, Jayawardene, J., Prasad, T., Hendavitharana, W. and Pastorini, J. 2011. *Current Status of Asian Elephants in Sri Lanka.* Gajah 35:93-103.

**Francis, C.M.** 2008. *A Field Guide to the Mammals of South-East Asia.* New Holland Publishers, London, UK.

**Funk, W.H.** 2016. *Nepal's extraordinary devotion of preserving its rhinos.* Mongabay.com December 12, 2016.

**Goodale, E.** and Kotagama, S.W. 2006. *Vocal mimicry by a passerine bird attracts other species involved in mixed-species flocks.* Animal Behaviour 72: 471-477.

**Goodale, E.**, Salgado, A. and Kotagama, S.W. 2008. *Birds of a Different Feather. By mimicking a variety of animal calls, Sri Lankan drongos influence the behaviour of mixed-species flocks.* Natural History 117(6): 24-28.

**Government of Nepal**, Ministry of Forests and Soil Conservation, Department of National Parks and Wildlife Conservation. 2015. *Bardiya National Park and Buffer zone Management Plan.*

**Grimmett, R.**, Inskipp, C. and Inskipp, T. 2009. *Birds of Nepal.* Om Books International, New Delhi, India.

**Hariadi, B.**, Novarino,W. & Rizaldi. 2012. Inventarisasi Mamalia di Hutan Harapan Sumatera Selatan. Journal Biologi Universitas Andalas 1(2): 132-138.

**Haribon Foundation.** 2014. *The State of the Philippine Birds.* Haribon Foundation for the Conservation of Natural Resources Inc, Quezon City, Philippines.

**Harrison, D.R.** and Swinfield, T. 2015. *Restoration of logged humid tropical forests: An experimental programme at Harapan Rainforest, Indonesia.* Tropical Conservation Science 8 (1): 4-16.

**Heaney, L.R.**, Balete, D.S., Rickart, E.A., Veluz, M.J. and Jansa, S.A. 2009. *A New Genus and Species of Small 'Tree-Mouse'* (Rodentia, Muridae) *Related to the Philippine Giant Cloud Rats.* Bulletin of the American Museum of Natural History 331: 205-229.

**Heaney, L.R.**, Balete, D.S., Rickart, E.A., Veluz, M.J. and Jansa, S.A. 2014. *Three New Species of Musseromys* (Muridae, Rodentia), *the Endemic Philippine Tree Mouse from Luzon Island.* American Museum Novitates, 2802. 22 pp.

**Heaney, L.R.**, Balete, D.S., Veluz, M.J., Steppan, S.J., Esselstyn, J.A., Pfeiffer, A.W. and Rickart, E.A. 2014. *Two new species of Philippine forest mice* (Apomys, Muridae, Rodentia) *from Lubang and Luzon Islands, with a redescription of* Apomys sacobianus *Johnson, 1962.* Proceedings of the Biological Society of Washington 126(4): 395-413.

**Heaney, L.R.**, Balete, D.S., Duya, M.R.M., Duya, M.V., Jansa, S.A., Steppan, S.J. and Rickart, E.A. 2016. *Doubling diversity: a cautionary tale of previously unsuspected mammalian diversity on a tropical oceanic island.* Frontiers of Biogeography 8(2): e29667.

**Heaney, L.R.**, Balete, D.S. and Rickart, E.A. 2016. *The Mammals of Luzon Island, Biogeography and Natural History of a Philippine Fauna.* John Hopkins University Press, Baltimore, Maryland, USA.

**Hutan Harapan.** 2014. *Strategic Forest Management Plan 2014 to 2040.* Hutan Harapan, Indonesia.

**Jeyarajasingham, A.** and Pearson, A. 2012. *A Field Guide to the Birds of Peninsular Malaysia and Singapore.* Oxford University Press, Oxford, UK.

**Jnawali, S.R.**, Baral, H.S., Lee, S., Acharya, K.P., Upadhyay, G.P., Pandey, M., Shrestha, R., Joshi, D., Laminchhane, B.R., Griffiths, J., Khatiwada, A.P., Subedi, N. and Amin, R. (compilers). 2011. *The Status of Nepal's Mammals: The National Red List Series.* Department of National Parks and Wildlife Conservation, Kathmandu, Nepal.

**Kasambe, R.** 2014. *Doyang Reservoir: A potential IBA in Nagaland.* Mistnet 15(2): 24-28.

**Katuwal, H.B.** 2016. *Sarus Crane in lowlands of Nepal: Is it declining really?* Journal of Asia-Pacific Biodiversity 9(3): 259-262.

**Kemph, E.** 2013. *The Saola's Battle for Survival on the Ho Chi Minh Trail.* World Wide Fund for Nature, Gland, Switzerland.

**Kinnaird, M.F.** and O'Brien, T.G. 2007. *The Ecology & Conservation of Asian Hornbills, Farmers of the Forest.* The University of Chicago Press, London, UK.

**Kotagama, S.W.** and Goodale, E. 2004. *The composition and spatial organisation of species flocks in a Sri Lankan rainforest.* Forktail 20:63-70.

**Kumar, R.S.**, Bhupathy, S., Nakro, V., Thirumalainathan, P., Paramadandham, J. and Sarma, P. 2012. *Blyth's Tragopan* Tragopan Blythii *(Jerdon 1870) in Eastern Nagaland: Peoples' Perception.* Journal of the Bombay Natural History Society 109 (1 & 2): 82-86.

**Kennedy, R.S.**, Gonzales, P.C., Dickinson, E.C., Miranda Jr, H.C. and Fisher, T.H. 2010. *A Guide to the Birds of the Philippines.* Oxford University Press, Oxford, UK

**Keo, O.** 2008. *Ecology and conservation of the Giant Ibis* Thaumatibis gigantea *in Cambodia.* BirdingASIA 9:100-106.

**Kumar, R. S.** 2015. *Tracking the Incredible Journey of the Amur Falcon.* Conservation India.

**Haralu, B.** and Sreenivasan, R. 2014. *Friends of the Amur Falcon, Year 1 Report.* Nagaland Wildlife & Biodiversity Conservation Trust (NWBCT), Dimapur, Nagaland, India.

**Hurrell, S.** 2016. *Huge Protected forest jigsaw completed.* BirdLife International Newsletter, 20 May 2016.

**Ibanez, J.C.** 2007. *Philippine Eagle* (Pithecophaga jefferyi) *Breeding Biology, Diet, Behavior, Nest Characteristics, and Longevity Estimate in Mindanao Island, Philippines.* ADDU-Ateneo de Davao University. Unpublished Masters thesis dissertation.

**Ravinder, K.**, Ong, T., Lim, K.C. and Yeap, C.A. 2011. *A Survey on mass movements of the vulnerable Plain-pouched Hornbill in the Belum-Temengor Forest Complex, Peninsular Malaysia.* The Raffles Bulletin of Zoology 2011 Supplement No. 24: 171-176.

**Lawrence, J.** 2012. *Help required to end hunting massacre in Nagaland, India.* BirdLife International. November 15, 2012.

**Lawrence, J.** 2013. *Action for Amur Falcons brings hope for an end to hunting in Nagaland.* BirdLife International. 29 November, 2013.

**Le, M.H.**, Pham, D.T., Tordoff, A.W. and Nguyen, D.D. 2002. *A Rapid Field Survey of Le Thuy and Quang Ninh Districts, Quang Binh Province, Vietnam.* Birdlife International Vietnam Programme, Hanoi, Vietnam.

**Lim, K.C.** 2010. *Belum-Temengor Forest Complex, north peninsular Malaysia.* BirdingAsia 14:15-22.

**Ministry of Environment.** 2012. *The National Red List 2012 of Sri Lanka; Conservation Status of the Fauna and Flora.* Ministry of Environment, Colombo, Sri Lanka.

**Nadler, T.** and Brockman, D. 2014. *Primates of Vietnam.* Endangered Primate Rescue Center, Vietnam

**Pham, A.T.** and Le, T.T. (compilers) 2015. *Action Plan for the Conservation of the Edwards's Pheasant* Lophura edwardsi *for the period 2015 – 2020 with vision to 2030.* Viet Nature Conservation Centre, Hanoi, Vietnam.

**Poonswad, P.**, Kemp, A. and Strange, M. 2013. *A Photographic Guide, Hornbills of the World.* Draco Publishing, Singapore & Hornbill Research Foundation, Bangkok, Thailand.

**Poudyal, L.P.**, Sing, P.B. and Maharjan S. 2007. *Status and Distribution of Bengal Florican* Houbaropsis bengalensis *in Nepal.* Report to the Oriental Bird Club, UK and the Club 300 Foundation for Bird Protection, Sweden. Department of National Parks and Wildlife Conservation, and Bird Conservation Nepal, Kathmandu, Nepal.

**Robson, C.** 2008. A Field Guide to the Birds of South-east Asia. New Holland Publishers, London, UK.

**Rostro-Garcia**, S, J.F. Kamler, E., Ash, G.R., Clements, G.R., Gibson, L., Lynam, A.J., McEwing, R., Naing, N. and Paglia, S. 2016. *Endangered leopards: Range collapse of the Indochinese Leopard* (Panthera pardus delacouri*) in Southeast Asia.* Biological Conservation 201: 293-300.

**Saola Working Group**. 2013. *Conservation Through Collaboration: Proceedings of the 3rd Meeting of the Saola Working Group.* Saola Working Group, Asian Wild Cattle Specialist Group of the IUCN Species Survival Commission. Vientiane, Laos.

**Sathischandra, S. H. K.**, Kudavidanage, E.P., Goodale, E. and Kotagama, S.W. 2007. *Foraging Ecology of Crested Drongos* (Dicrurus paradiseus lophorhinus) *in the Sinharaja Reserve.* Siyoth, 2 (1): 9-11.

**Schwabe, K.A.**, Carson, R.T., DeShazo, J.R., Potts, M.D., Reese, A.N. and Vincent, J.R. 2015 *Creation of Malaysia's Royal Belum State Park: A Case Study of Conservation in a Developing Country.* Journal of Environment & Development 24(1): 54-81.

**Silalahi M**, and Erwin, D. 2015. *Collaborative Conflict Management on Ecosystem Restoration Concession: Lessons Learnt from Harapan Rainforest Jambi-South Sumatra-Indonesia.* Forest Research 4: 134.

**Sinha, N**, 2014. *A Hunting Community in Nagaland Takes Steps Toward Conservation.* International New York Times, January 3, 2014.

**Smillie, S.** 2011. *The 'amazing' saga of this Amur Falcon'.* The Star, June 27, 2011.

**Smillie, S.** 2011. *Flight 95773: Part 2.* The Star, June 28, 2011.

**Sreenivasan, R.** and Dalvi, S. 2012. *Shocking Amur Falcon Massacre in Nagaland.* Conservation India.

**Szotek, M.** 2012, December 17. *From catastrophic to the sustainable: the flight of the Amur Falcon.* Mongabay.com.

**Sterling, E.J.**, Hurley, M.M. and Le, D.M. 2006. *Vietnam: A Natural History.* Yale University Press, London, UK.

**ten Velde, R.F.** 1996. *The Wild Elephants of the Royal Bardia National Park, Nepal.* Gajah 17: 41-44.

**Timmins, R.J.**, Robichaud, W.G., Long, B., Hedges, S., Steinmetz, R., Abramov, A., Do, T. and Mallon, D.P. 2008. *Pseudoryx nghetinhensis.* The IUCN Red List of Threatened Species 2008: International Union for Conservation of Nature and Natural Resources.

**Timmins, R.J.** 2012. *An assessment of the 'vulnerability' of the Proposed Western Siem Pang Protected Forest to climate change, with recommendations of adaptation and monitoring.* BirdLife International Cambodia Programme, Phnom Penh, Cambodia.

**Urriza, R.C.**, Edrial, M.J., Almazan, A., Guevarra, R. and Briones, E. 2007. `*Preliminary survey of the biodiversity assemblage within a secondary growth medium altitude dipterocarp forest on Mts. Irid-Angelo IBA, General Nakar Quezon'.* Haribon Foundation, Quezon City, Philippines.

**Wijesinghe, M.** 1999. *Nesting of Green-billed Coucals* Centropus chlororhynchos *in Sinharaja, Sri Lanka.* Forktail 15: 43-45.

**Warakagoda, D.** 2006. *Asian Bird: New Discovery: Sri Lanka's Serendib Scops Owl.* BirdingASIA 6:68-71.

**Warakagoda, D.**, Inskipp, C., Inskipp, T. and Grimmett, R. 2012. *Birds of Sri Lanka. Helm Field Guides.* London. UK.

**Wikramasinghe, L..J.M.**, Bandara, I.N., Vidanapathirana, D.R., Tennakoon, K.H., Samarakoon, S.R. and Wickramasinghe, N. 2015. Pseudophilautus dilmah, *a new species of shrub frog* (Amphibia: Anura: Rhacophoridae) *from a threatened habitat Loolkandura in Sri Lanka.* Journal of Threatened Taxa 7(5): 7089–7110.

**Wright, H.L.**, Collar, N.J., Lake, I.R., Vorsak, B. and Dolman, P.M. 2012. *Foraging ecology of sympatric White-shouldered Ibis* Pseudibis davisoni *and Giant Ibis* Thaumatibis gigantea *in northern Cambodia.* Forktail 28 (2012):93-100.

**Wright, H. L.** *Resource use and livelihood change in Cambodia's dry forests: implications for conservation.* BirdLife International Cambodia Programme, Phnom Penh, Cambodia.

**Wright, H.L.**, Collar, N.J., Lake, I.R., Norin, N., Vann, R., Ko, S., Phearun, S. and Dolman, P.M. 2012. *First census the the White-shouldered Ibis* Pseudibis davisoni *reveals roost-site mismatch with Cambodia's protected areas.* Oryx 46(02): 236-239.

**Yeap, C.A.** and Ooi, K.H. (eds). 2014. *In Celebration of Hornbills: Belum-Temengor Forest Complex.* Malaysian Nature Society, Kuala Lumpur, Malaysia.

**Yeap, C.A.** 2013. *Nesting Hornbills in Belum Temengor.* Suara Enggang Vol. 21/(2): 30-40.

**Yeap, C.A.**, Ong, T., Lim, K.C., Kaur, R. and Rashida, D. 2015. *Conserving the globally threatened Plain-pouched Hornbills in the Belum-Temengor Forest Complex, Peninsular Malaysia.* Malayan Nature Journal 67(2):145-158.

# Recommended Reading

**Clayton, S.** and **Myers, G.** 2009. *Conservation Psychology, Understanding & Promoting Human Care for Nature.* John Wiley & Sons Ltd. Chichester, UK.

**Cocker, M.** 2013. *Birds & People.* Jonathan Cape, London, UK.

**Couzens, D.** 2015. *Top 100 Birding Sites of the World.* Bloomsbury Publishing Plc, London, UK.

**Davies, B.** 2005. *Black Market: Inside the Endangered Species Trade in Asia.* Earth Aware Editions, San Rafael. USA.

**Frances, P.** 2007. *Bird, The Definitive Visual Guide.* Dorling Kindersley Limited, London, UK.

**Hirschfeld, E.**, Swash, A. and Still, R. 2013. *The World's Rarest Birds.* Princeton University Press. Woodstock, Oxfordshire, UK.

**Singh, B.**, Sahgal, B. and Grewal, B. 2007. *The Corbett Inheritance.* Sanctuary Asia, Mumbai, India.

**van Wyhe, J.** 2013. *Dispelling the Darkness, Voyage in the Malay Archipelago and the Discovery of Evolution by Wallace and Darwin.* World Scientific Publishing Co., Singapore.

**Wallace, A.R.** 2015. *The Annotated Malay Archipelago* edited by van Wyhe, J. National University of Singapore Press, Singapore.

**Wijeyeratne, G.S.** 2007. *Sri Lankan Wildlife; a visitor's guide.* Bradt Travel Guides Ltd, Chalfont St Peter, UK.

**Wheatley, N.** 1996. *Where to watch birds in Asia.* Christopher Helm (Publishers) Ltd, London, UK.

**Yong, D.L.** and **Low, B.W**. 2016. *The 100 Best Bird Watching Sites in Southeast Asia.* John Beaufoy Publishing Ltd, Oxford, UK.

The **Lesser Adjutant** (Leptoptilos javanicus) *is widely distributed across Southeast Asia. Individuals are often seen foraging quietly in trapeangs within the dense dipterocarp forests of northern and eastern Cambodia.*

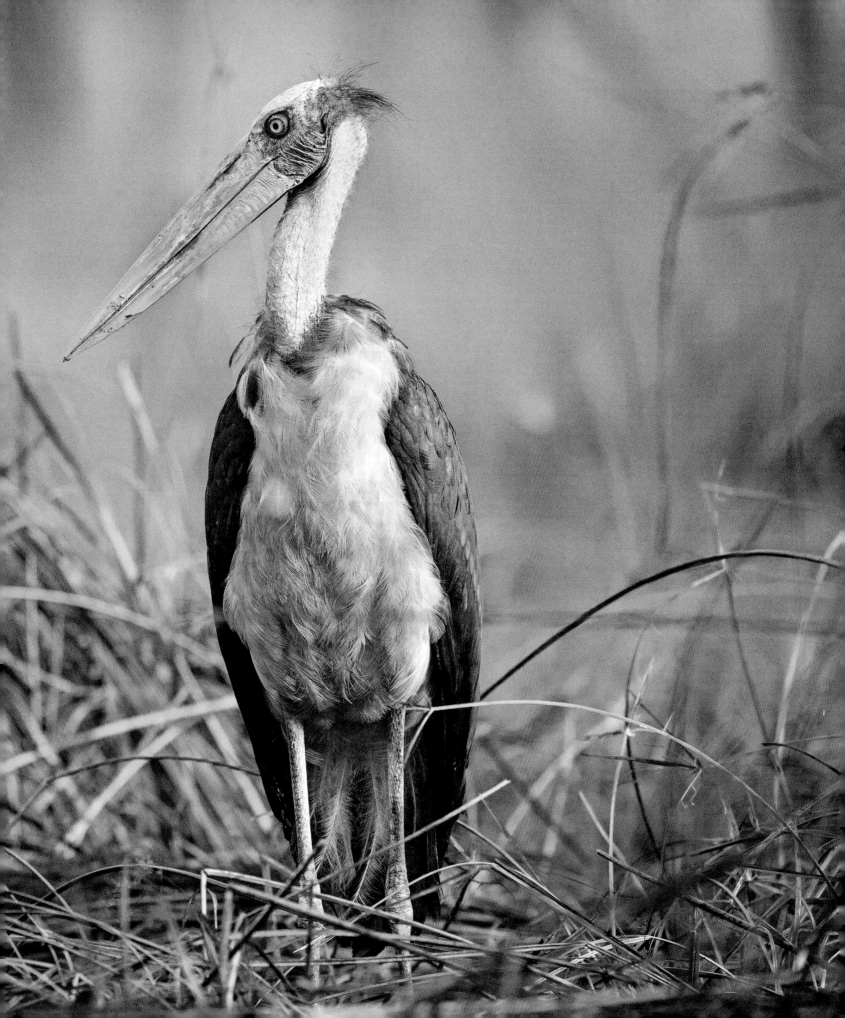

# Glossary and Abbreviations

**Apex predator** A predator at the top of the food chain, upon which no other creatures prey.
**Arboreal** Living in trees.
**Aquatic** Living in water.
**Avifauna** The bird assemblage of a particular region or habitat.

**BNHS** Bombay Natural History Society; the leading Indian wildlife research organisation which has been promoting nature conservation since 1883.

**Casque** A helmet-like structure or protuberance on a hornbill's head.
**CI** Conservation India.
**CITES** Convention on International Trade in Endangered Species of Wild Fauna and Flora; a multilateral treaty to protect endangered plants and animals.
**Clade** A taxonomic grouping of organisms believed to comprise all the evolutionary descendants and their common ancestor.
**CR** Critically Endangered; IUCN Red List conservation status classification.
**Crepuscular** (describing behaviour of an animal) appearing or active at twilight.
**Crustaceans** A large group of invertebrates, which includes but not limited to crabs, lobsters, shrimps and barnacles.

**DD** Data Deficient; IUCN Red List conservation status classification.
**Deciduous** The condition where a plant sheds its leaves seasonally.
**Diurnal** (describing behaviour of an animal) active during the daytime rather than at night.
**DNPWC** Department of National Parks and Wildlife Conservation (Nepal)

**EN** Endangered; IUCN Red List conservation status classification.
**ERC** Ecosystem Restoration Concession.
**Ex-situ Conservation** Measures to conserve a species occurs outside of the natural range of the species, e.g. in zoos or botanical gardens.

**Feral** An animal occurring in a wild state, but having descended from domesticated or captive individuals.
**FFI** Fauna & Flora International, the world's first international conservation organisation, established in 1903.
**Fledgling** A young bird that is sufficiently developed for flight, but still dependant on parental care.
**Flush** An act of frightening an animal out of concealing cover.
**FOGSL** Field Ornithology Group of Sri Lanka.
**FoH** Forests of Hope.
**Folivore** An animal that feeds predominantly on leaves.
**Folivorous** Feeding on leaves.
**Frugivorous** Feeding on fruit.

**Genus** A rank of classification in taxonomy above the species level, and below the family level.
**Gestation** The state of being pregnant; the period from conception to birth.
**Gunung** Malay and Indonesian word for mountain.

**Herbivore** An animal that feeds on plants.
**Herpetofauna** The reptiles and amphibians of a particular region or habitat.
**Herpetology** The branch of zoology concerned with the study of reptiles and amphibians.
**Hibernation** A survival strategy used by some animals in which their metabolic rate slows down and a state of deep sleep is attained, usually in winter. While hibernating, animals survive on stored reserves of accumulated fat.
**Home range** The extent and location of an area occupied annually by a wild animal in its natural habitat.
**Holotype** A specimen of an organism used in the first formal description of the species represented by it.
**Incubation period** The period from when an egg is laid to the time it hatches.
**Insectivorous** Feeding on insects.
**Invertebrate** An animal lacking a backbone. Invertebrates include but are not limited to insects, molluscs and worms.
**IUCN** International Union for Conservation of Nature.

**Kleptoparasite** An animal which habitually robs other animals for food

**LCG** Local Conservation Groups.
**LC** Least Concern; IUCN Red List conservation status classification.

**Megafauna** The larger vertebrate species of a particular region or habitat.
**Montane forest** Forests that usually occur above 1,000 m above sea level, and defined by specific groups of plants. Montane forests may start at higher or lower elevations, depending on various geographic factors.
**MAB** Man and Biosphere Reserve.
**MNS** Malaysian Nature Society.
**Morph** A variant of an animal or plant species, usually distinguished from the normal form by colour.
**Mutualism** Symbiotic interaction between two species that is mutually beneficial.

**New World** Geographical region defined by North and South America and the Caribbean islands.
**Nocturnal** (describing behaviour of an animal) Active at night, the opposite of diurnal.
**Non-volant** Incapable of flight.
**NT** Near Threatened; IUCN Red List conservation status classification.
**NTFP** Non-timber forest products.
**NWBCT** Nagaland Wildlife and Biodiversity Conservation Trust – A conservation non-governmental organisation in India.

**Old World** Geographical region defined by Europe, Africa and Asia.
**Orang Asli** Collective term for the indigenous peoples of Peninsular Malaysia.

**Passerine** A bird belonging to the large avian order Passeriformes. Passerine or 'perching birds' are defined by their distinctive foot structure of three forward pointed toes and one backward toe.
**Pelagic** Of the open sea.

**Primary forest** Old-growth forest; forest subjected to little or no human disturbance.
**Pulau** Malay and Indonesian word for island.

**Race** Another term for subspecies.
**RSPB** The Royal Society for the Protection of Birds, a major conservation non-governmental organisation in the United Kingdom.

**Secondary forest** Forest that has re-grown, and regenerated after a significant amount of disturbance, either man-made or natural.
**Speciation** The formation of new and distinct species arising in the course of evolutionary processes (e.g. adaptive radiation).
**Sp.** An abbreviated form of 'species'.
**Spp.** Plural of the abbreviated form for species, "sp."

**Taxon** (plural: taxa) Generic and hierarchically independent term for a taxonomic category (i.e. genus, species, etc)
**Terrestrial** Term to describe animal or plant which lives predominantly or entirely on land.
**Topography** The general artificial or natural land features of a place or region.
**TRAFFIC** A global wildlife trade monitoring network, established as a joint programme of the WWF and the IUCN. It aims to address issues of trade of animals and plants in the broader context of conservation
**Trapeang** Khmer term for a seasonal or permanent water body usually associated with deciduous dipterocarp forest or grassland in Cambodia.

**Understorey** The relatively open area beneath the main canopy of a forest.
**Ungulate** A large, loosely defined group of mammals, many of which possess hoofed toes. Recent classifications based on modern phylogenetic analaysis have expanded the definition of ungulates by including whales and dolphins.
**Upper storey** The layer in the forest immediately below the canopy.

**Vertebrate** An animal of a large, diverse group defined by the possession of a backbone or spinal column. Vertebrates include mammals, birds, reptiles, amphibians, and fishes.
**Viel** Khmer word to describe within the forest mosaic dominated by sedges and grasses and with only a sparse tree cover.
**VU** Vulnerable; IUCN Red List conservation status classification.

**WCMC** World Conservation Monitoring Centre - the specialist biodiversity assessment arm of the United Nations Environment Programme.
**WCS** Wildlife Conservation Society, an international conservation organisation headquartered at the Bronx Zoo in New York.
**WWF** World Wide Fund for Nature. An international non-governmental organisation founded in 1961, and headquartered in Gland, Switzerland.

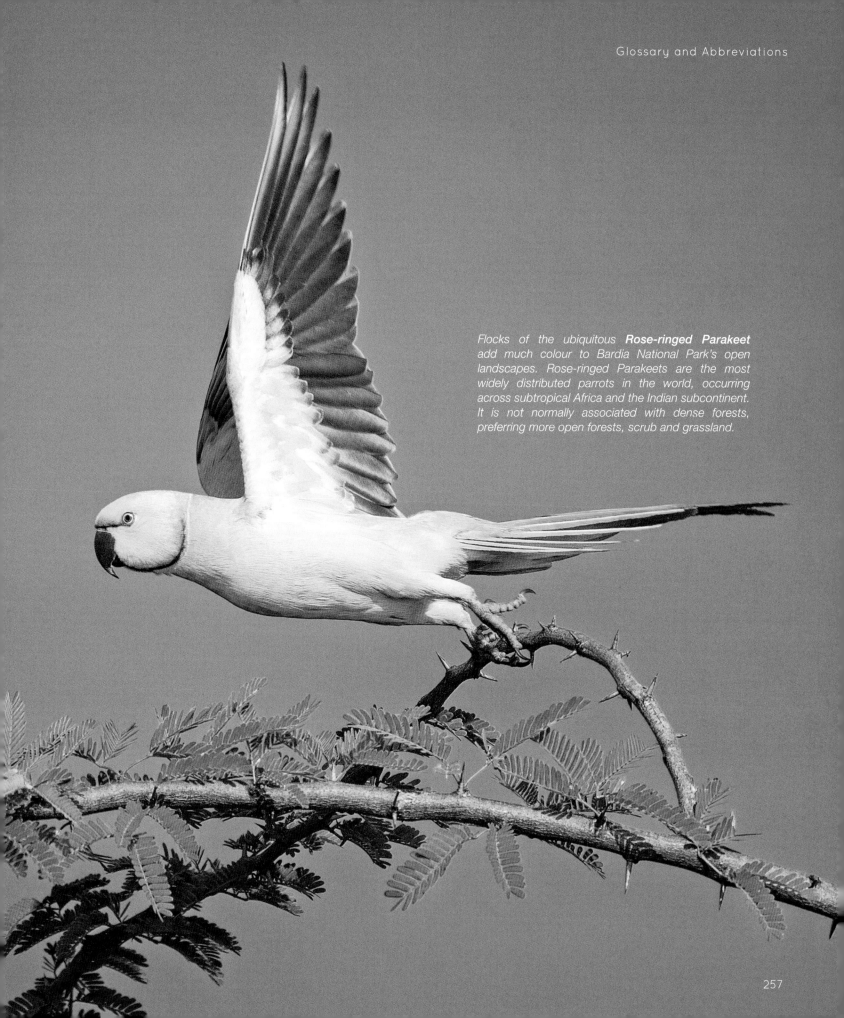

Flocks of the ubiquitous **Rose-ringed Parakeet** add much colour to Bardia National Park's open landscapes. Rose-ringed Parakeets are the most widely distributed parrots in the world, occurring across subtropical Africa and the Indian subcontinent. It is not normally associated with dense forests, preferring more open forests, scrub and grassland.

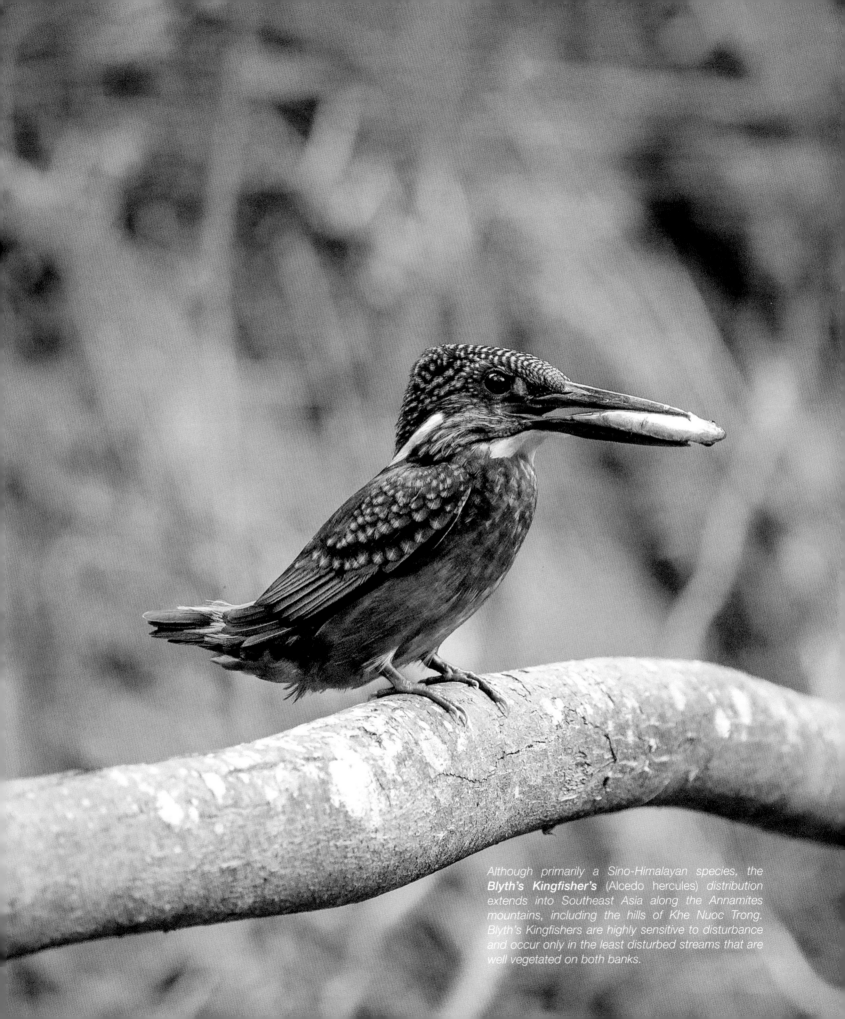

Although primarily a Sino-Himalayan species, the **Blyth's Kingfisher's** (Alcedo hercules) distribution extends into Southeast Asia along the Annamites mountains, including the hills of Khe Nuoc Trong. Blyth's Kingfishers are highly sensitive to disturbance and occur only in the least disturbed streams that are well vegetated on both banks.

Index

# Index

(Boldface figures indicates illustrations or main chapter)

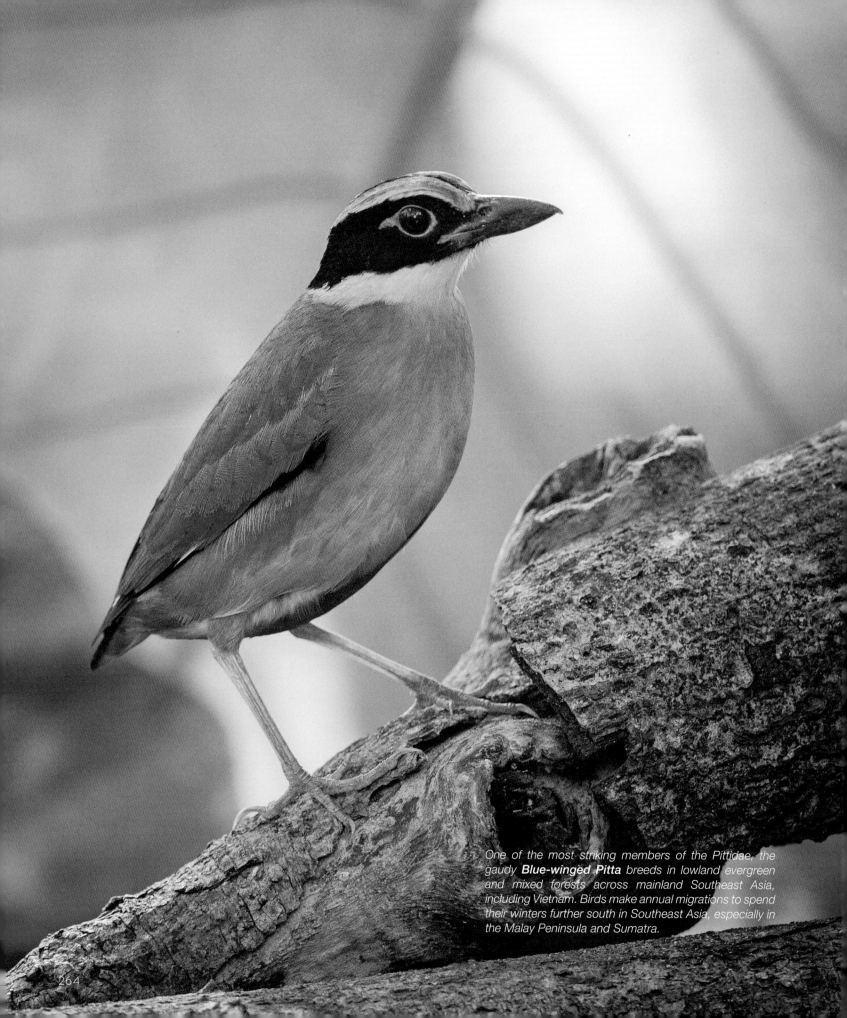

One of the most striking members of the Pittidae, the gaudy **Blue-winged Pitta** breeds in lowland evergreen and mixed forests across mainland Southeast Asia, including Vietnam. Birds make annual migrations to spend their winters further south in Southeast Asia, especially in the Malay Peninsula and Sumatra.

**BirdLife International** is the world's largest partnership of independent, national non-governmental nature conservation organisations. The BirdLife Partnership spans 122 countries and territories and is made up of millions of individuals contributing to conservation actions locally, regionally and globally. Through a local-to-global approach, the BirdLife partnership delivers effective and long term conservation for the benefit of nature and people. BirdLife is actively working in at least 16 countries across Asia.

**BirdLife International Cambodia Programme** is part of the BirdLife Secretariat and has been active in Cambodia since 1996. BirdLife Cambodia has an operational memoranda of understanding with the Ministry of Agriculture, Forestry and Fisheries, and the Ministry of Environment and has identified and documented Cambodia's Important Bird and Biodiversity Areas (IBAs). Following that, the focus of BirdLife Cambodia's work shifted to implementing conservation action on the ground for selected IBAs. The current programme of work in several Cambodian IBAs focuses on four areas:
(1) Preventing extinctions,
(2) Site planning, protection and management,
(3) Community-based conservation approaches, and
(4) Awareness and education.

**Bombay Natural History Society (BNHS)** is a pan-India, membership-driven wildlife research and conservation organisation. It has been promoting the cause for nature conservation since 1883. BNHS's mission is the conservation of nature through action based on research, education and promoting public awareness. BNHS aims to become a premier scientific organisation with a broad-based constituency that excels in the conservation of India's threatened species and their habitat.

**Burung Indonesia** was established in 2002 as an independent Indonesian non-government organisation after 10 years of being the programme office of BirdLife International in Indonesia. The organisation is legally registered as an association. Burung Indonesia aims to be the guardian of Indonesia's wild birds and their habitats through working with people for sustainable development.

The **Malaysian Nature Society (MNS)** is Malaysia's oldest, membership-based, environmental non-profit organisation. The mission of the Society is to promote the conservation of Malaysia's natural heritage. The objectives of MNS are
(1) to advocate for the protection of Malaysia's key biodiversity areas,
(2) to promote the better conservation of Malaysia's unique flora and fauna, and

(3) to advance conservation CEPA (communications, education and public awareness) across Malaysia.
MNS has over 2,000 members, 14 State Branches across the country and a Secretariat in Kuala Lumpur.

**Bird Conservation Nepal (BCN)**, established in 1982, is the leading organisation in Nepal focusing on the conservation of birds, and their habitats. It seeks to promote interest in birds amongst the general public, encourage research on birds, and identify major threats faced by bird species in the country. BCN has provided scientific data and expertise on birds for the Government of Nepal through the Department of National Parks and Wildlife Conservation It continues to work closely with various stakeholders to conserve birds and biodiversity throughout Nepal.

The **Haribon Foundation** is the Philippines' pioneer environmental organisation. Established in 1972 it is named after the "Haring Ibon" or "bird king", the Philippine Eagle. With more than 40 years of experience in biodiversity conservation, Haribon has built constituencies and empowered local communities through scientific and multi-disciplinary approaches. Haribon aims to carry out its mission to transform every individual into a biodiversity champion.

The **Field Ornithology Group of Sri Lanka (FOGSL)**, was established in 1976 as a membership based organisation institutionally approved by the Council of the University of Colombo. FOGSL was established with the vision of bringing together academic and amateur birdwatchers under the following objectives:
(1) Bring together people who are interested in the study and conservation of birds in Sri Lanka
(2) Generate interest among laymen and students of natural history on the study and conservation of birds
(3) Institute, direct and carry out island-wide programmes of field study, on various aspects of bird biology
(4) Establish links with other groups in other parts of the world with similar interest.

**Viet Nature Conservation Centre** is an autonomous national conservation NGO that has grown from BirdLife's involvement in over 20 years of programme development and support to civil society in Vietnam. Building upon the work and capacity of BirdLife, Viet Nature aims to continue to build national leadership in biodiversity conservation in Vietnam. The work of Viet Nature focuses on biodiversity monitoring, capacity building and raising awareness on the environment through education.

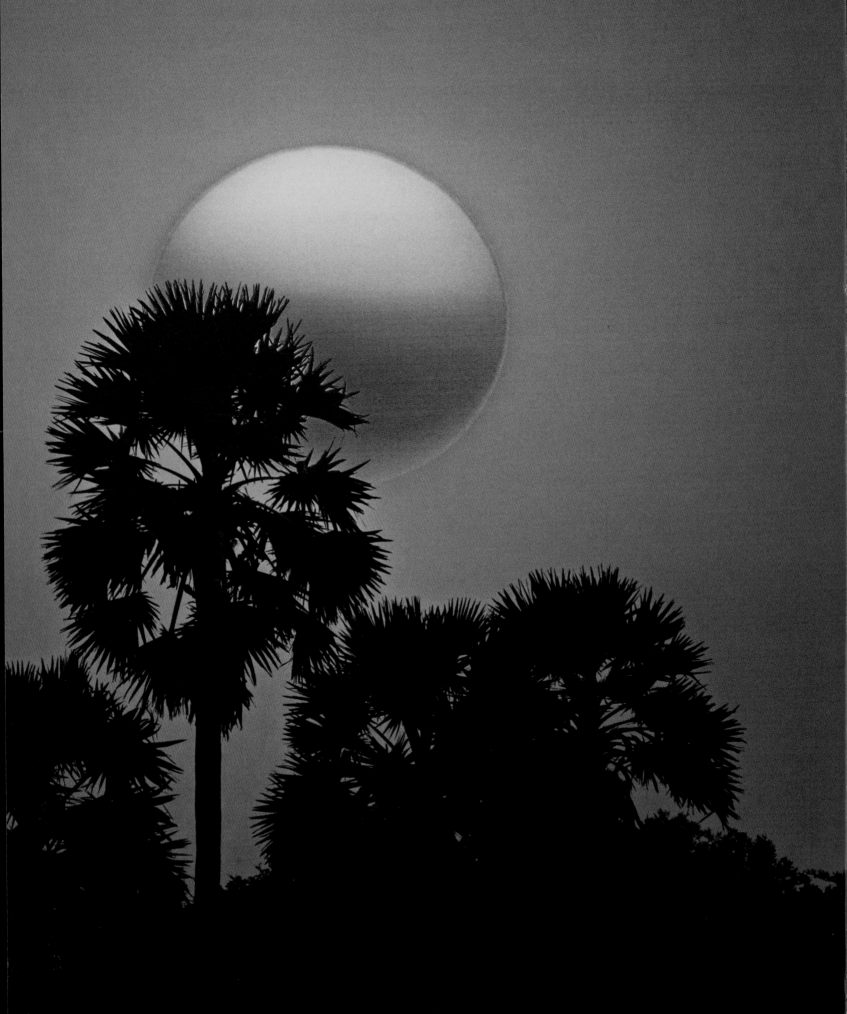